American

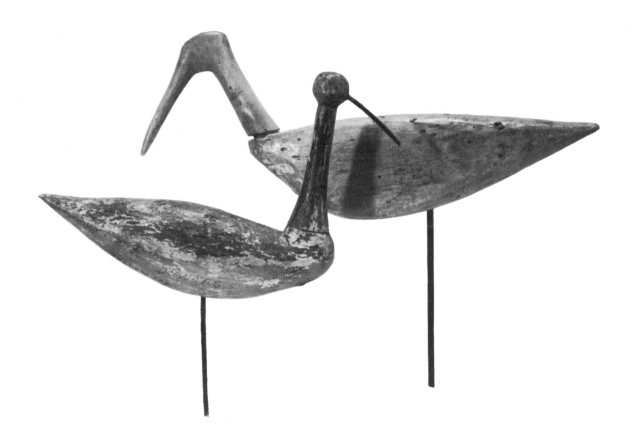

NEW YORK

Bird Decoys

WILLIAM J. MACKEY, JR.

With a chapter on
AMERICAN DECOYS AS FOLK ART
by Quintina Colio

New Edition with a Foreword by Richard A. Bourne
and A Remembrance by Kathryn H. Mackey

E. P. DUTTON

Grateful acknowledgment is made to the following for permission to quote from copyright materials:

Eugene V. Connett III for excerpts from *Duck Shooting Along the Atlantic Tidewater.* Copyright 1947, by William Morrow and Co.

Decoy Collectors' Guide for material first published in Winter 1964, Spring 1964, Fall 1964 issues.

Houghton Mifflin Co. for excerpts from *Natural History of the Birds of Eastern and Central North America,* by Edward Howe Forbush. Copyright 1939, by Houghton Mifflin Co.

Photographs by Quintina Colio, unless otherwise specified.

Published in the United States by E. P. Dutton,
a division of NAL Penguin Inc.,
2 Park Avenue, New York, N.Y. 10016.

Published simultaneously in Canada by Fitzhenry and Whiteside Limited, Toronto

Library of Congress Catalog Card Number: 86-72984
ISBN: 0-525-24500-6
W

Designed by George H. Buehler

10 9 8 7 6 5 4 3 2 1

Second Edition

Contents

		page
	Foreword, by Richard A. Bourne	6
	Preface	8
I	The American Decoy	11
II	Ducks and Geese	24
III	Shore Birds	35
IV	The Odd Birds: HERONS, EGRETS, TERNS, AND LOONS	54
V	Decoys of Vanished and Vanishing Birds: THE PASSENGER PIGEON, LABRADOR DUCK, AND ESKIMO CURLEW	60
VI	New England	64
VII	New York State	94
VIII	New Jersey	111
IX	The Delaware River	136
X	The Susquehanna and the Upper Chesapeake	142
XI	Virginia	150
XII	Carolina and Back Bay	166
XIII	The Middle West	178
XIV	Crows and Owls	195
XV	The Confidence Decoy	202
XVI	Factory Decoys	208
XVII	Beginner Beware!	237
XVIII	American Decoys: Folk Art, by Quintina Colio	240
	Appendix: THE MACKEY METHOD OF DECOY EVALUATION	248
	Afterword: A Remembrance by Kathryn H. Mackey	252
	Index	253

Foreword

I WAS DELIGHTED when I learned that Bill Mackey's *American Bird Decoys* was to be republished, for it is one of a select group of pioneer works in various fields of antique collecting that have been, and continue to be, used by me as essential reference works in producing my auction catalogs. When talking about Mackey's book in the decoy field, you automatically place it in the same company as other major reference works such as Nutting's *Furniture Treasury,* the McKearins's *American Glass,* or Carl Jacobs's *Guide to American Pewter.*

I have used *American Bird Decoys* repeatedly throughout the years since it was first published. In fact, I have a number of copies of the earlier edition as a reserve against loss and wearing out.

Bill Mackey was a dealer/collector with an equal love for both activities. I first met Bill through our mutual friend Wallace Furman of South Orleans, Massachusetts, an avid dealer in antiques and most particularly in decoys. It was Wallace who convinced me to commit a large consignment of decoys to an auction way back in 1966. This auction resulted in our commencing our annual decoy sales, which we continue to this day.

Thus I was in the right place with the right skills when Bill's untimely death brought about the auction of his collection and inventory. In my view, this sale is more responsible for the current appreciation of the true folk art value of decoys than any other, and incidentally, it quadrupled the prices they had been selling for.

There are probably many who visited Bill's Revolutionary period home and gasped at the array of spectacular decoys displayed there, but I doubt that many ever saw the hundreds of decoys, stacked like cordwood and covered with dust, piled against the stone walls of the cellar. It took us two hard days' work and a forty-five-foot semi-trailer to remove all of them.

That auction was conducted in five sessions during the years 1973 and 1974 and dispersed Bill's gathering of some 2,600 decoys and related carvings. It set many new records and made national television.

A number of men probably knew as much as Bill did about decoys, but it was Bill who first brought the wealth of information together for public consumption in *American Bird Decoys*. Many of the important birds from his own collection are pictured in this book, which has led to new discoveries and the preservation of many rarities during the years since its publication.

There have been a number of creditable and worthwhile works on decoys published since Bill's book, but to me, his remains the prize of the lot.

RICHARD A. BOURNE

Barnstable, Massachusetts
October 24, 1986

Preface

IT IS THE AIM of this book to focus attention upon the rich heritage of collectible decoys that have been made and used in America during the past century or more, to describe their inimitable characteristics, and to tell the colorful stories of the men who made them.

The material for the book has been almost forty years in the gathering. It all began for me, when as a young man, I picked up a no longer useful shore-bird decoy, admired it . . . and became a collector. Within a few years my claim to being an authority on the subject of decoys was staked out. How could there possibly be any more to know, or any additional objects to collect as evidence, than my initial frenzy had produced? It then took about twenty years to sift that evidence and become a humble student of the subject. The limited literature available pointed to other and less distinct trails that had to be followed to the end through many a false lead and un-expected turning.

As this fascinating search continued, the emerging facts about the men who made our decoys, their way of life, and the products of their skill began to form into patterns. However, the trails narrowed gradually, and in the more congested areas of our country disappeared entirely. The quest for fresh material was nearing an end. Shortly after World War I the professional market hunter disappeared from our bays and marshes, and during the past decade the old-time maker of handmade hunting decoys has vanished from the scene. Shore-bird decoys are rare because authentic working models must now be at least forty years old, while a swan decoy must be a veteran of several more decades. The greatest wildfowl hunt in history came to an end

almost fifty years ago, and a decision had to be reached. Would postponing the writing of the story of America's decoys and their makers contribute enough additional material to compensate for the loss of facts and recollections that must inevitably dim with the years?

We shall follow no rigid plan in our journey, but we shall have one constant objective: to seek and find some of the finest results of the decoy maker's craft and to present them in pictorial form, together with the stories behind them. The possession of a superb decoy gives a pleasant and heady sensation, but even more satisfying to me have been the friendships formed, and the exchanges of information that have taken place, in acquiring many of the decoys in my personal collection from their original owners. These sturdy, delightfully simple people were completely oriented to their outdoor tasks and pleasures. Faced with monotonous labors and subjected to unbelievable physical demands, these men, for the most part market hunters, carved their way to decoy fame.

My own collection of decoys is one that has increased over the years even though subject to periodic weeding out of less desirable items. This process, diligently pursued, has resulted in the collection and study of many thousands of objects. This purposeful selection with the aim of bettering every possible item has covered all of the species of which decoys are known, and at least a few of each of them have passed in review.

One of the genuine problems has been to decide which examples should be illustrated. The selection reflected in the photographs in this book is the result of careful consideration. It was a difficult but a pleasant chore to analyze, study, and ultimately decide on the examples to be presented pictorially. They reflect one man's opinion after examining almost six thousand decoys.

All illustrations are of decoys in the author's collection, except in those cases where other credit is given. The photographs reflect the skill of Quintina Colio, who handled the assignment with the understanding of a fellow collector who is the possessor of a fine collection of decoys in her own right.

In conformity with the current usage of the American Ornithologists' Union, the vernacular names of each species are capitalized in the text to distinguish them from families and other groupings, which are in lower case.

In addition to Miss Colio, my further thanks go to David S. Webster of the Shelburne Museum, Shelburne, Vermont, a true pioneer in the field of decoy study. There are others who come to mind whose loyalty to the subject deserves grateful mention here: Wallace Furman of South Orleans, Massachusetts, and Thomas Marshall of Fairfield, Connecticut, both historians of

decoys and their makers, and Frank Sahulka of Bronxville, New York, whose enthusiasm for decoys is equal to the writer's. My gratitude goes also to Richard E. Moeller of Nokomis, Florida, with nostalgic memories of those years when we collected together. Chris Sprague of Beach Haven, New Jersey, deserves many thanks for the wisdom he has imparted, and Lloyd Johnson of Bay Head, New Jersey, a master carver, has shared the joy of every find. My special thanks to the Midwest's greatest collector, Joseph French of St. Louis, Missouri, who has shared both his information and his decoys, and also to Hal Sorenson, editor of the *Decoy Collector's Guide.*

There have been others over the years with whom the initial association has ripened into friendship; they are mostly the honest and sincere people who live close to the haunts of wildfowl. When the last decoy is collected and the honk of the wild goose is no longer heard, I hope still to be able to visit and revisit with them and to live again the spirit of this book.

W. J. M., Jr.

Belford, New Jersey
March 1965

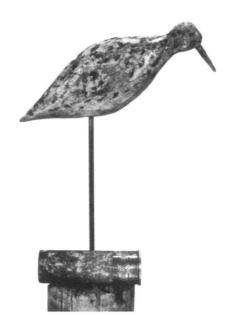

I *The American Decoy*

AT ABOUT THE MIDWAY point of the nineteenth century, three factors in American social and natural history combined to set in motion the greatest wildfowl hunt the world has ever known. It lasted for some seventy-five years, and it fed millions of Americans.

This most important of all wildfowl hunts began when the improvement in firearms in general, and shotguns in particular, made it possible to harvest flying birds economically and with increasing rapidity. The trusty flintlock of our colonial years and after was not only clumsy but inaccurate and expensive to shoot. It was therefore not well suited for airborne targets and was generally used on more valuable quarry. The breechloader changed all that and could produce a profit for the user when one Canvasback, Mallard or other saleable duck fell as the result of a good shot.

In addition, a population expansion was under way and demand for food was increasing. The hardworking outdoor laborers of that day craved meat—and the abundant and often delicious waterfowl of America were available for the skilled hunter to harvest. Obviously, the systematic taking of such game demanded certain skills and special equipment. Thus the specialist or market hunter came into being, and Canvasback and wild goose appeared on gilt-edged engraved menus in Baltimore, and simmered in the stewpots of slaves.

With this threefold situation—demand for food, improved equipment, and a seemingly inexhaustible source of supply—the opportunity for gain became apparent, and the hunt was on. The resulting slaughter, ending in the extermination of such species of birds as the Labrador Duck, the Passenger Pigeon, the Heath Hen, and some others, will always be mankind's loss. Finally outraged public opinion forced the passage by Congress of the Migratory Bird Treaty Act, and it was approved July 3, 1918. The sale of waterfowl and shore birds had come to an end. Thousands of wildfowl market hunters quietly turned to other pursuits. These respected citizens were flexible and ingenious, and their transition to perhaps humbler daily chores was uncomplaining. Some of their hunting gear is still stored right where it was placed almost fifty years ago.

The decoy was an essential of the hunter's equipment, if his method was the conventional one of shooting from a blind, battery, or boat of one sort or another. Obviously the use of big punt guns at night, trapping, and other frowned-upon methods of obtaining ducks for sale did not involve the use of decoys.

The history of decoys in all ages and all countries is involved, confused, and ends up having only a passing relationship with the object of our specific interest—the use and development of the American decoy. Live wildfowl tethered within view of passing flocks to lure wild birds to destruction, and replicas of them made of every conceivable material, have been used since the Egyptians decoyed Pintails along the River Nile. But even with that early start, decoys, as we know them today, made little or no headway in other nations of the world. One opinion as to the possible reason for this is that wing shooting at ducks and shore birds is too expensive, and coupled with the inevitable miss, too sporting a deal for the natives of most areas. Trapping is easier, cheaper, and can be carried on while the trapper is gainfully occupied elsewhere. All in all, at any rate, while foreign decoys may serve as conversation pieces, or have a special solitary place in a collection, my own opinion is that in general they offer little interest. Their use in any country outside the United States and Canada was extremely limited, and in many nations it was unknown. Their materials are generally shoddy, and their intended employment was largely ornamental.

The word "decoy" is derived from the Dutch *kooi,* cage, in combination either with the article *de,* or with the noun *ende,* duck, one theory holding that our word is a contraction of the Dutch *ende-kooi,* duck cage. This latter term goes back to the ancient method of capturing ducks by means of long, V-shaped nets, which were staked out over the waters of a bay or cove, converging toward a cage at the narrow end of the setup. Boats were used to drive the ducks that landed on the water of the cove slowly toward the cage, in which presently they found themselves trapped. It may readily be imagined that this system led to the loss of many birds that took fright and flew off before reaching the cage, and it was presently improved upon by using an especially trained dog, with the aid of a group of tame ducks, to lure the wild ones into the mouth of a long, pipelike net. Once inside, the wild ducks were driven toward the closed end and there captured, while the tame *"kooi* ducks," not alarmed by the drivers' antics, returned to the open water with untroubled consciences.

Regardless of the origin of the word "decoy," as applied to wildfowl in other nations and languages, it came into the meaning it now has in this country early in the nineteenth century. Its primary meaning in America was simply "an image of a bird used to entice game within gunshot." As indicated by a chronological study of American dictionaries, the word appears to have become common usage by the middle of the last century.

This chronology fits in perfectly with that of the gradual increase in numbers and

importance of the market hunters. The American market hunter and his decoys were inseparable, and to him goes the credit for the widespread adoption and gradual improvement in this country's decoys. The market hunter's practical experience and toil-worn hands created an object of interest, beauty, and genuine artistry for which we are everlastingly grateful. The carving done by some of these men borders on perfection. Some of their paint patterns are too good to subject to the elements. Why did these hunters spend additional precious hours perfecting an object that would have been effective with less effort on their part? The answer, regardless of the region from which they hailed or the dialect they spoke, is always the same: they had a pride in their work and a competitive spirit in their hearts. "Good enough" did not satisfy most of them.

To get back to the word "decoy," it is interesting that it is usually associated by the general public only with the duck family. The stereotyped idea of a decoy is that it is made of wood, resembles a duck in size and paint pattern, and floats. How far this oversimplified concept is from the actual wide range and variety of American decoys will be shown in the following chapters. Even within a given species of duck, moreover, hardly any two handmade decoys are exactly alike, and this is one reason why they are collectible.

Although the word "decoy" is the more usual and widespread term of reference, in some localities decoys are called "stools" or "stool ducks." This term goes back to the Germanic noun found in Old English as *stol*, in German as *stuhl*, in modern English as "stool," and in related forms in other languages, in the sense of a seat. Thus a "stool pigeon" originally was a tame bird tethered to a post, on which it often sat, to lure passing birds within range of the hidden hunter. The term "stool" seems to be used more frequently when natives discuss snipe or shore-bird decoys, rather than those for ducks or geese. Many men who have hunted shore birds will refer to their decoys for that purpose as "snipe stools." Occasionally, duck decoys are referred to as "blocks," but at no time was this common usage.

An assemblage of decoys, stools, or blocks, whether stored in a shed or in use before a blind, is known as a "rig." This all-inclusive term takes in all the decoys, even if, as is frequently the case, they consist of several species. Guides and market hunters would balance their rigs by combining various types of decoys in species and numbers carefully arrived at. Once this magic combination of species and quantities was decided upon, no amount of money, argument, or persuasion could pry a single item out of that successful rig.

One such rig that I shall never forget involved a happy bunch of Widgeon and Pintails, a couple of Black Ducks, and one tiny, exquisite, Green-winged Teal (Plate 1). I had great confidence that a day in the blind with the owner of that teal would find me its proud possessor at sundown. Nothing of the sort came to pass. That regal teal

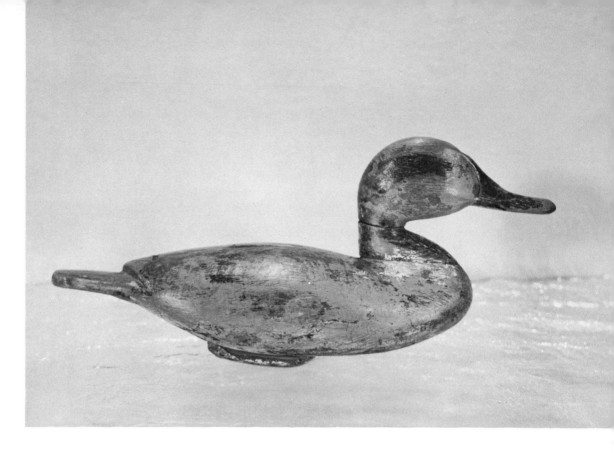

PLATE 1. This tiny Green-winged Teal decoy, its body carved from a cypress knee and its head of cedar, shows the unmistakable skill of either Lee or Lem Dudley, the twin brother decoy makers of Knotts Island, North Carolina.

just balanced the rig, and apparently was more essential to the success of the day's sport than all the rest of the decoys together. To remove it from its watery throne would have been like taking a lucky rabbit's foot from a small boy. Trip followed trip, but in spite of every stratagem and plot, the rig remained balanced, and that darling teal continued to reign over the flock. It became an obsession, affected my relations with a good and successful guide, and ruined my shooting eye. The showdown came on the final day of the hunting season. I had brought a facsimile of the object of my affection in the pocket of my hunting coat, and during a lull in the shooting, the owner allowed it to be substituted for the original teal. It served the purpose, and now the old one proudly rides a mantel. What matter the cost? That was a crusade. Go find yourself an old rig . . . but you have had your warning should the decoys have been balanced and found successful. Pass that rig by.

The wood generally used and preferred for decoy bodies was cedar or white juniper. This wood was readily available, cheap, easily worked, and resistant to rot.

In the New England states, bodies of white pine were usual. White-pine heads were standard on the cedar bodies in all areas, on both the machine-made and handmade ducks and geese. Other woods enjoyed local or occasional use. They included mahogany, cottonwood, tupelo, cypress, balsa, and some exotic woods, generally from shipwrecks. Old cork decoys are sometimes found. These consist of slabs of cork bark cemented together, or of glued aggregate, a comparatively recent development. Balsa, which comes in many different grades and degrees of hardness, was apparently either unknown to, or found wanting by, the market hunter. The earliest examples of balsa decoys that have come to my attention date from 1918, the year of the market hunter's retirement.

Actually no wood may be ruled out of the list of materials used occasionally by the decoy carver, since decoys were made on an experimental basis by some craftsmen of an inquisitive turn of mind. When one of these wooden oddities turns up, it makes a welcome addition to any collection. On the Eastern Shore of Virginia, for example, the wood of the crepe myrtle bush, which has limbs about the diameter of a plover's body, was ofttimes used to make shore-birds decoys. It seems to be light as balsa, or even lighter.

In the making of other decoys, wood was entirely ignored, or used only in part. By the year 1873, several patents had been issued for decoys consisting of metal duck bodies that floated on wooden bases, and folding tin shore-bird decoys found a wide sale. American Indian tribes stuffed bird skins with dried grass, or formed crude decoys out of tule reeds woven into the shape of a floating duck. Later, among white hunters, bird skins were sometimes tacked on wooden bodies, or real birds' wings were sometimes employed. Leather and cloth decoys were also used, but few considered them practical. It seems safe to say that almost every material under heaven has been tried at least once.

Given a supply of suitable wood, the steps in constructing a duck decoy, for example, were simple and the only tools necessary were a small hatchet, drawknife, pocket knife, and wood rasp, or perhaps sandpaper. The solid body blocks, cut to exact length, were roughed out with the hatchet. The degrees of skill decoy makers attained in the use of this tool had to be seen to be appreciated. The fashioning of the body was completed with the drawknife, rasp and occasionally sandpaper.

Heads required more delicate treatment. The sawn head was worked down and finished with a pocket knife or rasp.

Hollow bodies were constructed usually of two equal-sized pieces of wood, pinned together and then shaped to size as just described. When the body had been roughed out to size the pins were removed, the two halves hollowed out with a gouge, and then nailed together with white lead and soft caulking rope in the joint to keep it watertight.

There was no uniformity of opinion among even the great carvers as to whether or not eyes were essential in most species of shore birds and waterfowl. The matter of expense generally dictated a painted eye, but glass, tack, and cleverly carved eyes are found, particularly in later models and factory decoys that sold at a premium.

The characteristics of the birds involved, and their differing habitats, made inevitable the development of two basic types of decoys: floating decoys and "stick-ups." Most, but not all, duck, goose, and Brant decoys are designed to float on the surface of the water. They are anchored or held in position by a lead or iron weight attached to a line of suitable length. There are few exceptions to this in decoys made for wildfowl in the classifications just mentioned. The exceptions that do occur, however, are noteworthy. They are most general in the category of goose decoys. We shall get back to them in a moment.

Stick-ups, the second main type of decoy, are designed to represent the respective birds either on land or in water too shallow for swimming. A socket drilled in the bottom of the decoy enables it to be placed on a stake which is forced into the ground. When fitted onto their stakes, the decoys should duplicate the appearance of live birds congregating on similar terrain.

Geese and Brant periodically visit sandbars to "sand up," and so supply their digestive tracts with the requisite amount of grit. At such times, stick-up replicas of these birds (Plate 2) justified their specialized purpose. Some of the "puddle ducks," such as Mallards, Pintails, and Blacks, were made in stick-up models for use on marshy terrain, or more rarely, on ice. The diving ducks, such as the Canvasback, are unknown except as floating models.

The rigidity and lack of movement of all decoys stuck on a stake makes possible the silhouette or "shadow" type of construction. The use of these "profile," or two-

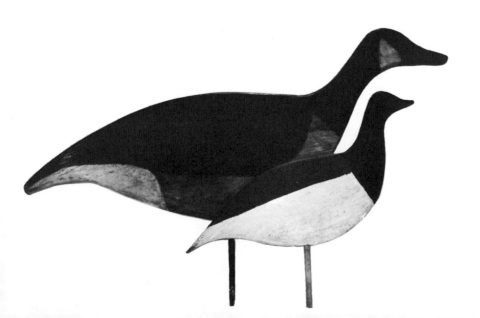

PLATE 2. Canada Goose profiles such as the one in the background are seldom found. The smaller Brant example is even rarer. When skillfully used both were very effective. Both are of New Jersey origin.

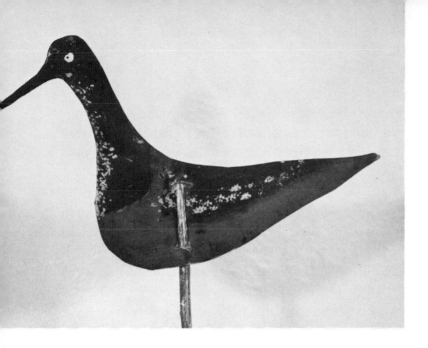

PLATE 3. Yellowlegs decoy cut from thin, stiff cardboard. The good paint pattern is similar to that found on wooden, factory-turned examples. A carefully whittled stake passes through two holes when the body is flexed.

dimensional outlines of geese and ducks, was, and still is common practice on the wheat- and cornfields of the Middle West. Cardboard, tin, and wood were the materials generally used. Most old and collectible wildfowl decoys of this type originate in the Midwestern area. The East Coast profiles generally used on sandbars are very rare, more so than full-bodied stick-ups made for the same purpose.

Turning to shore-bird decoys, we can categorically label them all as stick-ups. From the tiny Least Sandpiper to one of the biggest shore birds in the world, the Long-billed or Sickle-billed Curlew, they always reposed on a carefully whittled stake, a piece of heavy wire, or an improvised support made from a branch. Some carefully made stakes are found, tapered so that they in themselves constitute a collectible item of the whittler's craft, and make nice accessories to the decoys themselves. Once in a great while a lucky seeker of these hand-whittled stakes will spot a few that were appropriately stained so as to correspond in color with the legs of the species. But this nicety does seem to be carrying a good thing just a bit too far.

The use of silhouettes or "flatties," as well as three-dimensional models, was general throughout the entire spectrum of shore-bird decoys. Obviously they met with a measure of success. Such renowned makers and hunters as Harry Shourdes, the Cobbs, Ira Hudson, Chris Sprague, and many others, did not make or use them. But the fact remains that great numbers *were* used, and the unwary, guileless shore birds paused to investigate these flat impostors. It should be noted that flatties were light and easy to carry, and, when placed by a hunter who knew the habits and flight patterns of the birds being sought, were adequate for the purpose. Flat snipe stools come in several materials and varying degrees of excellence. Thin cardboard outlines (Plate 3) stuck

on a stake or in a split stick are one extreme, while silhouettes of a quarter-inch white pine (Plate 4), beautifully painted, represent the other. The Cape Cod area produced some flatties that all collectors prize. Many of the silhouette decoys formed of sheet metal are of great interest and have considerable artistic merit (Plate 5).

Such rare and unusual decoys as herons, crows, owls, and others were necessarily made in stick-up designs. They were intended to be set, if not on a stake in a marsh or field, then on a post or tree limb. Gull decoys seem to be about equally divided between the two types. An occasional crow, owl, or shore-bird decoy, generally of Midwestern origin, uses two flat outlines of the bird in question, one vertical and the other horizontal. When these two flat pieces are fitted together at right angles, as shown in Plate 5, the result is more realistic than that of a single profile, though it still leaves something to be desired. But collectors are always grateful for such oddments and eagerly seek them.

The unusual or offbeat decoy, whatever its species, stands out and commands a premium. Most authentic old decoys follow the patterns and traditional forms and

PLATE 4. The workmanship on these Black-bellied Plover flatties is the finest. The quarter-inch stock is carefully rounded on all edges. When live birds were known to follow regular flight patterns, a rig of flatties was effective.

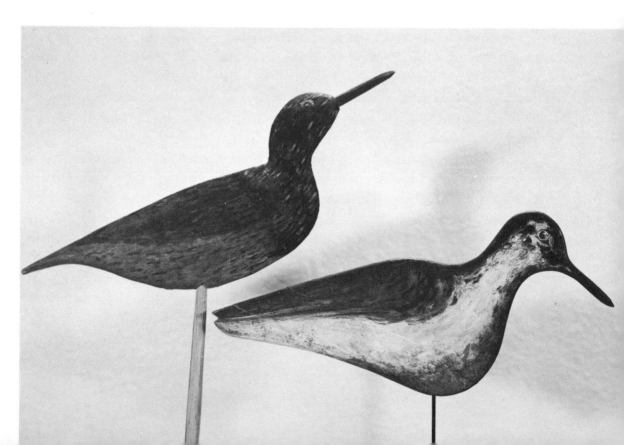

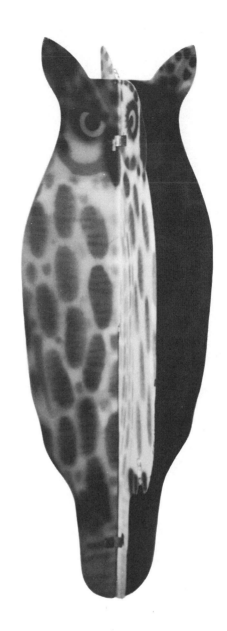

PLATE 5. This full-sized Great Horned Owl of sheet metal folds flat when not in use. The same manufacturer made similar folding decoys for crows and shore birds. The shore birds were attached to their stakes by a coiled spring to allow movement in the wind.

methods of construction of the locales where they originated. Any exception should be viewed with skepticism. This is a necessary protective measure on the part of the prospective buyer, as the unscrupulous have long since noted that a duck with a turned-back head commands a much fancier price than a conventional model. Since not one old duck in a thousand started life looking backward, the rarity, if authentic, is more desirable. This premium is only justified, however, when the original maker, and not the restorer, put the head in that position.

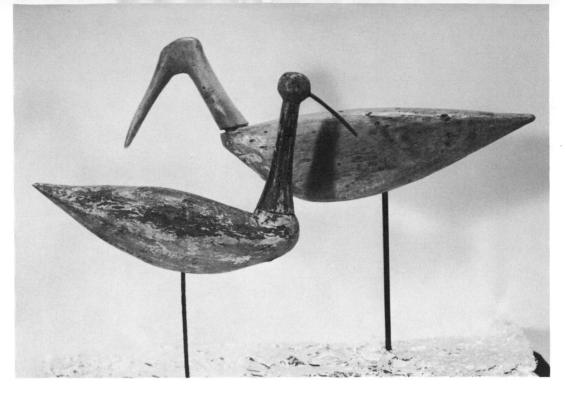

PLATE 6. Primitive shore-bird decoys, probably intended to simulate yellowlegs. *Left:* decoy from New Gretna, New Jersey, with wrought-iron bill and support. *Right:* Root head from Assateague Island, Virginia; head removable. Both probably before 1870.

Shore birds offered the carver a field where greater liberties could be taken as to variations in pose. Furthermore, the movement inherent in a rig of ducks bobbing on the water was not possible with a company of snipe rigidly at attention on the ends of sticks. Thus a rig of shore birds often had a few runners, feeders, or preeners. (These appellations are flexible and considerable license is allowed the decoy owner in describing the pose his prize represents.) But again take heed: a broken yellowlegs can sometimes be reassembled so as to end up in an awkward, unusual posture that fools the overeager buyer.

From the skin-covered decoys of the Indians until the present, men of considerable talents have labored to make their decoys look as much like the live counterparts as possible. Yet always, whether in ancient Indians' stuffed birds, carefully weighted so as to float on the water in a lifelike pose, or in the rubber and plastic models on sale today, some shortcoming detracts from the attainment of the perfect decoy. Between the two extremes, many men have put into practice many ideas and theories.

As we consider decoys from the collector's standpoint, it is important to arrive at an understanding with regard to the basic question of just what constitutes a collectible decoy. Shore-bird decoys present no problem. Simply stated, any snipe decoy is

collectible that was made for hunting purposes before 1918, when the Federal law began to ban the taking of most varieties. Several years later all hunting for these birds came to an end. Any shore-bird model or replica made after the law took effect is not a collectible decoy within our terms of reference. It does not qualify as an authentic hunting decoy of the period.

With ducks, geese, and Brant, the situation is different. Carvers have never stopped making these decoys. Several men still living have decoys illustrated in this book (for example, Plates 127 and 153), and they are obviously collectible. This work qualifies because the makers' ties with the past, and the decoys they made as young men rank with the best. Their later work and the decorative models some of them now produce are not working decoys. I say this not to belittle recent decoys or models. Collecting these modern handmade decoys is a separate and pleasurable field of collecting, but it is distinct from the collecting of decoys made during the market-hunting era.

The line of demarcation between decoys and decorative models is a fine one, and inevitably there is some overlapping. Perhaps it can best be settled by insisting that a decoy must be an object that was made to be used and shot over. In other words, an object to be used by a hunter, and made solely for that purpose. Let the decorative and ornamental touches fall where they may.

Before we start our collecting journey, let us look briefly at two other indispensable adjuncts of wildfowling, namely, blinds and boats. Since a blind of some sort is used alike for ducks, geese, and shore birds, when they are lured to you through the use of decoys, let us consider that first. The definition of "blind" that best suits our purpose is "a structure, often of brush or other suitable growth, in which hunters conceal themselves while hunting." A blind may be large or small, stationary or floating, but generally it is constructed of or at least faced with natural growth that blends with the immediate surroundings. If staked out in open water, it generally appears like a small island or clump of bushes. In many areas, boats are camouflaged to blend with the surroundings, and are used, as a secondary purpose, as blinds. In field shooting, the blinds were simply holes dug in the ground and carefully concealed. Some blinds are ingenious, comfortable, and difficult to build; others are just a pile of flotsam and jetsam. The sketchiest of all blinds were those used in hunting shore birds. Consisting of a few branches draped with eel grass or seaweed, they were expendable and seldom used more than once.

Boats, as we have noted, served on occasion as blinds. Their other uses as indispensable accessories to hunting should be outlined. Particularly in the pursuit of ducks, geese, and Brant, they transported the hunter, his decoys, and other equipment to the scene of action. So as to be inconspicuous, they were built low and usually partly decked over, with a coaming that supported the oarlocks and kept out some of the

water surrounding the central cockpit, which accommodated one or two men. A most important use of the duckboats was to set and pick up the hunter's rig of decoys and to enable him to gather his kill and chase the cripples. The question of the best types of duckboat for use under varying conditions has always been a difficult and hotly debated one. There are innumerable different designs and models, some of them extremely ingenious and practical for the task at hand. It is not pertinent to the main theme of this book to go into the subject of boats in great detail, but there are some special types that we shall often meet in our study of the decoys of various regions, and these should be understood.

The Barnegat "sneak box" is a lightweight, shoal-draft boat about twelve feet long, which is completely decked over except for the small cockpit. The early and widespread use of this small boat for duck hunting had a profound effect on the development of decoys along the Jersey coast. The small craft had a definite load limitation, and some allowance had to be made for the stormy trip home with the valuable cargo of dead game. Hence the development and high degree of perfection of the Jersey "dugout," or hollow decoys. It was a case of the boat dictating to the decoys, and the decoy makers of the state responding with some of the most practical and interesting decoys available. A Barnegat sneak box draped with seaweed, odd pieces of burlap, and on occasion slabs of ice served as a superior blind. Filled with salt hay, it made a dry, snug, and almost cozy spot to while away a winter's day. But a five-mile trip in open water after dark entitled the market hunter to that bit of luxurious living. Besides, there were shells to reload, game to be taken care of and the next trip back began at four A.M. There was no overtime pay, but the market hunters demanded nothing and generally lived to a happy, respected old age. We shall have an opportunity to meet some of them close up as we move along.

Also important was the scull boat, which was widely used from Merrymeeting Bay in Maine through Connecticut, Long Island Sound, the Delaware River, and the head of Chesapeake Bay in Maryland. Many variations in size and construction are inherent in these specialized craft, but all conform to the basic concept of sculling, which is to work an oar from side to side over the stern and thus propel the boat. In this manner even the movement of the oar blade is concealed from the ducks as the boat is worked directly toward them. These slim, low boats are camouflaged in appropriate ways, depending on the section of the country and the time of the year. Salt hay and rushes were common decorations, but during freezing weather ice slabs were effective. Since decoys were often placed to entice ducks to alight in certain spots, this form of approach by boat had an influence on the decoys used. The decoys not only attracted the passing ducks but once the ducks alighted the decoys must be constructed and painted so as not to alarm the visitors. The decoys most effective for use by scullers were those that matched the natural birds as closely as possible. The Delaware River

decoys illustrate this point and had no equal for holding the birds as the sculler began his quiet, deadly stalk.

Such were two types of duckboats that directly influenced the form of decoys. Another craft widely used in professional waterfowl shooting and closely connected with decoys was the battery. This was a low-lying, floating box on three sides of which panels, or "wings," covered with painted canvas supported special decoys called "wing ducks." In the boxlike central section, the hunter lay back out of sight until one or more waterfowl flew within range and gave him the chance to raise himself and fire. We shall come back to batteries for a fuller discussion in the section on wing ducks in the next chapter.

Where batteries and large rigs of decoys, sometimes as many as 500 or 600 of them, were used, special sailboats with hoisting gear designed for the purpose were used in handling the battery and rigs. Two places where such old decoy boats may still be seen rotting on the shore are Currituck Sound in North Carolina and the Susquehanna Flats in Maryland.

These simple facts regarding basic equipment and terminology will help us on our decoy-collecting journey. They will aid us in understanding the development and characteristics of American decoys in the various regions of the country, each with its typical styles, techniques, and traditions, and each with its own patterns of species and flyways, patterns that together formed the rich and colorful pageant of American wildfowl life.

II *Ducks and Geese*

WITHIN THE SPRAWLING framework of the overall decoy picture, certain groupings or specialized collections have their own appeal. Charming and unique groups of shore birds in general and sometimes curlews in particular can be assembled. Other strenuous collecting efforts end in the display of isolated examples of herons, gulls, owls, and others. There is a case to be made for a collection of the rare, unusual, or specialized decoy, but many feel that studying and collecting duck decoys is more rewarding. Throughout the history of civilization, most races have raised, hunted, eaten, and painted wild and domesticated ducks and have used them as an art form. The Pintail is known the world over and the same may be said of the Mallard. The concentration of effort on duck decoys rests upon such fundamental and recognized reasons. Since ducks are so well known, a collection strong in duck decoys will lead to a greater sharing of pleasure by the collector and the viewer.

Ducks, geese, and Brant easily justify their position as the dominating items in all important collections. This is not to detract from the other facets of decoy collecting, since it includes items of tremendous importance, but rather to suggest that one keep an eye on the prime objective. The fact is that more care, skill, and foresight were lavished on the ducks, geese, and Brant by those who carved and painted them than on all the rest of the decoys. All the great carvers made ducks and geese, but many never made a shore-bird decoy. Charles ("Shang") Wheeler, Lee and Lem Dudley, Steve and Lem Ward, and Charlie Perdew are some who concentrated their efforts on ducks. The variety and numbers of duck decoys still available make a rounded and adequate collection possible for a modest expenditure.

Any estimate of the number of duck decoys in use over a period of a given year would be the wildest speculation and border on the ridiculous. However, in an eye-witness account of the Susquehanna Flats in Maryland at the height of the season during the early 1920's, Severn Hall of North East, Maryland, recently told me: "On some mornings, if you got a late start it was impossible to find a good spot to put out

your decoys, because somebody'd beat you to it. I've left North East and worked south to Turkey Point, which is eleven or twelve miles, without finding an open spot. Then we would work west to Locust Point, five miles, and on north to Havre de Grace, which was about four more miles. If you hadn't found a place by then, it was time to quit. This is all open water and decoys were everywhere except in the channels. How many I couldn't even guess. We used big rigs of 400 to 500 stools, and there were hundreds of hunters."

Collectors who haunt this famous wildfowl ground have one more question. Where in heaven's name have all those decoys gone?

A review of the collecting potential inherent in the duck, goose and Brant field shows that decoys of birds in the following list have been identified:

1. Black Duck	11. Ring-necked Duck	22. Surf Scoter
2. Gadwall	12. Canvasback	23. White-winged Scoter
3. Mallard	13. Greater Scaup	24. Red-breasted Merganser
4. Pintail	14. Lesser Scaup	25. Hooded Merganser
5. American Widgeon or Baldpate	15. Common Goldeneye	26. Common Merganser
	16. Bufflehead	27. Canada Goose
6. Shoveler	17. Oldsquaw	28. Hutchins Goose
7. Green-winged Teal	18. Ruddy Duck	29. Brant
8. Blue-winged Teal	19. Labrador Duck	30. Black Brant
9. Wood Duck	20. Common Eider	31. Snow Goose
10. Redhead	21. Black Scoter	32. Blue Goose

I know of no old, collectible examples of the last three.

For good measure, and also because there is nowhere else to include it, we add the American Coot or "blue peter," which isn't a duck but a first cousin of the gallinules and rails. Though factual, heartless viewers describe them as clumsy, gawky birds with a silly countenance, from the collector's viewpoint some of the cutest, most interesting decoys are of these appealing little bird clowns (Plate 7).

It is important for the collector to note that decoys of almost all the birds listed were made in both handmade and factory-turned models. All wooden decoys had some hand finishing touches such as painting and smoothing of the rough edges, or perhaps eyes, but if the basic roughing out and shaping of the block were performed by machinery, then it is a factory model. Factory items are known in every species listed above except the Hooded Merganser, Labrador Duck, Black and White-winged Scoters, Hutchins Goose and Common Eider. The Ruddy Duck is listed as being made by Mason's Decoy Factory, but it has never been found. The remainder of the list is therefore collectible in both forms. All but the Black Duck, the geese, and Brant have distinctive plumage patterns for both the drake and the duck. A complete collection

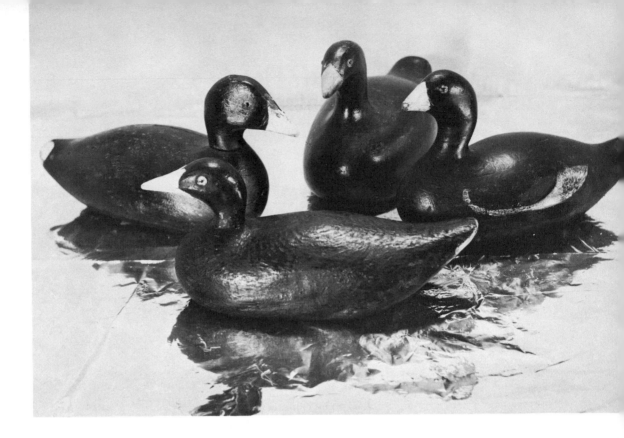

PLATE 7. Some primitive carvers cleverly captured the birds' form and pose, as in these American Coot decoys. Unusual pieces like these enhance any collection.

including just one excellent example in each category listed would be a collecting first.

The further ramifications of purposeful duck-decoy collecting are indicated by the case of one duck, the Canvasback, as supplied by Mason's Decoy Factory over a period of years. First, they had a standard size made in three basic grades. There was also the mammoth size, made in only one grade, and a special "battery" model. One each of Mason's "cans," including drakes and ducks, adds up to ten examples. I rest my case for collecting the ducks.

In any given area, the decoys used always reflected the species and numbers of visiting wildfowl normally expected. It is tremendously important to keep this basic fact in mind in evaluating the rarity and desirability of the several varieties. Oldsquaw decoys, for instance, occur frequently along the New England coast, but an example from the Midwest is unknown. Mallards occur with pleasing regularity along the Illinois River, but it is doubtful whether New Jersey's greatest maker, Harry Shourdes, ever carved one. This give-and-take of abundance and rarity cannot be charted for the beginner except in the vaguest way. Perhaps the best advice is to note that decoys rarely

got far from their original homes and almost never were moved or carried out of their original flyways. Simply stated, this means, for example, that decoys of the Connecticut school were seldom used on Great South Bay; a stool from New Jersey was looked upon as almost a freak when it turned up on the broad reaches of the Chesapeake, and a decoy from the Atlantic coast flyway was practically unheard of along the Mississippi flyway. These comments obviously apply only to the handmade products, as the factory output was shipped all over the country. This situation seems still to hold true for the handmade decoys, but the gift and antique shops, as well as swapping among collectors, will gradually obscure distinct territorial lines.

In the overall picture, Mallards, Canvasback, Greater Scaup, and Black Ducks seem to rank as the "Big Four." They probably exist in greatest numbers and are represented in the widest variety in all of the noted collections. The next group would comprise the Pintail, the mergansers—with the Red-breasted Merganser accounting for nine out of ten examples, since the Common and Hooded Merganser are really rare duck decoys—Redhead, Common Goldeneye, Canada Goose, and Brant. To these the scoters should be added as a group because of their common occurrence along the New England coast.

There are few other ducks in the relatively common category, but taking the country as a whole and reviewing the large collections, it would seem the next grouping would include American Widgeon, Blue-winged Teal, Lesser Scaup, Ring-necked or Ring-billed Ducks, Buffleheads, Oldsquaws and Common Eiders. Good examples of these species, in original paint, are surprisingly hard to find, but all occur with enough regularity to make the search worthwhile.

The rest of the list are grist for the optimist. A good identifiable Green-winged Teal or chunky Ruddy Duck is a rarity to be expected somewhere along the trail. The same may be said for Wood Duck and Gadwall replicas, but they are so scattered that finding them is sheer luck. A few Shovelers, Hutchins Geese, and one group of Labrador Ducks have been located and are now in collections. After all, bridge players have been dealt thirteen cards of one suit. Keep hoping; you may be next!

Some of the rarities, such as the Ruddy Duck and Shoveler, have sculptural characteristics that paint cannot obliterate, and are therefore identifiable if in sound condition. The same may be said for the Green-winged Teal because of its diminutive size, but the Gadwall, Wood Duck, and Labrador Duck had better have recognizable original paint to deserve the respect of senior collectors.

A few other areas of possible confusion remain. The Ring-necked Duck must have the original paint on the bill and neck; otherwise you have gotten yourself a scaup. The Hooded Merganser, as already noted, is an extremely rare find. The Bufflehead is far commoner. The Dodge Factory made quite a few Buffleheads with exaggerated crests, so don't be misled if one should come your way.

One vexing question is how to distinguish a Canada Goose from a Hutchins Goose. Authorities state the length of the Hutchins Goose to be from 25 to 34 inches. The same experts give the Canada Goose a length of from 34 to 43 inches; otherwise the birds are absolutely identical. Since a Hutchins Goose decoy is a rare and valuable part of any collection, there is a tendency to call a small Canada Goose a Hutchins Goose and also to repaint large Brant so as to transform them into Hutchins Geese. The following facts, however, should be kept in mind: the smaller goose was a very rare visitor along the Atlantic coast—so rare it seemed useless to spend the time and money to make a rig of them. One of the few places where they stopped with some frequency, however, was the marshes south of Ocean City, Maryland. Decoys for Hutchins Geese are known to have been made and used in this favored spot. To sum it up, if you have a goose decoy less than 34 inches in length, and if it was used in the vicinity of Ocean City, you could have a Hutchins Goose. If the facts and dimensions don't check out, however, you have collected for yourself a nice small Canada Goose.

Decoys of the Brant, which winters along the Atlantic coast, have received less attention than they deserve. Brant annually visited all the large bays and sounds from Pamlico in North Carolina to Cape Cod, Massachusetts. When they were able to get their fill of eelgrass, the birds were at least edible; now, with eelgrass scarce in most of the wintering areas, they gorge on sea cabbage, and even the cooking of one is obnoxious. Never popular birds with the market hunters, because of the lack of demand for them, their numbers and their direct, slow flight made them favorites with the sports, who found them easy and satisfying targets. These little geese have a look and characteristic pose on the water that set them apart from all other wildfowl. They always seem to be tipped forward just a bit; if they were boats, the bow would be too low in the water. By form and calculated placing of weights on the body, many decoy makers accentuated their actual look on the water. This was especially so in New Jersey, where the very early models (say about 1880) are much too low in front and too high in back. Since white is the dominant color on the tail and underparts, such exaggerated examples can be seen for miles. That, old-timers claim, is why those stools were so successful … "they really stood out." These old Brant decoys do make delightful and rare exhibits, but later carvers such as Roland Horner of Manahawkin, New Jersey, and Chris Sprague of Long Beach Island, New Jersey, added a gracefulness to their Brant replicas that is even more appealing to both birds and most collectors. (See Plate 8.)

Long Island gunners must have taken their Brant shooting seriously, judging by the numbers and fine quality of the Brant decoys that have survived from there. Most of the early models are oversize, solid, and of interest to the modern collector. (See Plate 9.) The slender neck, small head, and short bill of a Brant encouraged carvers

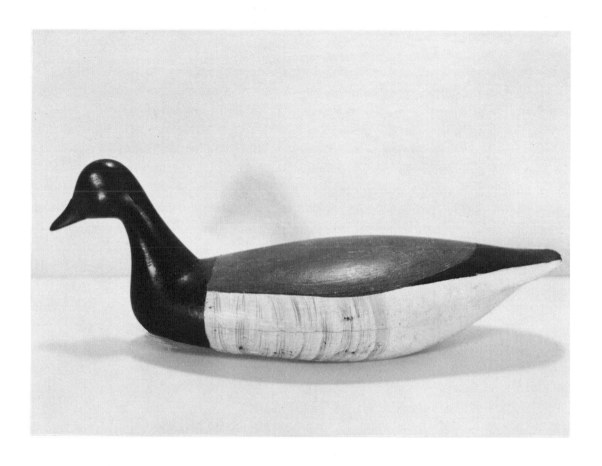

PLATE 8. Brant made by Roland Horner of Manahawkin, New Jersey. An example of his latest and finest style. By every standard, Horner ranks with the best New Jersey makers. Black Ducks, Brant, scaup, and geese were his specialties.

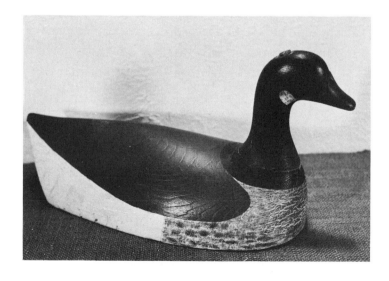

PLATE 9. Brant made about 1915 near Amityville, New York, and used on Great South Bay. It fulfilled every demand for a sturdy, sea-worthy decoy with good conformation. In original condition.

to use for the head a suitably sized limb with an attached smaller branch as that could be whittled into the neck, head, and bill of the decoy. The term "root head" or "knot head" was applied to this ingenious and practical form of construction. It was widely used by Long Islanders, but it is not exclusively theirs. Its advantages of simplicity and strength were seized upon by many early decoy makers. Both geese and shore birds of the root-head type (Plate 6) were widely used around Chincoteague, Virginia, and the Outer Banks of North Carolina. They were never made, however, by any famous carvers. Nathan Cobb solved the problem of the Brants' heads in his own way by whittling them out of sections of tough root growth such as holly and locust. Cobb also resorted to the use of an oak bill which pierced the pine head and was held in place by a spline driven in from the back of the head. This procedure was used on most shore-bird bills but only in Cobb's Brant and geese is it found in decoys for larger wildfowl.

Brant decoys offer the collector a rather overlooked field in which there is an endless variety of styles, ranging from the primitive to the stylish.

WING DUCKS

These specialized decoys, generally made of cast iron or lead but occasionally of wood, were used only in conjunction with battery shooting. For this reason their distribution was limited. They are identified with Great South Bay and other parts of New York State, the Chesapeake Bay and Back Bay areas in Virginia, and the coastal bays and sounds of North Carolina. Apparently no record exists of any battery shooting in New Jersey, which seems to be a puzzling exception.

Genuine old wing ducks are not easy to come by, since battery shooting has been illegal for almost fifty years. Obviously the most deadly method of shooting diving ducks ever devised, because the battery could be placed on the ducks' feeding grounds, it was a favorite with the market hunters. The equipment and manpower necessary to operate batteries could be justified only by enormous kills. Bags of 200 to 500 fowl a day were frequently recorded wherever they were in use. Rough water and ice, however, limited the number of days they could be employed.

The battery consisted of a watertight box just long and wide enough for a man lying on his back. This was a single battery. On occasion, double batteries were made, and two similar boxes were arranged, parallel, but with one box a foot or so ahead of the other to avoid having the gunners shooting shoulder to shoulder. From the head and two sides of the battery, wings were extended. These were wooden frames covered with canvas stained to match the color of the water at that particular place. These wings kept down the wave action and enabled the battery to ride low in the water. Once the tender boat had located the battery and placed the gunner, shells,

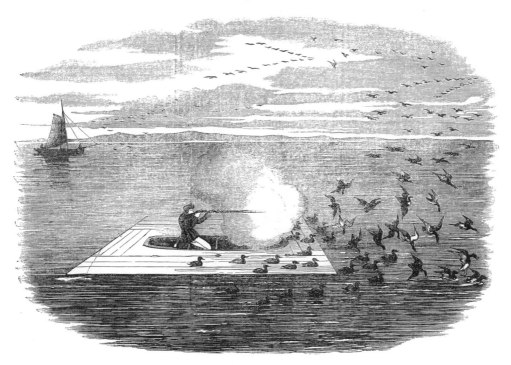

PLATE 10. Duck shooting from a battery on the Potomac. From *Gleason's Pictorial,* Vol. IV (1853).

guns, and other equipment aboard, the wing duck entered the picture. In order to make the rig as inconspicuous as possible, the final "trimming" was accomplished by placing the cast-iron replicas of ducks around the narrow deck. These wing ducks weighed from twenty to thirty pounds apiece and generally six or eight would be sufficient. The final determination was the weight of the man and equipment for that particular shoot.

The principal quarry in battery shooting was Canvasback and Redheads. The Greater Scaup ran a poor third. These are, in that order, the species the collector can have reasonably good hopes of finding duplicated in wing ducks. But the search for rare and unusual items need by no means end there. Although cast iron is typical of this type of decoy, some fine examples were cast in lead. The scarcity of lead wing ducks today is probably a result of the discovery that with little effort one duck made an almost endless number of fishing sinkers. That is what happened to them.

Other varieties of ducks, such as the Whistler or Common Goldeneye (Plate 11), were cast as wing ducks and used around Great South Bay or elsewhere on Long Island. From Currituck Sound an occasional Ruddy Duck has turned up. Some Black Duck wing decoys were also used, but they represent an unexplained contradiction because the Black Duck is not a diving duck.

Exceedingly rare are the Brant and Canada Geese from the Carolina batteries. Several sets of iron Brant (Plate 12) must have been in general use, judging by the examples remaining. One Canada Goose wing decoy (Plate 13) is known, but the

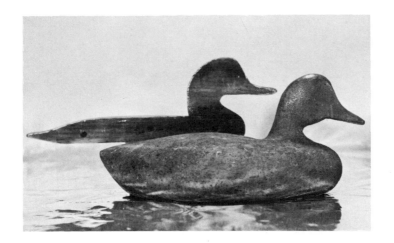

PLATE 11. *Foreground:* Iron wing duck from Long Island, New York. One of a rig of a dozen apparently intended to simulate the Common Goldeneye. Weight 25 pounds. *Background:* Wooden half pattern used by the Armstrong Stove and Foundry Company, Perryville, Maryland, in casting their standard Redhead wing ducks. Models supplied by the purchaser were used for special orders.

making of these was probably discouraged because of their excessive weight. Even for the stout men of that rugged country, the daily placing of cast-iron geese on a battery deck could become a chore. Today, of course, such a find would be more than worth the Herculean effort necessary to lug it home.

All indications are that small local foundries were the only sources of supply of wing ducks. We know definitely that Perryville, Maryland, Norfolk, Virginia, and Elizabeth City, North Carolina, had such foundries, which made a stock model or would cast from any model the customer supplied.

The Armstrong Stove and Foundry Company of Perryville, Maryland, which started making wing ducks in 1890 and closed in 1949, turned out thousands to sup-

PLATE 12. The famous Gooseville Gun Club at Hatteras, North Carolina, had several rigs of iron Brant like these. Nowhere else were they generally used. Anyone who has tried to handle them will understand why. Weighing about 40 pounds, they came from Elizabeth City, North Carolina.

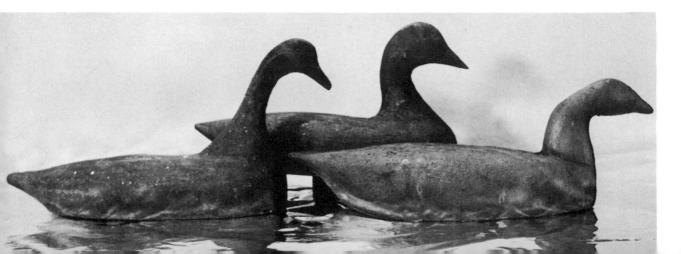

ply the demand for that end of the Chesapeake Bay. The average cost was fifteen cents a pound, a considerable sum for that day. The cost explains why many of them have a hole in the tail. A stout line and small float were fastened to the ducks in use on the deck. If a sudden gale made it advisable to abandon ship quickly, the cumbersome decoys could go overboard and be located by the attached floats on a happier occasion.

A fertile field for the collector of iron wing ducks is still largely unexploited. Find yourself an old landing or dock that has been standing for half a century. If batteries were used in nearby water, the chances are that a skin diver or a pair of clam tongs will bring you from the bottom an item for your collection. Except for a lack of paint, those rescued from such watery hiding places are generally in good condition.

Another rare decoy is the wooden wing duck (Plate 14). Used sparingly on only a few batteries as a sort of screen, they were convertible into regular floating decoys when their days on a battery came to an end. Actually they consisted of the top half of a normal wooden decoy. Always nailed to the deck of the battery, their removal was simple and their conversion to a floating decoy was easily accomplished by adding a suitable bottom half. Once converted, their previous use was concealed and forgotten.

Original wooden wing ducks with the bottom paint untouched, proving their original use, are all but unique. Charles Joiner found the example shown in Plate 14 and traced its interesting history. Any two-part decoy body from the previously mentioned battery hunting grounds should get a critical glance. It could have started life as a wing duck.

The important subject of duck, goose, and Brant decoys, including the wing ducks, is continued and enlarged upon in the illustrations and their captions. If no duck decoys from the Gulf coast of Alabama and Louisiana are shown, it is not because they were ignored, but simply because their workmanship does not compare with that of the decoys from the areas included, which are generally recognized as collectible. Hundreds of the crude Gulf coast cypress duck decoys have been reviewed and found wanting. Perhaps some may be attracted by their crude form, but the vast majority of this country's collectors have passed them by. They simply lack decoy appeal.

In preparing this book, no area has gone unscanned, and competent advice has been sought in almost every section of the country. We are dealing in a subject which, like art, must be governed by taste and judgment, elements that combine with factual knowledge to open the way to the fullest enjoyment in decoy collecting.

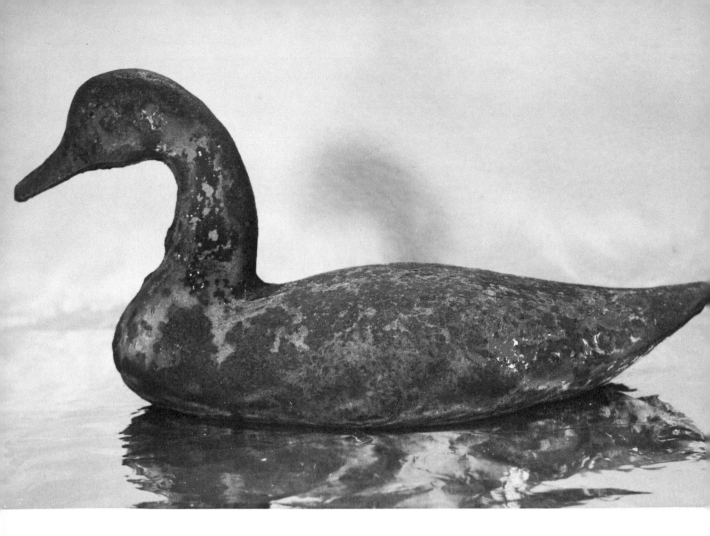

PLATE 13 (*top*). Iron Canada Goose decoy from a rig that originally numbered twelve. Purchased from the original owner, who used them on Pamlico Sound, North Carolina. As they weighed over 50 pounds and were nearly 2 feet long, they were never really practical. The body is cast with a cavity on the underside. PLATE 14 (*bottom*). Wooden wing ducks are rare, Canvasback occurring most frequently, followed by Redheads like this one from Betterton, Maryland. One wooden Green-winged Teal wing duck, from Charlestown, Maryland, is known.

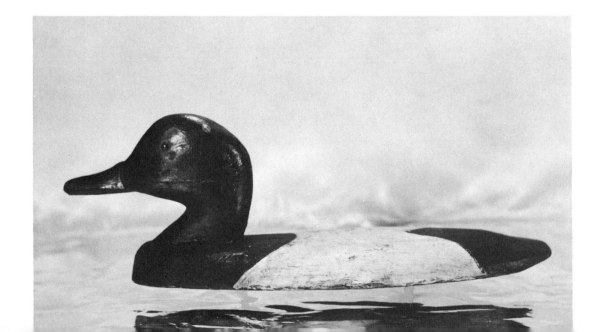

III *Shore Birds*

THE ATLANTIC COAST, its estuaries and tidal marshes, plays host to an almost endless variety of shore birds during their annual migrations. The sport of shooting these seasonal visitors was known as "bay shooting," and the victims, regardless of the species, were loosely referred to as "snipe." Every area and, on occasion, almost every town had its own name for each variety. The Dowitcher, for example, was called the Grayback in the fall, but the following spring the same bird was a Robin Snipe. This nomenclature varied from place to place, so that the Dowitcher had a dozen names from Cape Cod to Carolina. It all made for a pleasant confusion that continues to this day. The only generalization about the whole subject that holds true is that baymen are the world's worst and sloppiest ornithologists, except, of course, the sports who came only to shoot and couldn't care less about what their targets were.

Regardless of what the birds were called, they remained true to their own kind and decoys were made for each species and in the appropriate color phase for either the fall or spring shooting. A checklist of the Atlantic coast shore-bird decoys is rather formidable even for an ambitious collector. The following list is compiled from known examples that were in use before their shooting was legally banned:

1. Dowitcher	8. Marbled Godwit	15. Eskimo Curlew
2. Knot	9. Hudsonian Godwit	16. Black-bellied Plover
3. Pectoral Sandpiper	10. Greater Yellowlegs	17. Golden Plover
4. Least Sandpiper	11. Lesser Yellowlegs	18. Ruddy Turnstone
5. Red-backed Sandpiper or Dunlin	12. Willet	19. Piping and Semi-palmated Plovers (decoys may represent either species)
6. Semipalmated Sandpiper	13. Long-billed Curlew	
7. Sanderling	14. Hudsonian Curlew or Whimbrel	

These birds, without exception, were heavily and indeed excessively hunted until Federal laws brought all shore-bird shooting to an end during the 1920's. This drastic

action came too late to save one species (the Eskimo Curlew) from virtual extinction, and others, although not extinct, are rarely seen along our shores.

"Bay shooting" or "beach snipe shooting" was known as the "gentle sport" because it took place mainly in fine August weather. There was nothing gentle about it as we look at the wreckage of birdlife it left in its wake. Bag limits were either nonexistent or ignored, and the slaughter was at times beyond the bounds of reason. Nearly all of these species are unwary and easily decoyed. A flock would return several times if the shooter remained concealed and had the knack of imitating their calls (Plate 15). Also, wounded birds among the decoys had a fatal fascination for those that escaped the first time. The unsuspecting nature of shore birds, combined with the fact that both fall and spring shooting took place on all migration routes, was almost their undoing.

Here and there along the coast some old-timers have refused to part with their old rigs of snipe stools, examples from one of which are shown in Plate 16. Understandable efforts have been made to separate them from these hope chests and their contents, but to no avail. They insist the day will come when the "gentle sport" will be legal again. No thinking could be more wishful. The owner of a shore-bird stool has an adjunct to a sport that is gone forever.

As sports went, to be sure, snipe shooting had a relatively small following. Migration routes and terrain limited the areas where good sport could be expected. Furthermore, except in late August and September, it coincided with the more attractive wildfowl shooting which was always available nearby. The same situation prevailed in the spring. Some market hunting for snipe took place, but it was not general as was the case with ducks. Few shore birds are gourmet food; most are downright poor eating. The curlews, with the exception of the Eskimo, are tough and stringy. Eskimo Curlews were plump and tasty, but by 1890, no less an authority than Elmer Crowell writes, ". . . there were only a few Eskimo Curlews left. We called them Doughbirds, as they were so fat sometimes when shot in the air they burst open when hitting the ground. But, today, they have gone for good—I never see one."[1]

Crowell also notes that another flavorsome bird, the Golden Plover, had become very rare. So it was, by 1900, along the whole Atlantic coast. There was some market demand for the smaller beach birds like the Semipalmated Sandpiper and Sanderling, but the going price was one dollar a hundred. No self-respecting hunter could afford to shoot them unless many birds could be killed with each shell. The professional market hunters had to seek tastier and more lucrative targets for their guns. The Semipalmated Sandpiper and Sanderling had one quirk that the market hunter was quick to take advantage of. On frosty mornings these little birds would gather in

[1] *Duck Shooting Along the Atlantic Tidewater*, edited by Eugene V. Connett III (New York: William Morrow and Company, Copyright 1947).

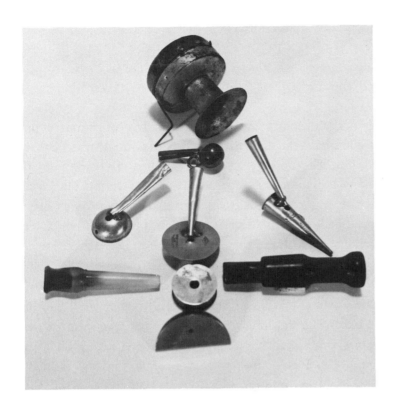

PLATE 16. Black-bellied Plover with an inquisitive Dowitcher on either side. The turned heads of this group make them rarities. Grotesquely shaped, the species they were meant to represent were identified by their original owner, the former market hunter William Matthews of Assawaman Island, Virginia, from whose estate they were obtained. These graceful decoys were given good care in his rig and survived in original condition.

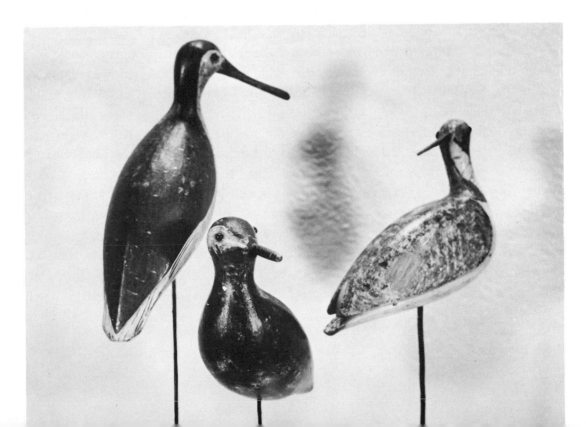

great flocks and bunch up. This characteristic earned them the name of "frost snipe" in some areas. When these concentrations were found, tremendous destruction took place.

There are many appealing and unusual facets to the collecting of snipe stools. They have only one thing in common—the fact that all are stick-ups regardless of their size, species, or point of origin. The average bird is full-bodied and carved from one piece, but early examples generally have a separate head and neck. The very earliest ones are "root heads," with head, neck, and bill carved from an appropriate root or fork from a tree limb. "Shadows," or "flatties," are encountered with more regularity, as we have noted, among shore birds than among geese and ducks. Effective in the hands of knowing baymen, they were sometimes preferred because they were easier to carry. Some New England "shadows" are very choice and daintily painted. The ultimate in "shadows" were, of course, those snipped out of sheet tin, or once in a great while, copper. For what must have been the most casual, once-in-a-while hunters, cardboard examples were available. Imagine their user's anguish as a rain squall threatened. The example in Plate 3 isn't treated or waxed in any fashion. No wonder cardboard flatties are now exceedingly rare.

For the bills of shore-bird decoys, oak, locust, or suitable hardwoods were usual, but from Down East comes an occasional bird with a whalebone or ivory bill. New Englanders generally drilled only partway through the head and then force-fitted the bill, depending on a tight fit to keep the bill in place. This generally worked. The birds from Long Island on southward carry bills that run through the head. The projection of the bill at the rear of the head was then smoothed off, split, and a suitably sized spline inserted. With this method, the bill was always in to stay. No good handmade shore birds originated with iron bills. When such a bill occurs, it is a replacement by a man in a hurry or a boy who didn't know any better.

Cedar is the favored wood for shore-bird decoys, but in New England white pine found adherents. Occasionally used were walnut, cottonwood, cypress, and exotic woods that intrigued the carver. In the last century beachcombing was a way of life for some men. Coastguardsmen in the Life Saving Service walked the lonely beaches, ever on the alert. One cannot rule out the use of any wood that might have come their way. Almost a hundred years ago, Luther Nottingham of Cape Charles, Virginia, salvaged an unusual plank which he used to make some Hudsonian Curlew decoys like the ones in Plate 17. It is a heavy, beautifully grained wood that no expert has been able to identify positively. Balsa was not in common use when shore-bird shooting was legal, but in my collection is an extremely lightweight yellowlegs decoy. I showed this decoy, which had "Ira Hudson" written all over it, to Miles Hancock, the respected gunning historian of Chincoteague Island. "Yes," he said, "I recollect the day Ira and I dragged that log out of the surf on Assateague Island. He made

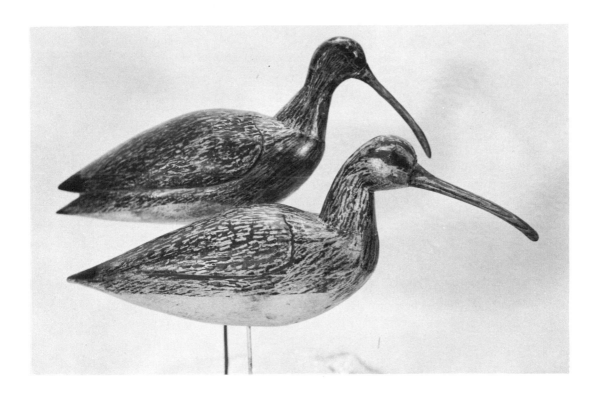

PLATE 17. Two of the Hudsonian Curlews made by Luther Nottingham of Cape Charles, Virginia. As a game warden, Nottingham had observed the birds well. Made from a hard, heavy, walnut-like wood, and carefully painted, each of the decoys in this rig is different. Hudsonian Curlews sometimes darkened the sky over the salt marshes along the Eastern Shore of Virginia.

that very bird from it in 1916. It was the first balsa that ever came ashore at Assateague."

Besides almost any kind of wood, including cork, the list of body materials used in shore-bird decoys includes papier-mâché, cloth stuffed with seaweed or sawdust, leather and pressed compositions. Some evidence points to the limited use of shore-bird decoys in the first half of the nineteenth century, but surviving examples are crude and not particularly plentiful. In view of the availability of nobler and more easily obtained game, plus the almost prohibitive cost of firing a shotgun in those days, one must be cautious in estimating the age of these decoys. The era of snipe shooting was almost entirely from 1850 to 1918.

For these unsuspecting birds, the first decoys used were crude and poorly painted, if painted at all. Clamshells on split sticks, bits of seaweed and driftwood, and the dead birds, when shot, comprised the decoy rig of the earliest hunters.

As the ceaseless shooting continued, in fact actually increased year by year, the early 1900's saw the shore birds' numbers dwindling and a certain fear of man drilled into the survivors. These relatively lean years provide the most-sought-after snipe decoys. Whittlers and decoy makers, both amateur and professional, as well as the factories, turned their energies and skill to making better and better shore-bird decoys of every description. They were fully aware that the better and more natural the decoy, the better was the chance of a successful hunt. Competition was keen. Regional masters such as Harry Shourdes, Ira Hudson, E. Burr, Elmer Crowell and many others made snipe decoys after the turn of the century that comprise an entire field of collecting, limited only by one's time, energy, and money.

This generation of carvers freely varied their work and the result is a collector's paradise. There are preeners, runners, feeders, and apparently some with a bit of an itch (Plates 18, 19). There are hollow decoys, laminated decoys, and dugouts from

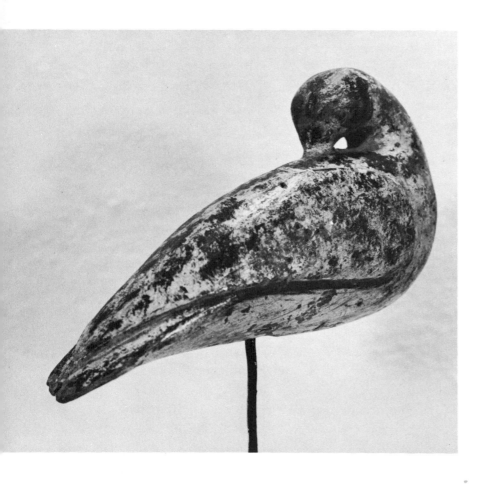

PLATE 18. The pose of this decoy with carved wings from Barnegat, New Jersey, makes it a collector's delight. This was one way to vary the impression of a rig, and such a decoy would stand more abuse than conventional models. Though crude and poorly painted, this decoy was evidently meant to simulate a Black-bellied Plover in fall plumage.

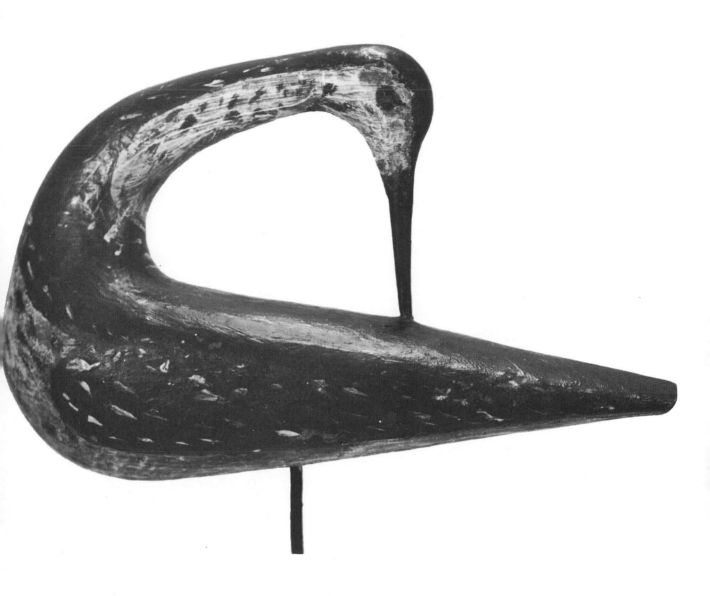

PLATE 19. Cape Cod version of a preening yellowlegs. Fashioned from one piece of wood except for the bill. A notable piece of folk art by an unknown but skilled hand. Other examples from the same rig have survived.

the underside (Plate 20). Clearly, the further explanation for the imagination and variety of the shore birds carved along the Atlantic coast is the joy and pleasure their creation and use must have given the makers. The same amount of creative ability and imagination was not lavished on the duck decoys. Perhaps they were regarded as too staple an item.

Among the shore-bird decoys, the yellowlegs, Black-bellied Plover, and Dowitcher are most frequently found, and in roughly that order. A variation prized by collectors occurs in only a few yellowlegs models. Occasionally a maker observed the bird with a minnow partially down its slender neck, and accentuated the bulging neckline. These so-called "minnow in the throat" yellowlegs (Plate 21) bring a premium. Considerable license was taken, especially in Jersey, in carving the Black-bellied or "Bullhead" Plover with an exaggerated head. When depicted with this feature, it makes a choice exhibit. Dowitchers, especially in the brick-red spring plumage, should be in original paint.

PLATE 20. Three shore-bird decoys from Massachusetts. *Left:* Lesser Yellowlegs, partially gouged out. *Center:* Greater Yellowlegs, made in one piece and hollowed out from the underside. It teeters and moves in the breeze when balanced on a stake. *Right:* Black-bellied Plover. A two-piece, dugout model.

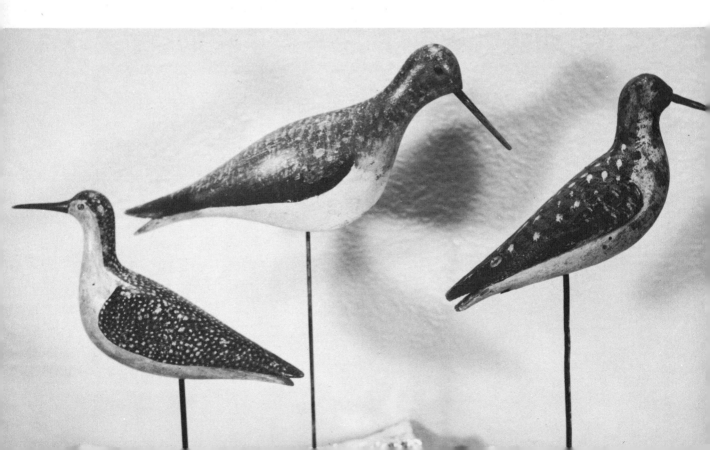

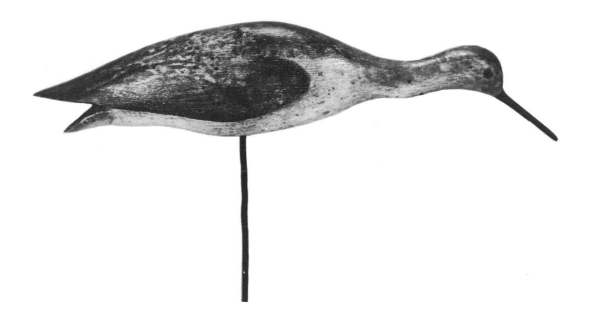

PLATE 21 (*above*). Greater Yellowlegs, by Elmer Crowell. A graceful "minnow in the throat" model that shows the artistry of this master. In New England this bird is sometimes referred to as the "winter yellowlegs."

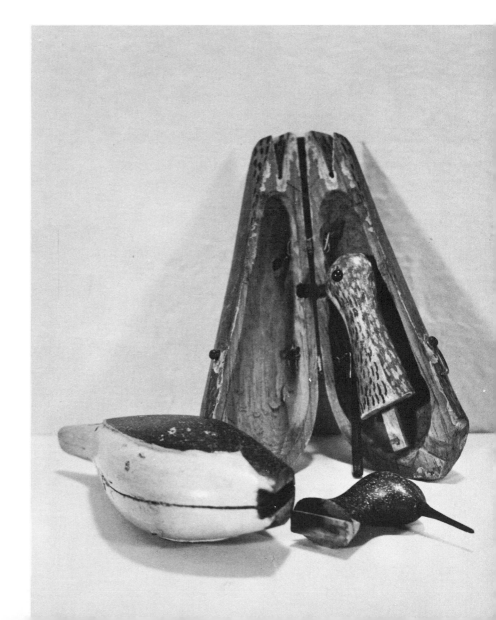

PLATE 22 (*right*). Pair of yellowlegs with demountable heads to prevent breakage as they were carried to and from the hunting grounds. One is hollowed out, as shown, to contain the head in transit. When and where they were made is unknown.

The curlews usually found are Hudsonians, and occur throughout their coastal range. The length and frailty of the bills make an original bill a prize for the collector. Decoys of the Long-billed Curlew and the now almost extinct Eskimo Curlew are exceedingly rare. Identification of a decoy as an Eskimo Curlew (Plate 23) requires not only that it be of small size, but that its place of origin should be established as either Cape Cod or Nantucket. This bird was rarely looked for, except as a stray, along the rest of the coast.

The Long-billed Curlew, most majestic of all shore birds, was common on Long Island before 1850. As it declined to the vanishing point, its place was taken by the Hudsonian Curlew. Very few Long-billed Curlew decoys exist. A decoy must be tremendous in size and carry the original curved bill to be beyond question the Long-billed Curlew. The most logical points of origin of these decoys would be Long Island and occasionally Virginia.

Willet decoys were made and used, but present a minor problem in that there is no way positively to distinguish them from Greater Yellowlegs. It seems to be customary, when the question arises, to classify the larger and bulkier examples as Willets. That automatically makes Greater Yellowlegs out of the rest; except for the fact that it forever precludes any collection's having an oversize Greater Yellowlegs, little fault can be found with dividing them up that way. Plate 24 shows an example of an oversize Willet. It was made and used for shooting that specific bird. The owner signed a statement to that effect. Such documentation adds to the interest of any decoy collection.

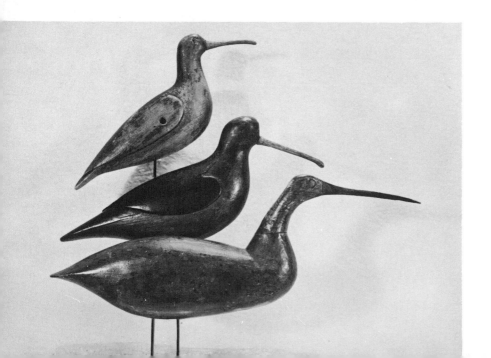

PLATE 23. Eskimo, Hudsonian, and Long-billed Curlews, in that order from the top, illustrate approximate size differences. Bills are original. Overall length of "long-bill" is 19 inches. All before 1900.

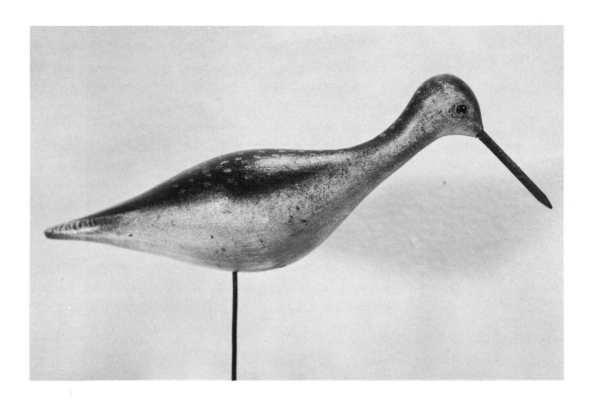

PLATE 24. Oversized Willet, sporting but tough table bird. The conformation and paint pattern bear out this identification. Measuring 16 inches overall, the decoy is obviously one of a special order made by Mason's Decoy Factory of Detroit.

The Godwits, both Marbled and Hudsonian, were formerly not uncommon on the Atlantic coast, and decoys for them were used. Few men now alive can recall seeing them in any abundance. Old-time Jersey baymen tell of a bird they call the "Marlin" or "Straight-billed Curlew" that was a regular visitor to the Jersey shore. Brigantine Island and the marshes from there south to Cape May were among its favored stopping places. A number of Hudsonian Godwit decoys with original bills and paint have turned up in the area. Seasoned baymen rarely made rigs of decoys for birds that never appeared. These decoys provide circumstantial evidence that the "Marlin" was possibly the Hudsonian Godwit.

The Marbled Godwit was only slightly smaller than a Long-billed Curlew, and considerably larger than most other shore birds. It was fast disappearing about the time of the Civil War. I had hardly any hope of finding any authenticated survivor of the decoys made to lure this bird. In 1950, however, I had the good fortune to obtain from Brigantine, New Jersey, a rig of Marbled Godwit, in excellent condition

and with the essential qualifications of correct huge size, straight bills, and original paint. There was dancing on the sands of Brigantine the evening when they were collected. Plate 25 commemorates the event by showing one of the birds.

The Golden Plover, Knot, and Ruddy Turnstone seem to occur in their respective localities in about the same numerical ratios. Their decoys are on the rare side and must be considered choice. All three are attractive and colorful in appearance. The Golden or "Green" plover, a choice table bird, shared its very few stopping places with its slightly larger and commoner cousin, the Black-bellied Plover. This "friendly family" association was not lost on the observant hunter, who was always looking for ways of simplifying his decoy problem. Since Black-bellied Plover decoys attracted both that species and the much rarer Golden Plover, the making of decoys for the less common variety almost ceased. In many states, New Jersey and Virginia for example, the use of Golden Plover decoys was unknown. It is surprising that they turn up as regularly as they do.

PLATE 25. This large Marbled Godwit decoy, all original, is hollow and carefully made. Found at Brigantine, New Jersey, it is now in the collection of Lloyd Johnson. 12-gauge shells indicate scale.

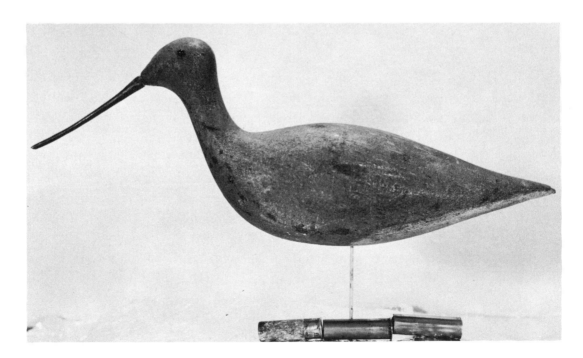

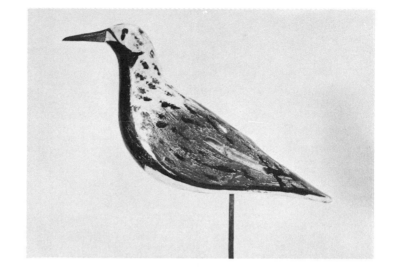

PLATE 26. The gaily colored Ruddy Turnstone is chunky and short-necked compared to other shore birds. Almost inedible, it was shot primarily for sport. The market hunter had no interest in these birds.

The Knot and Ruddy Turnstone were not prize table birds but they furnished sporty shooting. They have also provided today's decoy collections with quaint and colorful items. Occasional examples are known from all heavily gunned areas, such as Massachusetts, Long Island, New Jersey, and on south, but they turn up all too seldom. The Knot was shot more frequently on Long Island and in South Jersey than any other place, and the decoy was in common use in both areas. Some confusion is possible when Knot and spring Dowitcher decoys cannot be clearly distinguished. The Knot had a much shorter bill, generally lighter-colored back plumage, and a shorter neck. But models by different makers overlapped in appearance, and if the original bills are gone identification can be difficult.

Never difficult to identify is a decoy of the "busy" and beautiful Ruddy Turnstone (Plate 26). Even its popular name, "Calico-back," has a pleasant connotation. It was rather common along the whole coast from Canada on south to Florida, but its decoys are decidedly rare. Why one locality made and used the great majority is hard to explain. Almost all those known in collections today originated along the lower half of the Jersey coast. One reason for this may have been its seasonal diets. Never described as a really tasty bird, it was at times downright repulsive. Whalers always referred to the Ruddy Turnstone as the "Whale Bird," because above all else it preferred the vicinity of an old whale carcass on the high side. This association gave it an unappealing aroma for an indefinite time. But this is only a partial explanation for the rarity of the decoy in general and its frequent occurrence in a single area. It obviously had some appeal to those who gunned the marshes of Atlantic and Cape May counties. Otherwise the decoy would be as rare as that of the Eskimo Curlew.

The Pectoral Sandpiper, or "Hay" bird, would often appear in great numbers just after the salt hay had been cut on the meadows. It was attracted by the exposed sup-

ply of insects that formed its diet. Being a medium-sized, tasty bird, it immediately received the attention of the hunter. The decoy is not uncommon from Long Island south, but, unless the original, slightly downturned bill is intact, identification is impossible; also the original paint on the breast should show dark streaks of plumage or an overall buff or tan color. Without these specific characteristics, it becomes another "what-was-it?" snipe decoy. The little flock in Plate 27 illustrate the essential identification points.

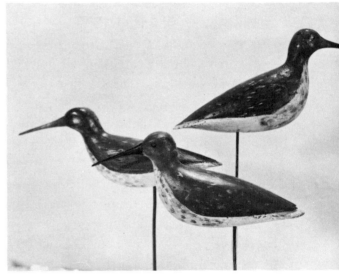

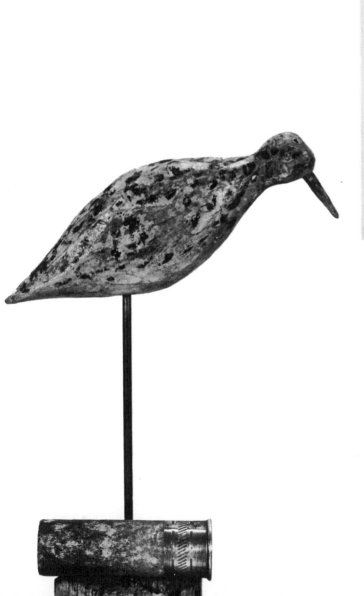

PLATE 27 (*top*). The Pectoral Sandpiper, with its buff-colored vest, is a little-known decoy. The graceful, tapered bill has a slight downward curve, an important feature for identification of the species. PLATE 28 (*left*). To see a flock of Least Sandpipers is to appreciate their appropriate name. When feeding with other shore birds, they appear tiny as they run around among and under their larger brethren. The shotgun shell appears almost as long as this smallest of all decoys the writer has seen. Identification is based on its small size.

The decoys of the Red-backed Sandpiper or Dunlin present the same problem of identification as those of the preceding species. Only the spring plumage pattern with the black belly is unmistakable. Since this bird was not always very common in spring along the coast, few decoys carry this positive trademark. One factory, in what seems to have been a forlorn and unprofitable effort to outstrip its competition, made the model in the background in Plate 168, which is apparently a Red-backed Sandpiper. No other examples are known. This and a few handmade ones constitute the only proof that decoys were made of this bird. Its migration schedule also prevented it from being a popular bird to shoot. The main flight down the coast could be as late as November. This was long after the "sport," or casual snipe hunter, had deserted the beaches and at a time when the local baymen were seeking more desirable ducks and geese.

A very select little company of sandpipers were also hunted, and there are many decoys that can be attributed to each species. The Least and Semipalmated Sandpipers, together with the Sanderlings, comprise this group of smallest shore birds. The Least Sandpiper may very well be the smallest bird ever decoyed and shot for both sport and food. The tiny "beach bird" decoy shown in Plate 28 is probably intended to simulate the Least Sandpiper. It comes from a working rig of about a dozen. The small Sanderlings and Semipalmated Sandpiper are somewhat difficult to distinguish one from the other. Baymen had the happy faculty of ignoring the slight differences and calling them all "beach birds." They carried this carelessness along as they shaped and painted these particular decoys, so that today's owners should not get too profound in their species identification. Even in an area as erudite as the South Shore of Long Island, two separate species shared the name of "ox eye," and a "peep" could be either a Least or a Semipalmated Sandpiper, or even a Sanderling. These variations and overlappings are really unimportant if your example is a pleasing decoy. The specimens shown in Plate 29 were very carefully selected and are true to the species named.

It is satisfying to end this account of the shore birds with a relative rarity. The Piping Plover and Semipalmated Plover were fat and delectable tidbits of birds. These similar birds occurred in South Jersey, where the decoy in Plate 30 was part of a rig. It has its original paint, but whether it was intended to represent a Piping or a Semipalmated Plover we shall never know. The decoy maker has captured the general form and nature of the bird in striking manner.

The checklist of shore-bird decoys on page 35 is based on the best evidence available after inspection of all important collections prepared for study. Additions to this list may always turn up. One would think, for example, that surely some lonely whittler in a Life Saving station must have noticed that the Purple Sandpiper was around most of the winter, and must have made a rig. Be on the alert.

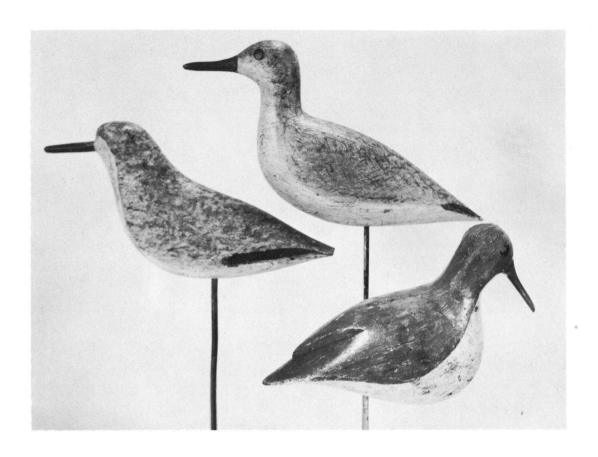

PLATE 29. So-called "beach birds," two Sanderlings and (*right*) a plump Pectoral Sandpiper. Workmanship on the decoys for these lesser birds was generally not so good as in these. Finesse was unnecessary, since they were unsuspecting and could be whistled back time after time to the rig.

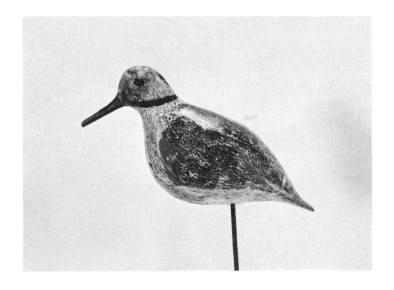

PLATE 30. This decoy from South Jersey represents either the Piping Plover or the Ring-necked (Semipalmated) Plover. The region's sandy beaches were visited every fall by small flocks of chubby Piping Plover. Though of no commercial value, these birds still received attention from local gunners. They survived the carnage and now seem to be increasing in numbers.

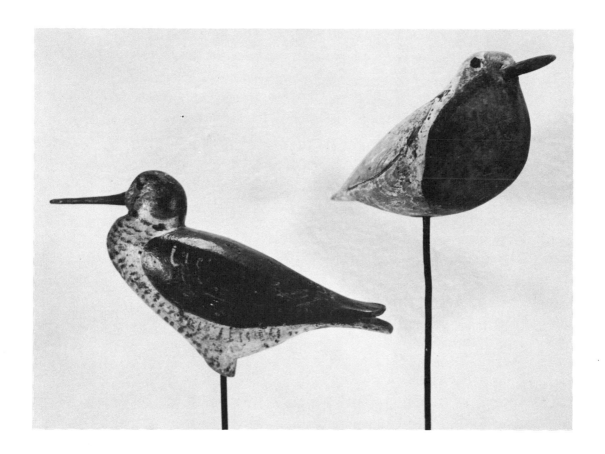

PLATE 31. Both the Black-bellied Plover, on the right, and the Dowitcher represent well-fed birds ready for a nap. Both are cleverly carved to minimize breakage. The Dowitcher has the rare "thigh" detail carved from solid wood. Both are from Long Island, New York.

PLATE 32. A crude, but bold and virile representation of a Black-bellied Plover from Long Island's South Shore, perhaps as early as 1875. The wings are pinned to the body with oaken pegs.

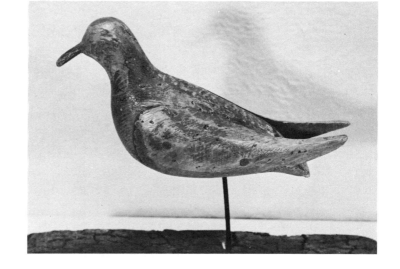

51

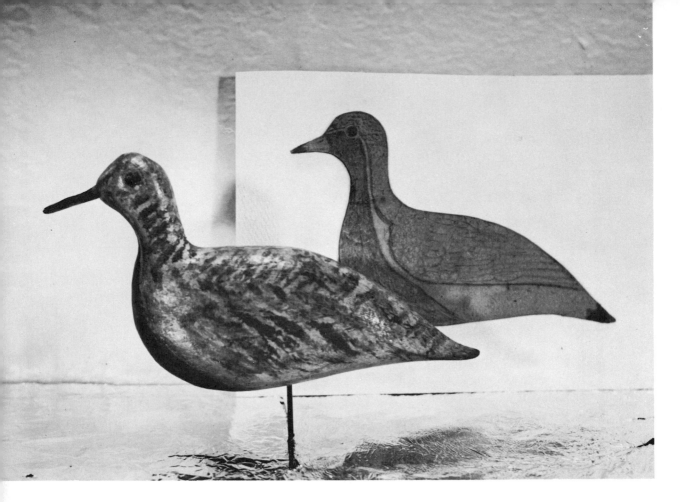

PLATE 33. John McAnney of New Gretna, New Jersey, made this Black-bellied Plover. Proof of that fact is the pattern in the background found recently in John's old shop. Exactly corresponding in shape to the bird shown, it provides the sort of documentation seldom found by the decoy collector.

Always to be considered is the fact that paint was not always available in the exact shade desired, and a make-do job was often quickly performed. Subtle shadings were considered unnecessary by most makers. Also, the paint used was often of poor quality and so has changed color over the years. Thus confusion and honest disagreement are the lot of the collector when borderline situations are discussed. One's only regret is that the possibilities for future discussions are constantly narrowing. The hunting of shore birds has been illegal for almost half a century and the surviving decoys are few. As folk art, hunting memorabilia, and mementoes of a way of life that is gone but well worth remembering, they are interesting and extremely collectible.

PLATE 34. Extraordinary folk art is this fanciful castaway found floating in a marsh on Assateague Island. No history available, but probably made about 1895. Only 7 inches long, its small size and traces of original paint indicate that it probably represents a yellowlegs. With its odd pose, it would serve to vary a rig.

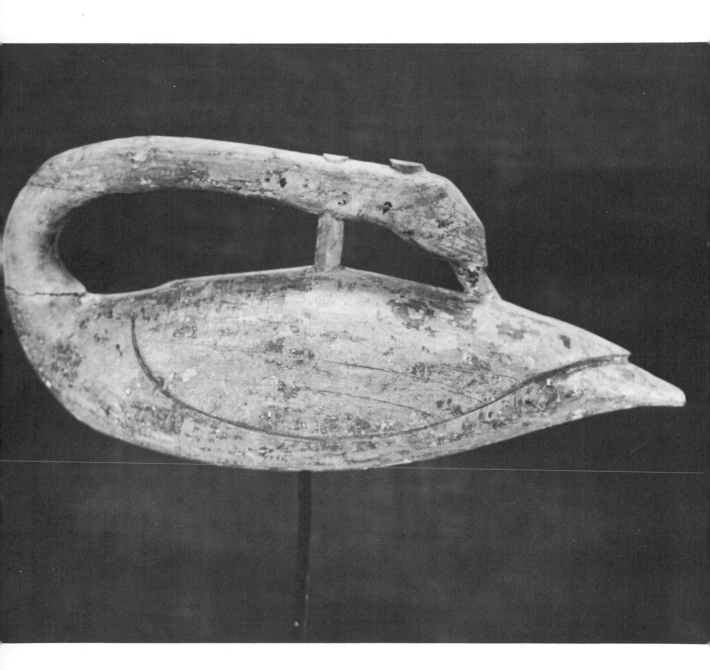

IV *The Odd Birds*
HERONS, EGRETS, TERNS, AND LOONS

THE WORD "DECOY" IS most commonly associated with ducks, shore birds, geese, and Brant, although not necessarily in that order. Apply the term to a replica of a tern or owl and you may get an incredulous look in reply. Weight of evidence must prevail, however, and serious collectors may aspire not only to the two rarities just mentioned but also to Great Blue Herons, American (or Common) and Snowy Egrets, crows, blackbirds, loons, and flickers.

These are not freaks or oddities of which only one is known, but in every case exist in some variety and have a record of luring their own species to the gun. The one exception is the owl, which qualifies in part as a confidence decoy.

Taking them in an order that observes neither importance nor rarity, the first of these "odd birds" that comes to mind is the Great Blue Heron. When well conceived and endowed with the awkward grace of the great bird itself, a heron decoy (Color Plate I) can take command of almost any collection. Their variety runs the entire gamut from the most primitive forms to beautifully carved and painted examples. The period of their use coincides with the era of the late Victorian garden ornaments that graced the lawns of the middle and upper classes. Many of these ornamental lawn birds are wooden and are passed off as decoys. The unsuspecting are sometimes deceived by these elaborate counterparts.

The widespread impressions that the Great Blue Heron decoy (Plate 35) was used as a confidence decoy, or that the bird was lured and shot for its feathers, are false. Most baymen made heron decoys and shot the birds for the simple and understandable reason that they were good to eat. Along the great salt marshes of Long Island the Great Blue Heron was known by the lip-smacking title of "Seaford Turkey."

Long Islanders were not alone in the shooting of this toothsome bird. It also found favor with some of the natives down Jersey way, especially around Atlantic City. Philip Bessor, sports authority of that area who has researched the heron

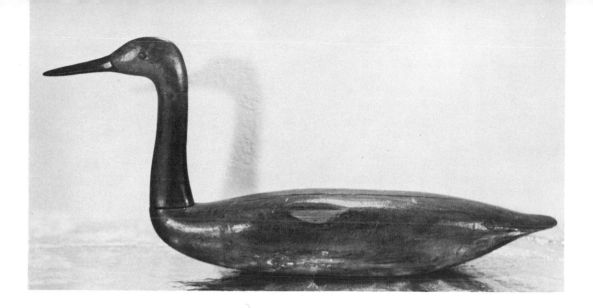

PLATE 35. Great Blue Heron made in three sections for ease in carrying. Identification is based on the paint pattern and statements of the owner. Made by John Cornelius of Forked River, New Jersey, it was given to Lou Barkelow, also of Forked River, in 1893 as a birthday present. Completely original, including stake. The body is 23 inches long.

story in those parts, writes in a letter to me: "Thought you might be interested in a talk I had with George Conover of Absecon. Mr. Conover is about 80 years old and claims to have used heron decoys. He used one decoy only and sold the herons for 25¢ apiece. I told you that a lot of the old-timers ate blue heron and rated them rather high. I have often seen my grandfather bring one in for a friend of his."

Wherever the Great Blue Heron was abundant, decoys for it were used. Sensible restrictive legislation has made it possible for all to see and enjoy this noble bird and collect the now useless wooden counterparts.

The story of the American Egret parallels that of the Great Blue Heron. They were found in the same environment on the Middle Atlantic coast and apparently tasted the same. The great and lamentable difference, now apparent, was in their respective numbers. The American Egret was a somewhat rare visitor along the coast, and decoys made specifically to lure it are excessively rare. Many decoys carved around Cape May, New Jersey, were large and awkward, yet practical. This makes it less surprising that several tremendous American Egret decoys have been found in the vicinity of Cape May. These monumental decoys are as exceptional as a decoy can be; in size, rarity, and design they are in a class by themselves. One is shown in Plate 36. While its antecedents are unknown, its purpose is obvious. In no sense a "contentment" decoy, it was used to provide its owner, every so often, with a "white heron" meal.

The Snowy Egret is a much smaller relative of the huge American Egret. It was none the less tasty, however, and because of this Snowy Egret decoys are found,

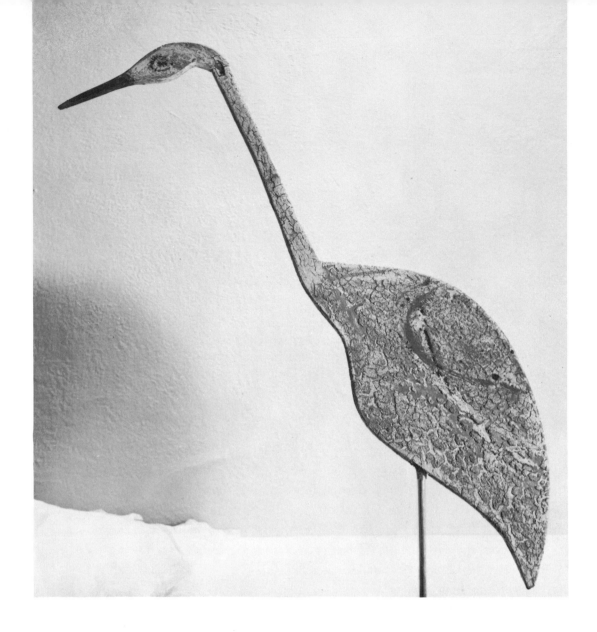

PLATE 36. American or Common Egret profile decoy from Cape May County, New Jersey. A very old decoy, its greatest length is 45 inches. This bird, a tasty addition to the bayman's diet, was common in the mid-nineteenth century but almost became extinct by 1900.

though they are extremely rare. Decoys played their part in the tragic story of the slaughter of these birds almost to extinction. The plume hunter, who operated in the southern United States, mostly Florida, and killed the birds in the rookeries, used no decoys. After the breeding season, these birds moved north, and a few of their decoys have turned up from Carolina to Long Island, though well-made ones are almost unknown. Plate 37 shows an example that is adequate from the viewpoint of both

the hunter and the collector. It was used, in company with several other similar examples, to obtain the bird for food, not feathers. It came from Maryland, but others, very crude, are known from Long Island.

Also from Long Island come the only known decoys of the Common Tern. All have turned up in the Amityville area and with one exception seem to have a common origin. The lone exception is the one in Plate 38 and is attributed to Nelson Verity, the "huntingest man" the South Shore ever produced. This version is skillfully carved and proportioned. The graceful wing of this handsome little bird was just right to adorn milady's hat in the day of the Gibson Girl. The going price was ten dollars a hundred birds. This friendly and easily lured bird lived a less dangerous

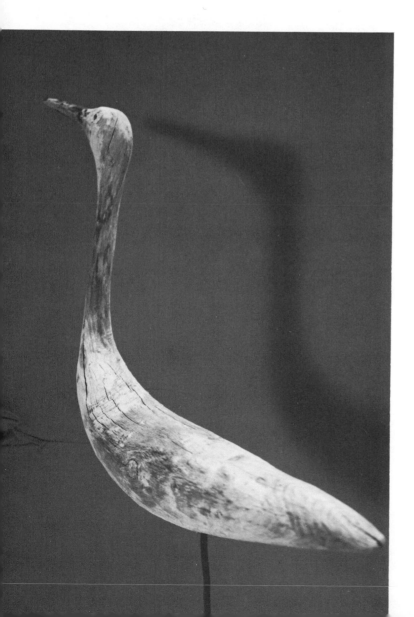

PLATE 37. Size and original paint classify this unique decoy as a Snowy Egret. It was carved from a single piece of wood about 1890. Once shot for its plumage and as food, the Snowy Egret is now a common summer visitor along the Middle Atlantic coast.

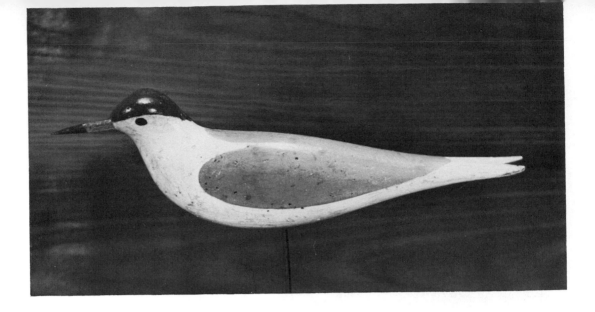

PLATE 38. The Common Tern, whose graceful wings decorated ladies' hats in the early 1900's, decoyed well. Nelson Verity of Seaford, Long Island, New York, is said to have carved and used this stick-up model. Happily, tern shooting is now a thing of the past.

and happier existence in the rest of its range. There is no record of any organized shooting of it except on the South Shore of Long Island. Only a handful of these precious decoys remain.

The mention of a loon decoy to a collector brings the immediate demand, "Where?" But obviously, no collector would ever tell another where he could procure a loon decoy. Good ones are that rare and really old ones even rarer. Their value

PLATE 39. It is almost impossible to justify the shooting of a Common Loon, because the bird is inedible and nonsporting. But a few fine old decoys indicate that they were shot. Now the decoys are intensively hunted. From the collection of Winsor White.

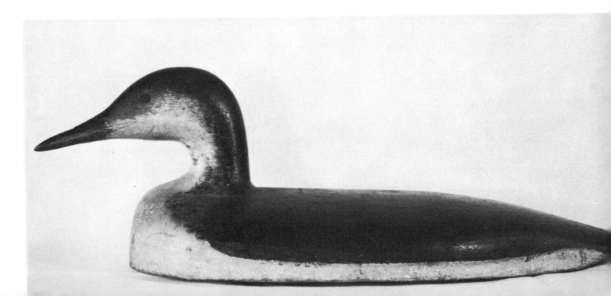

and importance are complicated by the fact that in the Down East states and the Maritime Provinces, their production has never stopped. Their use goes back for a century, and these older models are great prizes, though they are the exception. Always an individual effort, loon decoys occur as one of a kind. For the most part they are crude, heavy, and age quickly under the rough conditions of use. The inletted head and neck, characteristic of all decoys from Down East, should always be carefully checked for signs of recent tampering. Loons had no economic or gastronomic value. Their pursuit seems to have been prompted by the same reason given for climbing mountains: because they were there. On occasion gunners used an uncured piece of loon skin, on the underside of which is a layer of fat, to wipe their guns with. The story goes that nothing was so effective in preventing rust, so as long as the weather stayed really cold and damp a slab of loon fat was a handy thing to have around.

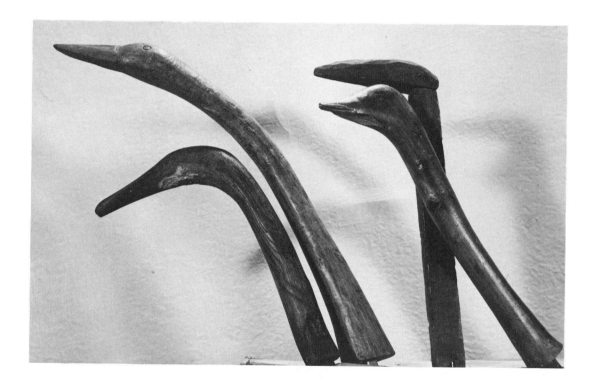

PLATE 40. Heads and necks of the Great Blue Heron were often made of holly, locust, and other durable woods. They resisted destruction much better than the soft cedar bodies. These superb examples, which have lost their bodies, deserved a better fate. All are of Long Island, New York, origin.

V Decoys of Vanished and Vanishing Birds:
THE PASSENGER PIGEON, LABRADOR DUCK, AND ESKIMO CURLEW

THIS IS OF NECESSITY a sad story. In a tragedy for conservation, human greed deprived later generations of their right to enjoy three entire species of birds. Unregulated hunting wiped from the face of the earth the Passenger Pigeon, Eskimo Curlew, and Labrador Duck. The case of the Eskimo Curlew is not entirely conclusive, as several sightings have been made that give reason to hope that a small flock of these birds may still exist. If this is true, may their tribe increase—but for all practical purposes they too are gone and are considered extinct.

The story of our treatment of the Passenger Pigeon is beyond belief. Many vivid articles and books of the period describe it; they should be read only by people with strong stomachs. Man's savagery toward these birds was not second to his destruction of the buffalo herds; in fact, it exceeded that carnage. As millions upon millions of pigeons were fed to droves of half-wild hogs, or left to rot, their extinction became inevitable. It seems almost as though nature, in her contempt for man's boundless carelessness, helped hasten the final act. Slaughtered by day and dynamited by night, the harassed birds were driven from their nests, diverted from their migratory routes, and deprived of their feeding grounds. Suddenly the gentle Passenger Pigeon was gone.

Occasionally an authentic Passenger Pigeon decoy turns up and is eagerly collected. Plate 41 shows Passenger Pigeon decoys of the period. Unfortunately such decoys are almost as rare as the poor birds themselves. Since age is an absolute prerequisite of any genuine Passenger Pigeon decoy, every precaution should be taken by the purchaser. Any indication of alteration, fresh paint, or foreign origin should be a reason for immediate rejection.

Many students of the subject believe a number of old Passenger Pigeon decoys

are still in existence. Some may still be in use as oversize Mourning Dove decoys, a purpose they would serve adequately. Others, probably mostly in the Midwest, are gathering dust in attics or sheds. If any appear from their present hiding places, they will be a real contribution to the hunting history of this country, tragic memorabilia of an event that should never have been.

The Labrador Duck passed rather quietly from its home along the East Coast during the late nineteenth century. The last specimen of record was sold in a New York market about 1873. It was neither a plentiful nor especially desirable duck, and received little attention from the gunners. No satisfactory reason has been advanced for its extinction. The Labrador Duck was once fairly common on Long Island's South Shore, and several decoys are known. The duck was about the size and general shape of the Great Scaup, but in general pattern and coloration superficially resembled an Oldsquaw. Any decoy submitted for consideration as representing any extinct species must, of course, be original in all respects. Labrador Duck decoys

PLATE 41. Passenger Pigeon decoys from Long Island, New York. These replicas fulfill every requirement demanded of a pigeon decoy. In original condition, they were probably made about 1870.

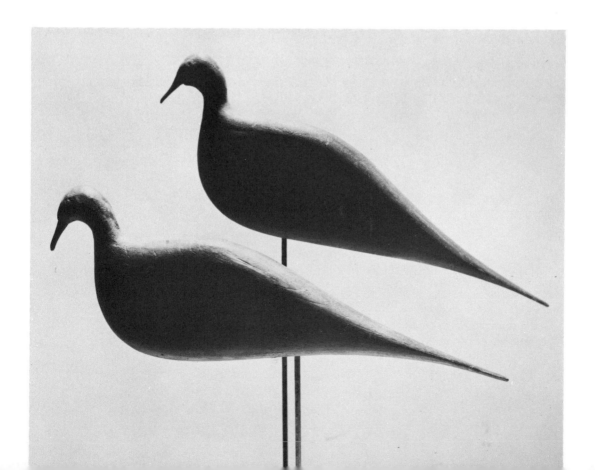

meeting these requirements are shown in Plate 42, and the evidence as to their authenticity is conclusive. These decoys were found on the North Shore of Long Island. Since the bird they were intended to lure could not possibly have existed after the end of the century, the decoys have obviously had a fortunate retirement of many years. One boy, a can of paint, and a brush would have completely wrecked this rare item. It seems a pity to have so many desirable models ruined by subsequent coats of paint.

The Eskimo Curlew formerly was one of the extremely abundant birds of America. Audubon spoke of "flights of them so immense that they darkened the sky." Heading northward in the spring, they migrated up the Mississippi Valley. It seems

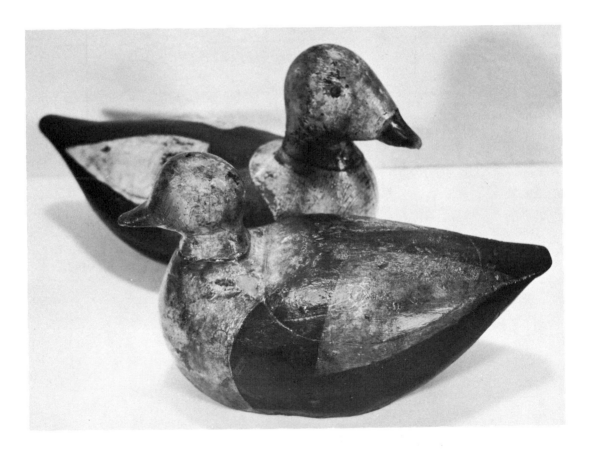

PLATE 42. These Labrador Ducks are complete except for broken bills. The paint is old and the construction is unusual in that they are hollowed out from the back. They must date from before 1870.

somehow prophetic that in that region they were called "Prairie Pigeons." When the Passenger Pigeon disappeared from the markets, the Eskimo Curlew helped take its place in the spring as market hunters followed it north state by state. Its fall migration down the Atlantic coast left us the precious legacy of some identifiable decoys of the species. Normally the birds followed a route well to the east of the coast of New England and the Middle Atlantic States. Only during strong easterly storms were sufficient numbers of these birds present on our shores to furnish sport. Because of these factors, gunning for them was unpredictable, and the eastern extremities of land such as Cape Cod and Nantucket were the favored spots for it. Known locally as the "Doughbird," the Eskimo Curlew was considered a choice morsel. In this it differed from the Hudsonian and Long-billed Curlews which were bigger and sportier targets but far less desirable as table birds. As the Eskimo Curlew grew scarcer, so also did the Long-billed Curlew. Happily, decoys of the Long-billed variety do not come within the confines of this chapter, because these birds are still seen occasionally, though very rarely of late, along the Atlantic coast north of South Carolina. The curlew decoys generally found represent the Hudsonian Curlew, which furnished good shooting from New England south to Carolina. Never in any danger of extinction, their numbers have increased during the last several decades. The relative size of the three Atlantic coast curlews is shown in Plate 23.

Two other unfortunate shore birds almost qualify for inclusion in this group of extinct birds. They are the Marbled Godwit and the Hudsonian Godwit (Plate 43), the latter known also as the "Ring-tailed Marlin" or "Straight-billed Curlew," which frequented the South Jersey coastal marshes. Today these birds are seen only occasionally. Those lucky enough to have that good fortune should cherish the occasion, for both of them, especially the Marbled Godwit, are noble and impressive birds.

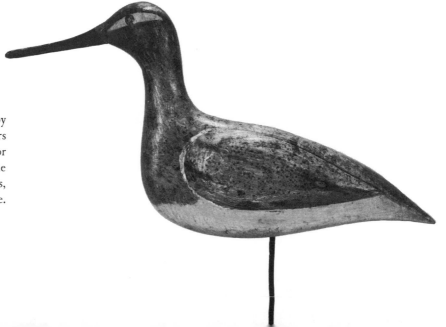

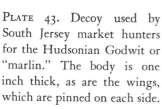

PLATE 43. Decoy used by South Jersey market hunters for the Hudsonian Godwit or "marlin." The body is one inch thick, as are the wings, which are pinned on each side.

VI New England

THE CONNECTICUT SCHOOL

The town of Stratford, near the mouth of the Housatonic River in Connecticut, lays claim to being the heartland of American duck decoys. Stratford's superlative decoy makers carved their way to fame despite the limited geographical area in which their products were used, and the fact that the region was not rich in the large marshy areas that offer the ideal habitat for most ducks. Theirs was a story of men striving to make, and succeeding in making, the finest decoys for use under a specific set of conditions.

Heading the list of the Stratford decoy makers are three men: Albert Laing (1811–1886), Benjamin Holmes (1843–1912), and Charles E. ("Shang") Wheeler (1872–1949). To name their equals would be impossible; considering them as a group, and on the basis of their collective work, they leave the competition far behind. Surely only one desire motivated these men who lived and hunted along the Connecticut shore of Long Island Sound and its tributaries: to make the best decoy possible. The superiority of their work extended to all phases of it: the selection of the wood, the construction of the body, and the appearance and riding ability of the decoys.

The pleasant story of decoy making in Stratford had its beginning more than a century ago. At that time the original decoys of this region were of a type locally known as "old rocking horses." This we know from the testimony of men with long memories and close ties with the old school of Stratford wildfowlers, men such as Thomas Marshall of Fairfield, Connecticut, who pursues wildfowl and hunting history with equal skill. These decoys were crude, solid jobs whose only claim to interest, for the discriminating collector, is their age. Their generally heavy and non-descript character scarcely distinguishes them from decoys of other regions, such as the sounds of North Carolina, where similar stools are still being made and used to

PLATE 44. Albert Laing of Stratford, Connecticut, is best known for his Black Ducks and Greater Scaup. This Black Duck has "LAING" burned in the bottom. Such documented examples are classic in the decoy field. The photo also shows the typical Connecticut pear-shaped weight.

this day. Those who made decoys of the "old rocking-horse" type in Stratford were hard put to justify their products as the Civil War came to a close.

About 1865 Albert Laing, a native of Rahway, New Jersey, settled in Stratford, where he made his home for the rest of his life. No single individual ever exerted a more direct or lasting influence on the designing and making of decoys. Albert Laing must be ranked as one of our very greatest decoy makers, if only because he was a pioneer who showed others the way. Plate 44 shows the bottom of a signed Laing decoy almost one hundred years of age. This decoy has the lifelike conformation, seaworthiness, attractive look, and durability of the most desirable modern decoy. The judges at any contemporary decoy contest would give it careful consideration for the top award. Albert Laing had an uncanny foresight as well as a sharp eye for design and great skill as a craftsman.

If Laing made or even used decoys in his native New Jersey, there is no record of it. It is interesting to note, however, that this Jerseyite came from the original home of the "dugout," or hollow decoy. Albert Laing's arrival in Stratford was the beginning of the end for the solid, clumsy "rocking-horse" decoys. His work brought an entirely new style and form to the Connecticut decoys, and from the time of his arrival until the death of Charles Wheeler in 1949 no better ones were made anywhere than in the Stratford area. That Laing was a citizen of some affluence is indicated by his style of life, the home he owned and lived in, as well as the contents of his last will and testament, which read in part that his rig of 111 decoys were to be sold for $45.00. The modern decoy collector views this now incredible bargain as the modern realtor does the original purchase of the island of Manhattan.

Laing was a pioneer craftsman of his trade. He was the first, for example, to use copper nails to fasten the two halves of the body together, a precedent so sound that it should have been immediately adopted by all makers whose decoys rode on salt

water. But only around Stratford was Laing's wisdom carefully noted. Elsewhere, from Canada to Carolina, the use of iron and galvanized nails continued to be standard practice. After the baptism of salt water, these nails began to split the wood, stain it, and eventually rust away until the heads and bodies parted company. Not so the early Stratford decoys. Their makers spent a few pennies more at the start for copper nails and brass screws, but they were years ahead in the overall durability of their stools.

An extremely significant development by Laing and his followers was the high and overriding breast on all of their models. They pursued their hunting on waters strongly affected by tides and currents. This presented a problem, especially when slush and ice were present. The high-riding breast sloped so that the angle pushed the decoy over, instead of under the flowing ice. Plate 45 clearly indicates this design.

For almost a century, no significant change or improvement was made that was not inherent in the original models of Albert Laing. An example such as the Black Duck by him illustrated in Plate 46 is to a decoy collection what a Rembrandt is to an art museum. Almost every example of Laing's work found has his name burned in the bottom in large block letters. Occasionally a similar model is located, stamped F. BURRITT in much smaller letters. Without doubt it is a Laing. Burritt was Laing's shooting partner, with whom he shared many days on that Black Duck marsh to end all Black Duck marshes, Nell's Island at the mouth of the Housatonic.

Benjamin Holmes was a worthy successor to the crown deservedly earned by Laing. As a young man, his contact with the older Laing was close, and his attitude one of respect. The workmanship, conformation, and painting of his decoys reflect the mature example set by his mentor and friend. It would seem at this time, with all the evidence before us, that they were men of equal talents and devotion to the carving of decoys. Comparison neither helps nor harms either man. Suffice it to say that to the first, Laing, belongs the lion's share of credit as an innovator.

Happily there is no need ever to confuse Laing's and Holmes's work. They can be distinguished by a salient difference in the body construction. All full-bodied Laing models have the hollow bodies made from two slabs of northern white pine of equal thickness. Holmes used the same pine, but in two unequal pieces; the bottom thickness is a half-inch board. The upper half is hollowed out and of course varies in thickness with the species under consideration. Why Holmes differed from his tutor in this one structural feature is obscure. His method saved no time or labor and has no readily explainable advantage. Theoretically, it has one fault: in a hollow decoy the joint between the two parts of the body is always vulnerable to leakage. The Holmes design placed the joint below the water level and encouraged leakage if the joint warped or opened up in any way. A Laing decoy rides with the joint above the waterline and on quiet water wouldn't leak even with an open joint. It

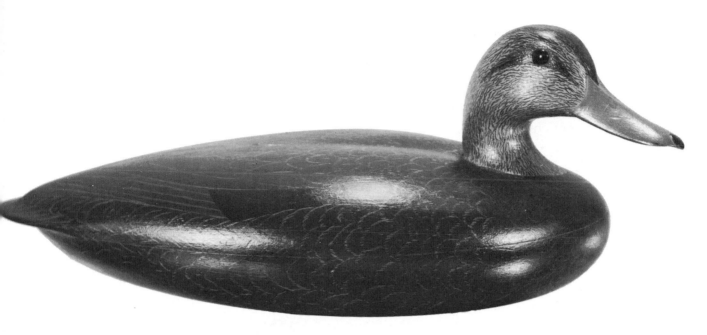

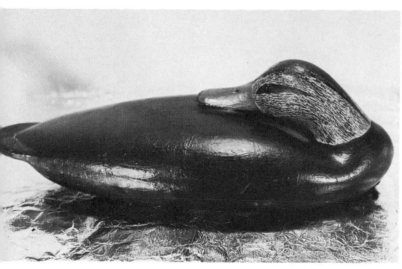

PLATE 45 (*top*). Black Duck made by Charles ("Shang") Wheeler just before his death. As a decoy it cannot be faulted, and from the esthetic standpoint it is a joy. It will never be used to deceive its wild counterpart. PLATE 46 (*left*). This Black Duck, by Albert Laing, has the maker's name branded on its bottom. These "sleepers" were placed on the exposed mud flats near the blind. A unique decoy that was never copied in other areas.

could have been Holmes's one way of displaying a certain independence as a decoy maker and indicating his faith in what he must have known was superb workmanship.

Acknowledgment of that fact was not long in coming. In 1876 the International Centennial Exposition was held in Philadelphia. Holmes entered a dozen Greater Scaup (Plate 48) and carried off all the honors. This rig has since become famous wherever decoys are discussed. One senior collector has personally handled and

placed his stamp of approval on at least thirty-six of this original dozen. One wishes the real exhibition models could rise and flap their wings.

Indeed, Ben Holmes could have put almost any of his work on exhibition anywhere and at any time and have been the winner. The other details of that Centennial exhibition that made wildfowling history seem to have been forgotten. Who placed second? Did Laing enter? And above all, where is the list of those who did enter? It's a dark and frustrating page in decoy history, with Ben Holmes the only shining light.

Charles E. ("Shang") Wheeler carried on in the Stratford tradition to make his undying mark on modern carving. Thus he mated the best of the past with the decorative art of today's ornaments, and he is best known for his beautiful "mantel birds." "Shang" Wheeler led a busy, diversified life that took him from the halls of the Connecticut Senate to the State Game Commission. In later years he was identified with oyster inspection in his state, and always kept his hand in as a practicing

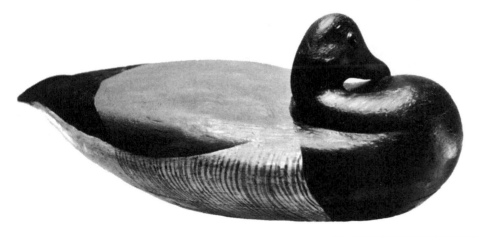

PLATE 47. A most unusual Connecticut Brant. It was made by Ben Holmes and used by Shang Wheeler when he gunned the famous Brant bays of Virginia.

PLATE 48. Greater Scaup by Ben Holmes. Several turned-head decoys were among the dozen he exhibited at the Centennial Exposition at Philadelphia in 1876. This decoy, in original condition, is one of them.

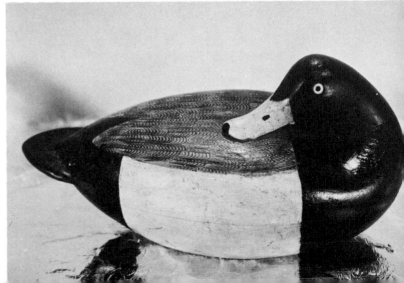

hunter and fisherman. We should be thankful that out of this rich, full life he left as much of his handiwork as he did.

Shang Wheeler's decoys fall into two general groups. The most desirable are his wooden ones patterned after Albert Laing's, but generally a little bolder and showing neck positions out of the ordinary. Plate 45, a working decoy if there ever was one, is bigger and bolder than Laing's work. It is Shang at his finest, but it still bears the influence of Laing. Wheeler could never have known Laing, but he was a close friend of Holmes, and the latter's influence, too, is sometimes evident in his ornamental wildfowl. Wheeler also made cork models, ranging from crude but very practical diving ducks to beautifully fashioned Black Ducks with tails of other wood, and heads and necks in the sleeping position. Shang was a realist and had fixed notions as to what a decoy should be. He was not one to waste a great talent on a decoy that he felt needed only so much detail. The scaup shown in Plate 49 was made and used by him. It represented all he felt a scaup decoy needed to be under the specific conditions in which he intended to use it. But each category of his work has tangible class and distinction; all Shang Wheeler's decoys show the hand of the master.

Laing, Holmes, and Wheeler all majored in Black Ducks, scaup, and scoters, with Goldeneyes and an occasional Oldsquaw to sweeten the list. Decoys of other species by them are hard to come by. No shore birds by them have been identified, although hope remains that a Laing shore bird may turn up. That it could be documented at this late hour seems problematical.

No Stratford maker could be classified as a professional decoy carver. All of them were at most part-time whittlers, and their output went into their own rigs or those of friends. It seems logical that Holmes made more decoys than the other two, perhaps as many as both of them together. Laing's output was certainly limited; a calculated guess would be five or six hundred. It is possible to draw a rather fine bead on the output of Wheeler's shop. Aside from the ornamental and decorative birds that brought him his chief fame, he turned out less than 500 actual decoys. It speaks well for the esteem in which these are held that so many remain to brighten collections. And it speaks even more for the man himself that those who knew him cherish his memory most of all. He was a great and skilled craftsman, but most of all he was a kind and outstanding sportsman who knew, enjoyed, and contributed to the golden age of wildfowling.

A great pride governed the work not only of Albert Laing, but also of Ben Holmes and Charles Wheeler. Never "How many?" but rather, "How good?" was the spirit that motivated them. The same thoroughness and pride are apparent in the work of the competent but less skillful men who were their contemporaries. Several made decoys that cannot be found faulty in any detail of construction or

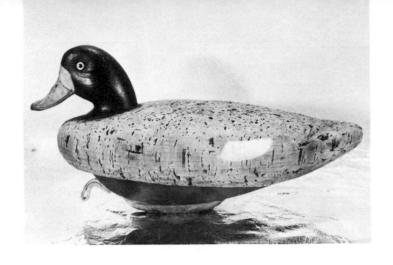

PLATE 49. Shang Wheeler lavished his superb painting on models for exhibition and special pieces. His practical working rig consisted of sturdy decoys without fancy details. This female Greater Scaup was made and used by him.

paint pattern and can hardly be distinguished from original Wheelers. But their work must take second place to the carvers of the original models and designs, since the copy always honors the original. Charles Disbrow, whose Black Duck placed first in the National Decoy Show of 1950, was one such gifted carver who followed in the footsteps of Wheeler. The few examples of his work still available are almost impossible to distinguish from the Wheeler classics.

PLATE 50. Canada Goose made by Shang Wheeler. It has a weight and thong for use as a decoy, but was never actually used. Exhibited at the National Decoy Show in New York in 1949. Body length, 27 inches.

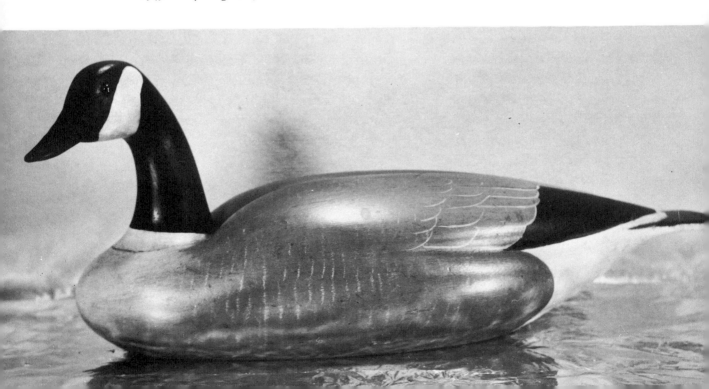

An added excitement is injected into collecting Stratford and Connecticut material, because only Laing seems to have held steadily to the branding of his decoys. With that exception, the identification of many decoys remains in doubt. Clever men copied the work of all those we have discussed and others solicited aid from the masters and received it. Many stools marked "R. O. Culver" were actually the handiwork of Ben Holmes, and many eager hopefuls took partly finished paint jobs to Shang Wheeler, who gave them a helping hand. Several rigs are known to enjoy heads which were made by Wheeler when the body makers appealed for assistance. So this most interesting of all decoy regions presents a confused picture.

Another Connecticut worker, Cassius Smith of Milford, played a lone hand. His cute, dumpy decoys carry the brand "C. Smith," as if to declare proudly, "They are mine, all mine." Smith's rig was made in 1890.

A large rig which carries the brand "S and S," and includes Oldsquaws, has cheered many collectors. This rig was made and used by the Smith brothers, George and Minor, also of Milford. It was carved in 1875. The Smiths asked no odds of anyone but went ahead and made some of the plumpest, most seaworthy diving ducks anyone has ever seen.

R. D. Sanford and one "Baldwin" are other names associated with excellent Stratford decoys.

Other gunning spots along the Connecticut coastline had their local favorites who made acceptable models. None of these decoys compared in quality with the work already discussed. They fail to stand out, and time and collectors have passed most of them by. Worthy of mention, however, is the work of the Collins family, from the Essex area. Several generations of this family, beginning with Samuel Collins, Sr., made solid working decoys that always help to round out a representative Connecticut collection.

NEW ENGLAND IN GENERAL

The decoys of New England in general show a range of individual characteristics that delights the collector. The endless variety of poses, sizes, and forms appeals to the good taste of discerning buyers. Individuality was the rule of the day when the New Englander set about carving his own decoys. Gunners along this staid and rock-bound coast put into use some of the biggest, some of the smallest, and some of the most imaginative and unusual decoys ever used. Others carved and painted shore birds with such skill and knowledge that they are true replicas of the live counterpart. The fact that extremes of all kinds are encountered in New England decoys makes any generalizations about them risky. Consider the north shore of Cape

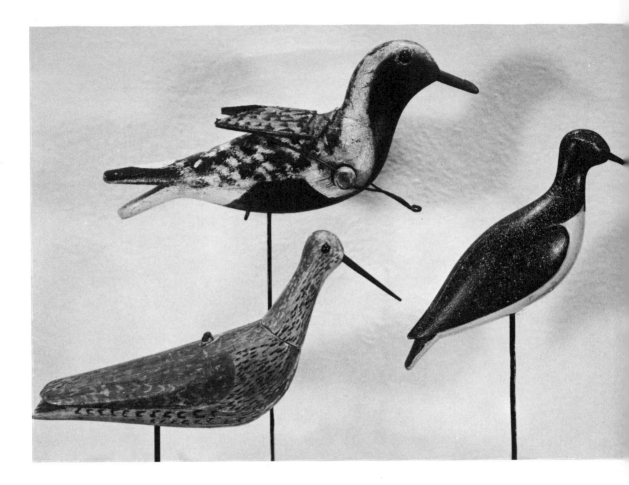

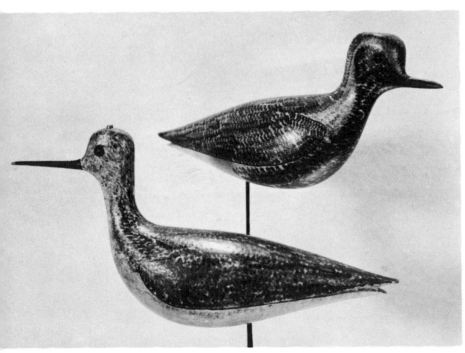

PLATE 51 (top). Shore birds of unusual design. The plover at the top will flap its leather wings when a line that runs to the blind is twitched. The yellowlegs at left carries its own head and bill in the hollowed-out body. The third bird is hard to identify but is also hollow, with a detachable head. All are especially attractive to collectors. PLATE 52 (left). Shore birds by a prolific, but unknown maker. Black-bellied Plover above and yellowlegs below. Decoys like these were sold between 1910 and 1915 by the Iver Johnson Sporting Goods Store in Boston. They are finely carved and nicely painted.*

* *Editor's note, second edition:* It has subsequently been discovered that these birds were carved by George Boyd of Seabrook, New Hampshire.

Cod about 1920. Here a stand of Elmer Crowell's superbly painted duck decoys would have had competition from a neighbor's rig of dingy canvas "money bags." These were black painted bags of unbleached cotton or duck stuffed with grass or crumbled cork and tied at one end with a piece of the cloth protruding beyond the tie to suggest a head. All the evidence points to the fact that at times both methods were very effective.

It was this high degree of individuality that created so many unusual and interesting New England decoys. Carving and other workmanship were excellent, but the selection or curing of the wood left something to be desired, as splitting and checking of the bodies are all too common. White pine was the wood generally used for bodies, but occasionally a maker, such as Joseph Lincoln of Accord, Massachusetts, favored cedar. The heads were, without exception, always made of white pine.

There is no record of any New Englander making decoys for sale except on a limited or part-time basis. Lincoln and Crowell sold some, but there is every indication that other pursuits were their major sources of revenue. Crowell carved and painted decorative birds, and some fish, throughout his lifetime. These items, over the years, far overshadowed his decoys in both numbers and revenue.

Elsewhere, from Cape Cod to the Bay of Fundy, the story of Down East decoys is the story of individuals making their own and in rare instances having some for sale or barter. A perfect case in point is Martha's Vineyard, Massachusetts, where J. M. Leavens has made an intensive study of all phases of wildfowl hunting over the past century. He has established that the following Vineyard men made decoys for their own use: Gene Rogers, H. Keyes Chadwick, Manuel S. Roberts, Ben D. Smith, Herbert Hancock, Russell Hancock, Bill Deegan, M. H. Mayhew, Charles Joy, Frank Adams, and Jim Look.

In the case of H. Keyes Chadwick (1868–1959) of Oak Bluffs, Martha's Vineyard, it is known that his entire life's output was between 700 and 800 decoys. Not many for a man who carved for almost seventy years. Possibly Ben D. Smith (1870–1942), also of Oak Bluffs, and Manuel S. Roberts made some extra rigs for sale, but none of the others did. From this example the collector can draw a general picture of the situation throughout New England: a multitude of makers, each contributing a distinctive and personal touch to his product.

H. Keyes Chadwick was, by New England standards, a prolific decoy maker and by any standard skilled and competent. By the year 1880 he was carving decoys under the critical eyes of his friend, Ben Smith. Both were skilled carpenters by trade, and the workmanship of their decoys confirms that fact. The relationship between Ben Smith and Chadwick, who was two years his senior, is pleasant to recollect. Without question Chadwick patterned his work on that of Smith, so closely in fact that years later he confessed that his decoys were identical with Smith's and he

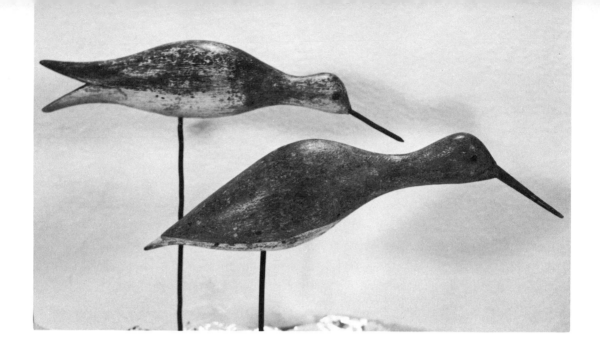

PLATE 53. Two yellowlegs, the top bird by Elmer Crowell, the other by a talented, unknown maker. Cape Codders favored a couple of runners or feeders in every rig. Proportionately more of them turn up in Massachusetts than in any other region.

could not tell one from the other. This makes futile, at this late date, any serious discussion as to whether Keyes or Ben made the early merganser in Plate 55. Chadwick developed a distinctive style of his own in later years. It may be summed up as follows:

A solid decoy with a flat, smoothly sanded bottom and a half-inch hole forward, for use in affixing the head by means of a three-inch brass wood screw from below. This hole is usually plugged with a cork.

A countersunk weight made by pouring lead into a one and three-quarter-inch hole until flush with the bottom.

Carved mandibles on the bill; painted nostrils.

The overall impression is one of great simplicity and naturalness.

For all of these unusual structural attributes, Chadwick's work was clothed in paint jobs that left much to be desired. It almost seems as though it was too much to expect a man of his exceptional carving ability to handle a brushful of paint with equal skill. Chadwick readily admitted this artistic shortcoming and called on his good friend, Elmer Crowell, to put the finishing touches on his decoys. An example of the combined efforts of these gifted men is shown in Plate 56. H. Keyes Chadwick, a perfectionist, takes his place as a great New England decoy maker.

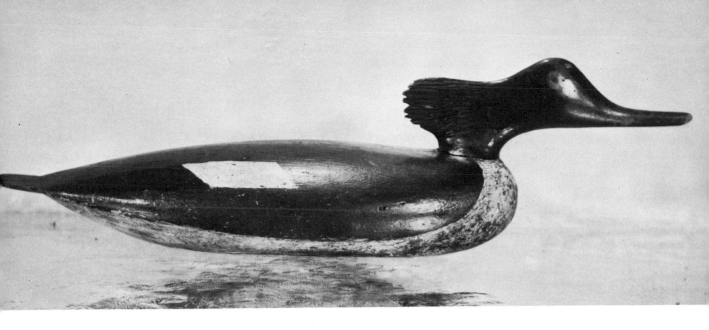

PLATE 54 (*top*). Exaggerated decoy carving at its best. The unknown maker must have observed the spring courtship of the Red-breasted Merganser before carving this wild, swift temptress. No others like it are known. PLATE 55 (*right below*). The perfect contrast to Plate 54 is this calm, serene example of a female Red-breasted Merganser by H. Keyes Chadwick or Ben Smith, both of Martha's Vineyard, Massachusetts. The conformation of this piece cannot be faulted.

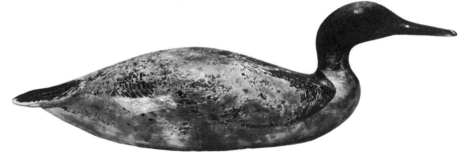

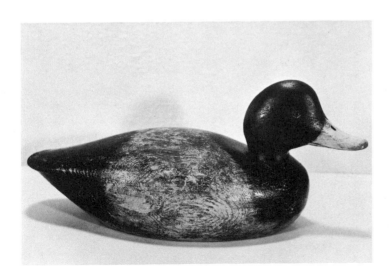

PLATE 56. All of H. Keyes Chadwick's Greater Scaup have heavy, chunky bodies. This example gives proof of his fine workmanship and design, but is mute evidence of his limited skill with a brush. Elmer Crowell painted it.

Nantucket, most easterly of the Massachusetts islands, was the spot to offer consistent success to the seeker of the Golder Plover as well as the Eskimo Curlew. The southern migration of that prodigious traveler, the Golden Plover, was usually over the Atlantic Ocean far from our shores. But when easterly storms come late in August, as they often do, numbers of Golden Plover seek rest and food on the eastern extremities of the northeast coast. Their most favored haven seems to have been Nantucket, and from the year 1850 plover-hunting enthusiasts made hunting history on that island. Contemporary accounts describe days when the Golden or "Green Plover" were everywhere in evidence, gorging themselves on the grasshoppers and then vanishing overnight into the vastness of the Atlantic.

Nantucket decoys are hard to come by and historically they are of great interest. Since they were used for relatively short periods of time each year, they were handed down from generation to generation. Plate 57 shows one of the earliest types, a "rocker." Decoys like this were shot over before 1850. The number of decoys used, whether for shore birds or wildfowl, seems to have been kept down to a minimum on Nantucket. In general excellent decoys were made there, though there appears to have been no outstanding or really prolific maker.

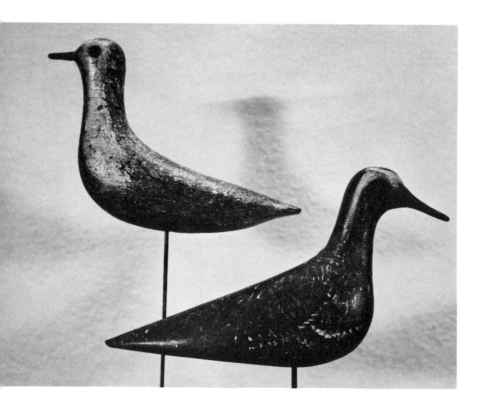

PLATE 57. Golden Plovers visited the island of Nantucket, Massachusetts, with predictable regularity late in August. Most of the decoys used for them are both old and choice. The upper bird in this pair of Golden Plovers is of the early "rocker" type and dates from about 1870. Golden Plover decoys must have the original paint for identification.

CAPE COD AND ITS ELMER CROWELL

Elmer Crowell of East Harwich, Massachusetts, was a man of tremendous ability and talent in several fields. Born in 1862, Crowell's ninety years until his death were dedicated to the outdoors and the birds of his native Cape Cod. As a boy he became a hunter, and in his teens he showed promise of exceptional skill in that field. Wildfowl, upland birds, and shore birds all received his attention as season or abundance indicated. All of his active adult years were spent in the field as guide, caretaker, and market hunter. The Cape Cod of Crowell's heyday abounded in feathered game, and Boston was a convenient and active market for the toll of his gun.

With this background, Crowell's first efforts at carving and painting birds must have been in the fashioning of decoys. Early and rather crude examples have been found that show Crowell characteristics; these are understandably his earliest efforts at decoy making. There is no indication, from any statements he ever made, that he benefited from the help and experience of any older hand during his initial efforts at decoy making.

The eye and hand of Elmer Crowell soon proved themselves, and many examples of his work made before 1900 are, today, choice collector's items. An excellent picture of Elmer taken in 1898 shows him with a drake Pintail decoy in his hand. It was symbolic of the perfection he had attained by that time. In Plate 58 a similar or perhaps the same Pintail is shown. In original condition, it shows the carving and painting that were soon to make Crowell famous. None of his early work was stamped or marked, and many collectors feel that was his best period. His early shore birds (Color Plate II) are of course unmarked, but the quality of the carving and painting makes them undeniably the work of this master. The oval brand he eventually began using dates from about 1915; much later he adopted a rectangular mark, which was also used by his son, Kleon Crowell.

Apparently Elmer Crowell's output exceeded the demand for several years beginning in 1915. For two years in succession he shipped ten dozen Black Duck decoys to the Iver Johnson sporting goods store in Boston. It is reported that they did not find a ready market, and after the twenty dozen had been sold the arrangement was canceled. The bodies of these decoys are plain and uncarved, but the inimitable brushwork that was Crowell's hallmark is readily apparent. If you find such a decoy with a white "Iver Johnson" in stencil, you have a most exceptional Crowell.

Throughout the early part of this century the output of decoys from Crowell's shop was steady but by no means prolific. He produced shore birds, ducks, Brant, and geese (Color Plates II, III; Plates 62, 65) for individuals. Some clubs received small stands of Crowell ducks. After World War I his pattern of life and the output of his shop gradually changed. Market-hunting days were ended and restrictive

PLATE 58. Pintail drake by Elmer Crowell. The wing and tail carving, combined with the gouge work on the back, represents his best style. The head and breast are finished with a wood rasp. Early examples of Crowell's work, such as this one, never carry his oval stamp.

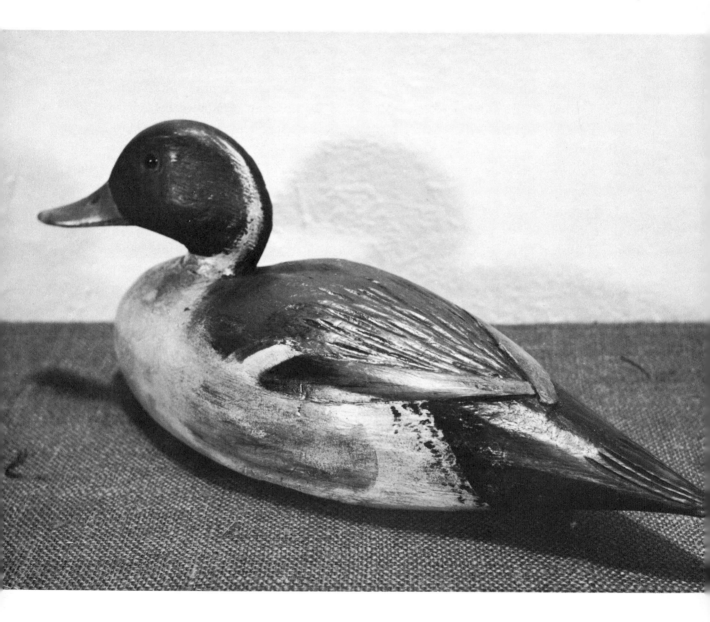

bag limits were put into effect. "That was the hunting I enjoyed," Crowell frankly admitted, "and those were the days for me. Now the fun has gone out of it."

Nevertheless, Crowell's energy and ability remained. They now found expression in the wide variety of bird carvings, fish models, and other ornamental objects to which he devoted his time. He became a recognized artist. Unfortunately for the purposes of this book, his output of decoys dwindled and finally faded away. His models and carvings brought him deserved fame. Crowell's good fortune, however, was the decoy collector's loss. Over his lifetime decoys, as such, were a secondary product of his remarkable talents. The only possible criticism of Crowell's decoys concerns the selection of the wood for the bodies. White pine was used and all bodies were of solid, one-piece construction. Bad cracks and checks seem to plague the examples of Crowell's decoy work that turn up today, especially the ducks. Something in the selection and drying of his lumber must be responsible for this shortcoming.

To those who knew him and were his neighbors, Elmer Crowell was more than a craftsman. He became a legend during his lifetime. For half a century Elmer Crowell dominated the sporting scene on the Cape. Truly, he was America's one indispensable decoy maker. Yet those who knew him remember the man himself even better than his decoys. Crowell was a kind, thoughtful, and patient man. Apparently his shop was an open forum for the discussion and solution of every decoy and hunting problem that arose. He became the arbiter in such matters.

PLATE 59. A Black Duck of Elmer Crowell's later or "commercial" grade sold through sporting goods stores in Boston about 1916. This one is stamped "Iver Johnson." The demand for them proved to be limited. All carving has been eliminated, but the rasp was still used.

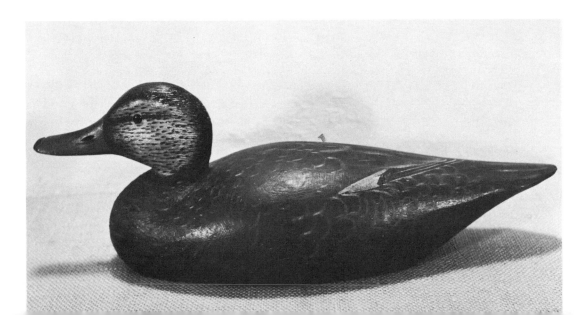

Crowell never reserved his help and knowledge for wealthy customers; he gave aid and advice to beginners and to the humble as well as the important. Perhaps the best illustration of this is the Black Duck in Plate 60. A dozen of these cheap and poorly painted factory decoys were taken to him by a young neighbor. Crowell told him to return in a few days. In the interval twelve decoys received an inimitable Crowell paint job, and there was no charge. That happened in the 1920's, when Crowell's fame was at its height. Plate 61 also reflects Crowell's consideration, early in his life, for those less gifted. It was about that year, 1890, a fellow gunner named Bronsdon, from Harwich, first received his help. Bronsdon could whittle a fine plover but was unable to do it justice when it came to painting. The illustration shows some of the Golden Plover carved by Bronsdon but painted by Elmer Crowell. Decoy collecting on Cape Cod can be interesting, but it usually leads to the craftsman from East Harwich.

Crowell's ducks and shore birds fall into three types or grades. The periods of production overlapped, and precise dates serve no particular purpose. The broad outline appears to be as follows: the earliest decoys he turned out in any volume were average-sized or slightly oversized models featuring a maximum amount of carving. The tail feathers are fully carved, as are the primaries. The ducks were carved with a gouge in small areas to simulate feathering. A rasp was effectively used on the breasts and backs of the heads. Without doubt, these early models are Crowell's best so far as the collector is concerned, but decoys of this quality do not carry the oval brand of the maker except in rare instances. It is a proven fact that several rigs of this type were made in 1905. How much longer he continued to produce this grade is uncertain, but by 1910 he was selling a simplified version.

The second type eliminated all carving except for the outlining of the tail feathers. The careful and effective use of the rasp on the breast and head continued; indeed Crowell's ducks were always finished in that way. All examples of his decoys of this and the following grade seem to be on the smaller side. They customarily show the oval brand on the bottom.

FACING PAGE: PLATE 60 (*top*). A unique Black Duck, representing opposite extremes in carving and painting. A machine-turned decoy of the cheapest grade, it was lovingly painted by Elmer Crowell for a young duck hunter—a perfect illustration of the kindness of this remarkable man. PLATE 61 (*middle*). Golden Plovers from the rig of a Mr. Bronsdon of Harwich, Massachusetts. The ten remaining examples carved by Bronsdon and painted by Elmer Crowell illustrate Crowell's artistry. They are subtly painted—each one is different—to show the various plumage patterns of the bird as the flocks arrived in August. PLATE 62 (*bottom*). This fully carved Canvasback is an example of Elmer Crowell's early work. Decoys of this type are especially pleasing to modern collectors, though some saw very little actual service, since baymen who handled them claimed they were too heavy and low in the water.

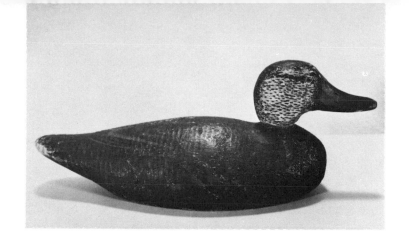

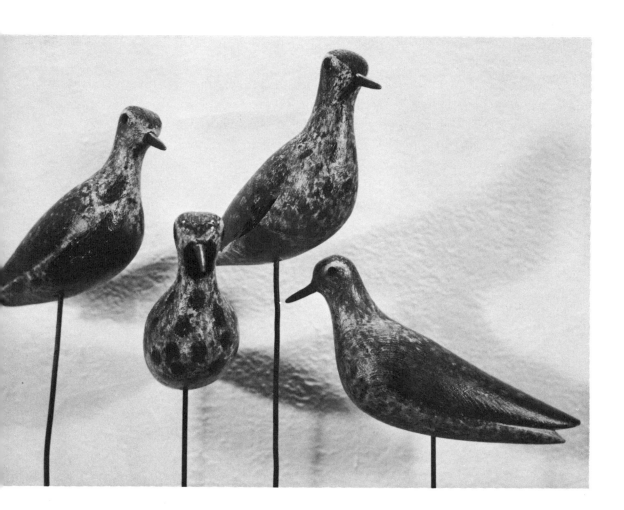

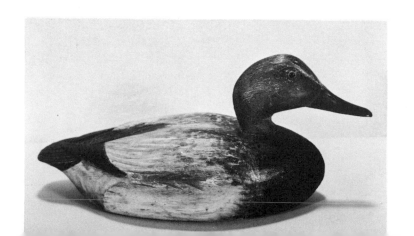

Last of the conventional decoys that Crowell made for sale were the plain and uncarved examples which escape from the ordinary only because of his unexcelled style of painting. It is believed this style prevailed from 1915 until his output ceased. They bear sometimes the oval and sometimes the rectangular brand; the rectangular is generally considered to be later, and in most cases identifies the work of Elmer's son, Kleon Crowell. The beginner is advised to handle and study documented Elmer Crowell work before making any substantial investment in his decoys. Spurious examples, with apparently authentic brands, have appeared. One should never be influenced by the brand alone. Crowell's style of work is unmistakable to the initiated and that should be the determining factor in making a purchase.

Also on Cape Cod, several early families in and around the town of Orleans made a living hunting for the market. One of these men, Josiah Paine (approximately 1840–1910), and his wife made a unique contribution to modern decoy collecting. This is the papier-mâché yellowlegs shown in Plate 63. Josiah obtained one of these papier-mâché models made in a factory, and Mrs. Paine copied it. She finally made a whole rig of these unusual stools. One of them, crushed beyond repair, was carefully dissected, and the newspaper used in its construction was dated 1860.

MASSACHUSETTS COAST

The famous goose stands of Massachusetts played an interesting and expensive, if purely local part in the early American sporting scene. The coastal bays and adjacent

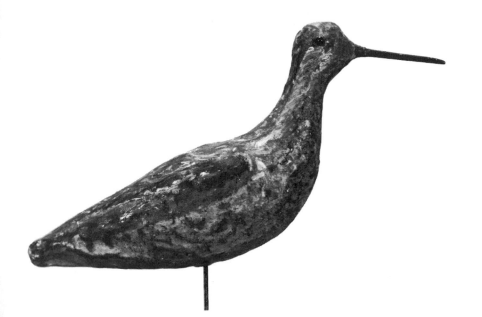

PLATE 63. Oversized yellowlegs typical of Cape Cod in form but made from papier-mâché. To make these by hand must have been a laborious and very time-consuming task. It would be interesting to know why Mrs. Josiah Paine was called upon to make the unusual professional rig from which this bird comes. Perhaps the gunner's inability to carry weight prompted the endeavor.

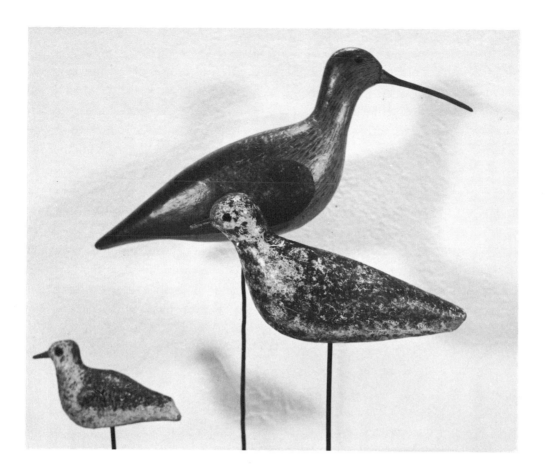

PLATE 64. Commercially made shore birds of paper were sold in New England through sporting goods stores. The Hudsonian Curlew (*center*) is a great rarity. The plover (*lower right*) and Sanderling (*on the left*) are occasionally found. Remarkably sturdy and correctly painted, they were convenient for the casual hunter.

ponds and lakes southeast of Boston were the scene of this involved and complicated operation. Considerable time and investment were involved in the elaborate construction of the stands themselves and other equipment involved. The results apparently justified the effort and amazing daily bags of Canada geese are recorded. The method required the use of live geese tethered on the water and also a group, in varying numbers, of carefully trained flying geese. So complex was the successful operation of a Massachusetts goose stand that gamekeepers and guides were engaged the year round and to take part in the elegant sport was a mark of social status. Elmer Crowell became an expert on the operation of these stands and was in charge of one of the finest of them, at North Beverly, for a decade.

In Crowell's own words, "In 1898 Dr. John C. Phillips of Boston came to see me about running his camp in North Beverly, at Wenham Lake. He had just built a fine camp there and wished me to show him how to handle ducks and geese decoys. We had some good shooting there. One day in December we killed 39 geese and 22 black ducks. Then I gave up hunting for a time and began making decoys out of wood. I was with Dr. Phillips 10 years."[1]

These famous refuges for the all-day goose hunter and all-night poker player have had their heyday. Memories and the incredible slat goose decoys they brought into being are all that remain. Many collectors overlook these decoys. This is a pity, as they were, if not the most artistic, the biggest, generally the simplest, and in many ways the most effective decoys ever devised. As its name implies, the "slat goose" had a body composed of slats or planks fastened to frames like those of a boat. These were, in the earlier ones, covered neatly with canvas, which was dispensed with in more recent years. The "slat geese" were of heroic size. Some of the best decoy makers in the business tried their hands at making them, and Plate 65 shows one from the shop of Elmer Crowell. Not good, but big, it measures 3 feet 6 inches long, 12 inches wide, and the height is 20 inches.

These "slat geese" were attached to the angles of a triangular wooden frame from 8 to 10 feet on each side and from 6 to 8 feet across the base. Thus they were floated in groups of three. They were designed for one purpose only, namely, to attract the attention of migrating geese from a great distance. There were no subtleties involved, since size and color impressions were all that mattered. Once these out-size "loomer" decoys had attracted the flock and turned them toward the stand, the live decoys, both on the water and in the air, took over and claimed the attention of the welcome visitors. The slat geese scarcely received a second glance, and to this very day many collectors feel the same way about them. But if you have room they do make a conversation piece when noncollectors visit.

North and east from the Cape a thousand miles of shoreline beckon. Along it, those endowed with time, patience, and a reasonable amount of money can follow some interesting and ofttimes untrod decoy paths. The goose stands used not only the oversized "slats" but also conventional-sized types. Watch for them; some are real prizes. The other obvious possibilities are Black Ducks in the "puddle" classification, and Goldeneye, Oldsquaw, and scaup among the divers. Sea duck decoys, coot or scoters, are also available, as are American Eider decoys which increase in availability as one travels north. Shore birds were also hunted north and east of Cape Cod, but on a limited basis as compared to the Cape and Long Island. In this general region, the variety of species lessens, but the variants of each are remarkably numerous.

[1] *Duck Shooting Along the Atlantic Tidewater,* edited by Eugene V. Connett III (New York: William Morrow and Company, Copyright 1947).

A case in point is the area of Duxbury, Massachusetts, some twenty miles north of Cape Cod. Here thousands of Canada Goose decoys in the three types, namely slat, solid wood, and standard size, canvas-covered, were made and used. Nor was each made in a hidebound or stylized manner. For instance, Captain Clarence Bailey, who worked about 1900, made big, oversized geese for his own use, but not the slat or lighter canvas-covered varieties. No, indeed, this skillful individualist made his Canada Geese solid. If you become the proud owner of one you will find they are very, very heavy.

A small, gifted group of both known and unknown decoy makers centered around Duxbury. Best known and most industrious of these men from a decoy viewpoint was Joseph W. Lincoln (1859–1938) who worked in the town of Accord, near Duxbury. Joe Lincoln was a fastidious workman who strove for perfection in the fashioning, finishing, and painting of every decoy. His wooden ones are of perfect symmetry and sanded to a sleekness immediately apparent even today. They are literally streamlined to a degree that no other maker, with the possible exception of Keyes Chadwick, attained. Lincoln's perfectionism and preoccupation with detail are best shown by the canvas-covered geese and scoters that he made. The example in Plate 66 is typical of the neat and tidy covering of canvas that was tacked and sewn around the equally well-conceived form that serves as the body. Despite warpage, abuse, and the vicissitudes of several decades, one of these Lincoln creations is still a model of good tailoring. Someday they will receive the attention of the discerning collector.

PLATE 65. Slat Canada Geese represent a local use of a specialized decoy. Especially noteworthy are some with heads by Joseph W. Lincoln and Elmer Crowell. They are all crude, and the biggest decoys ever used. This example bears Crowell's stamp.

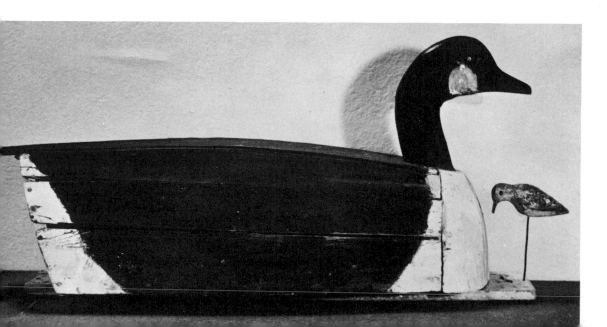

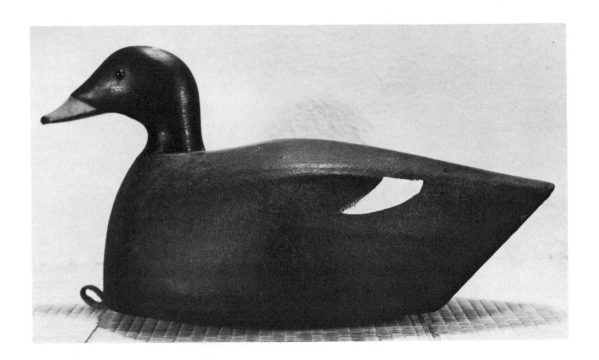

PLATE 66. This Canvas-covered White-winged Scoter by Joe Lincoln illustrates the proud craftsmanship many New Englanders put into their decoys. Body height, 7 inches; length, 16 inches. Similar Canada Geese were also made.

Joe Lincoln's concern with the output of his part-time shop—he is reputed to have been a shoemaker by trade—began with the wood itself. For bodies he preferred cedar. Every year, during the coldest part of the winter, he would prowl the cedar swamps and select dead trees which he would fell. Their trunks were then cut into suitable lengths and stored under cover until their turn came to be made into bodies. Lincoln's reasoning with regard to the advantages and benefits of decoys made from dead cedars felled in the wintertime is obscure. Yet if some of his bodies have split and checked, the work of his contemporaries, compared duck for duck, shows a far higher percentage of badly split bodies. Just why we do not know, but Joe Lincoln's trips to the cedar swamps certainly paid off.

Investigations reported to me by Winsor White, of Duxbury, have made it possible to identify some shore-bird decoys made by Joe Lincoln. This was a question that had remained unanswered since his death. Herbert F. Hatch, a friend of Lincoln's, kept a diary and also some of Lincoln's decoys for yellowlegs (Plate 67). Both photograph and diary have been made available through Hatch's son. Excerpts from the diary follow:

Wed. June 8–1898—Made yellow leg decoy at night like Joe Lincoln's.

Fri. July 15–1898—Ordered from Joe 6 winter yellow legs (greater). New shape and bigger. Paid him $2.

Mon. Aug 1–1898—Stopped at Accord to see Joe on way home. First Cider. WOW.

Tues. Aug 2–1898—Joe Lincoln brought over the 6 winters (greater yellow legs have better tails).

Wed. Aug 3–1898—Stomach ache. Poor cider I think. Summer apples too green.

Mon. Aug. 8–1898—Went to Accord to see Joe on way home. Gave me a summer (lesser yellow leg) to copy.

Wed. Aug 31–1898—Went down river with Joe Lincoln got 51 summers, 13 winters, 7 peep. Hand is lame and stiff.

The happy and rewarding friendship between Herbert Hatch and Joe Lincoln continued for many years, a combination of pleasant days afield and congenial evenings that has left us with a revealing bit of sporting history. It is doubtful that many of Joe Lincoln's worthy shore birds survive, but each one that does is a prize. Lincoln's ducks, geese, and now his shore birds make secure his position as one of America's top decoy makers.

Competition was keen, however, among the carvers of the Duxbury area. Another local maker whose work has much to commend it was E. Burr. Fortunately Burr branded some of his work, and the alert, beautifully finished little "Whistler" (Common Goldeneye) in Plate 68 is one of his best pieces. The Black-bellied Plover and yellowlegs shown in Plate 69 were also made and used by him. This group bear his stamp and clearly indicate his distinctive style. All shore birds featuring details such as the carved wing tip and the "drop tail" illustrated are prone to breakage. Examples in unbroken condition are extremely rare. In this connection, an interesting

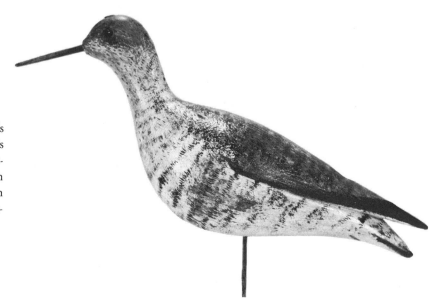

PLATE 67. One of Joe Lincoln's yellowlegs. Until recently his shore birds had not been documented. This example, when compared with his known ducks and geese, is unmistakably by the same hand.

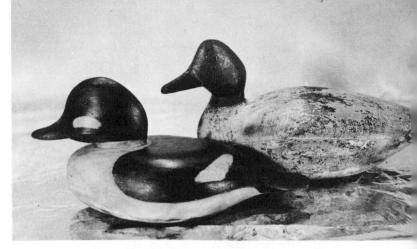

PLATE 68 (*top*). Every decoy that carries the stamp of E. Burr of Duxbury, Massachusetts, has a distinctive air and character. The well-used female Common Goldeneye at the right in this picture illustrates his style. The bold little Bufflehead is by John Winsor.
PLATE 69 (*bottom*). E. Burr put his name on the Black-bellied Plover on the right in this photo, and also the two yellowlegs. Along the Massachusetts coast the Greater Yellowlegs was common. The bird at the lower left is a Lesser Yellowlegs, seldom made or used in the Duxbury area.

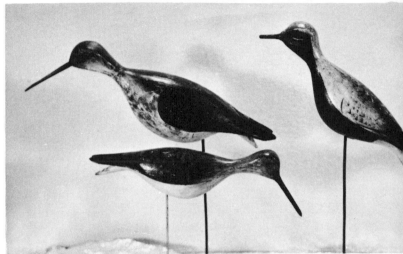

generalization seems in order. New Englanders took better care of their snipe stools and treated them with more respect than any other regional group. Certainly the overall quality of the Down East product was superior, and perhaps for that reason alone their owners took better care of them. At any rate, the present-day collector is grateful.

With a thousand miles of shoreline and clam sheds smelling of tarred line beckoning to the northward and eastward, one further pause is justified before leaving the Duxbury area. Lothrop Holmes of Kingston, Massachusetts, made the monumental pair of Red-breasted Mergansers in Plate 70. Holmes surely made other ducks and in all likelihood some shore birds, and all of them are good. But in every respect the two mergansers illustrated are superb examples of the finest in decoy craftsmanship. Lott Holmes can rest on his laurels.

John Winsor of Duxbury also tried his hand at decoy making and turned out a

modest rig of ducks. There is no evidence that he continued his efforts in that direction and no other examples of his work are known. The hen Bufflehead in Plate 68 has an unruffled air that perfectly becomes this little diving duck. Even the cruel blast of a load of #4 shot has failed to disturb its tranquillity or lessen its appeal. If ever a carver could indicate the character of a duck, it was John Winsor, and this Bufflehead proves it. It would be almost hopeless to expect any more of his work to turn up.

As he heads north and east from the Duxbury region, the collector encounters bigger and bulkier decoys. Except for the Black Duck, puddle ducks are practically unknown and shore birds become scarce. The scoters take over, especially the White-winged Scoter, although the other varieties occur with pleasing regularity. Goldeneyes, Oldsquaws, and an occasional Bufflehead complete the list of potential finds in the duck category. Makers with well-known names fail to appear, and almost without exception each rig was the individual effort of one man. Doubtless the owners made additions to their original layouts, but that seems to be about the limit of their decoy making.

With almost every serious gunner translating his idea of what a decoy should be into actual wood, the result is a wide field of varieties for collectors to choose from. It also makes for a great conglomeration of junk decoys hardly worth the space they take up in the trunk of the car bringing them home. Undeniably they served their original purpose of luring very effectively the rather dull or unwary scoters or coots, Goldeneyes and Oldsquaws, but most of them do not grace a collection.

PLATE 70. Pair of oversized Red-breasted Mergansers by Lothrop Holmes of Kingston, Massachusetts. These decoys have been treated with care and retain all of their original paint. The carving puts them in a class by themselves. Exceptional examples, they are from the collection of Winsor White.

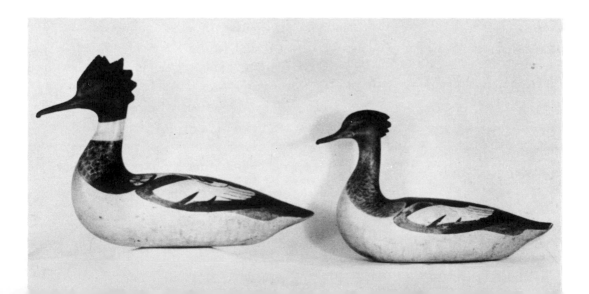

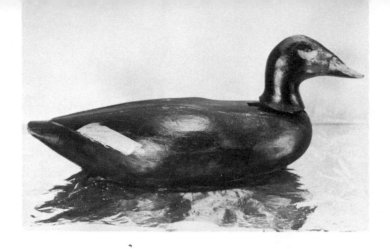

PLATE 71. This White-winged Scoter has almost everything —bold, fine carving, excellent conformation, and good color pattern, plus a head that bows to each live counterpart. The workmanship on the rocking head is very clever.

There is a brighter side to the picture, however, for of course other New Englanders, skilled and capable craftsmen, also made decoys. The work of this limited group is prized today. The White-winged Scoter in Plate 71 shows Yankee ingenuity at its best. Here is a clever and effective way to impart life and movement to the decoy as it bobs on the water. The head is loosely pinned to the body and rests on a rounded or tottery surface. Every movement of the body throws the head backward or forward. This refinement called for considerable extra work, and it and the carved wings indicate the work of a perfectionist. This is typical of the odd variations that beckon the student of New England decoys.

Off the coast of Maine lies the small island of Monhegan, which has a year-round population of less than a hundred, but such a great reputation for decoy making that it is sometimes credited with models that actually originated elsewhere. A tendency to attribute all good, sound coot, eider, and other sea duck decoys of the rugged type to this little community is an error in logistics. Despite the Monhegan Islanders' skill, so few could never have made decoys for so many.

Without question, the isolated Monhegan Islanders made some superb decoys, especially White-winged Scoters or "coots," in limited numbers for their personal use. All are extremely collectible and some are apparently the finest of their kind. But confusion results if every model that is rugged, flat-bottomed, and has a mortised neck is credited to this worthy island. Rather let us recognize Monhegan's leadership by identifying the school of design and quality and letting the work of their neighbors also come under the same general heading. The tremendous White-winged Scoter shown in Plate 72 qualifies as a decoy of the Monhegan school.

The ancient, primitive eider in Plate 73 has no recorded ancestry, but its fine carving and bold appearance make it welcome in any group, and it is of a type occasionally found along the northernmost coast of Maine, or more rarely in Nova Scotia. The rather similar and particularly desirable White-winged Scoter stool shown in

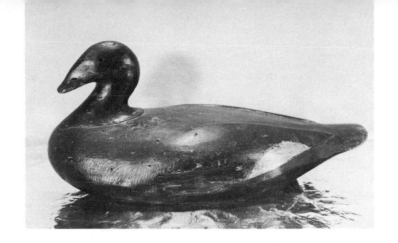

PLATE 72. Maker and date of this White-winged Scoter are unknown, but a "coot" as good as this Down East one may be included in the Monhegan Island school. Of the usual oversized type, its body length is 19 inches.

Plate 74 has carved wing tips and tail along with the inletted head and neck. An additional feature of interest in this model is the use of oak pins to fasten the head to the body.

These examples illustrate the hoped-for exceptions that diligent search should turn up along the coast of northeastern New England, among a multitude of heavy, crude, and commonplace decoys.

The hunting of scoters, eiders, and Goldeneyes was a rugged, dangerous game practiced in the open sea. The first consideration in the construction of a decoy was its seaworthiness. Subtleties of paint, conformation, and details of carving were of lesser importance.

Down East was the home of the "double shadow" decoys, each basic unit of which generally consisted of eight two-dimensional "shadows." These were fastened on boards of graduated length, one shadow on each end, so that the assembly nested one within the other. The shadow rig of Surf Scoters in Plate 75 illustrates not only the construction of the unit, but also the high quality of the skill and carving that went into these particular decoys. Most of them, however, were crude and of no interest to the discerning collector. These rigs were almost without exception for shooting "coots." But the canny Yankee was always trying something new, so the unusual and delicately made "shadow" Oldsquaw shown in Plate 76 came into being. The experiment must have been either a well-kept secret or a failure, since the use of Oldsquaw decoys of this type never caught on.

It is from the coast of Maine that all great loon decoys seem to come, a fact that all seekers of decoys will do well to remember. The example from the Monhegan Island area shown in Plate 39 is in a class by itself. Absolutely authentic, beautifully painted, and every inch a loon, it has no competition in this category.

Beyond Maine lie the Maritime Provinces, and though they are not New England, since we are so near, this seems the best place to look at their decoys. The

Maritimes have added little to the history of decoys, and their makers, for the most part, duplicate the efforts of carvers on the Maine coast. No one carver stands out from the field and except for the offhand, primitive examples a certain sameness exists in the rather heavy-handed decoys of this region. It is somewhat of an enigma that so many decoys that are inferior from the collector's standpoint were made by generations of men who produced such great woodworkers in the fields of boats, furniture, and homes. One very good reason for this, however, lies in the fact that such limited market hunting took place from Maine through the Canadian provinces. Another reason, no less important, was the generally less desirable quality, from the eating standpoint, of the wildfowl available. This entire coastline was one that demanded a great deal from those who elected to make it home. A good living did not come easily, and little time was left to pursue a sport as generally unrewarding as shooting fowl. All the more reason to respect the occasional outstanding relic from a bleak and rockbound coast.

Still farther northward, however, on lovely Prince Edward Island, all was not boats, unwieldy decoys, and windy seas. The thrifty Prince Edward Islanders did not fail to appreciate the butter-fat Golden Plover that tarried on their shores during the month of August. The Golden Plover from "P.E.I." shown in Plate 77 must be very, very old, for we know that generations of men have shot over it. It must be considered not only a most unusual and attractive example in its own right, but also of interest as one of the few known shore-bird decoys that originated so far to the northward.

FACING PAGE: Plate 73 (*top left*). Common Eider decoys should be seaworthy, sturdy, and simply painted. This striking example from Maine illustrates all these essential points. The head is inletted and the body wide enough to make weights unnecessary. Plate 74 (*top right*). Female White-winged Scoter, not oversized, which is unusual along the Maine coast. The oak-pinned, inletted head lends this piece additional appeal for the collector. It gives every indication of great age. Plate 75 (*center*). Exceptional is the word for the carving that this set of Surf Scoter shadows displays. Maker and date are unknown. It is probably from Maine. Plate 76 (*bottom left*). The writer has no knowledge that shadow rigs consisting of Oldsquaws were ever used. This is, however, one of several intended for that purpose. They were in Elmer Crowell's shop and show his type of workmanship. Plate 77 (*bottom right*). One of the first stops for the southbound Golden Plover must have been Prince Edward Island, in the Gulf of St. Lawrence. Here these perky decoys, which are very early, saw generations of use. The hole made it easy to carry a rig of them.

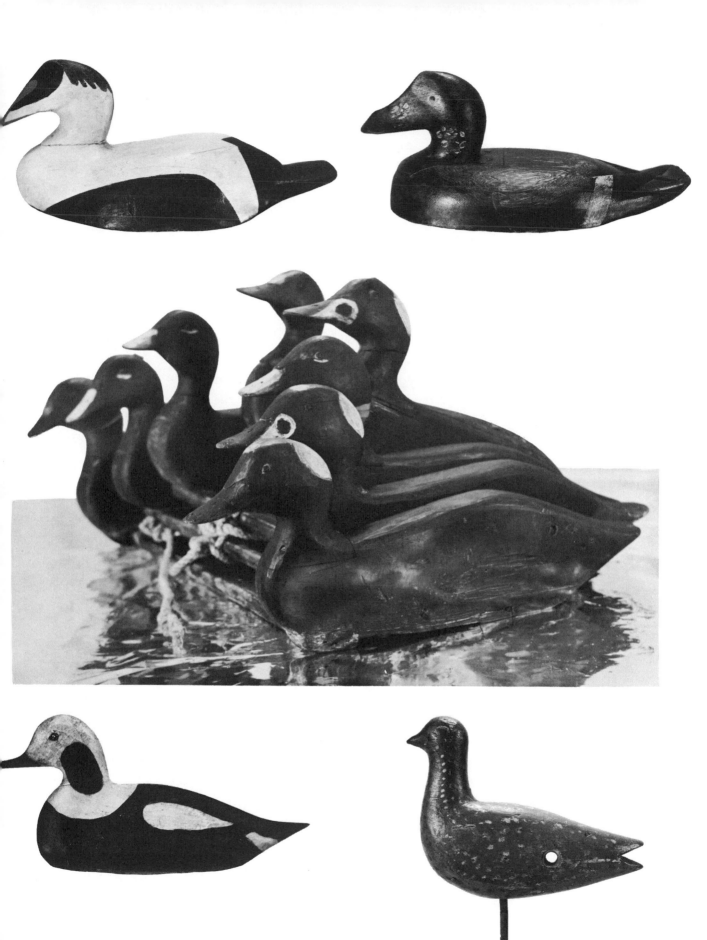

VII New York State

FROM ITS NORTHERN boundary along the St. Lawrence River, where winter comes early, south to the sandy reaches of Long Island, New York State offers an unparalleled variety of decoys. There were handmade varieties of every kind. Factory-made decoys were represented by the output of the tiny Stevens outfit, which operated at Weedsport, in central New York's Cayuga County, from about 1865 to 1910. The rare and interesting Stevens decoys will be covered in a later chapter because of their classification as a factory product. To outline the local types and styles of individual decoy makers from Long Island northward to the Niagara frontier is our present interesting and varied task.

LONG ISLAND

Since Long Island, without doubt, means wildfowl decoys to more people than any other spot on earth, that's the place to start. In turn it is logical to pinpoint Jamaica Bay and its environs as the site of the first systematic market hunting for wildfowl and shore birds in America. The decade from 1840 to 1850 would be close to the time when the New York markets received their first shipments. The advent of market hunting, as we have seen, always pointed the way for the development and use of decoys. More interesting, rare, and genuinely old decoys occur on the South Shore of Long Island than in any other spot in this country. Old publications that hold the recorded history of market hunting make clear the reasons for this fact. Frank Forester's *Field Sports,* published in 1849, has this to say:

> The great tract of shallow, land-locked water which lies along the southern side of Long Island, improperly called the Great South Bay, for it is rather a lagoon than a bay, bounded on the south by the shingle beach and sand hills, which divide it from the Atlantic, and on the north by the vast range of salt meadows, which form the

margin of the island, is the resort of countless flocks of aquatic fowl of every description, and is especially the paradise of gunners. The tribes and varieties of these birds are so numerous, that to attempt a detailed account or description of them all, would far exceed the possible limits of such a work as this.

A brief summation of the varieties cited by Forester includes nine varieties of the plover family, twenty-eight of "snipe," six of geese and sixteen of sea ducks. His final statement follows: "There are seventeen members of the cranes, herons, bitterns and ibises which are generally shot by the sportsman, when he finds an opportunity."

With so much game to write about, Forester's comments on decoys are casual and less than helpful; but the hunting ability of John Verity and Ben Raynor, pioneer gunners of the period, who like other members of their families also made decoys, is mentioned in *Field Sports*.

Fanny Palmer, a well-known artist of her day, painted many charming and historically interesting hunting scenes for Currier and Ives, using Jamaica Bay and even Brooklyn as her locale. While she was working on these pictures, Mr. Currier had his carriage pick her up each morning and take her to the scene of action. This means of transportation indicates that her daily trip did not carry her very far down the Island. The Currier and Ives print, "Beach Snipe Shooting," although unsigned, is considered her work and shows a typical Long Island scene. Fanny Palmer, who is described as a lovely and talented lady, was depicting the American shooting scene as early as 1850 and snipe decoys apparently were in general use at that time.

Without question a few Great South Bay duck and goose decoys were made before 1850, but, after more than one generation, decoy history becomes sketchy and word of mouth stories grow exceedingly vague. Great age is only one of the factors that determine the desirability of a decoy; others must also be weighed. Crudity of design is a poor yardstick to determine age. Crude decoys of primitive type can be very old, but they can also be quite recent if made, as many are, by untalented and unskilled hands. Also, the normal wear and tear of generations of use can be simulated and speeded up by gross neglect. Thus it is difficult to be specific about which are the oldest Long Island decoys and impossible to state who made them. Better to enjoy the simple fact that some fine, classic examples are available. Plate 78 shows the superb carving on an early Long Island scaup. Every consideration points also to the great age of the "root-head" snipe in Plate 79.

The lack of documented ancestry, of course, should not really detract in the least from the joy of possession. Almost all such items come from days just beyond recall, but what pleasant pictures the haziness of time conjures up!

While the muzzle-loaders of the early market hunters blazed day and night on Jamaica Bay and at the extreme western end of Great South Bay, little sport shooting seems to have taken place at that time. Toward the end of the nineteenth century

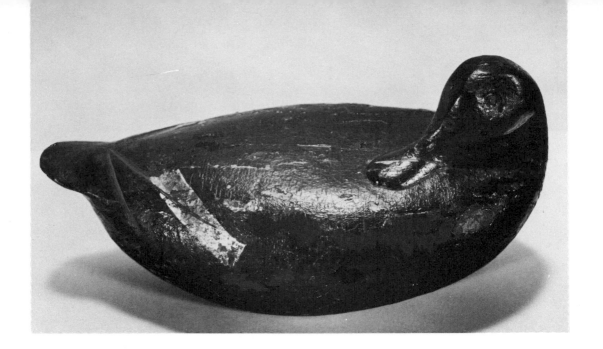

PLATE 78. This decoy is an often painted but worthy example of a Long Island scaup. Perhaps a century old, it is carved from one piece of wood, a most unusual and wasteful procedure.

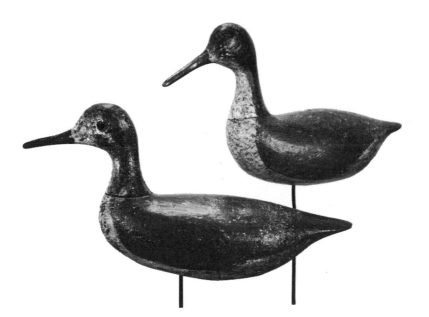

PLATE 79. Shore birds of the earliest type, from the South Shore of Long Island, about 1850, possibly yellowlegs. The separate heads and necks are fashioned from roots or limbs of suitable size and shape. This crude type of construction resisted breakage to a remarkable degree.

market hunting still persisted, extending by now to the eastern end of the Bay and to Peconic Bay as well, but the "sport" and his now generally used breechloader also began to make their economic influence felt. Guiding became a fruitful occupation and decoy making flourished. Shore-bird decoys or "snipe stools" have been found from Brooklyn to Montauk and consist of every known variety, including the Golden Plover, which was a frequent visitor to the "plains of Hempstead."

A study of old hunting stories leads one to wonder that anyone used, let alone carved, a Golden Plover decoy. Some patient souls stuck them up and hopefully waited, but the best bags on the "plains" were made by using a horse and walking up to the flocks, making sure that the horse was always between the birds and the gunner.

As the sport or nonprofessional gunner became the dominant factor in the wild-fowl picture, he increasingly left his mark in the field of decoys. Harry Knapp's kit of Sanderling decoys, shown in Plate 80, is proof that he enjoyed an afternoon with the "beach birds." Mr. Knapp is believed to have enjoyed his pastime in the early years of this century on the beach at Rockaway. These delightful Sanderlings, which he stuck on ribs from an umbrella, are carefully carved and painted. Surely, here

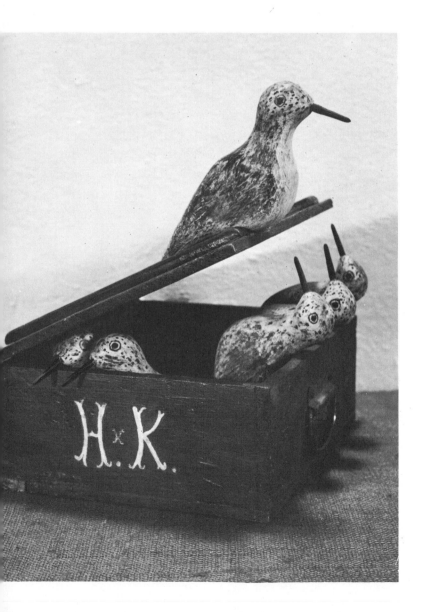

PLATE 80. Few sportsmen took the sport of shooting "beach birds" as seriously as the owner of this neat little kit of Sanderlings. Using only the six birds that the handmade box holds, one could never be called a "game hog." With Harry Knapp the shot was apparently the thing.

must have been a purist in the art of "snipe" shooting, using a 20-gauge gun of the finest English make and never missing a shot . . . well, hardly ever.

The name of Thomas H. Gelston occurs frequently when Long Island sportsmen are under discussion. Gelston lived the full, rounded life of a gentleman hunter. Sheepshead Bay was his home but the town of Quogue claimed his summers. Apparently a man of independent means, he enjoyed himself to the fullest and turned a hobby into a vocation, making some superb shore-bird decoys along with a goodly number of ducks. He combined a keen, practical viewpoint with considerable artistic ability. He and the great Charles Wheeler were the two outstanding amateur carvers. Both of them often worked with cork in making decoys for their personal use. For some qualities, such as light weight, cork is very practical. Tom Gelston turned to it when he made the yellowlegs in Plate 81. With artistic imagination he happily carved and painted the white pine body of the curlew in Plate 82. His curlews with wooden bodies are tremendous examples of decoy making, and in original condition rate with the best. For a brief period in Tom's life it is known he made limited numbers of shore birds which he sold through the New York sporting goods store of Abercrombie and Fitch. That being the case, examples of his birds could turn up in the most unexepected places.

With little fear of contradiction, Long Island can claim to have been home to the "greatest whittler" of them all. John Lee Baldwin (1868–1938), of Babylon, spent his many active years in a little shop which displayed for all to read a sign proclaiming, "Never worked and never will." It was a warning that here was a man who ran his business as he chose. Actually Baldwin was an industrious, dedicated man at the task he enjoyed most, which was making the flying duck models one of which is shown in Plate 83. The incredible thousands of duck models he made were eagerly purchased by the public year after year. Being a man of strong opinions and snap judgments, however, Baldwin would often refuse to sell his wares at any price, only to turn to a youngster peeking in at the door and give him a present of a duck model. For at least twenty years John Lee Baldwin made thousands of models annually, the price averaging $2.50 apiece.

Using a jackknife and working on white pine, Baldwin was a master whittler in the American tradition. Almost as a sideline, he made what are remembered as fine duck and goose decoys and songbird models. Apparently he had no time or inclination for any other pastime. He never hunted a day of his life. Some of his decoy work, of course, must remain in private hands, but none is known and available for illustration. So the work of a prodigious whittler, carver, and decoy maker must be presented on the basis of recollection, hearsay, and a small model signed by

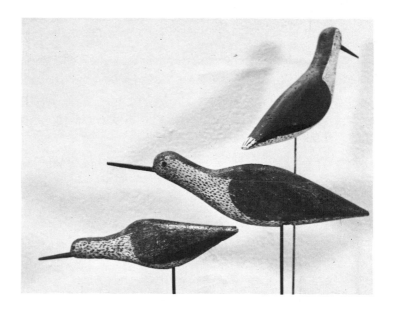

PLATE 81. Cork Greater and Lesser Yellowlegs, the work of that excellent sportsman-carver, Thomas Gelston of Long Island. Abercrombie and Fitch, the New York sporting goods store, carried these birds as a stock item. The ones illustrated were purchased there in 1916.

PLATE 82. Thomas Gelston carved some of the finest shore birds. Several of these Hudsonian Curlews are known to have been made by him. His ducks were well made and adequate, but not outstanding.

PLATE 83. Flying Mallard model made by John Lee Baldwin of Babylon, Long Island, New York. This unusual man, who devoted his life to whittling, was versed in several fields. His decoys take second place to his models.

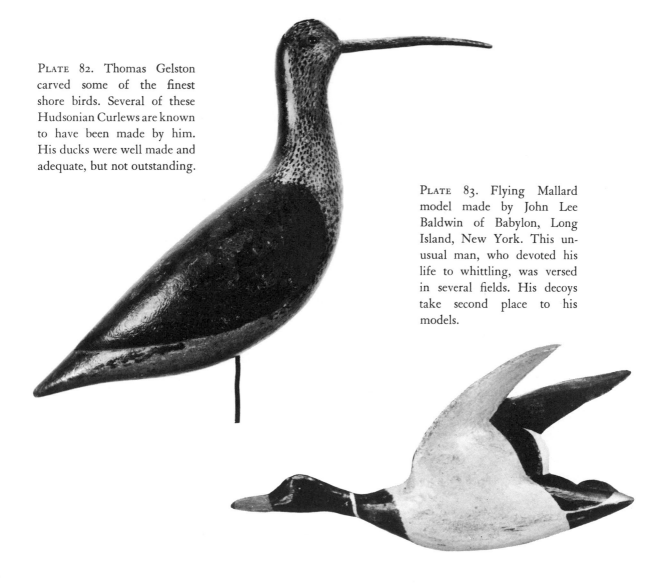

Baldwin many years ago. After his death, his heirs had over two thousand finished models to dispose of, and they did just that. John Lee Baldwin's models and decoys vanished without a trace and the mystery of their whereabouts deepens.

The Great South Bay and its problems were a way of life for generations of such local clans as the Verity, Carman, Osborn, Ketcham, Whittaker, and Pennell families. Theirs was a varied way of life and good baymen could always utilize their time profitably. Fishing was excellent and eels were in constant demand in the New York markets. Also, the fame of the Blue Point oysters had spread to the fine restaurants, and they were available for the gathering in all parts of the Bay. Aside from these pursuits, the bay people made and used all manner of decoys.

A man who surely qualified as a senior member of that gunning fraternity which centered around Amityville, Babylon, and Massapequa was Nelson Verity. This durable bayman was never known to miss a day's gunning from boyhood until his death in 1945 at the age of ninety-three. An unplanned interruption occurred when as a middle-aged man, during a crow hunt near Cedar Creek, he lost part of his arm in a shooting accident. Snow plugged his gun barrel and the exploding gun tore his forearm terribly. Upland shooting was a little out of Nels's line, but crows were bringing two dollars a hundred at the time, and that was hard to resist.

Another bayman who gunned over the years with Nels was George Pennell, but he had only fifty-two years of hunting experience compared with the seventy or more years compiled by Nels. It was George Pennell who went to pick up Nels Verity for their daily trip on the Bay and found the almost indestructible Nels dead from a gas leak in his kitchen. Both these men made decoys and Pennell's cork plover were extremely effective. The tern in Plate 38 was made by Nels when the tern wings were used to decorate women's hats, but it must have been tame sport for a man of his prowess. With Nelson Verity, even at the age of ninety-three, the shot was the thing, and no one disputes his claim to being Long Island's "shootingest man."

The entire South Shore was a favorite resort for shore-bird gunners, both professionals and sportsmen. Cork-bodied decoys found wide acceptance, and most of them were made with care and skill. The cork beach birds, one of which is illustrated in Plate 84, are of a fineness of quality unknown in other areas. Following the careful carving of the body, it would appear that subsequent coats of paint were applied to build up a film that protected the cork surface.

Turning to Long Island wooden replicas, from the curlew down to the "peep," the average shore bird of this region has a curious and distinctive design. Let us classify and group them under the general heading of the "Long Island School," and enjoy their ownership rather than quibble over the makers of each and every one. These birds of the Long Island School were made by the thousands and date back to the late nineteenth century.

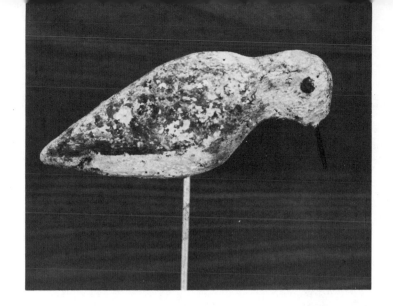

PLATE 84. "Beach birds," on the South Shore of Long Island, meant Sanderlings and Semipalmated and Least Sandpipers. The distinguishing features are not always shown or, indeed, needed, in these decoys. This one is of cork.

Captain Al Ketcham (*ca.* 1840–1910), of Copiague, was an early maker of these plump, short-necked, shore-bird decoys with carved wings and tails. Not only did the carving fall into a certain pattern but the plumage and style of painting as well. The group in Plate 85 are in the style of H. F. Osborn, a pioneer Bellport gunner and decoy maker. These attractive and practical patterns found many imitators, and decoys with minor variations in the carving and plumage patterns have turned up all along the South Shore.

Since they constitute such an important and desirable group, others of the Long Island School types are shown in Plate 86. Known makers of bird decoys similar to those shown include Nelson Verity (1861–1954) of Seaford, Obadiah Verity (*ca.* 1870–1940), of Massapequa, Frank Kellum (1865–1935) of Babylon, T. Carman (1860– ?), of Amityville, Al Ketcham of Copiague, John Lee Baldwin of Babylon, and many others in this area around Amityville. William Southard of Bellmore, working early in the present century, made one large rig marked "J.B." They are of the best quality.

The curlew shown in Color Plate I and the Dowitchers in Plate 87 are not to be classified as typical examples of Long Island work. Though undoubtedly from this area, they indicate a skill in carving and painting that sets them apart. Considerable research has been done to trace their origin. The best evidence, supplied by George Pennell, who used some in his old rig, indicates that he got them from John H. Verity. He recalls that John made fine shore birds and believes that he could very well have made these. Only a handful are known, but those who have examined them are unanimous in the opinion that these are the finest shore-bird decoys that have been found anywhere.

To balance our perspective on the Long Island gunning picture, we should recall that shore birds were only a part, and actually a small part of it, since ducks and

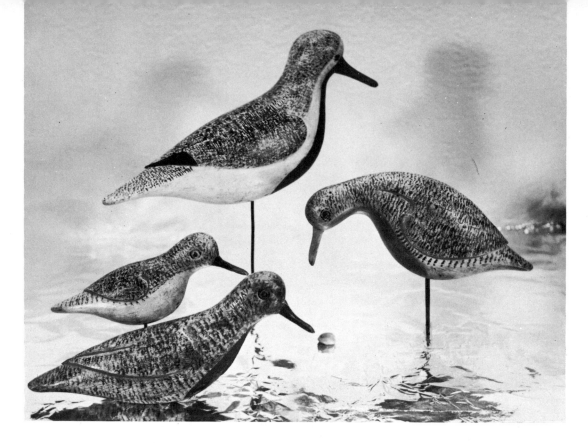

PLATE 85 (*top*). Three typical Long Island Black-bellied Plover, with a tiny Sanderling on the left. Birds of this style and quality are attributed to H. F. Osborn of Bellport. They are well designed and durable. PLATE 86 (*bottom*). A Black-bellied Plover rises over three yellowlegs. They are proof that the classic "Osborn" style influenced other Long Island carvers. Paint patterns and carving followed the basic tradition. This group comes from the western end of Long Island.

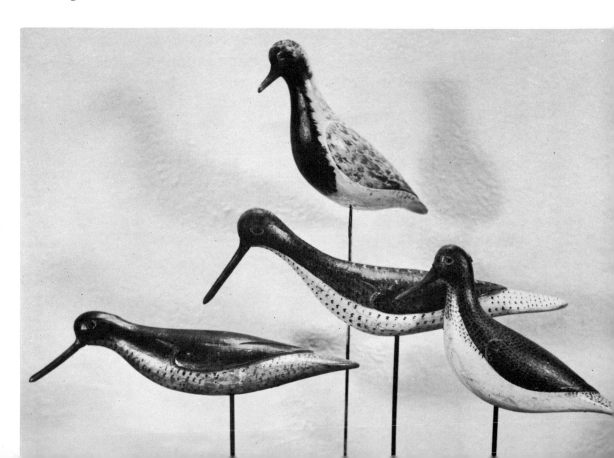

geese were the important quarry. Battery shooting for the diving ducks was excellent, while on points and along bogs blinds and punties took their toll. Cork, used for all types and kinds of decoys, was especially employed for Black Ducks. They attained a high degree of perfection, and men like Ralph Cranford of Babylon made some of the finest. The use of cork Black Ducks, however, goes back many generations. An outstanding survivor of the nineteenth century is shown in Plate 88. It is hard to imagine a better all-around hunting decoy, and its remarkable state of preservation, for a cork decoy, is a joy.

It was probably along these shores that the so-called oversize decoys were first put into use. A generation before the Carolina battery men ever saw a Mason Mammoth Canvasback, Black Ducks tumbled out of the sky over Long Island blinds, fooled by pieces of cork twice as big as they were. Oversize decoys apparently just developed gradually and did not, in all cases, prove their superiority. Some of the

PLATE 87. A pair of Long Island Dowitchers with carved wings, split tails, and heads shaped with exceptional skill, made to exact scale about 1910. Their origin is not definitely known, but the carver created a replica of the live bird as well as any decoy maker of record.

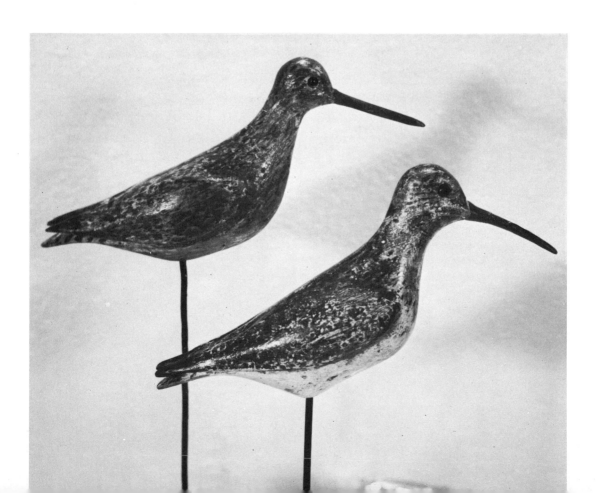

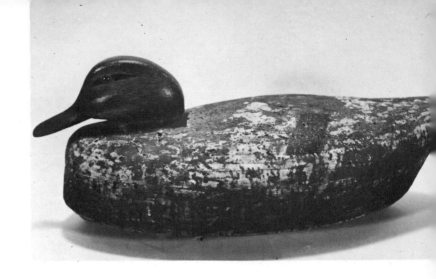

PLATE 88. Black Ducks are among the wariest of Atlantic coast ducks. Long Islanders were the first to exploit the benefits of cork decoys. In color and texture, a cork stool such as this one met every need. Such oversized models were most effective under conditions of ice and snow.

experts took to them, but most assuredly some could leave them alone. The Long Islander had his choice long before oversize "blacks" were being used anywhere else.

The tight, traditional town of Bellport offered some of the best wildfowl gunning on Long Island. Bellport had good decoy makers and still affords exceptional facilities for wildfowl gunning. All this goes back to the year 1767, when the Smith family and the township of Brookhaven signed a pact covering the use of the Bay which took in such activities as oystering and gunning. Brookhaven has leased these rights over the years to individuals and more recently to clubs. Sensible restrictions have protected the entire area from overgunning, and firm controls have preserved the hunting and the traditions of the bay.

The Corwin family, headed first by Captain Wilbur R. Corwin and later by his son, Wilbur A., dominated the hunting scene at Bellport from 1890 through the early part of the present century. Market hunting, decoy making, and guiding had been a family occupation since the first Corwin hunting camp was started in 1861. Captain Wilbur R. Corwin became a legendary bayman. The often repeated story of his record kill of Greater Scaup in 1898 substantiates the legend. In one day, from dawn

PLATE 89. The mergansers of Long Island parted company with the more conventional models. This racy Red-breasted Merganser decoy from Great South Bay has a crest of horsehair. It is very rare.

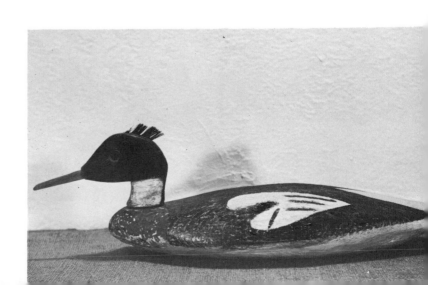

to dusk, Captain Corwin and his crew shot 640 ducks. That amazing total for a double battery places Captain Will in the forefront of Atlantic coast market hunters. His decoys were sound, crude, undistinguished, and made for hard usage. They certainly got it.

The North Shore never attracted the shore birds in any numbers and little hunting for them was ever done there. Ducks and Brant, however, were another story. At the eastern extremity of the North Shore, extending eastward between the Sound and Peconic Bay, a well-organized group made decoys and batteries were operated. The main revenue was derived from market hunting rather than from catering to the sportsmen. Locally made decoys are mostly Brant, "blacks," scaup, and Goldeneyes. Captain Jack Muir, who gunned for the market when it was legal, was dean of this closely knit group, both as a hunter and as a maker of decoys. His Brant have a bold, robust way about them and are well worth seeking out.

Also on the North Shore, during the heyday of shooting for the market, twelve men operated batteries and shipped waterfowl out of Greenport. Since few so-called prize ducks such as Canvasback and Redheads used Peconic Bay, the bag of scaup, Goldeneyes, and Brant generally brought lesser prices on the market. Greenporters asserted, however, that so great was the abundance of scaup and Goldeneyes in their region that their earnings equaled those of gunners in the more popular places. One Peconic Bay market hunter, Jack Hardy, a specialist in battery shooting, was heard to remark on a number of occasions that if he could have one good month on "whistlers" (Goldeneyes) the rest of the year would take care of itself.

Peconic Bay would seem to be an unlikely and even dangerous bay on which to gun a battery. It is deep, rocky, and the wave action, if there is a wind, is likely to swamp any battery. But these were skilled and resourceful men who knew every whim of their local weather. Using Robbins Island as the center, and knowing that good feeding grounds surrounded the island, they could always place their batteries in its lee and enjoy relatively calm waters. But it was still the most hazardous gunning that will be brought to the attention of the readers of this book. Wing ducks from here make interesting and rare exhibits. But all was not grim hunting for profit around Robbins Island; someone whose skill should be rewarded carved the Redbreasted Merganser in Plate 90 and shot just for the sport of it.

UPSTATE NEW YORK AND ONTARIO

Even though the rest of New York State beckons the collector it is difficult to leave Long Island. Decoy-wise, distant fields are not necessarily the greenest. The gulls, herons, and shore birds will not be met with again in such profusion or such choice

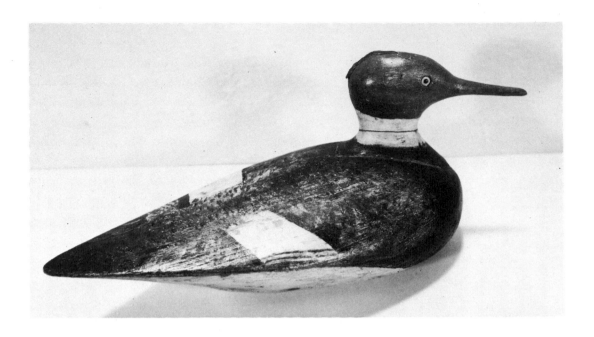

PLATE 90. Red-breasted Merganser decoys were made and used from one end of Long Island to the other. This bold example, a female, sported a crest made by inletting a piece of sole leather. Properly notched, it is a delightful item.

quality. Throughout the balance of the state, however, there has always been duck hunting in abundance. Lake Champlain and the Hudson Valley carried heavy duck migrations. Lake Oneida and the Montezuma Marshes supported market hunting operations of considerable extent, and the Finger Lakes were famed for good Canvasback shooting.

The discerning collector will have a difficult task, nonetheless, to garner a prize from the dreary assortments generally available in the areas mentioned. Crude and poorly made local decoys share the scene with the lowest grades of factory decoys. No local Lee and Lem Dudleys, as in Carolina, add a zest to the decoys of these areas. If any decoy maker of merit existed, his work is unknown and uncollected. But there is always this ray of hope: Weedsport, New York, was the home of the Stevens Decoy Company, and every so often one of their choice items turns up in nondescript company. If it's a Stevens you want, try central New York State; most of them didn't get far from home.

A closely associated trio of carvers whose products occur mostly in the region around Alexandria Bay and Clayton were Samuel Denny, Chauncey Wheeler, and Frank Combs, all of whom worked during the 1920's and 1930's. All three made

sound and lasting contributions to the decoy situation along the St. Lawrence River. Salient features of their work are an alert look, and long necks on solid pine bodies, characteristics generally shunned by makers in other areas since that posture is associated with ducks in a state of alarm or fright. Why these high-necked decoys were favored is a matter of interesting conjecture; a possible explanation may be that northern New York was the first heavily gunned area that the ducks encountered on their migration south. Thus the birds, particularly the juveniles, were unwary and not as discerning as they would become as their migration progressed southward. To test this theory it would be interesting to have a rig of Frank Combs's high-necked Redheads or scaup on Back Bay, Virginia, late in the season.

Chauncey Wheeler of Alexandria Bay made choice decoys, as the scaup in Plate 91 proves. Wheeler was a skilled craftsman, and his paint patterns and coloring are exceptional. The female scaup illustrated depicts the plumage of that particular bird in a most effective manner.

An equally skilled contemporary of Wheeler was Samuel Denny of Clayton. Father of fourteen children, Sam was hard pressed to make decoys balance all his bills and turned to his violin to help make ends meet. He was a North Woods fiddler of considerable local renown, and when the mood struck him he could be the life of any party. Rumor has it, however, that the artistic talent evident in his decoys made him a temperamental musician. Let one circumstance or situation upset his joyous mood, and his fiddle took on a slightly off-key tone. The rhythm continued but the melody was gone. Denny died in 1935, but people still shudder as they recall the last time they heard him play "Turkey in the Straw," when his heart wasn't in it. Organized stamping was, on occasion, resorted to, but even that failed to drown out the off-key squeal of Sam's fiddle. Nevertheless, his carving and painting have brought pleasure to hunter and collector alike. Sam devoted the winters, especially, to decoy

PLATE 91. Solidly constructed, normal-sized scaup by Chauncey Wheeler of Alexandria Bay, New York. This duck scaup illustrates Wheeler's paint pattern, which featured free brushwork and subtle shadings. He never achieved such mastery in the painting of his drakes.

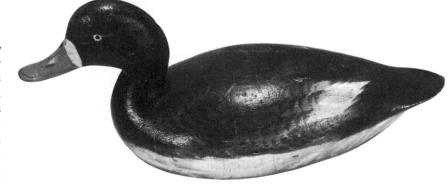

making. He stayed safe and snug through those bitter St. Lawrence winters right in his bedroom, which also did double duty as his shop. The decoys of Samuel Denny, artist, father, and music-maker, are preeminently deserving of the collector's attention.

Frank Combs, of Alexandria Bay, rounds out this distinguished trio. The outstanding feature of the Combs decoys is that, on the average, his work carries the highest heads. Actually Denny, Wheeler, and Combs all made almost similar decoys; the differences in one man's work as compared to another's are minor. Over the years there was also some variation in their respective work styles, so that it takes a keen eye to separate their models.

It was literally by accident that Frank Combs became a prolific decoy maker. Though always a hunter by avocation, he was by profession a barber. On a hunting trip, he lost his right hand when a companion accidentally shot it off. Many may question his decision that it was easier to carve and paint decoys with only one hand than to shave and trim hair. But the decision was Frank Combs's to make, and barbering lost out. From then on he was the best left-handed decoy maker on record. Plate 92 shows a Redhead drake highly typical of his work.

Ducks were shot for the market on both the Canadian and New York State sides of the St. Lawrence River and Lake Ontario. It would appear that the Canadians were most active in this field, and Picton, Ontario, was a market-hunting center. Many fine early duck decoys have been found nearby. The early models, one

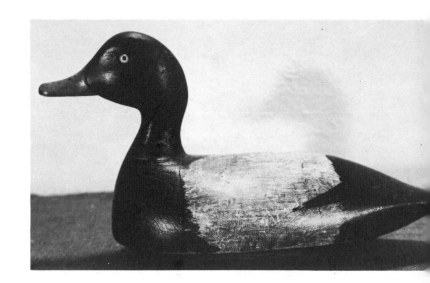

PLATE 92. This Redhead drake shows the alert position of the heads on most Lake Ontario and St. Lawrence River models. This one is by Frank Combs, who had a tendency to exaggerate the high head. His decoys are of solid construction, with wide, flat-bottomed bodies.

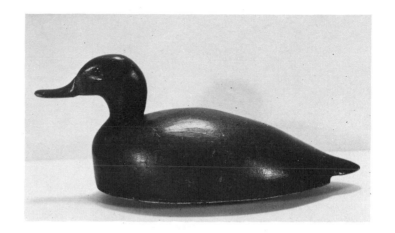

PLATE 93. William M. Rumble favored extremely light, hollow decoys such as this female scaup used on the Canadian side of the St. Lawrence. The special skill needed in their construction apparently prevented their ever coming into general use.

of which, a female scaup, is shown in Plate 93, are masterful examples of carving and the lightest decoys of their size that are made of pine or cedar. The bottom is a flat piece of pine less than one-quarter inch thick and shows no sign of shrinkage or cracks. This remarkable type of construction dates from the 1880's. William M. Rumble, market gunner, made the decoy shown about 1880.

Another Canadian whose work falls within the general geographical area of this chapter was Ken Anger. A great outdoorsman with fine artistic abilities, Ken lived most of his life in Dunnville, Ontario, and died there in 1961 at the age of fifty-six. The location of his home on the marshy bank of the Grand River gave this avid bird watcher an ever-present supply of live models for observation during the migratory periods.

Ken Anger first made decoys, for his own use, during the 1930's. These he patterned after the meticulously carved and painted blocks of a local engraver and amateur carver named Collyer Pringle. Although Ken always worked alone and never talked much about his methods, he did say that he later preferred live models and only occasionally resorted to stuffed birds for study.

Because of the excellence of his first decoys, it wasn't long before Ken Anger was devoting all his time to filling orders, which continued to pyramid. In 1948 he sent five decoys to the International Decoy Makers Contest in New York City and won three blue and two red ribbons. During a period of about twenty years, he carved hundreds of Mallards, "blacks," "bluebills," Canvasback, Redheads, and in lesser numbers teal, Pintails, and Canada Geese which were destined for all parts of the United States and Canada.

So well did Ken Anger use the rasp that its texture-producing effect, together with his stylized, relief carving of the wings, might be called his trade-

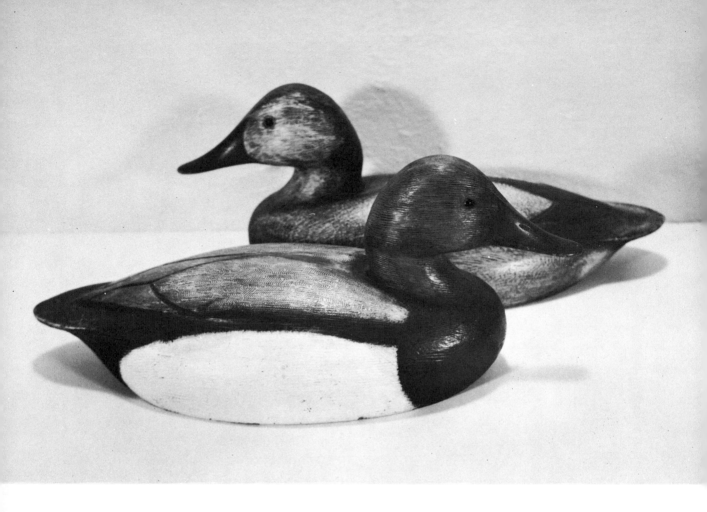

PLATE 94. Ken Anger's finely modeled and contented-looking Canvasbacks are sturdy enough for hard use, and highly collectible. Gouge markings outline the finely detailed wing patterns.

mark. He preferred 2¼-inch basswood for the heads and his painstaking carving, even to the inclusion of the nail on the bill, is outstanding. The sensitive painting and the subtle color changes in his decoys are indicative of the artist rather than the production man.

A visitor to Dunnville some years ago in search of Anger relates an incident illustrative of Ken's reputation. On inquiring the location of the decoy carver's house from a group of men in the local sporting goods store, he received the directions and then listened for some minutes to eulogies of Ken's work. He was returning to the street door when one of the group added, "You're going to meet the most modest man you've ever met." "And the kindest," another put in. How well they knew Ken Anger!

VIII New Jersey

NEW JERSEY cannot boast the biggest or most of anything in the wildfowl world. Her bays, marshes, and rivers tend to be smaller and less famous than counterparts beyond her borders. But the Garden State does have enough of nature's environmental benefits to beckon and hold its share of the migrants of the Atlantic coast flyway—ducks, geese, and Brant. I can personally testify, also, to the past excellence of my native state's shore-bird gunning. No sporting memories ever equal those of a young man possessed of boundless energy, a gun given more care and attention than most children, and a frugal supply of shells at forty cents a box.

That my ancestors hunted some of the selfsame marshes seemed to induce a sense of pride. One of my treasured yellowlegs ponds was within gunshot of what is now the south end of the north-south runway at Newark Airport. As the dear, dead days when shells were forty cents a box ended, the era of the man-made "tin goose" began. With it my pattern of life changed, and for over thirty years I periodically cleared the end of that runway and noted the transformation taking place below. Similar changes regretfully and terrifyingly have been made wherever one soars over the end of any runway all across the land. The gun has been joined by other forms of destruction that now take their toll silently and relentlessly. Chemical and human sewage, combined with pesticides and drainage of suitable habitat, greet our dainty visitors. What fools we are to fail to note that even they keep their own nests clean!

Those who tool along Jersey's turnpikes at 60 mph can see much of the state superficially in a few hours. It once offered, on a small scale, an endless variety of sport and a satisfying amount of game. Two famous marshes that ranged from fresh to brackish lay at its northern and southern extremes. In the north the Hackensack meadows were frequented by the rails, some varieties of shore birds, and early flights of Blue-winged Teal, as well as Wood Ducks. As the season progressed, the hardier species appeared. From late August until ice locked its food supply, every pond had

its quota of pleasant surprises. Picture in early September a bag of Sora Rail, topped by one or two King Rail, then finish the day with a chance at several flocks of teal. That is a choice and satisfying mixed bag.

In southern Jersey, the lower Delaware and its adjacent marshes offered the same fare. But the Maurice River especially pleased both the soul of the hunter and his desire for success. A tranquil, unspoiled stream from Millville down to the Delaware, it provided, in season, bags to suit all but the greedy game hog. An added attraction was the opportunity on hazy days of Indian summer to put aside the more active sport of hunting and lazily indulge in some fine fishing for striped bass. Bill Parker's famous "tin" blind at Port Elizabeth on many occasions provided us with the perfect sportsman's daily double: a limit on Black Ducks and a string of stripers.

It was in this state and because of the outlined activities that I became decoy conscious at an early age. I have always considered decoys as a tool. I cannot help but view them in the practical light of their effectiveness in luring the quarry. That some are more attractive than others, ride better, are more durable, and qualify as works of art, cannot be denied, but I view any decoy first with the eye of the hunter.

THE HEAD OF THE BAY

The name "Barnegat" at once evokes for the wildfowler the picture of one of the finest natural habitats for ducks, geese, and shore birds along the entire Atlantic flyway. In the loose jargon of the sportsman, "Barnegat" takes in the waters, marshes, and beaches from Bay Head south to Great Bay, a distance of some forty miles. These great stretches of mud flats, open waters, and marshes teemed in season with both ducks and shore birds. Nowhere has the collector found a greater variety. Even the rare Hudsonian Godwit, known also as the "marlin" or "straight-billed curlew," stopped annually at Barnegat and identifiable decoys of this bird have come from the lower part of the bay (Plate 43).

All species of ducks found in the East, as well as Canada Geese and Brant, found suitable resting places and abundant food somewhere on Barnegat Bay. The fact is now almost forgotten, but the head of the Bay, where the Metedeconk River poured its fresh water into it, formerly enjoyed a fine growth of wild celery and other vegetation that needs fresh or brackish water. Thus the northern end of the Bay was one of the greatest gathering places for Redheads on the whole Atlantic coast. These birds are still recalled in the name of Redhead Bay. Sadly, since the opening of the Point Pleasant Canal, the salinity of the water has increased and forever ruined the balanced, brackish environment that once existed. No longer do the Redheads and Canvasback call the Head of the Bay home. They have left Barnegat for the most

part. Still to be found nearby, however, is an occasional Redhead decoy made by one of the Johnsons, Ben Hance, Hen Grant, or some one of the other market hunters who used to work out of Silverton. Look well at any old "broadbill" or scaup decoy from Barnegat. Under the black head may be an original coat of turkey red or just plain barn paint. If you find one, you have obtained a trophy which rode the Head of the Bay in happier times. Barnegat Redheads are hard to come by and Canvasback decoys even scarcer.

Despite Barnegat's wide variety of fowl and the almost countless number of men who made decoys and used them on these waters, there is one characteristic that applies to all floating decoys of the Barnegat school. Almost without exception the bodies are carved from two slabs of cedar and are of hollow construction. Commonly known as a "dugout," this design was dictated by the necessity of saving weight. Every pound counted because of the general use in the region of the small, light Barnegat boat known as the "sneak box." This hollow construction became traditional in the area and was retained even when such odd and unusual decoys as swans and herons were made. The one exception to it is that hollowed-out shore birds from Jersey are almost unknown.

Let us, then, start at the Head of the Bay and work southward through the Barnegat region, observing the work of its decoy makers as we go.

Among the most prolific of these men was Taylor Johnson (1863–1929) of Bay Head, who followed the Bay for his livelihood from not long after his birth in 1863 to his death in 1929. Between seasons Johnson turned his hand to making modest numbers of decoys for sale. He excelled at producing a distinctive type of goose decoy that can readily be identified by its greater-than-average length and the hump carved just forward of the tail. Relatively long and thin and with a definite, grooved eyeline, Taylor Johnson goose decoys please the collector as well as the hunter.

Greater Yellowlegs decoys were another of Johnson's specialties that are sometimes found. Again there is a distinctive look to his work, and the long, thin neck and bill he fashioned are immediately recognizable.

When you have a Taylor Johnson decoy in hand, study it well. Note especially the carving of the head. He carved and sold heads by the basketful to fellow hunters who could whittle out a passable body but couldn't quite master the shaping of the head. Lloyd Johnson of Bay Head, the master contemporary carver of birds (though not for use as decoys) recalls that Lloyd Johnson, Sr., his father, had at least 500 stools in his rig, many of which were made by Taylor Johnson.

Ben Hance (1857–1928), was another Bay Header who made and used a large rig of decoys, and a Canvasback out of it is a prize. Sturdy, rugged, and bigger than the average, a Hance "can" stands out in any decoy company. The folklore of the natives indicates that Ben Hance also stood out from the crowd in his chosen occupa-

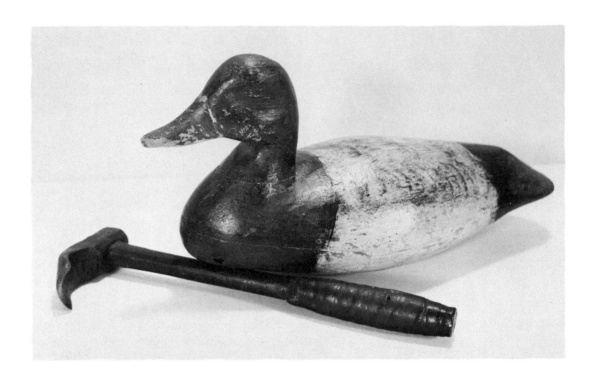

PLATE 95. This scaup, by Taylor Johnson of Bay Head, New Jersey, showing the narrow body and exaggerated eye groove, is typical of the "Head of the Bay." The tool is a custom-made gouge used for hollowing out the usual Jersey "dugout" decoys.

tions of bayman, clammer, and hunter. These entailed long days and, on occasion, long nights spent on the Bay—so much so that Ben Hance and many others passed more time on water than they did on land. But Ben must have known more than his neighbors or applied his knowledge more effectively, for there is no question but that he was the bayman among baymen. The winding channels and vast mud flats were his domain even on the darkest nights. He was never lost and could locate his position at any time by jabbing an oar or pole into the bottom and then giving the muddy sample a quick look and sniff. This was his infallible method of nagivation through storm or darkness. It assuredly was a rare and hard-earned accomplishment which he apparently failed to pass along to those who followed in his watery path.

Point Pleasant, on the south shore of the Manasquan River, had a competent decoy maker in the person of Ezra Hankins. Though not a bayman in the Barnegat tradition Hankins—he was a master carpenter and cabinetmaker by trade—saw fit to follow the baymen's lead in the patterns of his decoys. Graceful and finished in a

stylish, workmanlike manner, they rank high among New Jersey's decoys. "Blacks," Redheads, and Greater Scaup by Hankins can be found, but so far as is known he never made a shore bird. It was his custom to imprint his name on the concealed side of the lead weight of each of his decoys. Carefully remove the weight and you will find this identification if it is a genuine Hankins. He worked until about 1925.

A nearly forgotten hamlet that seems to have had more than its share of decoy makers is Lovelandtown, just west of Bay Head. The Loveland family, a large clan, made and used their own products, but just which Loveland made which decoy is uncertain at this late date. To confuse this pleasant problem, the Birdsall family, also of Lovelandtown, had some equally skilled makers. Two of them, Jean and Nat Birdsall, left behind some identifiable scaup. One is shown in Plate 96, which speaks for itself. It is a small, light, and almost dainty decoy that would grace any collection. It must be pointed out that only a trained eye can distinguish between most of the decoys from the Head of the Bay.

In the early 1900's Bay Head was a closely knit community and a spirit of neighborliness and goodwill prevailed. Much swapping took place and many rigs were the common efforts of two or more men. Some made bodies, some heads, and occasionally a specialist in painting took a hand in the performance. So, with the usual exceptions, the rare relics of this area are best described as being of the "Bay Head School." They are probably the most underrated of all decoys.

PLATE 96. The small, light, almost dainty scaup in the foreground illustrates the basic Barnegat Bay model. Many decoys of this type date from about 1880. Tom Gaskill's Redhead, shown in the background, departed from precedent, as described in the text, but the salient differing features went uncopied by other carvers.

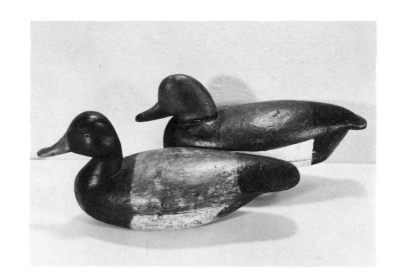

The town of Toms River, situated on an arm of Barnegat Bay, had a different flavor compared to that of the other bay towns. Perhaps the environment was less "salty," and more citified. Certainly its most famous decoy maker, Tom Gaskill (*ca.* 1879–1932) dared to differ with his competitors. His entire output consisted of Redheads, Greater Scaup, and Black Ducks, and at these models he excelled. Gaskill lowered the head and in that way strengthened the neck and lowered the center of gravity. Next, he used a flat, half-inch bottom piece and a correspondingly larger top piece, which was hollowed out. His final break with Barnegat tradition was partially to hollow out the head. That is hard to do, but Tom Gaskill did it (Plate 96).

Excellent conventional "dugouts" were made early in the 1900's by one of the large clan of Applegates of Toms River. Bulky for their size and with carefully carved eyes, these models had one further distinguishing trademark: the dowels that held the two halves together for shaping were square. One will probably never see that feature in any other maker's decoys. The decoy history of Toms River came to an end early in the 1900's as the character of the town changed and those who followed the Bay for a livelihood moved to other areas. The decoy-making Applegate was no exception, and this sketchy information, together with his work, is all that is known about him.

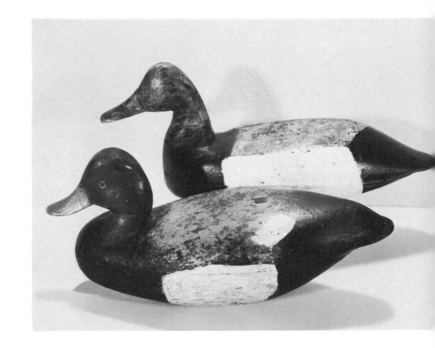

PLATE 97. The scaup in the foreground was made by a Toms River, New Jersey, carver named Applegate. Carefully detailed, it shows the square dowel used to hold the body together during shaping. The other decoy is a "Barnegatter" that was a Redhead until that bird's numbers declined. Now the same model serves as a scaup. It is at least 75 years old.

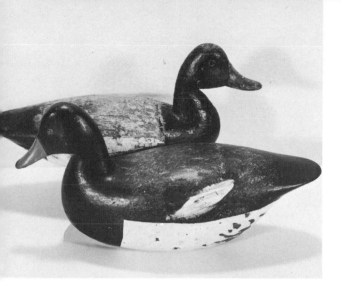

PLATE 98. New Jersey swamps occasionally yield enormous cedar logs that have been buried for centuries. This perfectly preserved "bog cedar" was used to make decoys that resisted cracking or splitting. The two scaup shown here are over 70 years old and came from Silverton, New Jersey. Their perfect condition indicates that they are ready for another 70 years of use. Cost and scarcity limited the use of this remarkable wood.

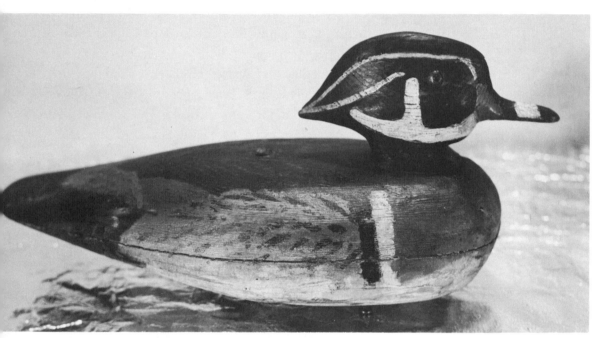

PLATE 99 (*top*). Wood Duck decoy made and used at Silverton, New Jersey, about 1900. Original paint. The gregarious "woodie" would join almost any group of ducks, which eliminated the necessity for a special rig of Wood Duck stools. Why even a few were used is not clear. PLATE 100 (*bottom*). The basic Barnegat patterns seldom were altered. This striking Red-breasted Merganser is therefore a bold departure from tradition. It is believed that Taylor Johnson made this swift swimmer, which is in a lighter, more imaginative vein than his usual work.

BARNEGAT

Located midway down Barnegat Bay and almost directly across from the famous inlet of the same name is the weather-beaten town of Barnegat. Hub of the Bay area, its tradition is a proud one and justly earned. Its sons have sailed as many leagues, shot as many ducks, caught as many large fish, and carved as many fine decoys as the men of any town of its size on the entire coast. The rosters of the Life Saving Service and the crew lists of many coastal vessels of the late nineteenth century carried a large complement of Barnegatters.

Famous in sporting circles, Barnegat Bay has come to mean many things to many people. Forty years ago its fishing was superb, its crabs and shellfish delicious, and its opportunities for hunting unlimited. A sandy barrier beach protects the Bay from the sea for its entire length of about forty miles, with the sole exception of Barnegat Inlet. Through this inlet ebb and flow the waters of the Bay, and on the sandbars inside the inlet well-nigh fabulous goose and Brant shooting was available in season. The Bay proper ranges in width from three to six miles and is generally shallow. The eelgrass that formerly grew in profusion furnished abundant food for wildfowl of many varieties, but especially Brant.

Prior to the 1930's the relative inaccessibility of Barnegat and its lack of facilities for visitors discouraged tourists and casual vacationers. Thus those who nevertheless undertook the journey and overlooked the inconveniences incurred, generally had excellent sport. A blight affected the eelgrass in 1932; then the fishing and hunting of Barnegat Bay began to decline. Superhighways now bring to Barnegat those interested in its other benefits, and recreational pursuits such as boating, swimming, and camping have begun to take the place of sport shooting and fishing.

The salty town of Barnegat, at one time full of sneak boxes, decoys, and market hunters, has indeed changed, and memories have taken their place. The gray, weathered sheds are empty as far as the decoy collector is concerned; there is perhaps no less likely place today to turn up some fine old decoys than Bay Avenue, Barnegat. Just as the waters that lap its bulkheads have been overgunned and overfished, so the inhabitants have been overcollected, to their gain and pleasure.

My own recollection of the town goes back over fifty years, when the collector of decoys and historical lore did have good hunting at Barnegat. A list of a locker's contents thriftily kept in 1889 by one Barnegatter, E. S. Green, Jr., is shown in Plate 101. Some of the items are easy for the collector to pass by, but others arouse all his acquisitive instincts. The extremes are illustrated by "Rubber blanket—about played out," on the one hand, and "15 snipe decoys—2 with heads off" on the other. Obviously the owner thought well of his locker's contents and protected himself against any light-handed borrowing. Since no one has reported finding exactly that number

List of Things in Locker
at Barnegat, 9th April 1889.

1 Oil skin souwester. — Carltons old green hat.
2 Pair old canvas shoes good enough to wade in
1 Rubber blanket — about played out.
1 Bamboo rod — guides all off
1 Brass reel — single acting.
1 50 yds. braided linen line #3 unused.
4 Floats — a few hooks on wire — 2 small sinkers.
1 Rubber air cushion.
1 Small ball of Twine.
1 Bottle with ½ inch gun oil in it.
1 Box "allen Primers"
3 Loading Blocks
1 Box Eleys wads P.E. 8 guage.
1 Box Eleys concentrators 10 gauge.
15 snipe decoys. 2 with heads off.
2 Baskets.

PLATE 101. List of the contents of a Barnegat locker in 1889.

of "snipe," two without heads, perhaps they are still collectible and in a dark locker next to a "bottle with ½ inch gun oil in it."

A few remain who recall when the air along Main Street and Bay Avenue in Barnegat had the sweet scent of freshly worked Jersey cedar as such local families as the Grants, Ridgways, Sopers, Birdsalls, Kilpatricks, and others fashioned their tools of the Bay: decoys, boats, baskets, clam rakes, and other wooden utensils. Almost everything that floated on or used under the water was made from that wood.

Also a part of the overall Barnegat community was the nearby hamlet of Forked River. Its noted decoy maker, Lou Barkelow, who was over eighty when he died in the early 1950's, has left us some unique contributions. Barkelow's shore birds have a charm unmatched by those of anyone else from Jersey, and can be unmistakably identified by the "L.B." stamped on them. Sanderlings, Pectoral Sandpipers, Greater and Lesser Yellowlegs, as well as Black-bellied Plover complete Barkelow's list of shore birds. (See Plate 102.) No curlews have been found. Apparently the curlews were infrequent visitors to the northern reaches of Barnegat Bay, but they were commonly gunned from Tuckerton down to the tip of Cape May.

The Forked River marshes also saw considerable hunting for the Great Blue Heron. Lou Barkelow made a further contribution to decoy history by saving a noble heron decoy given to him on his birthday in the year 1893. It rested on his lawn, after many years of active use, until 1950. Lou always said that it attracted

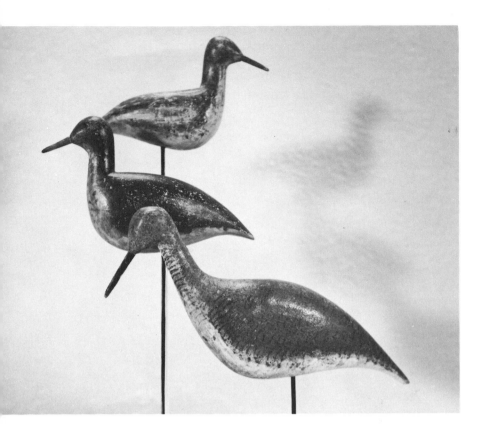

PLATE 102. Tradition played small part in the whittling of Barnegat shore birds. It was literally "every man for himself." From the top down, these represent Lou Barkelow's idea of a Sanderling, Pectoral Sandpiper, and yellowlegs. His pride in the result is proven by the initials "L. B.," impressed on each one. Lou was from Forked River, New Jersey.

collectors as well as it did the herons. He was reluctant to see it leave. Lou was a fine, friendly gentleman who always enjoyed a chat with visitors.

Barnegatters were individualists and carved accordingly. There seems to be no single decoy pattern typical of the locality, except possibly in the Greater Scaup. Scaup decoys from Barnegat, in size and profile, were quite similar regardless of maker. The shore birds show the greatest amount of variation. It must be confessed that no Barnegat area shore bird can be attributed to any specific Barnegat maker. Who made what "snipe" has passed into history. But most of the thousands that were used, assuredly were made locally. Most of them are a bit undersized, dainty, and have clean lines, but no clues in them lead specifically to the workshops of the well-known makers. The best judgment would seem to be that the shore-bird decoy was of minor importance compared to the comparatively lucrative traffic in ducks, geese, and Brant. Therefore, each gunner made his own in his own fashion. This resulted in a pleasing and varied potpourri of offhand "snipe stools" (Plate 103).

A well-known pioneer decoy maker, gunsmith, and boat builder of Barnegat was Henry Grant (1860–1924). These robust accomplishments kept Grant fully abreast

of the sporting life of the community. He made excellent decoys and superb boats. Some of both are still in service. Grant carved thousands of scaup, Black Duck, and Canada Goose decoys. His son, Stanley Grant, who died in 1960, later ranked as an able decoy maker in his turn. The fact that Stanley used his father's patterns confronts the collector with a problem. The different methods of attaching the lead provide a quick and easy means of distinction. The son generally put a fifth screw in the center of the rectangular lead weight. Naturally the father's work, in good condition, is preferable to the later work of his son. Together they represent Barnegat's only father-and-son combination, and both were prolific carvers.

Another Barnegatter, Henry Kilpatrick, whose name is known to collectors, was a specialist in sneak boxes and decoys. He made both in sturdy fashion, and in the 1920's and 1930's his shop was a place for a young wildfowler to revel in. Greater Scaup were Kilpatrick's specialty, but his Goldeneye (Plate 110) stands out in any company.

Two other well-known baymen in the Barnegat tradition were Alonzo Soper (*ca.* 1870–1935) and his younger brother Sam (1875–1942). The Sopers used rather than made decoys, and turned an honest dollar shooting for the market. All of Barnegat Bay played host to great numbers of sports. Market hunting flourished there, but in the latter part of the nineteenth century catering to the sportsman became equally important, and it continued to increase in economic importance through the early years of this century. Following this trend, the Soper brothers early turned to guiding, and Sam found time to make a rig of Canada Goose stick-ups to use on Sea Dog Shoals, which lie just inside the inlet. Time has proven that Sam should have spent more of his time making decoys. Not only did he make this rig of goose stick-ups, which are most unusual in New Jersey, but he varied the posture of each one. Plate 104 shows the "watch gander." Joel Barber always claimed this was the one best decoy he had ever seen. He intended to use it as his frontispiece in the book he was

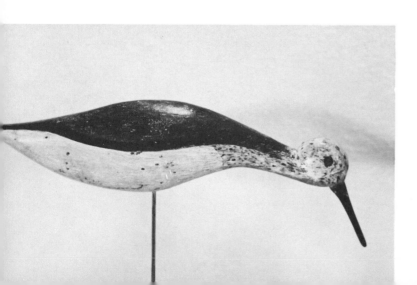

PLATE 103. A contribution by a Barnegat carver to American folk art. A yellowlegs of unknown age.

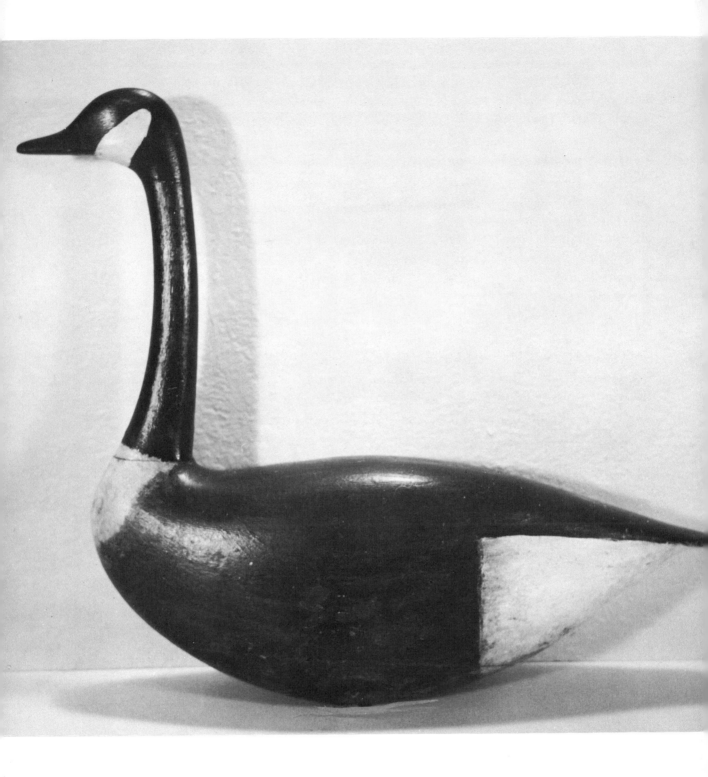

PLATE 104. Canada Goose in the "watch gander" pose. Though of typical dugout construction, it could only be used as a stick-up decoy. Sam Soper of Barnegat, New Jersey, made but seldom used this specialized item. It is original in every way.

writing at the time of his death. Barber's original watercolor of this decoy is owned by Irving Feist of Shrewsbury, New Jersey. Few would quarrel with Barber's judgment of this outstanding decoy.

The whole Jersey coast may well be proud of the hollow geese which were made and used from the Head of the Bay down to Somers Point. Collectively they are the finest, most carefully made, and altogether pleasing goose decoys left to us today. This kind of competition makes it impossible to single out any one maker as the best in that particular field. The difference between a Horner, Shourdes, Sprague, or Brown goose comes down to a matter of personal taste. These well-known makers incorporated only minor variations in their models.

Another name to add to this distinguished list of makers of goose decoys is that of Captain Jess Birdsall, a coastwise skipper sailing out of Atlantic City who was making decoys before the turn of the century. Captain Birdsall's geese were of superb quality, pleasing to the eye, sturdy yet light in construction, and effective as working decoys. His knowledge and selection of woods must have been exceptional, since checks and splits are rare on the examples of his work that are known today. Some criticism of the short necks is permissible, but on the other hand that feature increased the model's durability and made a rig easier to handle. The high profile, bulky tail area, and broad beam gave good visibility to these medium-sized stools of Jess Birdsall's (Plate 105). Finally, to overcome the inherent instability of all round-bottomed decoys, he flattened their bottoms more than any of his Jersey contemporaries did. If Captain Birdsall's goose sounds like the all-around decoy, it very nearly is just that. One only wishes there were enough of them to go around.

PLATE 105. A Canada Goose decoy by Captain Jess Birdsall of Barnegat, New Jersey. Geese carved by Henry Grant of Barnegat were very similar, except that Henry made them a little rounder on the bottom.

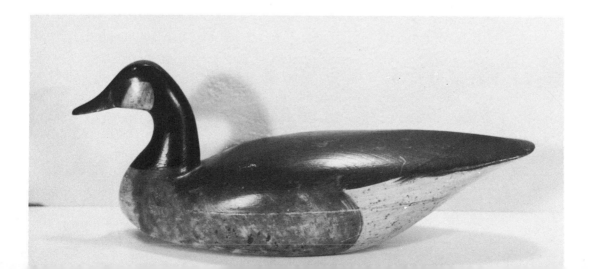

Many fully documented decoys carved by Captain Jess Birdsall remain, and his honored position among the distinguished decoy makers is secure. It is important to make this point in view of the statements that follow, which are in no sense intended to detract from the stature of Captain Birdsall, but simply to set right the facts concerning one series of shore birds that I may previously have attributed to him in error, although it is still possible that Captain Birdsall was their maker.

One day in the fall of 1941 I was on duty at the Bonds Coast Guard Station, located about twenty miles from Barnegat, when I received word that Mrs. Jess Birdsall, of Bay Avenue in Barnegat, the widow of Captain Birdsall, had some decoys for me. Having always accepted news of this kind as a form of command, I hurried almost immediately to Barnegat. After the introductions had been completed, Mrs. Birdsall brought out six shore-bird decoys, each carefully wrapped in a black cotton stocking, from which she removed them tenderly. I had never seen decoys handled so carefully. The reason was at once apparent: they were superbly shaped and beautifully painted birds, all in mint condition and correct in every detail and feather. Each was different. I soon owned a Ruddy Turnstone, a Lesser Yellowlegs, two Dowitchers, and two Black-bellied Plover, each of the pairs representing two different seasonal plumage phases. This unprecedented find left me excited to the point of paying less careful attention than usual to historical details. The blurred facts I recalled gave Captain Birdsall as the maker, and a date somewhere between 1880 and 1890. These were noted on the bottom of each bird, and I departed.

Since these six shore birds (See Color Plate IV) were in some respects the choicest ever found, the tidings spread in collecting circles and they were exhibited on a number of occasions. One was given to the Shelburne Museum in Shelburne, Vermont, and another went to the Bush Collection at the Staten Island Historical Society. The fame of the "Jess Birdsall snipe" became established, and for years there was no reason to doubt their origin.

Fifteen years later, however, in 1956, a batch of identical decoys were discovered at Amityville, New York. They had been shot over for years, but were still in their original paint. No history came with this group, and they could have originated in Barnegat. A year later, however, as the pace of decoy collecting increased, another similar lot was found, and here and there single ones have since appeared. There were still no further facts as to their history, but now doubts as to who had made them arose. One fact stands out: the only examples that have ever been reported from New Jersey were the six from Barnegat. Dozens were scattered around Long Island. Call them what you will, but I now doubt that the able Captain Jess Birdsall ever made them. By whatever name they are called, their paint patterns are superb and their interest is enhanced by the fact that they were made as working decoys, not as mantel ornaments.

THE TUCKERTON SCHOOL

A town of considerable importance in New Jersey during the American Revolution was Tuckerton. Located west of Little Egg Harbor Inlet, Tuckerton's deep-water channels made it a port for the southern-central region of the state. The town soon became famous for the excellent fishing and hunting areas in its vicinity, and it prospered from these natural assets.

Of all the men who made and sold decoys in the Tuckerton area, one stands out. Harry V. Shourdes was born October 3, 1861, and died January 6, 1920. Thus his life-span covered the great era in hunting and fishing on the Jersey coast. From all of the evidence available today, he was the greatest professional decoy maker of New Jersey. Although he was a house painter by trade and on occasion acted as guide for both hunting and fishing parties, his basic livelihood came from the making of duck, geese, Brant and shore-bird decoys.

Every investigation I have made of Harry Shourdes' work proves that he did everything from the selection of the wood to the final sale of the finished decoy himself. One of his daughters was occasionally called upon to sand some of the bodies, but nothing else did he leave to other people.

Even during his lifetime his skill became a legend. It seems to be a well-established fact that Harry Shourdes could take a rough decoy head in his hand, lie down in a barber's chair and be shaved, and as the barber finished, Shourdes would rise from the chair with a jackknife in one hand and a whittled duck head in the other. Plate 106 illustrates his remarkable skill.

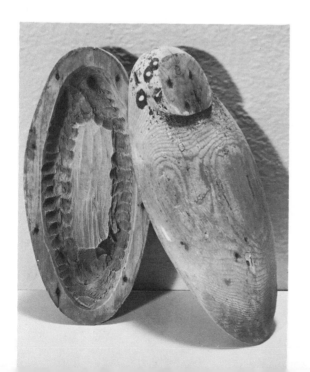

PLATE 106. Inside view of a scaup by Harry Shourdes. The skill and precision of this Tuckerton, New Jersey, maker are shown by the gouge marks around the sides. The flat center area is raised to allow the lead to be poured into the cavity in the outside center of the bottom half.

Shourdes' unique abilities did not go unnoticed, and the demands for his products increased. They became so great that his daughter, Mary Emma, recalls that she and her sisters were often unable to entertain their friends in the parlor of the Shourdes' house on Water Street, facing Tuckerton Creek. The parlor, and indeed the whole house, was crowded with decoys. However, it was a seasonal rush and Mary Emma added that no serious complication occurred. The house on Water Street still stands, but the last decoy has long since departed.

Seemingly every decoy Harry Shourdes made became a silent salesman. As a young man he devoted all his time to the making of decoys of all varieties. During the first two decades of the twentieth century, through the efforts of this one man, Tuckerton could be said to be the handmade decoy capital of the United States.

I am sure Harry Shourdes carried his honors lightly. They were hard-won honors, and meant continual effort. In 1920, when he died, his decoys were floating in every famous wildfowl gunning area in the United States. This we know from the fact that records exist showing that from the railroad station in Tuckerton hundreds of crates of Shourdes' decoys were sent to Maine, the Carolinas, and all of the states in between, and one memorable shipment went to California.

Today Harry Shourdes' decoys are prized by collectors. The neat, trim, careful work turned out by his capable hands has the quality of art. Fortunate indeed is the collector who has an example of Shourdes' work with its original paint intact, for his painting was worthy of the excellent carving beneath. Shourdes' decoys continually turn up, not in Tuckerton, because for over twenty years collectors have been frequent visitors to that area, but generally in out of the way places to which he sometimes sent shipments.

Greater Scaup, Black Ducks, Brant, and Canada Geese constituted about 90 percent of Harry Shourdes' output. Some Goldeneyes, Red-breasted Mergansers, Redheads, and Buffleheads by him also exist to cheer up the ambitious collector. Several Oldsquaws and Pintails are known. The Herring Gull shown in Plate 161 is unique. Shourdes' shore birds are as high in quality as his ducks, Brant, and geese. A collection of his shore birds is greatly to be desired. He made Sanderlings, Dowitchers, Knots, plover in two plumage patterns (Plate 107), Lesser and Greater Yellowlegs, Hudsonian Curlews, and Ruddy Turnstones.

Shourdes was the great "pro" for two reasons. First, he earned his living by decoy making. Over a period of forty years Shourdes must have produced more decoys than any other man. Secondly, the excellence of his work increased as the years passed. A tremendous craftsman in the carving of wood, Shourdes must have tried to make each one a little better than its predecessor.

Some confusion regarding Shourdes' work may result from the fact that his son, Harry M. Shourdes, moved down to Ocean City, New Jersey, and made a

few decoys on a part-time basis. Harry M. Shourdes' patterns and workmanship are very similar to his father's. Black Ducks seem to have been the bulk of his output. In any event, if you have a choice of Shourdes' Black Ducks, take the heavier, larger type, as they were made by the father. If you have no choice, but it is obviously a Shourdes, count your blessings anyway.

Harry Shourdes' passing brought an end to the real craft of decoy making, in a professional sense, in the state of New Jersey. It was certainly a slow and difficult way to become rich. Most of the duck decoys that Shourdes sold, for example, went for six dollars a dozen complete with weights. It is fortunate that so much of his work is left to those of us who now appreciate it. His kind will never appear again along the tidewaters of the Atlantic coast, and all of us are the poorer without him.

Even without the massive contribution of Harry Shourdes, however, Tuckerton would still stand out prominently in the story of American decoys. Many collectible carvers preceded him there and many worked contemporaneously with him and after him. Here we find the regional decoy in all its basic character. Differences in size and structure are minute. Paint patterns are similar. Even the method of attaching the keel was the same. The pouring of hot lead into the chiseled rectangular opening fashioned into the bottom half of the body did not originate with Shourdes. Many other Tuckerton decoys were balanced in that peculiar manner. This method, it may be noted, has a basic weakness, because the molten lead would char and burn the aperture it was poured into. Later the

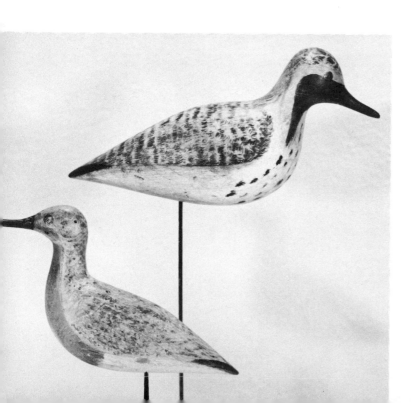

PLATE 107. Harry Shourdes' shore birds are graceful, nicely painted, and free from cracks and checks. He was a master in the selection and drying of wood. His Black-bellied Plover (*top*) are perhaps his best shore birds, because his tendency to shorten the necks was appropriate in the case of that bird. The Knot decoy is seldom found. Shourdes' paint was durable and many examples of his work exist in good, original condition.

charred area would rot and the lead would loosen. This was the one small flaw in the ingenious Tuckerton technique of weighting floating decoys. (See Plate 106.)

All of these delightful similarities make senior collectors wary of definitive statements as to the makers of most Tuckerton-type decoys. All makers varied their own patterns and styles more, from year to year, than their products varied from one maker to the other. It was a case of the "Tuckerton School of decoys." Members of the Truax, Lippincott, Salmon, and other local families all made superb examples, sometimes for sale but generally for use in their own rigs. To authenticate more than a few of the remnants of what must have been tens of thousands of decoys made and used in Tuckerton alone, is impossible and meaningless. Each one speaks for itself and can be enjoyed in its own right.

Perhaps the last practitioner of the Tuckerton School was Samuel Smith, who exhibited a goose decoy at the Second Annual Exhibition of Wild Fowl Decoys in New York. This was in 1924. Close examination of this comparatively latter-day product of the "School" shows no basic changes. It could have been made in 1875 or 1924 by any one of dozens of fine decoy makers. Tuckerton decoys are all good; some are just a little bit better than others.

PLATE 108. An example of New Jersey decoy ingenuity. Flying Brant such as this were made by Harry Shourdes. Some were stuck on tall stakes; others, with large staples in their backs, would slide down a wire toward the floating decoys. The rarity of flying Brant decoys indicates that they did not work out as expected.

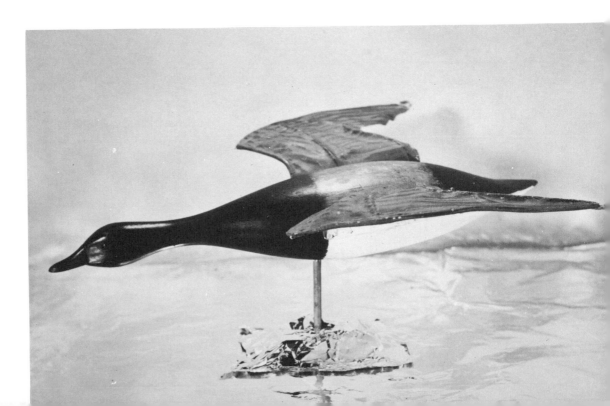

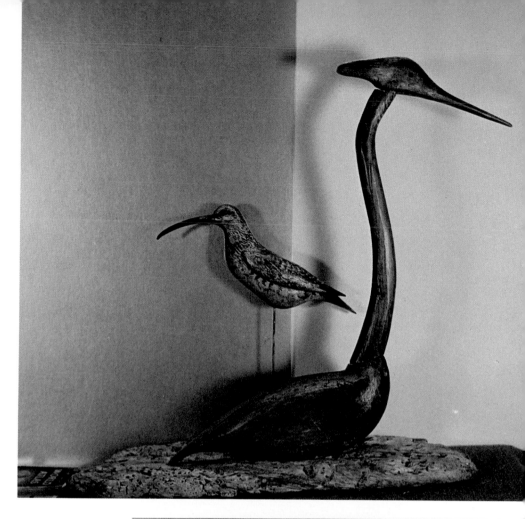

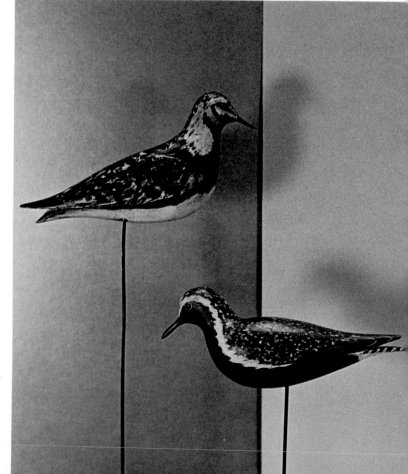

1. The Great Blue Heron in the foreground was used for almost a century in the Absecon marshes of New Jersey. It should now be admired for what it is, a proud example of American folk art. The life-sized Hudsonian Curlew from the Lloyd Johnson collection is a fitting companion for the stately heron.

11. Although almost every shore bird received the attention of the master decoy maker of Cape Cod, Elmer Crowell, some of his models of these species are seldom found. This Ruddy Turnstone *(left)* and Golden Plover by Crowell are two of the great rarities among American decoys. Indications of use prove they were not isolated examples, since rigs of at least a dozen were usual.

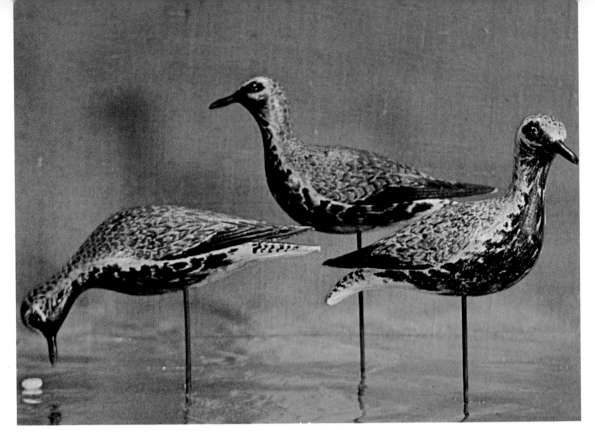

III. Elmer Crowell at his best. These Black-bellied Plovers combine his detailed carving of wing and tail feathers with the bold, true paint pattern that made him a master. Though the decoys are in fine condition, the scattering of shot holes is proof of their baptism by fire.

IV. This Black-bellied Plover *(left)*; Ruddy Turnstone *(second from left)*; and two Dowitchers, in fall and spring plumage respectively, represent the "Jess Birdsall type" of shore birds. There is a question as to their origin. There is no question that the detailed, stylized painting is unsurpassed. They are beautiful examples from the hand of a fastidious workman.

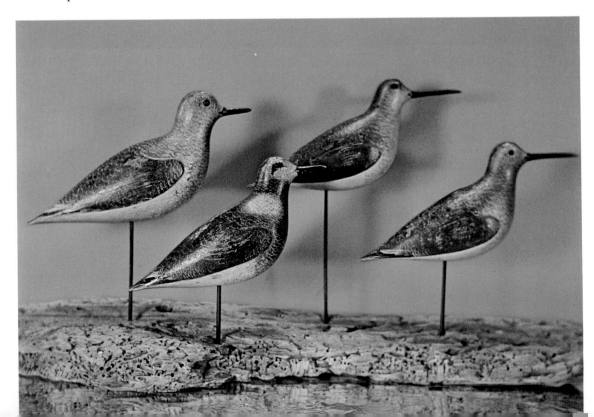

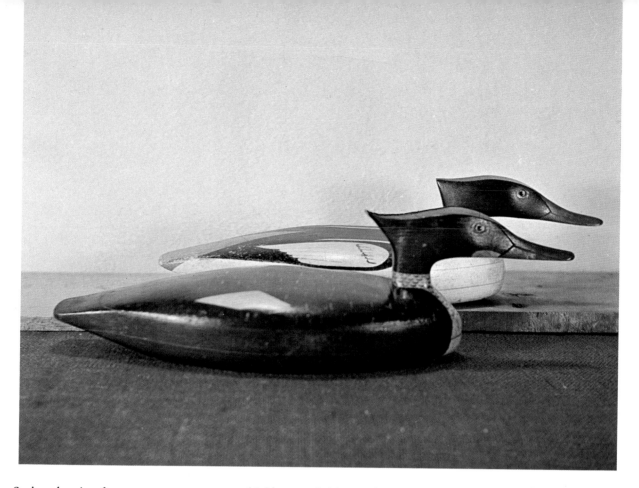

v. Spring shooting for mergansers was a sport highly regarded in South Jersey. The unknown maker of this female Red-breasted Merganser *(foreground)*, and male Common Merganser, lavished unusual care on this swift, handsome pair.

vi. John Dawson of Duck Island, near Trenton, New Jersey, refused to follow precedent in his plumage patterns. His distinctive decorative designs, as in this Pintail drake, blend into extremely natural effects. This skilled artist sometimes worked on decoy bodies carved by others.

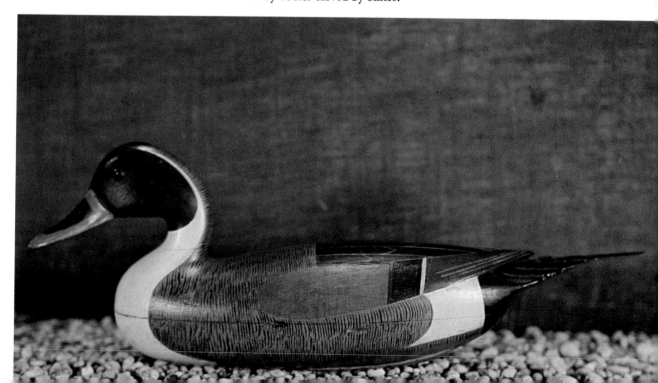

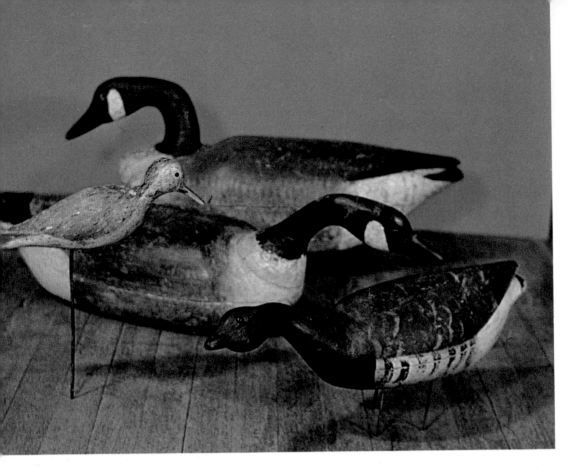

VII. The single Brant *(right foreground)* and pair of Canada Geese indicate why the rigs of Nathan Cobb of Cobb Island, Virginia, had such lifelike appeal. Every Nathan Cobb decoy had its own natural pose. Even his Hudsonian Curlews like that in left foreground (bill shortened by breakage) seemed to run, feed, and walk. All these decoys were made before 1890.

VIII. Mason's Decoy Factory of Detroit, Michigan, left us our finest heritage of factory-made decoys. The greatest single item from their shop is their Premier grade Wood Duck. This example is in unusually fine condition.

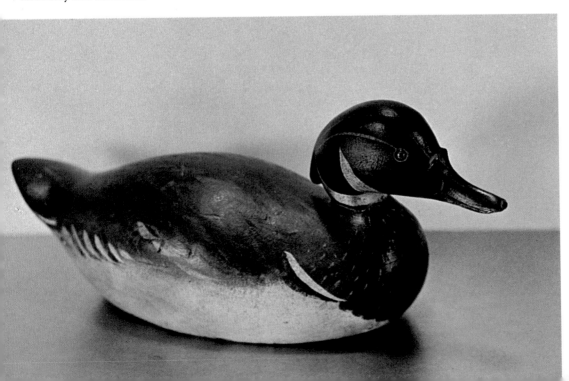

PLATE 109. Canada Goose by Lloyd Parker of Parkertown, New Jersey. Parker's geese are distinctive in that their necks are longer than usual, and extend forward. This pose gives a feeling of movement and alertness to the decoys. Parker's ducks are also larger in body and ride higher on the water than those of his competitors. Their paint style is only average.

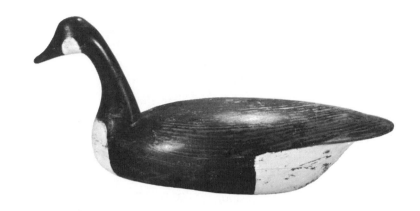

Though the Revolutionary town of Tuckerton was the hub of this South Jersey sporting area, the spokes of the wheel led to New Gretna, Green Bank, Manahawkin, and Long Beach Island. Here were tiny hamlets, each with a shed or two littered with white cedar shavings and occupied by local decoy makers.

Only one of these makers, however, worked at it as a trade and could qualify as a professional. Lloyd Parker of Parkertown, an hour's walk northeastward from Tuckerton, certainly earned that title and must be considered a competitor of his neighbor, Harry Shourdes, although his output over the years was much smaller. No evidence is left, unhappily, that Parker ever carved a single shore bird. Black Ducks, Brant, Canada Geese and a few Goldeneyes by him, all bold and stylish in their carving, exist today. Parker shipped decoys to the Carolinas and to many duck clubs along the coast. There are still Parkers to be collected.

Parker's output was limited by the fact that he was also a market hunter. During the season his day began at 4 A.M. and ended at the "landing" well after dark. The intervening fourteen to sixteen hours were a time of constant physical exertion and continuous exposure to some of the most inclement weather along the Eastern seaboard. This went on day after day during the winter months. Decoy making had to take its place in Lloyd Parker's scheme of things. There appear to have been some variations in his style over the years, but Plate 109 shows typical Lloyd Parker work.

Five miles farther northeast from Parkertown lies Manahawkin, near the bay of the same name. Off this part of the coast, separating Manahawkin Bay and Little Egg Harbor from the open Atlantic, stretches Long Beach Island, a thin, sandy strip

some twenty miles in length. Spaced along it from north to south are the hamlets of Loveladies, Ship Bottom, and Beach Haven. The United States Life Saving Service had stations in or near most of these communities, and the men staffing them were seldom transferred far from their homes.

Untold quantities of decoys were whittled and carved by men in the Life Saving Service. Lumber suitable for every kind of decoy washed ashore on the lonely beaches, where it lay for the taking. Entertainment and diversions by our standards were unknown; little wonder that the men turned to decoy making.

Captain Jed Sprague of Beach Haven, grandfather of the eminent present-day decoy maker, Chris Sprague, also of Beach Haven, was such a man. Captain Ike Truax, member of the family of decoy makers from Atlantic County, was head of the Ship Bottom station about 1890. Perhaps the most skillful, certainly the best known of this trio, was the gifted Bradford Salmon, number-two man under Captain Truax. Salmon, whose home was across the bay in Mayetta, made fine decoys in the Tuckerton style. It is inconceivable that most of these men did not make shore birds of some sort, but, if they did, no one can identify them at this late date. We can appreciate all the better the ducks, Brant, and geese they left as their contribution to the sporting heritage of America.

As the years passed and the Life Saving Service became part of the United States Coast Guard, the "old guard" of decoy makers dropped away until none are left, but their sons and grandsons carried on and preserved old decoy-making traditions.

Ellis Parker of Beach Haven and Roland Horner of Manahawkin worked until the early 1940's. These two men, like Chris Sprague, were masters of decoy making. Every refinement they could learn from their predecessors has gone into the stools carved by these three men. Their later work is a fitting epitaph to the dying art of making Jersey "dugout" decoys.

Roland Horner was about forty years old when he died, and his work (Plate 8) had reached a peak of perfection. The decoy-making life of Chris Sprague, who is still active, spans the present and the past. Early Sprague decoys are in many collections. Also collectible is a large rig made in 1935, under pressure of time, jointly by Sprague, Parker, and Horner. Examples of this rig are shown in Plate 110. Good friends that the three men were, each agreed to do a specific part of the job, such as carving the bodies, carving the heads, and painting. The deadline was met, the decoys proved unbeatable, and each collaborator took his share. These decoys represent more skilled workmanship by more men than any others known. Just who did each part of the work remains a secret.

The reaches of the Mullica and Wading Rivers claimed many hunters, but only one, John Updike, made any appreciable number of decoys. Green Bank, on the Mullica, where he worked, was "puddle duck" country and Black Ducks were his

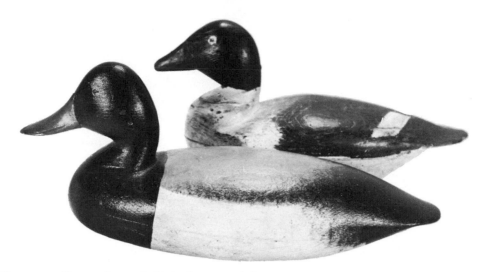

PLATE 110. Greater Scaup drake in foreground shows basically the fine hand of Chris Sprague. The assistance of Roland Horner and Ellis Parker (see text) helped Sprague make an almost perfect New Jersey decoy. Common Goldeneye female by Henry Kilpatrick of Barnegat is also shown.

specialty. His work is a cut below that of the Tuckerton School in quality because of the lumpy, small heads, which do not grace the good-to-average bodies they are placed on.

The last stop, and in many ways the most interesting, is at New Gretna. Near here the clean but dark-stained waters of the Mullica, tinted by the roots of the alders upriver, lap the head of Great Bay, just south of Little Egg Harbor. It is land steeped in Revolutionary history, but it has always been a harsh and demanding region, where the price for success and survival is high. In the eighteenth century, pine robbers, the adult gangs of the day, roamed the pine barrens. Pirates were known on the coastal beaches, yet the village of New Gretna survived and grew for two centuries. Its population is now about 800. Whether New Gretna, which outlived pine robbers and pirates, can master the cancer of pollution at her doorstep and the doubtful blessing of a turnpike through her vitals, is the present question.

Old baymen like the McAnneys, Robbinses, Cramers, and Mathises, however, will try to hold the line and somehow preserve their way of life. Consider Chalkly Cramer, who departed this world in the year 1929. He did a number of things extremely well; one of them was to make Black Duck decoys. Another was to run the general store in the center of New Gretna. Still another interest and fruitful occupation of Chalk's was building small boats. All the wooden containers and boxes shipped to his store were checked for usable boards. Not a scrap was wasted. Neighbors like "Bootsie" Mathis say Chalk made fine boats and that some are still afloat.

With marshes extending in every direction around the village, trapping played a large part in the economy of New Gretna. Muskrats abounded and the demand for pelts was steady. Chalk Cramer, having some time on his hands, began to harvest his share of muskrat pelts. He never used a trap but perfected a method of shooting muskrats with #6 shot as they swam on the surface. Chalk hunted only at dawn and dusk, so that it did not interfere with the rest of his day's work. This kind of shooting required skill to avoid ruining the skin with shot holes, and agility in rowing, wading, or if necessary even swimming to the carcass and grabbing it before it sank.

With all these demands on his time it is difficult to picture Chalk Cramer as a market hunter into the bargain, but he was one of the best. He gunned the whole season on Wading River, about ten miles from his home. This was fresh water and the Black Ducks shot there were generally fat and tasty and therefore sold at a premium. The twenty-mile trip was no problem to Chalk. To the front of a large woman's bicycle he attached a big carryall, perhaps the forerunner of the modern supermarket pushcart. His contract with an Atlantic City hotel called for twenty-five ducks a day. In spite of snow, darkness, and muddy roads, Chalk got his bicycle and its load of twenty-five ducks back to New Gretna and his store day after day, for year after year. Plate 111 shows, in the background, one of the decoys that made these trips. When he died Chalk was a solid, well-respected citizen of the community. He was well off in worldly goods and had lived past the allotted span. His general store has been moved to the historic Smithville Inn where it may be visited—but go early. It has always been a very busy place!

Another man who knew the waters and marshes around New Gretna as well as anyone was John McAnney. A sign in front of the McAnney home solicited hunting and fishing parties. John became famous for his ability in this field. He carved all kinds of decoys, but generally for his own use. His oversize Black Ducks (Plate 111, foreground) and his shore birds seem the most desirable. A few years ago at an auction some small, cardboard patterns for making Black-bellied Plover decoys were offered for sale and fell into my hands. Since the auction was at the McAnney home and a basket of plover decoys matching the pattern came from the same shed, we know that the Black-bellied Plover shown in Plate 33 was made by John McAnney, probably between 1900 and 1910. Decoy collectors owe many debts to New Gretna and its sturdy men who never seemed to wear out.

Without question, the southern half of Jersey's seacoast produced a greater variety of decoys than any other area in the country. Shore birds of nearly every type have been found. The one possible exception is the Golden Plover. Several examples have been picked up, but the best opinion points to Nantucket as their place of origin. Duck decoys in the same varied profusion have been found scattered through boat-

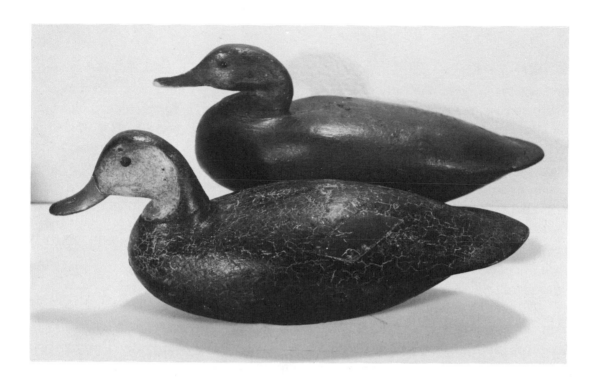

PLATE 111. The big, husky Black Duck in the foreground was made and used by John McAnney of New Gretna, New Jersey, the one behind it by "Chalk" Cramer, also of New Gretna. One such rig by Cramer is still in use after fifty years of service.

houses and sheds that smelled of tar, cedar, and the flats at low tide. Together with offhand pieces such as flying Brant, gulls, and the incredible Great Blue Herons, all this made a collector's dream.

There remain many loose ends that seem impossible to run down. Shore-bird decoys like those shown in Plate 112, for example, were made and sold almost by the gross and have been found scattered from Maine to the Carolinas. It is known, for instance, that the Accomac Club in Virginia had hundreds of them. They are often called "Joe King birds," after the supposed name of their maker. It is possible that a Joe King did make them, but if so he could not have been the Joe King (1835–1913) who lived in Parkertown in New Jersey and did make some decoys there. Parkertown's Joe King had a local following for his decoys, but his work did not pretend to rival that of a Shourdes or Birdsall, and he never operated on a large enough scale to produce such an output as is represented by the widely distributed "Joe King birds." Obviously these so-called "Joe King birds" had another source that we have not been able to locate or identify.

Whether Harry Shourdes' ability to whittle a duck head while a barber worked on his chin inspired one barber to get in on the act, we do not know. However, the town barber in Tuckerton was named Nate Frazer, and not surprisingly his spare time was spent carving decoys. Shore birds were Frazer's specialty. His work just misses ranking with the best from the Tuckerton area, its main weaknesses being that the heads of his yellowlegs and plovers lack gracefulness in shaping and the bodies are not quite round enough.

The great salt marshes west and south of Atlantic City tempted most shore birds to tarry awhile, and the local gunners took advantage of this fact. The Black-bellied Plover gathered there in great numbers, as did the Hudsonian Godwit, or as it is locally known, the "marlin." Market hunting flourished as the carriage trade who patronized Atlantic City's famous hotels demanded game dinners.

The well-known market hunter Mark English of Northfield left a legacy of fine decoys; both shore birds and ducks comprised his large rigs. Almost all are identified by his initials, as shown in Plate 113. It may be asked why a professional hunter of his ability would own a dozen Oldsquaw decoys, since there is no record of an Oldsquaw duck's ever being sold as food. Mark English had a simple, understandable explanation: it seems that he enjoyed hunting so much that once in a while, in the spring, he went just for fun. On those sporting occasions he would go down to the inlet, put out a dozen Oldsquaws, and bang away to his heart's content. The decoys used have, in turn, given pleasure to collectors ever since.

The name Hammell occurs time and again when South Jersey decoy makers are discussed. Guarner Hammell, a Pleasantville, New Jersey, man, made many good stools, mostly Greater Scaup and Goldeneyes. Later some of his work turned up on the Eastern Shore of Virginia, where he spent his later years. All Hammell decoys, however, are believed to have been made in his Jersey period. He died in 1939 at the age of ninety-nine.

Rhoades Truax of Absecon also made excellent decoys, but only a few ducks and Brant can definitely be attributed to him. Truax died during the 1930's. Decoys from the Cape May region do not measure up to the standards set by Tuckerton and Barnegat makers. Many are of solid construction and tend to be comparatively heavy and clumsy; the same holds for the Cape May shore birds. Curlew were fairly common around Cape May, but the decoys for them stand out only by their awkwardness and bulk. A rather choice one known as "Ol' Hookbill," and his mate, are shown in Plate 114 to illustrate this fact.

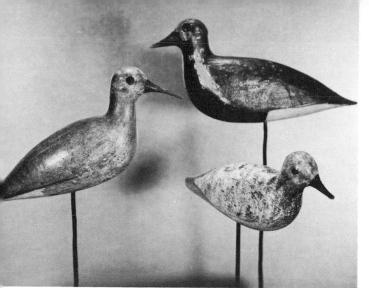

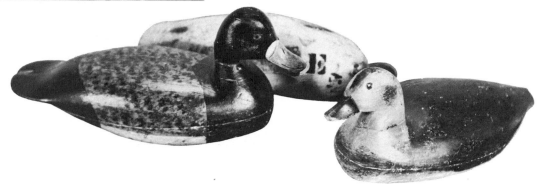

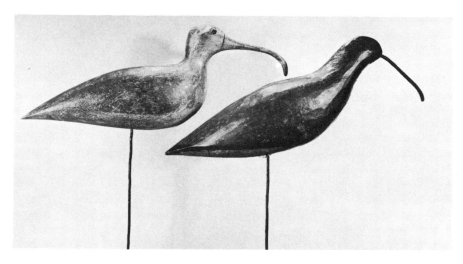

PLATE 112 (*top*). Black-bellied Plover by an unknown New Jersey maker. Hudsonian Curlews, Sanderlings, Dowitchers, and Ruddy Turnstones were also produced by the same hand. Some have plain, full bodies, others have carved wings. The maker's identity has faded into the past. PLATE 113 (*center*). Mark English of Northfield, New Jersey, hunted for both the market and recreation. The Oldsquaw on the right was anchored out when he was enjoying a lighter moment. The stenciled "E" on this decoy took the place of English's earlier hand-lettered "M.E." PLATE 114 (*bottom*). Hudsonian Curlews from Cape May County, New Jersey. Few shore birds equal in quality to the one on the right were made in that county. The other shown is more representative of Cape May work, being crude, heavy, and drably painted.

IX *The Delaware River*

BOTH NEW JERSEY AND Pennsylvania can be proud of the work turned out by the decoy makers of the Delaware River region. Most of them came from the Jersey side of the Delaware, but there are honors enough for both states. The lower reaches of the river from Trenton to the broad expanse of Delaware Bay are a small, compact world of ducks and their hunters. There is a choice of fresh, brackish, and saltwater environments and a corresponding variety in the species of ducks obtainable. The overall picture favors the marsh or "puddle" ducks. Pintail, Mallard, Widgeon, "blacks," and teal poured down the funnel of this river in bygone years. Many of them had the dubious pleasure of falling, when shot, among some of the best painted and most carefully carved decoys ever made. These well-designed Delaware River decoys do not tend to extremes in size or conformation. Their one touch of ostentation is in the delicate tail and wing carving associated with the region.

Those who maintain that a Mallard decoy should look as much like a live Mallard as possible will have happy hunting in the field of Delaware River decoys. With the possible exception of the Connecticut decoys made around Stratford, the duck decoys of the Delaware look most like the ducks they are designed and painted to represent. The talent of the carvers of the region would appear to be directed almost without exception to making ducks. Shore birds, geese, herons, and gulls just never seem to be found. This is stated more as a historical fact than as a complaint. The ducks alone are a great and sufficient contribution. Perhaps the only note of regret for the collector is that large rigs were not used and comparatively few men worked as guides or market hunters. Thus the output of decoys was limited.

Most of the hunting along the Delaware was on the river itself, and blinds were seldom used. Here generation after generation of hunters developed the technique of sculling into almost a fine art. After the selection of a location, about forty decoys were anchored between the edge of the channel and the shore. An average group

would be twenty "blacks," ten Greater Scaup, a few Redheads and "cans," then a Pintail or two for luck. If Mallards were used, they would replace some of the "blacks." With the stage set and decoys in place, the gunner began his busy day. Rowing would take him upstream to his station, there to wait for the arrival and decoying of the birds. Once they lit among his stools the cautious, calculated sculling began. The boat must approach to within gunshot—about 30 to 40 yards—before alarming the birds. One false move or sound meant failure and better luck next time. Professional rivermen could not afford mistakes.

After picking up his kill, the hunter would again row back to his station to await the next opportunity. This method certainly explains the fact that, as mentioned above, Delaware River decoys are as nearly perfect as a decoy can be. It was necessary not only to fool the quarry from the air but also to continue the ruse as the birds made contact with their fake counterparts on the water. It was a form of hunting that demanded exact timing in the sculling and perfection in the decoys to enjoy even moderate success.

This section of the Delaware Valley, however, had seen many generations of men who looked to the river for their daily bread; they knew its every ripple and mood and season. They spent more time in boats than in bed and along the Delaware the term "river rat" carried no stigma.

Admittedly "Mocker" Bell of Bordentown, who trapped, built boats, and hunted, was a gifted "river rat." One day many years ago he was observed in the following drama. It was late in the spring. Just before dark Mocker made his way upstream in his scull boat. Suddenly, he saw a few scaup on the river and he instinctively dropped down and began to work down on the birds. His every move, from then on, was closely watched, because Mocker Bell had no gun with him; he had been fishing. Suspense hung heavy on the spring air as the deadly stalk progressed. Even a gifted riverman needed all of his accumulated skills to get one last duck dinner without a gun. The little band of ducks seemed hypnotized by the quiet, lifeless boat that crept along inch by inch. Mocker timed it to a split second. When his calculation of the wind, stream flow, and direction the ducks would take told him he had reached exactly the right spot, he stood up. With a mighty swipe of his sculling blade he cut a nice fat drake from the flock and continued his trip. Fish or no fish, he had his dinner and doubtless felt pretty pleased with himself.

In its lowest reaches the Delaware River, bordered on both banks by extensive marshes, loses its identity in the ebb and flow of Delaware Bay. A discernible difference in the decoys used in this region is also noticeable. The lead weights are moved forward, since there was no need to compensate for the flow of current. Tail and wing carving plays a less conspicuous part and duck bodies become wider and flatter. But the slick, well-groomed look of the Delaware River stools remains.

The so-called "Blair" decoys, one of which appears in Plate 115, are symbols of the finest decoys to ride the Lower Delaware. Considerable has already appeared in print concerning these worthy and classic birds. Shelburne Museum has displayed and illustrated several of these decoys with the suggestion that they were made by John Blair of Philadelphia in 1865. This date seems early to me in view of the facts concerning the decoys of similar type. It can also be revealed that exactly similar paint patterns are found on body styles unlike the examples shown. It's hard to believe that any portrait painter, as John Blair was, would paint more than one rig of decoys. How to sift the fact from the fiction and place these decoys in sure perspective is beyond our present knowledge. Perhaps some turn of events will enable the date of their construction to be approximated more closely.

Apparently there were several other rigs of "Blairs" similar in every respect to those illustrated. Some of these decoys are unmarked, while many of them carry the brand "C. SPRECKLES." As more of these classic Delaware River items are found, the mystery merely deepens. Since they are among the best painted decoys found to date, it is a pity that such uncertainties obscure their past. They rode the Delaware in very distinguished company.

A Delaware River gunner of distinction was Charles Black, of Bordentown, who almost made his ninetieth birthday and hunted the river up until the end. As a young

PLATE 115. The superb painting that distinguishes a so-called "Blair" decoy occurs on scaup, Black Ducks, Mallards, American Widgeon, and Wood Ducks such as this one, which was made about 1910. Examples in original condition are rare decoy classics.

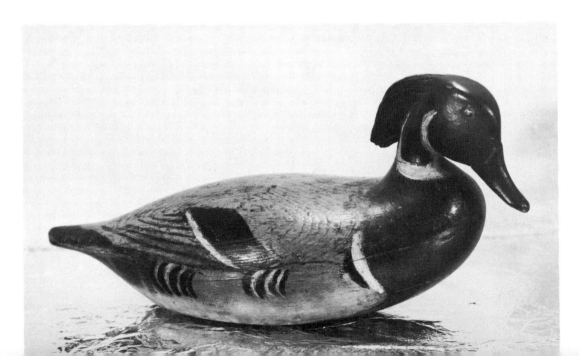

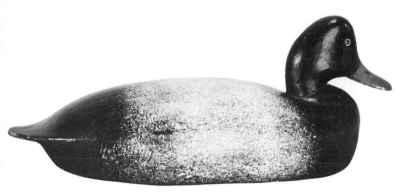

PLATE 116. Charles Black of Bordentown, New Jersey, made this scaup. All decoys used on fresh water survive in generally better condition than their counterparts exposed to the corrosion of salt water. Delaware River decoys benefit from this fact.

man Black developed into a fine wing shot. With the passing years his skill increased and today he is still remembered as "the best gun on the river." More tangible evidence of his ability remains in the excellent decoys he made for his own and his friends' use (Plate 116).

John Dawson, who had a hunting cabin, appropriately enough, on Duck Island, near Trenton, made decoys that collectors will prize for generations to come. Dawson brought several talents into play in constructing remarkably original decoys (Color

PLATE 117. Hooded Mergansers that received almost loving care. Decoys like this swift dandy and his mate were occasionally used along the Delaware River. They are very rare and desirable.

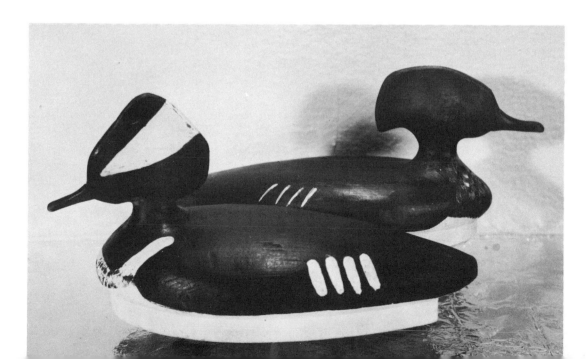

Plate VI). His trade was that of a skilled potter, and he was also an able carpenter and woodworker. Dawson, who had an unusual artistic sense, has left us some of the most beautifully painted decoys known. The carefully drafted plumage patterns and choice selection of colors make a John Dawson decoy as desirable as any. His brother, Joe, sometimes played a part in finishing the Dawson decoys, but John was the one deserving the major credit.

Unhappily John Dawson, who died in 1959, had trouble disposing of his output, and on one occasion took 300 of his finest decoys to a sporting goods store and asked for help in selling them. He quoted a price of two dollars each, and after one look the owner of the store bought them on the spot. Few of the 300 matchless decoys fell into the hands of appreciative owners. The majority went to beginners and youngsters and have either been repainted or met a worse fate. The serious collectors in New Jersey are still slowly shaking their heads and a dull look clouds their eyes when the facts are mentioned.

All the rivermen were masters of several river trades. None of them depended only on the making of decoys for a living. Those whose work and names are known to us today made a rig for their own use and from time to time either added to it or made some more for a friend. Market hunters operated only when the birds were plentiful; at other times fishing or the capture of the huge snapping turtles kept them busy.

PLATE 118 (*below*). Black Duck decoy typical of the Delaware River. The style of carving, paint patterns, and conformation in Delaware River decoys changed little over the years. The manner of placing the head on the body made for a sturdy bird with a restful, contented look. Dozens of now unidentified makers worked in this style. PLATE 119 (*right*). These Hooded Mergansers, known along the Delaware River as "hairy heads," probably date from around 1875. Unmistakably from the Delaware, they show the salient characteristics to which the decoys of this region have clung over the years. PLATE 120 (*far right*). Lazy, well-fed, Pintail decoys like this one must have been irresistible to their passing brethren. The observant rivermen of the Delaware never changed their style. Normal-sized, hollow bodies, with carved tail and wing feathers, are their trademark. The restful head and good paint pattern complete the Delaware River image.

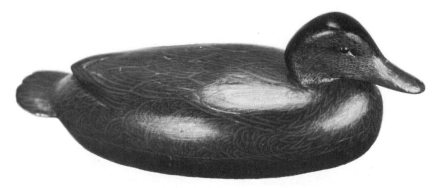

Two other noted rivermen out of Bordentown, New Jersey, were the Truland brothers, Ed and Jack, who spent almost every day of their adult lives on the river. That takes in a considerable span of years, since Ed was born in 1814, Jack, in 1815. Both passed away in 1890. They never married, but lived with two brothers and two sisters who were not related to them.

Recognized as the deans of all the market hunters, the Trulands' every move was studied by their less successful competitors. They lived and worked as a team, and not a move was wasted from the time they left their home before dawn until after nightfall when they shipped the day's bag to market. I have talked with elderly neighbors of the Trulands who still recalled watching the brothers start the day by launching their boat, seating themselves, and rowing away up the river with all four oars flashing. The Trulands were by all odds the best oarsmen the river has ever seen. This unison and rhythm in rowing, hunting, and carrying out the day's other occupations were such that everything was often accomplished without the utterance of a single word for hours or even, it is said, days. Their every act was a perfect and finished effort that needed no oral embellishment. This polished pantomime became locally famous in its time, and one suspects that the Truland boys may have played their parts very well. It is pleasant, nevertheless, mentally to see their oar blades flashing in perfect unison as dawn broke over the river. Mahlon Schuyler, of Bordentown, New Jersey, who today carries on the best traditions of the riverman, used to hear his father tell about them. Very few of their neighbors could tell Ed from Jack; both sported moustaches and sideburns, and both wore derby hats. But it was easy to distinguish the Trulands from the rest of the crowd as they gunned and fished the Delaware River.

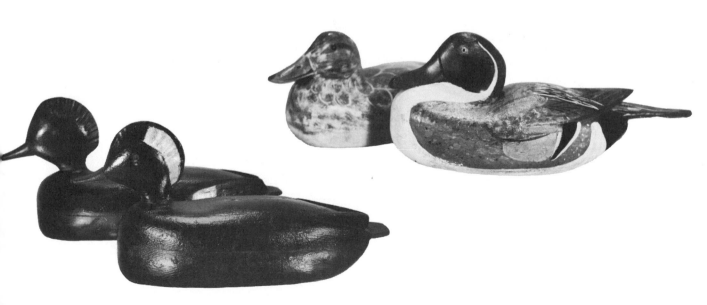

X *The Susquehanna and the Upper Chesapeake*

THE MIGHTY CHESAPEAKE Bay and its complex of sloughs, rivers, creeks, and marshes can boast of over five thousand miles of shoreline. Every point along that shoreline at some time has played host to a duck blind and a spread of decoys on the water in front of it, and many favored points, such as those along the Gunpowder and Bush Rivers, just north of Baltimore, have been gunned for over a century. Wildfowl, both economically and recreationally, were also a way of life on the lower length of the Susquehanna River, which empties into the northern part of Chesapeake Bay.

The city of Baltimore became an insatiable market for choice game. In that era of epicurean living that was the last century, Maryland seems to have set the pace. Canvasback and terrapin were an indispensable part of this luxurious way of life, and Baltimore was famous for both game specialties.

Every device and stratagem for the taking of ducks, geese, and swans have been put into use on the Chesapeake. Batteries, floating and point blinds, bushwhacking, punt guns, swivel guns, and traps of every description have taken their toll. The choice ducks, Canvasback and Redhead, that once abounded in the region, made a brave but losing show of it. In all this winter homeland for both species, it has been illegal to kill a single one of these birds for the past few years. Now that the use of "can" decoys has come to a halt, however, they are but a pitiful remnant of their former numbers. The proud rigs of 500 and 600 decoys that lured birds on the Susquehanna Flats have gone. Their strange new surroundings include antique and gift shops; they rest on mantels or lamp bases. Wherever their present resting places, however, they generally receive an appreciative glance, just at they did when they served their original purpose and their live counterparts whirled overhead. This entire area is a happy hunting ground for the collector of duck decoys in general and Canvasback in particular.

Though Redheads, scaup, and a scattering of teal were also shot in former days,

it was the Canvasback that dominated the scene both on Chesapeake Bay and in the marketplace. The entire head of the Bay was an area of specialization in Canvasback hunting. A celery-fed "can" would bring almost twice as much as any other duck in the Baltimore market.

The duck decoys of the Chesapeake region are solid, made of white pine or cedar, and have unusual uniformity in form and appearance. Few if any experimental liberties were taken over the years with what appear to have been the designs established in the pioneer Chesapeake Bay Canvasback decoys. The size and conformity of the heads and bodies remain consistent. Obviously the decoys were not found wanting in any respect. Used in tremendous rigs, they saw hard and continuous service, and durability was certainly of first importance to their users. Their size varies very little, any variation that does occur tending to the small side.

Any documented decoys of the mid-nineteenth century are interesting and rare, and oversized duck decoys made for use on Chesapeake Bay are all but unknown. The decoy in Plate 121, made in 1850–1860 by Dick Howlett, falls into both these rare categories. After being retired by its maker and original user, it was given to Jim Currier, of Havre de Grace, Maryland, who treasured it for sixty-five years. It is a forerunner of all the tens of thousands of decoys made in the towns skirting the Susquehanna Flats since Dick Howlett's day. These decoys remain basically unchanged after a century. Even the earliest examples had the broad beam that made for stability on rough water. In their subtleties and their interesting historical background, these decoys make for a fascinating field of collecting. They and their kind furnished sport and recreation for such notables as Presidents Grant and Cleveland, and are even more prized by today's collectors.

At the turn of the century Havre de Grace, Maryland, had a busy waterfront that played host to gunners from all over the country. No locale ever attracted the wildfowler, over a period of one hundred years, as did this town. Its shoreline bordered the Susquehanna Flats, a watery expanse at least a hundred square miles in area. The abundant vegetation on these silt-laden shallows attracted some of the greatest concentrations of choice ducks the Atlantic coast has ever seen. Fabulous bags were shot by local market hunters who are remembered to this day and spoken of with considerable awe. One of these men, in a single day, could often kill more birds than the average dedicated wildfowler would shoot in ten years. Their skill with a shotgun and their knowledge of the birds were extraordinary. A miss by one of them was almost unknown, and certainly would be compensated for by a double with one shot as two birds crossed the next time around. On occasion each of many battery shooters killed hundreds of Redheads, scaup, and Canvasback between dawn and dusk . . . but it serves little purpose to recount the gory details. While we may regret that market hunting was ever permitted, the hunters

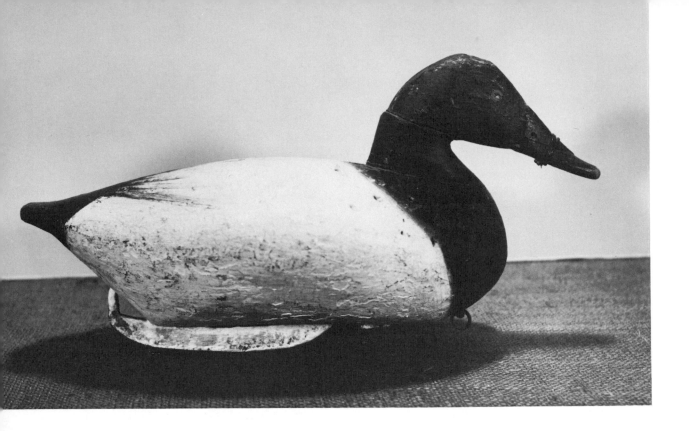

PLATE 121. Traditional battery Canvasback made by Dick Howlett of Maryland before 1860. The iron "horseshoe" keels used on these decoys show little corrosion because they were used in brackish water. This duck has been repainted at least twenty times.

were a skilled, hard-working group of men, and they had to be successful and deadly in order to survive. Dead birds were their stock in trade.

A bayman about whom the older members of the Havre de Grace ducking fraternity always speak with reverence was "Daddy" Holly, who passed away when they were youngsters. Holly was an old man by the year 1900. He knew as much about the Flats and gunning as any man. His first rig could have been the decoys that set the traditional local style for the next century. The parade of competent decoy makers who followed "Daddy" Holly's lead includes Ben Dye (see Plate 122), members of the Morgan and Barnes families, and the more recent Madison Mitchell, James Currier, and Bob McGaw. They all made decoy history.

Many others, though less well known, also deserve recognition. Such a carver was Henry Lockard of North East, Maryland. Fine sturdy decoys of carefully se-lected pine came from Lockard's shop. On at least one occasion he turned to an unusual pose and the preener shown in Plate 123 left his workbench. It saw little

if any service and became a mantel ornament in his home. Any decoy with a turned head, in original condition, is excessively rare south of the Mason-Dixon Line.

The Susquehanna, mighty tributary of the head of Chesapeake Bay, was a flyway that poured a substantial stream of ducks down from the northwest, and many of them were the prized Canvasback. For several hundred miles the lower Susquehanna offered a type of duck hunting about which little is generally known. It was not an area where market hunting prevailed, but rather one for the sportsmen. Of interest, first, is the almost standard practice on the Susquehanna of using oversize Canvasback decoys, a tradition that goes back as far as anyone can recall. Also unusual was the custom of placing the decoys in the selected spot before the gunning started and then leaving them in position throughout the season. About thirty or forty decoys were generally set out, and because of the flow of the current and depth of water extremely long lines or wires were used. The last day saw what remained of the rig snipped off and taken back to await the next season.

Owing to floods, driftwood, and, sad to relate, piracy, the mortality among decoys on the Susquehanna was great. Then there came into use on the river a decoy code that is quite faithfully adhered to by respectable hunters to this day. All decoys have a small metal tag attached to the bottom; it gives the name and address of the owner. All loose decoys may be picked up and used during the season by the finder, but then the system goes to work. The finder of any or all derelict decoys sends one postcard to the name on the metal tag, giving the finder's address. The original owner may then claim his property within a reasonable time.

PLATE 122 (*left*). A Redhead drake that illustrates the style of Ben Dye of Havre de Grace, Maryland, at the turn of the century. Its small size, with body less than 12 inches in length, and traces of original paint, are unusual. Stylized paint patterns such as this were seldom used after 1900 on Chesapeake Bay waters. PLATE 123 (*right*). Decoys with the head position of this Canvasback were looked upon as impractical by baymen who gunned the Susquehanna Flats. The anchor line had a tendency to slip off and tangle.

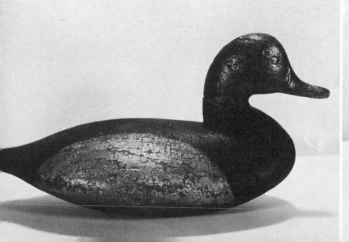
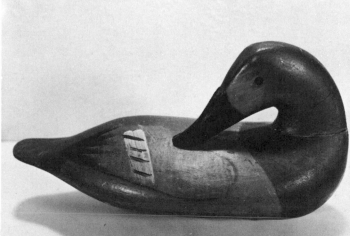

Bob McGaw (1885–1952) of Havre de Grace, either gunned wildfowl, made decoys, or chatted with decoy collectors most of the years of his life. He was a kind, helpful man given to encouraging those less knowledgeable than himself. His generosity brought to light a local curiosity known as a "John Goose" (Plate 124). This was used by "bushwhackers," the local term for hunters who sculled up on ducks resting on the water. The hole in the goose's body held the boat end of the anchor line used to moor the hunter's boat between sculling trips. It made a distinctive and easily located buoy. Its like is not to be found anywhere else I know of, but as Bob explained, "We used them around here because decoys were one thing we always had."

Several other items which all too rarely turn up on the Chesapeake include swan decoys, with which I shall deal in a later chapter, and decoys of the smallest ducks, teal and Ruddy Ducks. The teal have a special appeal and Plate 125 tells that story better than words. Actually the teal, especially the Green-Winged, was really a toy of a duck for these mighty market hunters to waste powder and shot on. But years ago a considerable number of excellent teal decoys were found in boathouses around the head of the Bay. Harry Barnes of Charlestown, Maryland, settled the question once and for all by explaining that teal arrived in fall in great numbers before the advent of the Canvasback and Redheads. They provided tricky targets and were used to sharpen the shooting eyes of the army of market hunters. After a hunter had practiced for two weeks on the sporty teal, what chance did a big fat "can" have when it lumbered by?

Excellent handmade decoys in the old tradition are still being made by Madison Mitchell and Jim Currier in Havre de Grace and by Charles Joyner in Betterton, all of them of the old school. An educated guess would be that more wildfowl have been shot over the simple, sturdy, and easily handled decoys made around the upper end of Chesapeake Bay than over any other decoys in the country. Their use was general on down the Bay and into the Potomac River, where some batteries operated.

On the Eastern Shore of Maryland, around Cambridge and Easton, there were decoys made, of course, but their fame was local and the work apparently was not outstanding. This is most emphatically not true, however, of the region a little farther south influenced by the Crisfield carvers.

All of the sameness and uniformity of the Chesapeake Bay decoys we have discussed so far is scattered to the four winds when a representative collection of Crisfield decoys is studied. This important bay town on Tangier Sound shared none of its pioneer decoy makers with neighboring towns or communities. All of the good makers were natives of Crisfield. They produced a duck with a freedom of form and gaiety of style that can produce either delight or despair in the heart of the collector; some are that good, and others simply are that bad. These so-called "Crisfield

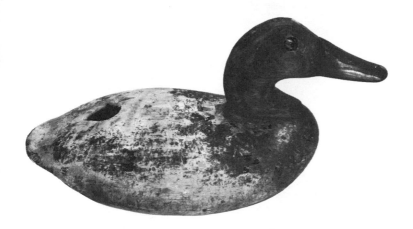

PLATE 124. A battered old Canvasback decoy that had seen better days was sometimes made into a buoy or "John Goose." This one came from the shop of Bob McGaw of Havre de Grace, but was made long before his time.

models" have been produced by generations of the Sterling, Ward, Tyler, Nelson, and other families. Articulate descendants of all these families are still available, and they still hunt and make decoys, but the mystery of who originally created the Crisfield style is unsolved. Gunner Will Sterling, who was ninety-two when he died in 1962, made and used decoys all his life, but the origin of the graceful decoys was, as he said, "before my time."

James L. Nelson, who worked until 1918, probably made as many decoys as anyone in the Crisfield section. Various Tylers, and one Elwood Dize, also added their output to the local production (Plate 126).

It was about this time that two young Crisfield brothers, Steve and Lemuel Ward, turned their hands to fashioning decoys, and fortunately they have never stopped. Their father was a superb though not prolific decoy maker, and the boys learned from him. Theirs is a cooperative effort, and a better team has never operated. Steve is a carver and Lem an artist with the brush. Working together since 1920, they have steadily enriched the decoy collector's field. With delightful artistic license, they have varied their patterns and continued to improve them over the years (see Plate 127).

PLATE 125. A dainty Green-winged Teal that can be immediately identified with the Susquehanna Flats. Its body length is 9 inches and its overall height less than 5 inches. The weight and line are as last used.

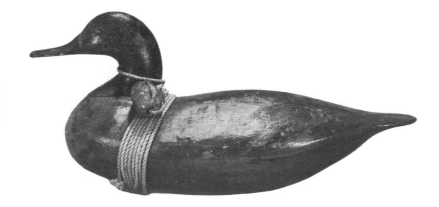

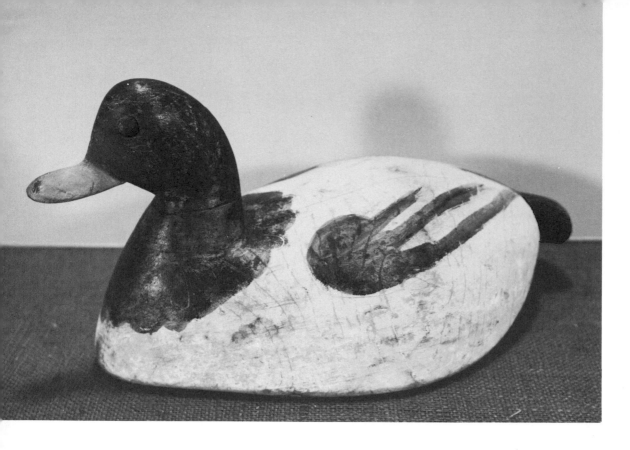

PLATE 126. The name "DIZE" stamped on this scaup identifies the maker and user of the decoy (see text). Few of these striking, oversized Crisfield, Maryland, items are marked.

PLATE 127. A drake American Widgeon or Baldpate from Crisfield, Maryland, that needs no mark to identify the makers. It shows unmistakably the skill and artistry of Lem and Steve Ward. It was made during the 1930's.

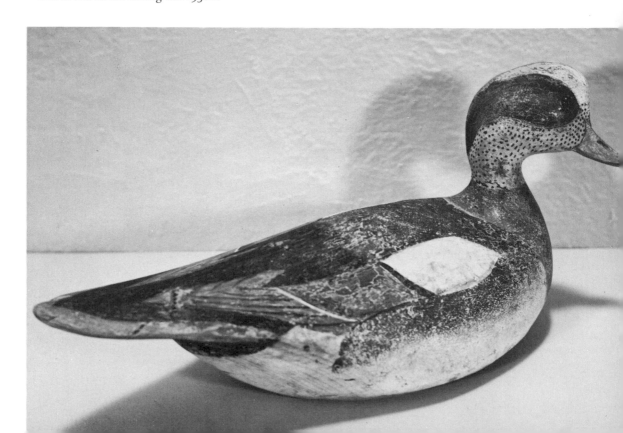

Ducks in great variety constitute the bulk of their decoys, with Pintails, Widgeon, and Goldeneyes high on the list. The Wards had no call for shore birds, but do make a great Canada Goose occasionally, though far too seldom.

Down Crisfield way the Chesapeake is a mighty and stormy body of water. Many a fine rig of Ward or Will Sterling decoys has been lost. Here there was no such system of return as is traditional on the Susquehanna, and finders were keepers. Fine Crisfield decoys have turned up, due to the vicissitudes of tide and wind, in every backwater of the Bay. Almost like the sailors' drifting bottles, they carry their own message to the collector.

Lower Chesapeake Bay has a number of islands with populations dating back several centuries. One of these is Smith Island, which has a record of shipping huge quantities of ducks to the Baltimore market. It apparently lies in an area frequented by rafts of Redheads. One might suppose from these facts that this delightfully isolated spot would be a perfect place to visit and revel in ancient decoys. Alas, as I have discovered, nothing could be further from the truth. Smith Island was so remote that almost all the market hunting there was done at night with the swivel guns. These multibarreled guns made the daytime use of decoys futile, and the long watery journey of this hopeful collector equally so. The fact that years ago Smith Island catered to very few sportsmen is apparently another reason why decoys were seldom used there.

Tangier, a sister island, still beckons the inquisitive. Perhaps this flat, remote island, the site of a fishing hamlet, may reward the seeker of decoys with an interesting item, but none has turned up in any collections. In fact, the problem of simple survival on the bleak islands of the lower Chesapeake was so demanding that very little time remained for the making of decoys. The island holds more promise, therefore, for the seeker of primitive work, rather than for those collecting classic and stylish models. But admittedly any decoy that does turn up from remote, interesting places such as these has a special appeal that is all its own.

XI *Virginia*

VIRGINIA FROM THE Maryland line south to Cape Charles is a region especially favored and endowed by nature. The resources of its coast and bays were magnificent in their abundance and variety. Today the exploitation of these resources by modern methods of destruction, coupled with the paralyzing approach of pollution, makes the future dark indeed. But the abundant fish and game of Virginia's waters must be saved by men of goodwill and foresight. Whether the objective be the continuance of a livelihood, or the opportunity to enjoy a favorite sport, all must unite to save the greatest tidewater heritage on the entire Atlantic coast.

The tremendous sweep of Chesapeake Bay seems to have concentrated its wildfowl blessings along its eastern side, which washes that region known as the Eastern Shore of Virginia. This narrow peninsula has all of the benefits of the Chesapeake on one side and of the coves and marshes of the Atlantic coast on the other. At many points, only a few miles of solid land separate the Bay from the ocean. Pity the puzzled wildfowler of, let us say, Accomac, a few generations back, who had to make the momentous decision of whether to go west or east. Many profound calculations related to tides, wind, and varieties of game must have had to be made in order to reach a decision. Is it any wonder that the older men of the Eastern Shore are continually asked for their opinion as to "how the weather looks"?

The entire Eastern Shore of Virginia, therefore, is naturally rich in decoys and duck hunting lore. From the time of its first settlement, the average Eastern Shore boy took to the bays and marshes as a matter of course. It was an almost inescapable way of life and developed a breed of men who have reflected credit on their communities. The decoy history of Virginia was made largely by these people.

On the western or mainland side, the lower Chesapeake Bay and its tributaries in Virginia were, in a sense, less favored in the variety and abundance of their wildfowl. Many of the tributaries offered good duck hunting, and the battery shooting for Canvasback on the Potomac used to be excellent.

150

Perhaps some other favored spots, too, should be noted. In the main, however, the area lacked the exceptional abundance of ducks, geese, and shore birds that characterized the Eastern Shore. It is not surprising, therefore, that decoy-wise the Western Shore of the lower Chesapeake has failed to produce. Surely somewhere there is a choice decoy on the western side of the Chesapeake Bay, in Virginia, but I could find none for the purpose of illustration.

Of course, duck decoys were used on the Western Shore, and old rigs are available for inspection there, but the quality of the handmade decoys is inferior and the grade of factory decoys the lowest. No similar void from the standpoint of collectible decoys, where not a single maker emerges from the pack, exists along the entire Atlantic coast. Can it be that so far as the waters of the Western Shore were concerned the economy of this entire region was based on oysters, and since decoy making was almost always a part-time operation, this preoccupation with the bivalves left little time for decoy craftsmanship? It seems to be as good an explanation as any. Admittedly, it is a vast area to cover, so if and when some enterprising collector in Tidewater Virginia comes up with a local Shourdes or Perdew, he will have an unspoiled and unharvested field all to himself. It consists of over 3,000 miles of shoreline spliced by dozens of major rivers and hundreds of creeks and sloughs—the single largest wildfowl terrain in America that has not produced a decoy maker of more than local repute.

Not so the opposite shore, where carvers from Whale's Gizzard, near the Maryland line, south to Oyster command the attention they richly deserve. It seems appropriate to dwell at length on the earliest and undoubtedly the greatest of these carvers.

Early in the fall of 1837, a young man named Nathan F. Cobb set sail in his own sloop from his home in Massachusetts. His wife, Nancy Doane Cobb, was in poor health, and a climate less harsh than that of the Massachusetts winter had been recommended for her. How far south the Cobbs had planned to sail we do not know. Though Cobb was already a master sailor, off the Eastern Shore of Virginia he and his sloop met their match. A bad storm drove the Cobbs ashore and their boat was lost.

Apparently none the worse for this shattering experience, Nathan F. Cobb set about the immediate task of establishing a home and a means of livelihood. He boldly opened a shop which he called the Yankee General Store, and his Southern neighbors made it a success from the start.

Within a year one of the seaside islands, then called Sandy Shoals, caught Cobb's fancy, and for a hundred dollars a neighbor, "Hard Times" Fitchett, sold him what from that time on was to be known as Cobb Island. Thus began the saga of the Cobbs of Northampton County, Virginia. This family of able and industrious men

of the sea were adopted by a land new to them, and—most interestingly from our viewpoint—became pioneer decoy makers and sportsmen in a sportsman's paradise.

If ever the expression "the good old days" applied to a specific locale, it was to the area surrounding Cobb Island, which was favored by nature to an unbelievable degree. All varieties of wildfowl, shore birds, geese, and Brant lingered there all through the fall and winter. As a stopping place for the Hudsonian Curlews, Cobb Island had few equals on the whole Atlantic coast, and it became the Mecca for devotees of that sporty shooting.

Over the years Nathan F. and Nancy Cobb raised a large family. Of their many children one son, Nathan, is of principal interest to us as a decoy maker and sportsman. As this large family matured and prospered, the fame of Cobb Island spread abroad. The unexcelled hunting and fishing attracted many important guests. After the Civil War, Cobb Island boasted of an excellent boardinghouse, a church, and bowling alley. Jefferson Davis, former President of the Confederacy, was a regular patron during the 1870's, and Thomas Dixon, Jr., the author, wrote in praise of the island's hunting and fishing.

The first Cobb decoys to come to the attention of serious collectors caused some confusion, since all decoys have regional characteristics and the Cobb decoys showed a form of construction that was identified with New England makers. This problem quickly resolves itself when we recall that the Cobbs were Yankees in a new home and simply reverted to the style of decoys made in Massachusetts. Strangely enough, the superior construction of the decoys they made was never copied by any other Virginia decoy maker. Perhaps the Cobbs had previous skill in boatbuilding; at any rate, they were determined to produce the best decoys possible, and their work excellently served the needs of both the nineteenth-century hunter and the modern collector.

All who came and gunned over the Cobb decoys spread the good tidings concerning the sport to be had. Toward the end of the last century, Nathan Cobb could no longer carve enough decoys himself to meet the steadily increasing needs of his brothers, who guided hunting parties. Other guides, too, joined forces with the Cobbs, and still more and bigger rigs were needed.

Nathan Cobb and his "shootingest" brother, Elkenah, therefore looked around for decoys that would suit their requirements. Their search ended about 1900 in Tuckerton, New Jersey, where another master decoy maker lived and worked. Hundreds of Harry Shourdes' decoys ended their useful days bobbing on the waters surrounding Cobb Island. Because of the difference in style, however, the collector need never confuse Shourdes' work with Nathan Cobb's, even though almost all the Shourdes decoys bought by the Cobbs are marked with the Cobb name burned on their bottoms.

Those from the hand of Nathan Cobb were initialed with an "N" for Nathan, an "E" for Elkenah, or an occasional "A" for Albert. The skill and artistry with which the initials are carved indicate the dedication and talent that Nathan Cobb lavished on his work. The detail work on each decoy was painstakingly performed and calculated to produce the most naturalistic result. An original box of goose eyes found in Nathan's shed shows that he sent to Germany for them and obtained the finest. The wood he selected for the bodies was superb. After seventy years of use in many cases, the white juniper or cedar bodies remain perfect and show no splitting.

Perhaps the part of Cobb's work in making a decoy that consumed the most time was selecting the wood for the heads and then attaching them to the bodies. Each of his decoys had an individual character and pose, which resulted in their having a most realistic appearance when they were assembled as a rig before the gunner's blind. This is especially true when a study is made of Cobb's Canada Geese and Brant (Color Plate VII).

Ordinary heads carved from pine seldom measured up to Nathan Cobb's standards. They proved to be too fragile and often missed the lifelike appearance he desired. He adopted a solution that delights the collector. After a storm he would comb the nearby beaches for weathered roots of the holly tree. Looking the roots over with a skilled eye, he hacked out the sections that suited his needs and thus, with a minimum of whittling and fitting, he had a set of naturally carved heads and necks for his next decoys. This tough, almost grainless holly wood has withstood the ravages of time, seawater, and use better than the wood of any other decoys. Nathan Cobb used it in making some of the best geese and Brant heads ever produced.

As this indicates, Nathan overlooked no detail in making the best and most rugged decoys possible. The lead weights on the bottoms of his decoys, for example, are not nailed on with iron, galvanized metal, or copper nails; every weight is fastened with brass screws, again reflecting Nathan's eminence as a master of decoy making. But above all he transformed into wood his feeling and knowledge of the birds that were part of his way of life.

One night in 1893 Cobb Island was literally wiped from the face of the earth when a tidal wave swept over it. Next morning not a building remained. The inhabitants who survived moved to the mainland. The "good old days" were gone forever. But decoys were made to float, and most of those that still survived were picked up adrift after the storm and used again, their fame increasing through the years that followed. Following the 1893 storm a gradual return to the island began and some rebuilding took place. In 1933, however, the island was again swept bare and today it remains a sandy waste.

Most famous of the Cobb guides was John Haff, another man who became a legend in his own lifetime. Haff was dragged half dead from the Cobb Island surf

about 1860. He was apparently in his twenties and seemed to be a Hollander, though no word of his origin or of the cause of his narrow escape from death ever passed his lips. The island became his home, and his loyalty and devotion to the Cobbs were unquestioned.

Johnny was soon famous for his decoys and his strength. The decoys speak for themselves, but a few words about this seaborne stranger's muscles are in order. Known throughout Northampton and Accomac Counties as "the strongest man on the Eastern Shore," Haff's feats were such as to make this generalization seem far from adequate. There are men still alive who have seen him take a white potato in each hand and crush them to a pulp. When potatoes were in short supply, he would do the same with two hard clams, of which Cobb Island's environs could always provide unlimited quantities. Haff preferred potatoes, though, as the sharp, hard clamshells cut his hands severely on several occasions.

Such incidental and offhand exhibitions as these took second billing to John Haff's regular Sunday morning show on the front lawn of the boardinghouse. At these demonstrations he would direct his attention to a tremendous ship's anchor weighing 1,000 pounds, which had been salvaged and now served as an ornament. With a minimum of huffing and puffing, Haff would lift the anchor clear of the ground and walk a few steps with it. After this Herculean effort Johnny Haff would mingle with the guests and help amuse them with other stunts and conversation. Sunday was a rest day and no hunting was allowed.

As John Haff neared the age of eighty, his powers declined, but this he stubbornly refused to admit. He went on performing the anchor trick. The end came one fateful Sunday morning. Not only did the anchor refuse to budge, but after a convulsive effort John Haff slumped to the ground and, encircled by bewildered spectators, died. The decoys he left, all shore birds, have a massive, vigorous quality that sets them apart, as befits the work of a man gifted with a strong character and unusual strength.

Also associated with the Cobbs were their neighbors, the Crumb family, who also came from New England. Splendid baymen and hunters, they seem to have made few decoys, and none are known with identifiable Crumb markings. Captain Charles H. Crumb of Oyster, Virginia, who was born in 1840 and was badly wounded in the Civil War, hunted until 1920. A student of nature and an excellent taxidermist, he must have had some outstanding decoys. His rig and that of Joseph H. Crumb (1885–1935), the family's best-known hunter, have disappeared.

Game warden for Northampton County during the early part of the present century was Luther Nottingham, who made and used fine shore-bird decoys. His curlews and other shore birds carry the brand "L.L.N." Nottingham's decoys have two unusual characteristics. First, many have slightly turned heads, which give a rig

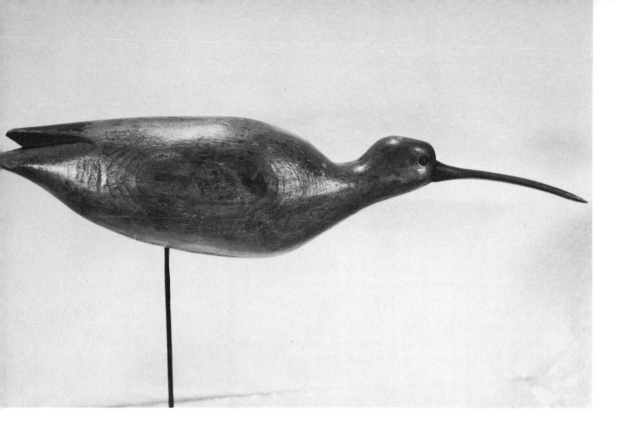

PLATE 128. Hudsonian Curlew decoys like this one from Cobb Island, Virginia, may date from as early as 1860. These birds found the environment of Cobb Island perfect. They provided unequaled hunting there as they migrated down the Atlantic coast.

a sprightly and natural look; secondly, very few are made from native cedar. Nottingham often used a dense, heavy wood tentatively identified as butternut, and fashioned other decoys from exotic woods that he salvaged from the shipwrecks along the beach. The condition of his paint is still so excellent that a close study of the wood used is impossible without defacing the birds. His plumage patterns are uniformly good. Only the decoys' unusual weight indicates Nottingham's departure from the use of the customary local cedar.

The Life Saving Service station on Smith Island, Virginia, was a lonely outpost, hard to reach and seldom visited by sportsmen. Thomas Dixon, Jr., the author, described this shore-bird paradise as it was in 1900: "North and south stretches the long, white strip of sand as far as the eye can reach. Behind lies in shimmering beauty the mirror of Broadwater Bay. There is not a human habitation in sight—the happy hunting ground the red man saw in visions of the olden time."[1]

[1] Thomas Dixon, Jr., *The Life Worth Living: A Personal Experience* (New York: Doubleday, Page & Company, 1907).

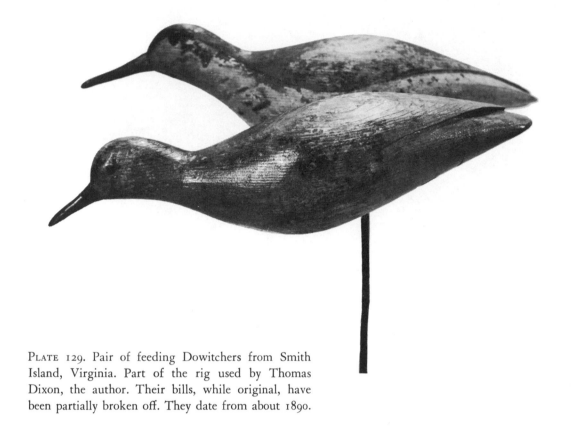

PLATE 129. Pair of feeding Dowitchers from Smith Island, Virginia. Part of the rig used by Thomas Dixon, the author. Their bills, while original, have been partially broken off. They date from about 1890.

The isolated, rugged Coastguardsmen who played host to Dixon were carvers. Many decoys came into being as Captain George Hitchens and his small group whiled away their inactive hours. Plate 129 shows some of their Dowitchers or "gray backs." These decoys, which generally carry a big, bold hand-carved "R" and look very fat, gave the Coastguardsmen successful shooting. The Dowitchers, Dixon writes, "require no calling. The moment they see our decoys they set their wings in all sorts of fancy shapes and sweep into the happy hunting ground to share the mussels with our fat wooden birds whose round shapes excite their hunger. Sometimes the sky is black with them. We generally take the poorest chance on such occasions and perhaps get one bird out of five hundred."[2] A lucky find made it possible to preserve the very decoys used around the time of Dixon's visit to Smith Island.

Another documented carver of this area was Walter Brady, a market hunter until 1918, who died at an advanced age in the 1940's. He specialized in geese and made several large rigs. A peculiarity of Brady's is his adoption of the inletted head and neck design brought down from New England by the Cobbs. The example shown in Plate 130 illustrates the sturdy, competent goose decoys Brady turned out. For many years they were accepted as the work of Cobb, but close study of the example

[2] *Ibid.*

shown will indicate the distinct differences. Brady's shore birds have not been satis-factorily identified.

Accomac, in the heart of the Eastern Shore of Virginia, is one of the oldest towns in the country. From Accomac come several groupings of shore-bird decoys that have a style and appearance completely unique to the immediate area of the town. All familiar varieties of shore birds except the Hudsonian Curlew have been col-lected at Accomac. The examples shown in Plate 131 illustrate, better than words can do, their distinctive air. Construction details indicate that a number of different men made decoys of this type at Accomac, and that they were the accepted style in shore birds for the Accomac gunners at one period. There is not a shred of evidence, however, by which to attribute them to any specific maker, or to assign them even an approximate year of origin. Their style and construction, however, as well as the very lack of any information regarding them, all indicate great age. They were in use before the oldest old-timers now living were big enough to hunt. Perhaps 1850 would be a good guess as the date when they were made, but they could be even older. They could, in fact, be among the oldest decoys in this country, as well as some of the most interesting and distinctive.

Assawaman Island in Accomac County, Virginia, was home to William Mat-

PLATE 130. Canada Goose by Walter Brady, who used the Cobb geese as criterion. In this type of goose the oaken bill was set into the head and splined from the rear—a time-consuming procedure that reduced breakage.

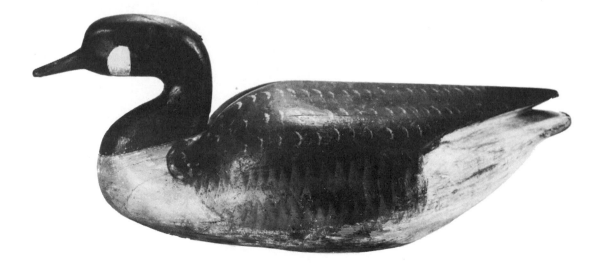

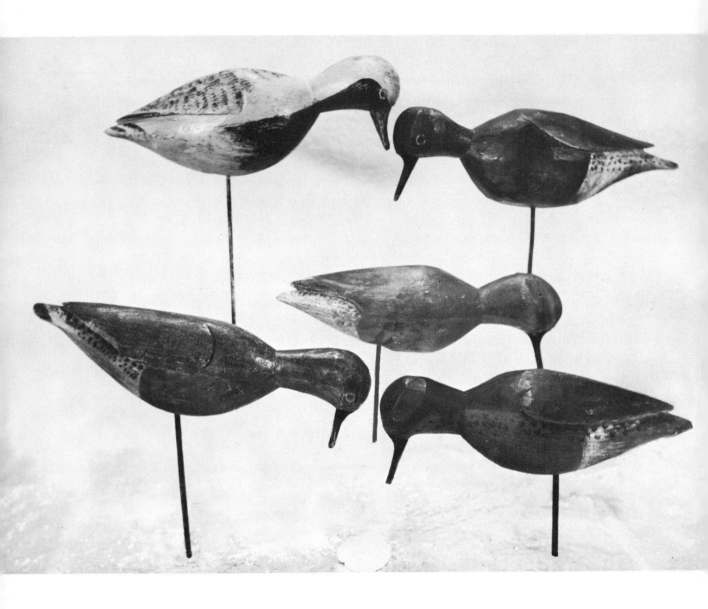

PLATE 131 (*above*). This busy group of Black-bellied Plover from Accomac, Virginia, speak for themselves. Individually they have a quaint clumsiness, but when grouped together they must have been remarkably effective decoys.

PLATE 132 (*facing page*). The Black-bellied Plover was often referred to as the "bullhead." The rig of William Matthews of Assawaman Island, Virginia, from which these were taken, featured in various poses the large head of this really beautiful bird.

thews, who for seventy-six years left his mark on many decoys from that section. Most of Matthews' decoys were of the common, sturdy type favored by Virginia guides, for whom he apparently made them. His personal rig, however, was far from ordinary. Many of its Dowitchers and curlews had that nicety of detail, as well as the turned-head feature, that distinguished Matthews' best work. Matthews' personal rig (Plates 132 and 133), consisting of about fifty shore birds of nearly all varieties, ranks with the best.

Our journey northward along the Eastern Shore of Virginia must end at Chincoteague Island, close to the Maryland line. Chincoteague is a wonderful place to terminate a journey, enjoy the best in oysters and other seafood, talk decoys, and listen to good stories told in a unique style by old-time storytellers.

Miles Hancock of Chincoteague, terrapin keeper and hunting historian, is an articulate bond between the early market hunters and decoy makers and the present.

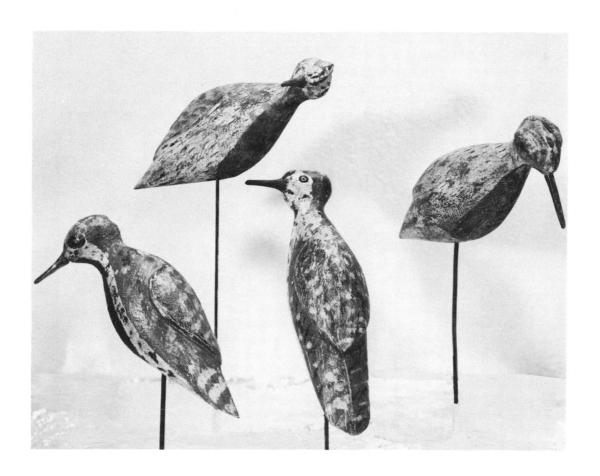

A former market hunter himself, Hancock's recollections are treasures. The most consistent shot on the island, he specialized in waiting for two ducks to cross and then getting them both with one shot. Miles Hancock and the late Frank Dirksen gunned a battery for the market; the only other battery was operated by Dan Whealton. Miles can recount great bags and unusual shots made in the many years he followed the sport, but, modestly, he soon turns the subject to decoys. He still makes a few decoys by hand in the old tradition.

The most prolific and best commercial decoy maker Virginia ever produced, however, was Ira Hudson (1876–1949), of Chincoteague. Hudson also built excellent small boats, his main source of income, but duck, geese, Brant, and shore-bird decoys occupied much of his time. He was a professional hand maker of decoys in every sense of the word. A recognized carver by 1900, for almost forty years he turned out hundreds of decoys annually. Unlike most of his contemporaries, Ira gave his customers a choice of several grades (Plates 134 and 135), ranging from a perfectly plain and sturdy painted model, to models much more detailed in both their carving and their paint patterns. Hudson's finer work is seldom found today, since he had

PLATE 133. Additional birds from William Matthews' rig, on the right, a Dowitcher, on the left, a yellowlegs. He used a dozen of each species currently in season.

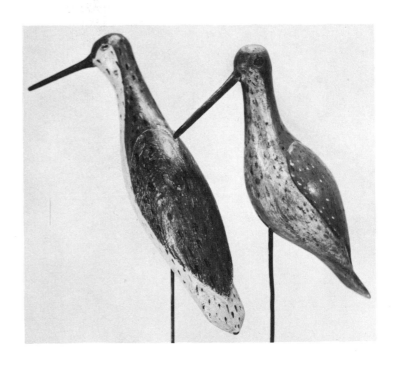

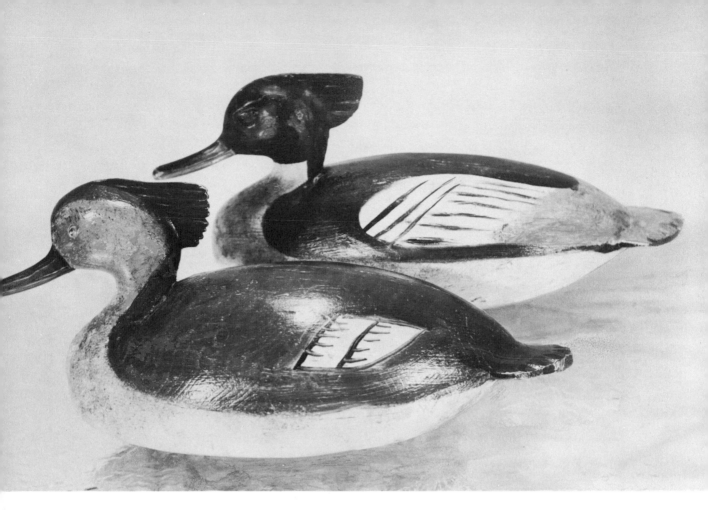

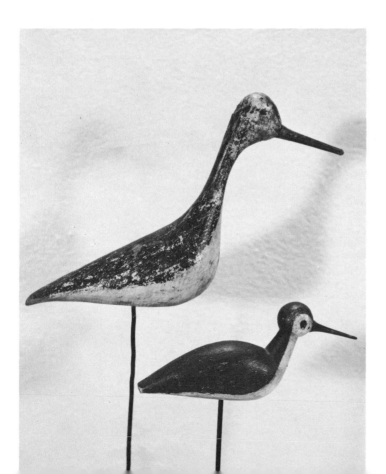

PLATE 134 (*above*). A pair of Red-breasted Mergansers that illustrate the best work of Ira Hudson of Chincoteague Island, Virginia. Gouge work embellished the tail surfaces, and the heads are given more detail in this grade. PLATE 135 (*left*). Ira Hudson saw all shore birds with thin necks in an extended, alert position. Consequently, most collectors find his snipe without heads. The delightful yellowlegs by him at left in this photo was most impractical, and few survived intact. The little "peep" at right, an unidentified "beach bird," could only come from Barnegat, New Jersey.

less call for it; the very poverty of the territory he served and worked in held its people's expenditures to the minimum. The Atlantic tidewater communities in those days were desperately poor, and the natives could survive only by cutting every corner. Ira Hudson's "service models" were more than adequate for the times and the area. They were solid, boldly carved, made for rough use, and tended to be oversize.

Ira's customers recognized a bargain, and their orders for both boats and stool ducks made his little shed prosper. Like his models, the woods used in Ira's decoys also showed considerable variation. His favorite wood, and the only one used in his earliest work, was the white pine of the spars from wrecks driven ashore on Assateague Island. This wood, he maintained, made the best bodies, and in later years, whenever more came his way, he put it to use. Luckily for sailors, the supply of spars from wrecked ships did not keep pace with his needs, and cedar from North

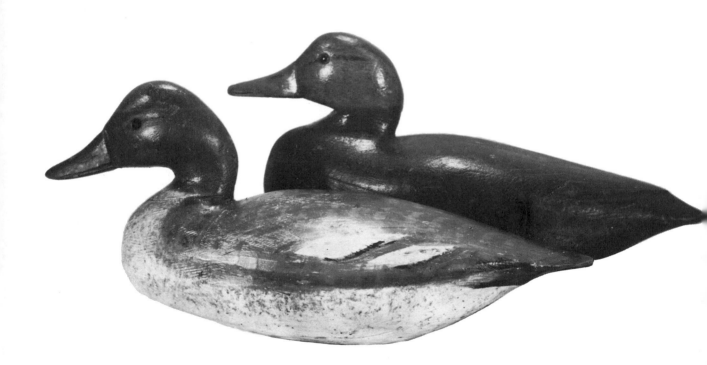

PLATE 136. In the foreground is a fine, bold Common Goldeneye duck by Ira Hudson of Chincoteague. It clearly shows his original painting style. Dave ("Umbrella") Watson's Black Duck, behind the Common Goldeneye, is beautifully made and must have inspired confidence.

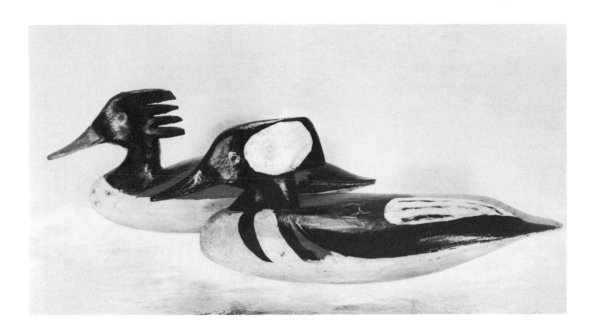

PLATE 137. Hooded Merganser decoys turn up in a few places, one of which is Virginia. This male (*right*) and female were carved by Doug Jester of Chincoteague.

Carolina took their place. Ira used this completely adequate but much more expensive lumber for several decades, and it is the wood found in most of his work. In later years he also introduced still another wood in the bodies of larger decoys such as Brant and geese. This was cypress, and the source of it was the poles used by the telephone and power companies as they extended their service along the shore. There were not enough discarded poles to make a constant or reliable source of supply, but when they did turn up they were perfectly suited to the job.

Ira Hudson's duck, geese and Brant decoys, regardless of the wood used, have a tendency to check and split. But this defect, more apparent to present-day collectors than to the original users, did not detract from his reputation, and he lived to become one of the country's best professional decoy makers. Until the early 1920's, Ira's price was firmly fixed at the amazingly modest price of four dollars a dozen for Black Ducks, Goldeneye, and scaup. This included necessary weights and fastenings. The output of his shop included all local ducks, geese, Brant, and the shore birds, also an occasional decorative piece featuring miniature fowl in flight. Hudson's top-quality Pintails and Red-breasted Mergansers are prize collectors' pieces. During the 1930's his years began to catch up with him and the orders tapered off, but he continued to produce decoys until about 1940.

Not even hardworking Ira Hudson, however, could fill all the demands and tastes of the hunting community that made Chincoteague its center. Among others at Chincoteague who made quantities of stool ducks were several members of the Jester family. The so-called Jester-type decoys have failed to acquire a large collector following. They show a lack of concern with niceties of design and painting, and the fact that the same style is still being made lessens the appeal of the earlier models. Salient exceptions in the work of an earlier member of the Jester family, Doug, are occasional extremely collectible Hooded Mergansers (Plate 137).

Another well-known Chincoteague maker was Dave ("Umbrella") Watson, who passed away in 1938. Watson sold decoys to duck clubs as far away as the Gooseville Club at Hatteras, North Carolina. Breaking with accepted Chincoteague procedure, he made hollow models requiring skill in selecting seasoned lumber and great patience in shaping and finishing the heads and bodies. Dave seems to have led a busy but solitary life and seldom tidied up his shop. One eyewitness during the 1920's claims the shavings, at that time, were knee-high. The fact that Dave

PLATE 138. From Virginia come these delightfully carved decoys which were probably meant to simulate Pectoral Sandpipers, but were attractive to all the smaller shore birds.

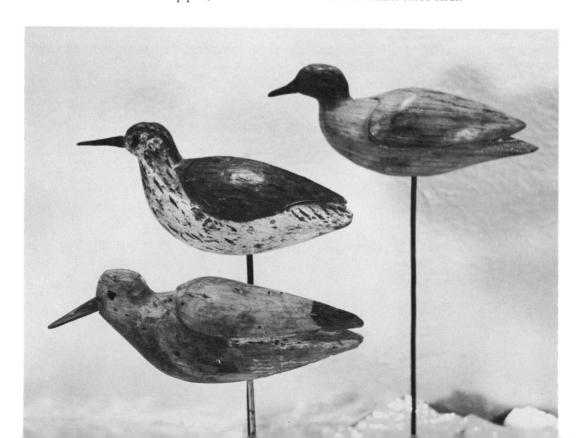

always wore hip boots enabled him to ignore such things. Apparently ducks were his specialty. He also carved some Brant, but shore birds by his hand are unknown. Surely the fine modeling of his ducks took much more work on his part than goes into the average decoy, yet this does not entirely explain the scarcity of his work. Probably his higher prices eliminated him from the local market and most of his output was shipped hither and yon. It is only recently that these superb decoys have been identified as the handiwork of Dave Watson. He earned his nickname the hard way, which was never to appear in public without an umbrella. Only a few dared question his wisdom, since his answer was always the same: "Any damn fool has brains enough to have one ready when it's raining."

Sooner or later, talk of decoys and hunting at Chincoteague always brings up the name of Dan Whealton. Dan would gladly have gunned every day of his life. Chincoteague was an isolated island until 1920, and the Chincoteaguers were a spirited and undisciplined group in regard to unpopular game laws.

Captain Dan was no exception. On his eighty-second birthday, he decided to take his gun and gather up "a mess of yellowlegs." He was doing just that when a beautiful flock started for his decoys and then, at the last minute, flared away. The skilled Dan Whealton was at first perplexed and then infuriated as a lawman walked up behind him. Game to the end, old Dan told him off: "Damnit! You just spoiled the best shot I had all day." It was just about Dan's last hunt of record, but his decoys have made many collectors proud and happy ever since. The Dan Whealtons and their kind were tremendous men, and no one would care to change them, even a little.

Since Back Bay, an arm of Currituck Sound, though largely in Virginia, is linked with Carolina in terms of hunting methods, market-hunting conditions, and decoys, Back Bay and its noted decoy maker John Williams of Cedar Island, Virginia, will be discussed in the course of the next chapter.

XII *Carolina and Back Bay*

COASTAL CAROLINA, FOR our enjoyable purpose, begins at Back Bay, an arm of Currituck Sound which juts a score of miles into Tidewater Virginia. Since Back Bay's and Currituck's physical and ecological unity is obvious, Virginia can well share her claim to this small waterfowl paradise with her sister state of North Carolina. So for our purposes, Back Bay and Currituck Sound have a bond that not even a state line can dissolve. Wildfowl fly between the two connecting bodies of water oblivious of man's jurisdictional problems down below.

The Outer Banks, a sandy strip that begins just north of the Virginia line and continues down the Carolina coast for hundreds of miles, is the barrier between bay and ocean that created one of the finest and largest wildfowl havens on the Atlantic coast. An interesting connection is evident between the ideal conditions this region offered to wildfowl, and the decoys that were typical of the area. They are for the most part solid, crude, roughly finished and poorly painted. Yet in spite of this they were effective. Local canvas-covered models on wire frames were also made for ducks, geese, Brant, and swans. These canvas replicas, some of which date back fifty years, show the same crudeness and lack of finished workmanship as the all-wooden models. They are not in the same class as the wood-frame, canvas-covered coots and geese made by Joe Lincoln and others in the New England area, and are considered lacking in collector appeal. An example, carefully selected, may justify its inclusion in a collection by serving to illustrate a regional type. The point to be drawn would seem to be that the ideal habitat, competition between the species for food, and the tremendous concentrations of birds made any nicety of construction in the decoys almost wasted effort.

It will pay to expand a little on these matters. The latitude of this Carolina coastal region and the sweep of its magnificent bays, which were uniformly shallow, made a wintering ground for diving ducks, geese, Brant, and swans second to none. Nor were these shallow, food-filled bays and sounds the only natural inducements.

Bordering the open waters are marshy areas that dwarf those of the coastal states to the north. The "puddle ducks," such as Widgeon, Pintails, Black Ducks and teal, stop, sample the environment, and decide it is their winter home. Nor are these the only winter visitors; the vast marshy wilderness is also a perfect habitat for the Gadwall, the Wood Duck, and the Mallard. A wide variety of ducks visits the coastal waters of North Carolina. This speaks well for the variety of decoys, but the rarer species are certainly harder to acquire in this region.

Winter comes late to the Outer Banks, and sometimes hardly at all. The ice-chilled bays and week-long freeze-ups which occur on Barnegat Bay and Long Island Sound are almost unknown, and the wildfowl, instinctively aware of these benign conditions, begin to arrive in October, not to leave before the end of February. Although the visiting wildfowler may not have to shoot from an ice-sheathed Barnegat sneak box, or lie on the ice near a lead of open water, he had best anticipate inclement, even if not really frigid weather. Prepare for a chilly, wet, and incessantly windy trip if your interest is in observing decoys at work. There most assuredly is something finer than to be in Carolina on these bleak mornings.

Currituck and its companion waters, with all that they encompass, are the last great frontier for the wildfowler and his birds. Largely unspoiled and unpolluted, the region has some defense against defilement in its vastness. Wildlife refuges already established now beckon to the weary, harassed remnants of our wildfowl heritage that have traveled thousands of miles to this, their ancestral winter home. The least this generation can do is to preserve these refuges, for these birds have few other places to go. A trip to the Pea Island refuge, where probably fifty thousand noble Canada Geese will play host, is a moving experience. Any goose decoy, however good or bad, found that day becomes a prize possession in commemoration of the occasion. To see and hear, just before sunset, the arrival of a flock containing at least 20,000 Greater Snow Geese is an unforgettable experience. The excitement is heightened because they are all determined to alight on just one marshy area. One finds no collectible decoys for this bird, since they are inedible and protected by Federal law. It's a rare protective combination for which a bird can be thankful. That one clannish flock contains the main population of this particular subspecies on the Atlantic coast.

Other visitors to this winter haven that have left their mark on decoy history are the Whistling Swan and the Ruddy Duck. I have found decoys for both species in greater numbers from the Virginia–North Carolina state line south to Manteo, North Carolina, than anywhere else in the country. There is a simple reason for the abundance of Ruddy Duck decoys here. The "ruddy" was also known locally as the "booby" or "dollar duck." The latter term came into use because the bird's small size made it suitable for serving whole to a diner. This, combined with its

excellent flavor, enabled the hunter to get a dollar apiece for them. This led to several exceptional rigs of "ruddys" (Plate 139) being used by two famous Carolina hunters and decoy makers, John Williams and Lee Dudley. It also led eventually to the former rarity of this bold, fearless little duck, which elsewhere along the coast was shot only occasionally.

The work of Lee Dudley is a partial exception to the perhaps harsh generalization stated above about the regional decoys of the Outer Banks. But since decoys with the prized "L.D." burned on the bottom are so rare, and since their bodies are not especially significant, they hardly qualify to reverse the general indictment. In one important respect, however, they command the attention and study of every collector and student of folk art. Mounted on smallish, competently carved but on the

PLATE 139. Authentic old Ruddy Duck decoys add charm and value to any collection. These, from 6 to 8 inches long, illustrate the type to seek. Some very good ones also come from the head of Chesapeake Bay.

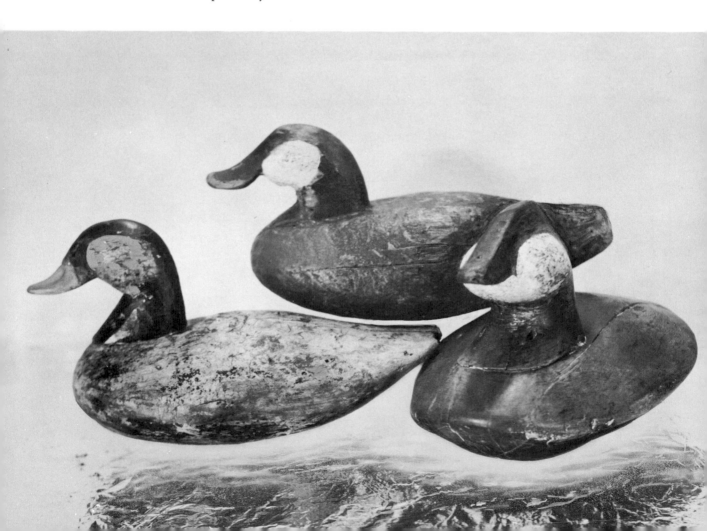

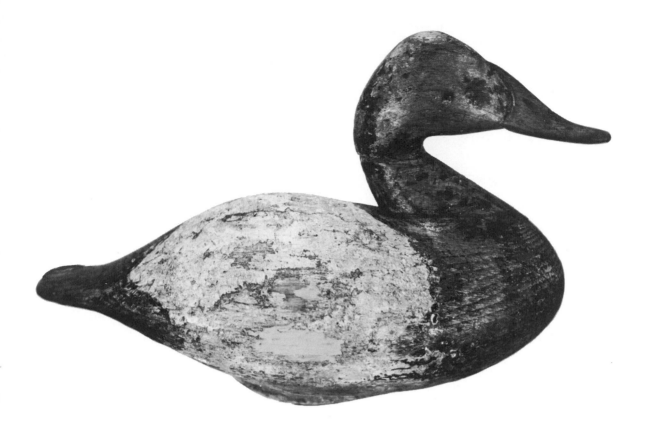

PLATE 140. The brothers Lee and Lem Dudley of North Carolina made a contribution to folk art whenever they carved a duck head. The heads on Dudley decoys are the finest the writer has ever seen. The bodies are small and nondescript. This Canvasback illustrates both points.

whole very ordinary bodies are the most beautifully conceived and splendidly carved heads ever placed on duck decoys. The original lines and design of the heads are all the more remarkable since there were no precedents or previous models for an Outer Banks carver to study and improve upon. The Dudley heads, whether "cans," Redheads, teal, or "ruddys," are bits of sculpture of the purest ray. (See Plate 140.)

Everything about these Dudley decoys—their age, their point of origin, their individuality, and their undeniable merit—makes the most thorough review of their origin appropriate. The written accounts now available to collectors are remiss in certain statements. The brand "L.D." does not necessarily mean Lee Dudley.

In January, 1861, boy twins were born near Knott Island, North Carolina, and were named Lee and Lem Dudley. Throughout their lives both their pleasure and their work centered on the open waters and marshy borders surrounding their home. Working together as a team, the Dudley brothers pioneered market hunting in the region, did some trapping, and prospered on the small scale that represented prosperity in this harsh and lonesome land during the 1880's and after. Lee and Lem made no decoys of record before 1892, but from 1892 until 1894 they spent their spare time making a large rig to their own specifications. These are the "L.D." models that the decoy world knows. What recent information, given me by direct descendants, now shows is that though Lee certainly made some decoys, it was Lem who made the greater number. This shows the danger of generalizing on the basis of an isolated example. The "Lee Dudley" decoys should in most cases be called "Lem Dudleys" but it is now far too late to differentiate.

Lem and Lee Dudley earned their livelihood shooting diving ducks, such as Canvasback, Redhead, and Greater Scaup. Most of the "L.D." models, which were used in their own rig, are of these species. A few Ruddy Ducks, Widgeon, and Pintail by them are known. Their work did not include swans or shore birds. Lem Dudley died in 1932; his brother Lee outlived him by ten years.

Another nearby family who followed the bay as did the Dudleys, were the Ballances. The Ballance family had no decoy makers of their own, but one Ballance, not further identified, benefited at the hands of Lee and Lem. Decoys are found bearing the undeniable workmanship of the twin brothers, but with a large, hand-carved "B." An attempt to identify the one member of the Ballance family who knew the Dudley brothers and hunted for the market proved a waste of time. Every Ballance for several generations had been a market hunter. There is no evidence to indicate that the Dudley brothers made any decoys except their own extensive rig and those bearing a "B" for Ballance.

John Williams (1857–1937) spent most of his life on Cedar Island in Back Bay. This tiny island, right in the middle of the flyway, enabled John Williams to observe wildfowl as closely as any man before him or since. Year after year, millions upon millions of birds of many species passed within his sight and hearing. John enjoyed his way of life and in later years he became a renowned, successful guide and an authority on the local sporting scene. As a decoy maker he is known to have been a specialist. This is the one term proper to describe a carver whose claim to fame now rests securely on his swan decoys, which differ one from the other, as a rig cleverly capturing the movement and life of the actual birds. Every head and neck is carved in a graceful, natural position. To carry the effect even further, the cygnet, or young swan, is gray, so the purist, John Williams, painted one of his blocks (Plate 141) that color. The gray paint is original, so credit must go to the maker

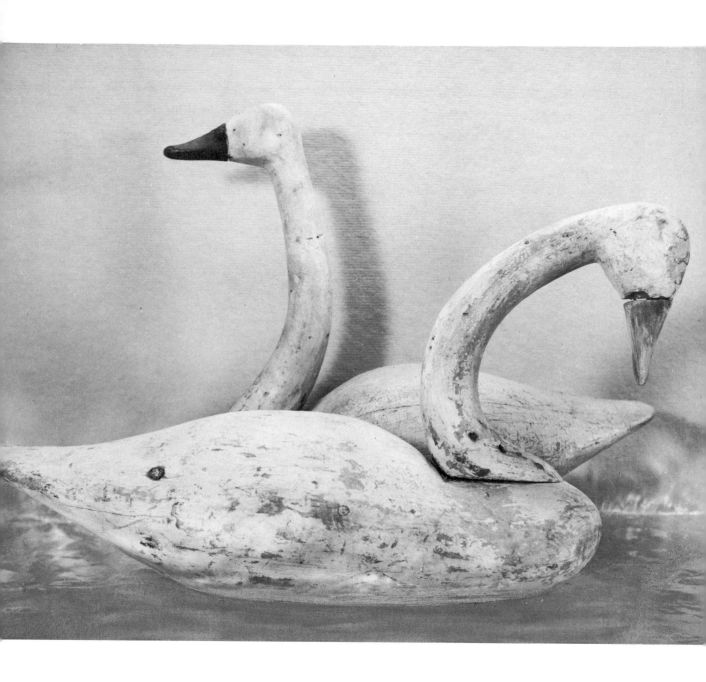

PLATE 141. Two of the monumental Whistling Swans hewn and carved by John Williams of Cedar Island. Each of the known examples is treasured as an example of American folk art.

for this unique touch, which makes the decoy a classic. His little Ruddy Ducks represent the other extreme in size, but reflect equal credit on the carver. These active, shovel-billed ducks have a comical look and manner that John's knowing hands captured in wood. He made a few other decoys but nothing to compare with what must have been his two favorites. All were made for his own use. The folk art of America is forever richer because John Williams lived and carved on Cedar Island.

There is no shortage of stool ducks on the bays farther to the south, but there the eager seeker will find his enthusiasm gradually blunted. Though many decoys are used, they are uniformly poor. The farther down the coast one goes, the less care decoy makers took in fashioning their work. In the Cape Hatteras area, many Brant and geese made from sections of telegraph poles and spars barely have the edges rounded off. That would seem to be about the point for the weary collector to retrace his steps.

But the overall importance of Carolina's bays and sounds in the wildfowl picture almost demands that decoy collections contain some example of Carolina origin. The big battery ducks, mostly Canvasback, scaup, and Redheads, should be checked carefully to make sure one's example is completely original. Rough treatment was the order of the day in the Carolina country, so much so that almost all old decoys have had several replacement heads. Having checked that detail, consider the outline of the head and its proportions relative to the body. A much better than average battery duck (Plate 142) is by A. Grandy (1890–1951), of Back Bay. Carolina gunners sometime before 1914 must have consulted Mason's Decoy Factory about big battery ducks. It is a known fact that a lot of 300 Mason "cans" and Redheads were used on Back Bay during the 1914 season with excellent results. These were the biggest ducks Mason ever made, both 16 inches long, exceeding the Mammoth models. Plate 143 illustrates the size of these whoppers, which were known as the Back Bay model. Several other lots were also ordered and successfully used. The cost was thirty-six dollars a dozen, an unheard-of price for that day. They were used and used hard for some years; as a result, not a single example is known with original paint.

The early hunting history of Currituck Sound emphasizes the numbers and excellence of its diving ducks and geese. Clubs such as the Currituck Club, with members living as far away as Boston, were established. The Currituck Club has been in continuous use ever since 1850, except for the Civil War years. During that period some hotheads who hated Yankee duck hunters burned the clubhouse and its contents to the ground, a tragedy when one thinks of the old decoys with which the place must have been filled.

The puddle-duck shooting played only a small part in attracting sportsmen from

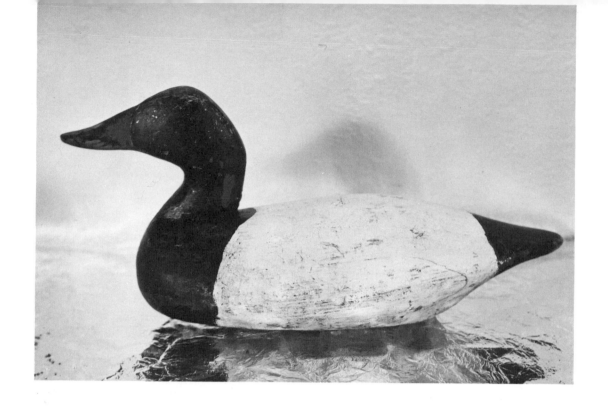

PLATE 142 (*top*). The typical battery Canvasback of the Back Bay and Currituck Sound areas was oversized, carelessly made, and poorly painted. Few have the conformation which makes the specimen shown here collectible. It was carved by A. Grandy about 1915. PLATE 143 (*bottom*). Perhaps the largest type of Canvasback decoy ever in regular use is the one illustrated in the foreground. Mason's Decoy Factory called these the Back Bay model. The Common Merganser behind it corresponds to one depicted in an ad published by M. C. Wedd of Rochester, New York, in 1878. It is turned on a wood lathe.

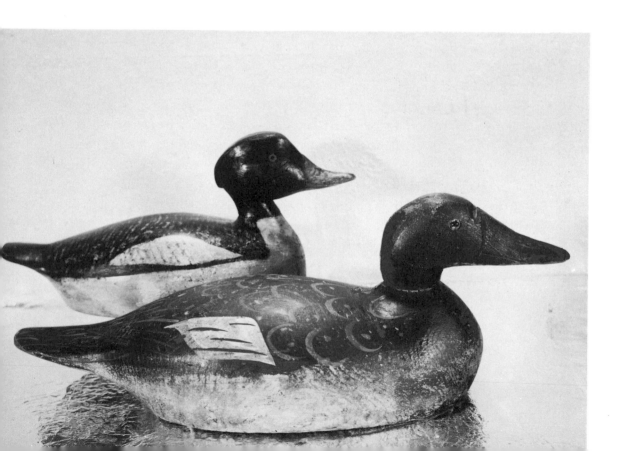

other states to the Carolinas, and even less where the market hunter was concerned. Geese, Canvasback, scaup, and Redheads shot from batteries were the most popular targets for battery shooting, with the money birds the "cans" and Redheads. It follows that decoys are found in about this numerical order: Canvasback, Redhead, scaup, geese, Widgeon, and finally the puddle ducks.

Wildfowl hunting and the income derived from it was the main economic factor of the entire region. At first this support came mostly from the sale of game, but the visiting sportsmen played an increasingly important part. In both cases decoys were of prime importance. Big rigs were the custom of the day for battery use. Though not as large as the Susquehanna Flats rigs of from 500 to 600, they averaged some 200 decoys. At one time, about 1910, thirty-two batteries gunned the Lump, a favored spot midway down Currituck Sound. Augmenting that total were four outfits each out of Knotts Island and Church Island, while Bell Island boasted of two.

Luther James Parker of Knotts Island, who is now a spry, cheerful eighty-one, was a part of that era. As a market hunter he poled his way back and forth to the shooting grounds before motors were available. Even when they came into use, he held them in low regard because, in his words, "they were ready to quit at any time." Luther Parker has now turned to farming, and on a recent visit I had to catch him before eight A.M., since he would be busy the rest of the day plowing in the fields.

Luther started out, he told me, with a muzzle-loader, but when the breech-loaders became available he got one. A modest man, he recalled his best day as one when he fired 409 shells and picked up 301 ducks, 24 swan, and 20 geese. This brought to Luther's mind the biggest day he had ever heard of—one that saw Dan Griggs sell 735 ducks, all of them good—in other words, Canvasback and Redheads.

These are exceptional scores, but they do confirm the economic importance of this activity operating in one general area day after day. The take of game was enormous, and an ingenious do-it-yourself cooperative came into being. Many of the hunters lived on the Outer Banks and islands, miles removed from any form of land transportation. Ed Johnson, who ran a general store in Currituck Court House, solved their marketing problem. Late every afternoon, except weekends, he would cruise in his cargo boat down the middle of the Sound for many miles, and those dealing with him pulled into position for the exchange. The birds were counted and paid for in cash, or credit was extended at Ed's store.

Since time was a factor, Ed raced for the shore to catch the evening train, which ran through Currituck Court House five days a week, to ship the birds to market. He carried ammunition for those who needed it. Every Christmas, for good measure, he handed out a new, shiny, five-dollar gold piece to each hunter.

"We started November 10th each year," Luther Parker recalled, "and stopped the end of February. One year I began October 20th, but it was still too warm and the birds rotted. I never did much with swans; they only brought fifty cents."

Every market hunter from Maine to Carolina was a superb shot; some were just better than others. This skill with a shotgun was regarded as natural, and few of the men today talk of their prowess. Luther Parker was no exception, but when pressed he admitted once getting nine ducks with five shots, using a pump gun. He was sorry not to see two drop with the last shot, but he believes the strain got him.

That, however, was not the shot that Luther recalls with the most pleasure. From the way he tells it, the following story seems to be his favorite: "It was getting late, and shooting a muzzle-loader, I'd about used up my powder and shot. I shook out every last shot in my pouch into the palm of my hand and counted only twenty-seven. My average load of fours and sixes would be around 300 shot. But the ducks were flying around me, so I rammed home a charge of powder and carefully dropped in the 27 shot. Then I waited until a big drake Canvasback came in real nice, and I pulled the trigger. I could hardly believe my eyes when he dropped stone dead. Then I came home."

It was a shame that Luther Parker, eighty-one years old, had his plowing to finish. Everyone hates to see a man like that leave.

From Kitty Hawk to Hatteras, any discussion of old-time hunting is held steadily to the subject of ducks and geese. A visitor feels almost apologetic about introducing the topic of shore-bird shooting. It may take repeated efforts to swing the conversation in that direction and get even the most fragmentary background. The sum total of such questioning over a period of thirty years is interesting, though not extensive. Shore-bird decoys are few and far between in Carolina, since men shot over them only when they wanted to gather a bunch of birds for their own tables. There was no commercial shore-bird hunting whatever. As a result, the "snipe" stools (Plate 144) are perhaps cruder and less carefully made than those for ducks. Many consist of profiles, or "flatties," whittled from a single board; others are of the crudest possible root-head construction. Only the smallest minority combine a rounded body with some details of workmanship on the heads and bills. Both the numbers and the varieties to be found are limited. Yellowlegs and Dowitchers make up the bulk of Carolina shore-bird decoys, as might be expected. Since the natives only hunted shore birds for a change of diet, they naturally wanted the tastiest.

In a way this crude, primitive workmanship becomes the shore birds much more than it does the bigger decoys, and most of them are worth a careful second look. There are two characteristics indicating that a shore-bird decoy is from

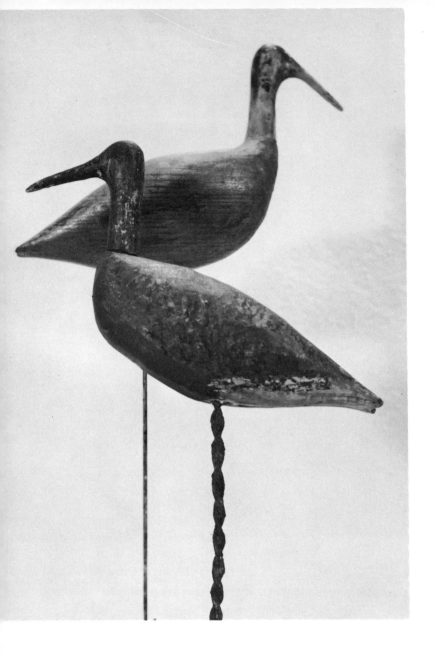

PLATE 144. Dowitchers which show the characteristics of early Carolina shore-bird stools. The "root-head" construction, roughly carved bodies, and permanent wire stakes are all typical of the region.

Carolina: first, the use of a wire fastened into the body to set them out on, instead of a separate wooden stake; and second, the use of a nail for the bill. If the wire support has been twisted to form a simple loop midway in its length, the decoy is unmistakably from the Outer Banks. Another wire strung through each of these little loops made the best possible way to carry the whole rig. But, once again, shore-bird shooting was, in Carolina, a chore performed almost entirely by boys and old, rheumatic market hunters. It's better not to be a bore, but to swing the conversation back to what are locally known as the "good ducks" before one's welcome wears out.

The feats of endurance of the men who shot for the market along the Atlantic coast, and their contempt for the elements, are almost legendary. The imagination naturally pictures a man who endured this grinding work day after day and month upon month as a physical specimen of heroic proportions. Yet nothing could be further from the truth. Those who cultivated the friendship of these men, whose breed has almost vanished, seldom encountered one who was even of average height. On the basis of a decade of study and questioning, I can report that they tended to be on the small side, but stocky and compact.

But of course there were exceptions, like John Haff of Cobb Island, Virginia, and another hunter of whom Luther Parker, a small man himself, told me.

"Louis Lewark gunned south of here," said Luther. "He was born in 1885, at Whale's Head, on the Outer Bank. Nowadays they call it Slabtown. He was a good-natured fellow but he was so big the boys played tricks on him. Louis had a big boat, twenty feet long, that tied up to the landing here once a week, while he walked up to the store a quarter of a mile away for supplies. Well, one day the boys stole some decoys out of his boat, and it made him mad. After that, when he came, he just put the anchor rope over his shoulder and dragged the boat with him all the way to the store. He was some powerful, Louis was!"

It was naturally time to ask just how big young Lewark was. Luther Parker went into the house and came back with a yellowed photograph.

"Well," he said, "here is a picture of Louis just before he died in 1909. He was six feet four inches tall, and he weighed 735 pounds."[1]

It would be pleasant to report finding the decoys as well as the photograph of Louis Lewark, this salty Paul Bunyan among market hunters, but sad to relate I have never found a trace of them.

[1] John C. Phillips in *A Sportsman's Scrapbook* (Boston and New York: Houghton Mifflin Company, Copyright 1928), p. 197, bears witness that he met this man, who was then seventeen years old and already weighed over 600 pounds. Phillips refers to his enormous strength and says he could pick up a heavy wooden skiff.

XIII *The Middle West*

THE MISSISSIPPI FLYWAY, second to no other in the quality and quantity of its wildfowl, got off to a slow start in the decoy race. Several generations of Atlantic coast market hunters had plied their trade of harvesting ducks before their Midwest counterparts turned to that source of revenue. As a corollary to this time lag, the main tool of the market-hunting trade, decoys, had a correspondingly shorter history.

It is easy to pinpoint the reason for the absence of market hunting for ducks, geese, swans, plovers, and curlews in the Middle West until this relatively late date. It was simply the lack of demand for this kind of fare. Until almost the end of the nineteenth century, the palates of Midwestern epicures could command tastier victims of the market hunter's efforts.

From the Canadian border down to the Southern states, all of the Midwest, from Michigan to Iowa, teemed with game. Easier to secure than wildfowl and more appealing to the public taste were venison, buffalo, Prairie Chickens, Passenger Pigeons, quail, and antelope, which was said to be the most delicious meat of all. These were commonplace staples of the Midwest diet. The fact that such game could be easily and cheaply obtained by means of guns, traps, snares, and nets, and without resorting to boats, temporarily saved the wildfowl, while the other game was gradually almost wiped out. Later the wildfowl met an equally devastating fate at the hands of man's greed.

Some examples of the bargains in game offered by provision merchants are afforded by the Lancaster, Wisconsin, *Herald* in 1856: "Game is plentiful. Venison is sold daily as common as pork or beef, and the same price. Prairie chickens and grouse are offered for one dollar a dozen. Partridges or quail 40 cents a dozen. Hare one dollar a dozen and wild turkeys 25 cents apiece." Obviously the wildfowler would have starved himself to death shooting Canvasback to compete with these offerings.

In 1856 the *North American* of Philadelphia, Pennsylvania, noted: "Game from

178

the west. Two hundred boxes of partridges, averaging 100 birds to the box, were received from Janesville, Wisconsin. Just previously 200 deer from Sparta, Wisconsin, were received." Fortunately lack of refrigeration prevented such shipments from occurring with regularity. Most of those that were attempted, spoiled.

Another newspaper story of 1855 reads: "N. Powers of Fayette County, Iowa, drove into Dubuque with one load of 1000 partridges, 1000 grouse, 100 hares, eight deer, five wolves and two bear." That was a mixed bag to end mixed bags! Quite obviously the day of the decoy collector had not dawned in our great Midwest.

But unregulated hunting with constantly improved weapons thinned out the previously mentioned birds and animals, including the last Passenger Pigeons, and the wildfowl became much more important in the economic scheme of things. The change was gradual, and the majority of those who turned to an occasional meal of Canvasback, Blue-winged Teal or Mallard accomplished it without the use of collectible decoys. The almost incredible numbers of ducks that came down from the borders of the Arctic were such that no man today can picture them. Favored sloughs, rivers, wild rice fields, and the occasional corn- or grainfields were natural attractions that needed no decoys to enhance the hunter's chances. George Bird Grinnell, writing in 1901, states ". . . in the good old days before the white man's plough furrowed every prairie or his crooked gray fences disfigured each landscape, the wild rice fields were the homes of innumerable wild creatures. . . . In those days when ducks were food for the few dwellers of those regions a single gun discharge would supply the hunter with birds enough for several days."[1] Needless to say, in all this vast land laced with rivers, lakes, and marshy areas, hardly a shot was then fired at ducks or curlews for the sport of it.

Writing for *Forest and Stream* about a trip in 1875, T. S. Van Dyke describes hunting along the Illinois River near Henry, Illinois, a town later famous as the home of Charles Perdew of decoy renown. Says Van Dyke: "There were enough ducks to satisfy anyone. Long lines of black dots streamed along the Illinois River and over Swan Lake, while down the slough, up the slough, from over the timber on the west and over the timber on the east came small bunches." Little wonder the guns volleyed and thundered without benefit of decoys. But within a few decades all this ended. The prairies were dotted with homesteads of the settlers, the breechloaders and cheap ammunition were available at the general store, and decoys were helpful. The sloughs and puddles all held enemies, and the ducks learned to shun them. The birds, harried and warier now, were channeled down the main rivers and large lakes, where the more definitive routes were studded with blinds. On a much smaller unit scale, the wildfowler of the Midwest began to pattern his techniques and equipment after his

[1] George Bird Grinnell, *American Duck Shooting* (New York: Willis McDonald & Company, n.d.).

Eastern predecessor. Modest-sized rigs of decoys and specialized boats, some designed for sculling, were introduced. The shooting in stubble and cornfields required carefully dug blinds and local knowledge of the habits of the birds using the area.

Nearly all decoys of collectible quality from the Midwestern region date back no earlier than about 1880, when decoys began to appear in substantial numbers along the Mississippi and Illinois Rivers and in other favored stopping places for wildfowl. (See Plate 145.) From Minnesota to Detroit's Lake St. Clair and on southward as far as Reelfoot Lake in Tennessee, the harvesting of the ducks began. Wild ducks became identified with gourmet dining and the booming Gold Coast of Chicago set the style in demanding more and more of them.

The first commercial offerings of the Dodge and Stevens Brothers decoy factories were soon being augmented by handmade duplicates of Eastern models. The greatest single influence on Midwestern decoys came with the International Centennial Exposition held at Philadelphia in 1876. It will be recalled that Ben Holmes of Stratford, Connecticut, fame entered a decoy contest held at the Exposition with a rig of twelve Greater Scaup, all in the traditional Connecticut style which has not been improved on to this day. The form and construction of Connecticut decoys played an important part in influencing the Midwest carvers engaging in this new field. That Holmes's prize-winning models were copied is proven by a study of any representative collection of Mississippi flyway examples. Characteristics pioneered by Connecticut makers, such as the combed plumage patterns, high breasts, and demarcation line where the tail joins the body, were adopted. Also, it was more than a coincidence that the hollow body that Connecticut decoy makers used, though they did not originate it, was the rule in the Midwest.

Thus there is inescapable evidence that after the 1876 Exposition Ben Holmes's decoys had received that form of flattery called imitation. The unidentifiable plagiarizer who set a precedent for Midwest decoy style must have been working by 1880 or 1885 and logically would be located in Illinois. These suppositions, meager to be sure, indicate that Robert A. Elliston (1849–1915) was the man to whom collectors are presently indebted. Elliston's business background would further indicate that he had the training as a skilled mechanic to engage in decoy making. He had traveled at the age of eighteen to South Bend, Indiana, where he worked for the Studebaker Company as a carriage bodymaker. Later trips took him to New York City and Philadelphia, then, about 1880, back to Illinois, where he lived near the town of Bureau.

Robert A. Elliston would have been about thirty years old when he first engaged in decoy making as a means of livelihood. He was also a beekeeper, but decoys were his main source of income. His fine, carefully made hollow decoys (Plate 146) must rank as collectors' prizes, particularly when the combed paint patterns of the backs are original. One peculiarity of his work is the placing of the glass eyes much higher

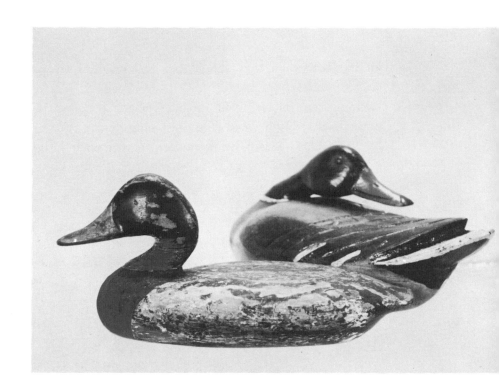

PLATE 145 (*right*). The Canvasback in the foreground, of unknown origin, is typical of the earliest Midwestern examples that enhance a collection. They avoid the crudity apparent in so many older, but unworthy items. The turned-head Mallard is by Kenneth Greenlee of Burlington, Iowa, working in the 1930's. PLATE 146 (*below*). Robert Elliston's work in original condition ranks with the best produced in the Midwest. Examples like this drake Canvasback (*foreground*) and Mallard are rare.

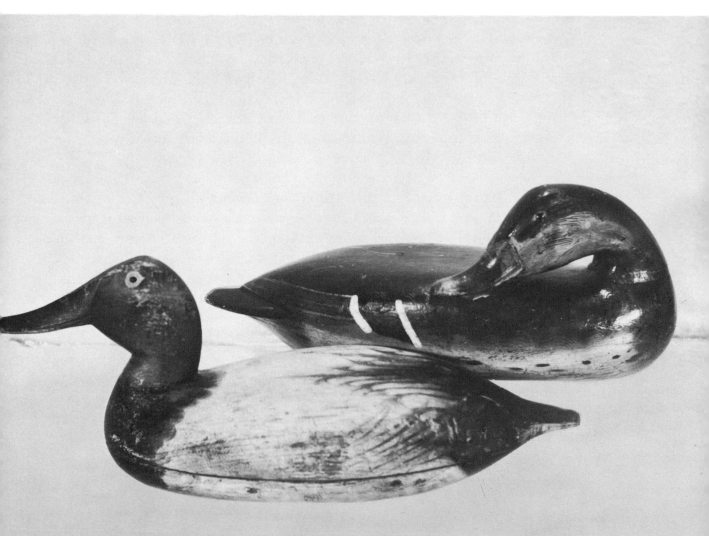

on the head than they should be. The result is an almost froglike expression when only the heads are examined. Whatever Robert's reason for this obvious inconsistency, it is apparent on all of his models, including Canada Geese. He did not hunt for the market, probably because of the growing demand for the products of his shop. Models by Elliston of the following species are known in original paint:

Drakes and ducks	*Drakes only*	
Mallard	Pintail	Ring-necked Duck
Blue-winged Teal	Canvasback	Canada Goose
Greater Scaup	Redhead	American Coot

One further thing is known about Robert A. Elliston, and that is that his wife helped with the painting. No one could have had a better helpmate; the finished Elliston decoys, patterned after the Connecticut counterparts, do credit to her skill. As the Midwest's first professional maker and because of his superior products, Elliston's name should be placed at the top of the list by collectors of Mississippi flyway decoys. As Joseph French, the hunting historian of St. Louis, Missouri, puts it, "This must be said of Elliston's work: he was the grand-daddy."

At Henry, Illinois, lived Charles H. Perdew (1874–1963), who became a sporting legend in his own lifetime. Honored and respected as a gunsmith, decoy carver, and maker of crow calls that have become heirlooms to pass down from father to son, Charles Perdew started with little formal education. While in his teens he shot ducks for the Chicago market and experimented with decoy making as a sideline. Just a few miles to the north lived Robert Elliston, already an established supplier of decoys, and Elliston must have had an influence on young Charlie.

The youth proved to be a competent and ambitious follower who learned well and quickly. Market hunting received less of his time and his shopwork benefited. For almost fifty years Perdew turned out a variety of decoys that without doubt included nearly all of the wildfowl native to the region. Mallards probably outnumbered all other ducks combined, in his work, while Pintails were second numerically. There is an exciting variety for the serious collector of Perdew's work. The prolific output of his little shop includes many special pieces for shows, presentation pieces, and also sample models. Carved-wing examples are noteworthy among the Mallards, while he also made turned-head decoys of all common species, which are all too seldom rediscovered. His crows (Plate 147) are top items, as are his occasional scaup and Buffleheads. Sad to relate, Robins and Cardinals were looked upon as tasty bits of food in those days, and Perdew is known to have made counterfeits of these songbirds. The only assistance Charlie received in his long, busy life came from his gifted wife, Edna, who had a way with the brush.

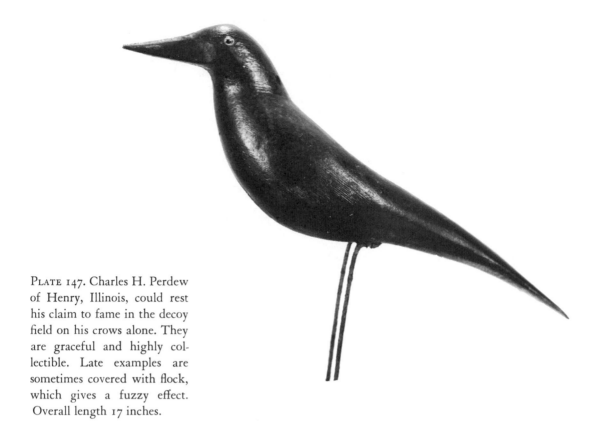

PLATE 147. Charles H. Perdew of Henry, Illinois, could rest his claim to fame in the decoy field on his crows alone. They are graceful and highly collectible. Late examples are sometimes covered with flock, which gives a fuzzy effect. Overall length 17 inches.

Perdew's sleek, hollow ducks, over the years, underwent a subtle change that should be noted. Earlier models, prior to 1925, tend to have larger heads and shorter necks. Examples from that era are considered his finest work. Later on the Mallard and Pintail heads were slimmed down to the point where a skinny look is all too obvious. Late Perdew models also lack the superb paint patterns and paint quality of the earlier ones. It is almost straining a point, however, to fault any of the skillful handiwork turned out by this craftsman, artist, and friend of the sportsman. (See Plate 148.)

Another Middle Western decoy maker who, by every standard, must rate with his two illustrious predecessors was Charles Walker (1875–1954) of Princeton, Illinois. His output was limited to probably less than 2,000 decoys over his entire lifetime, since he was a house painter by trade and worked at it steadily. So unlike the professional decoy makers, Perdew and Elliston, Charles Walker was able to produce decoys only on a part-time basis. This was a pity. For Walker, as for almost every other young man growing up along the Illinois River in the later years of the nineteenth century, ducks and duck hunting were a way of life. The meandering river with its

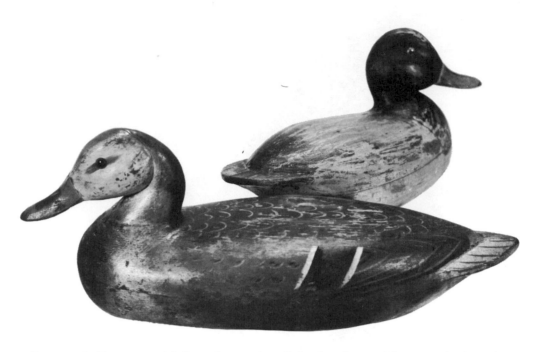

PLATE 148. Clean, graceful lines characterize all Perdew decoys. The scaup by him shown in the background has the full, rounded head that marks his earlier work. The Mallard with carved cheek is also in his early and finest style.

sloughs, overflows, and adjacent lakes formed a north and south flyway, both spring and fall, that wildfowl found irresistible. That the majority were delicious corn-fed Mallards, Canvasback and Pintails, now in great demand by the city epicures, increased the hunting pressure. The Illinois River areas of that day, from Princeton to Peoria, may literally be called the center of commercial duck shooting of the entire Mississippi flyway.

Young Charles Walker was a fixture of this sporting scene, but only as a hunter. He turned to serious decoy making in his later years, specializing in Mallards. Most of his models have the rounded bottoms that are almost standard in the work of his Midwestern contemporaries, but some have flat bottoms, tending to give them more stability on rough water. Besides Mallard drakes, Walker also made Pintails, but only drakes. Harold Walker, his son, recalls his father's making Green-winged Teal, but these choice items have so far escaped the grasp or even the eye of a collector. A few turned-head Mallards by Walker are known, and that concludes the range of his work.

Walker was a competent workman generally, and particularly gifted as a painter. The shallow, crisp, wing carving on his Pintails is as fine as any maker in his region

has to offer. His plumage patterns are restrained but distinctive. His work, until recently unappreciated, will command new followers as the few remaining examples of his skill are examined and given their rightful place in collections. (See Plate 149.)

G. Bert Graves (18? –1944), then a middle-aged carpenter, boatbuilder, and hunter, in Peoria, Illinois, started his career as a professional decoy maker about 1936,

PLATE 149. This Pintail (*foreground*) and Mallard by Charles Walker of Princeton, Illinois, are of a quality to make every decoy collector regret the limited output of Charles Walker's shop. With its crisp, fine carving and bold, free paint patterns, his work ranks with the best.

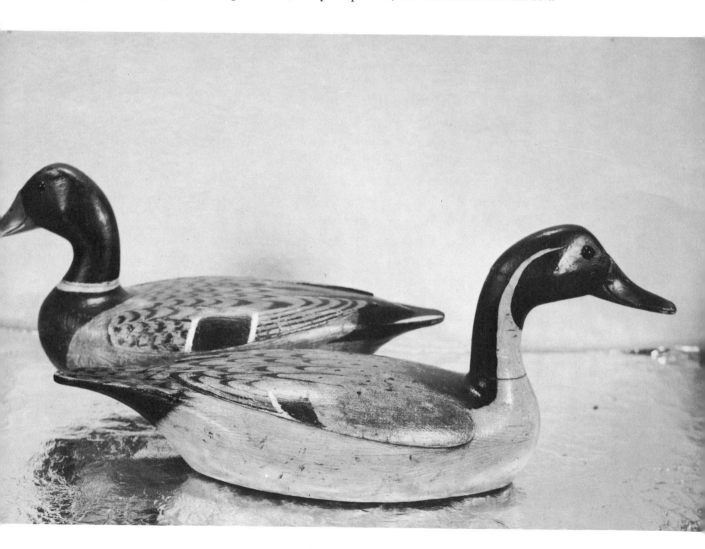

working in a shed in back of his home. This ambitious and extremely able workman had made decoys before he became a professional, but without the distinctive marking on the lead weights that characterizes his professional work. His earlier lead weights, which occur only infrequently, carried the initials "B.G." They were superseded by the well-known weights of Graves's professional work, on which the words "G. B. Graves Decoy Co., Peoria, Illinois" are cast in relief. That Graves's operations were as extensive as the title "G. B. Graves Decoy Co." might suggest, may be questioned. Everything known about him, however, confirms that he was a professional decoy maker and sold decoys for about eight years. A brother, Orville, and he worked in the shop on a part-time basis and Orville's wife Millie did the bulk of the painting.

The Graves's shop equipment consisted only of a band saw and a power sander. The proud possessor of either a marked or unmarked Graves decoy should therefore regard it as a handmade and hand-finished product, rather than as a factory decoy in the true sense. It may be argued, perhaps, that there was a similarity between the Graves operation and that of the Stevens brothers, who are discussed in the chapter on factories. My decision to class the tiny Stevens shop among the factories is based on its full-time operation, the Stevenses' long tenure in the business, and the image they created by extensive and clever advertising to their trade. Perhaps the salient point, however, is that Bert Graves's friends felt decoy making was a serious hobby for him rather than a serious commercial venture. Perhaps the distinction is a fine one, but for the reasons outlined it must be made.

Acceptance of these points places Graves in the exclusive top echelon of Midwestern professional hand decoy makers. Few will debate the assertion that Elliston, Perdew, Walker, and Graves are the first four.

As with the other Illinois carvers, Mallards predominate in Graves's work, followed by Canvasback, Pintails, and an occasional Black Duck, in that order. One unique item is a colossal Mallard that has a body 17 inches long and 10 inches wide, a real prize and every inch a choice Graves. Millie Graves deserves the gratitude of collectors, for her paint patterns and color tones, especially in the Mallards, are superb. The excellent quality of the paint used is reflected in the lack of peeling even on decoys that have had hard usage. The Connecticut tradition shows up in the combing patterns on almost all Graves decoys. If Bert Graves copied from Elliston, both were great carvers. The much sought after production of the small G. B. Graves Company came to a halt during World War II when the proprietor left for the West Coast and shortly afterward, in 1944, died.

Certainly fancier, more ornate, and more intricate carving occurs on occasion when comprehensive Midwestern collections are studied, but the four makers whose work I have reviewed are entitled to the first rank. They pioneered, respectively made thousands of decoys, and adhered to the highest standards of excellence. The

occasional decoy made in a fussy manner, impractical for the professional to duplicate, has slight claim to overall decoy greatness.

It happened all too seldom in the history of this vast region that the mind of the wildfowler turned to birds of other varieties. If decoys happen to have been made for these birds that were less often hunted, the interest heightens. Sandhill Cranes were sometimes shot on the Mississippi flyway. No collection contains a nine-teenth-century decoy of a Sandhill Crane, but time and diligence will someday locate one. The evidence follows: in 1877, Charles Zimmerman, writing under the title "Field Sports in Minnesota," gives one of the few descriptions from pioneer days of the use of Sandhill Crane decoys. Zimmerman tells of hunting in Kandiyohi County, Minnesota, using three decoys. "I have discovered a flock of cranes," he writes, "wing-ing their way in a direct line for this field. Stepping into my blind, I grasp my trusty gun and somewhat nervously await their approach. They are not long in traversing the intervening space and presently are circling over me. When directly overhead, the decoys are invisible to them [they were evidently profiles], but are again clearly

PLATE 150. Two Midwest rarities. Bert Graves made a limited number of colossal Mallards, one of which is shown here (*foreground*). The little preening scaup behind it is one of those occasional unexpected finds that is a joy forever.

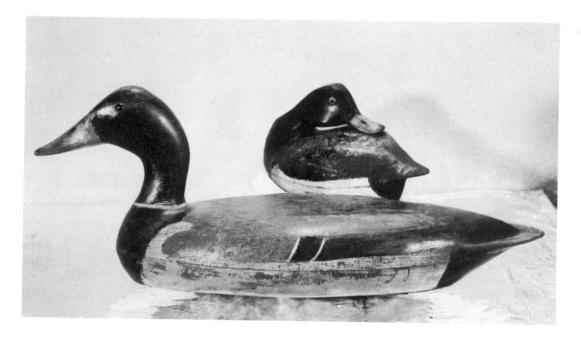

seen when they have swung off at an angle. The leader of the flock offers a tempting shot at 35 yards and doubles up instantly."

At the end of the hunt Charlie Zimmerman gathered up his three decoys and bag of five cranes. If Kandiyohi were not such a big county, those decoys would almost be worth a barn-to-barn search!

Indeed, several nineteenth-century sporting books reporting on the hunting scene refer to the use of decoys in luring Sandhill Cranes. The discovery of an old crane decoy tucked in the rafters of a Midwestern barn is a distinct possibility. Anyone with a good lead should follow it, since a successful chase would make decoy-hunting history.

Canada Geese were lured and shot throughout the Mississippi flyway, but especially along the major rivers and in the adjoining corn- and grainfields. Most were killed by using profile decoys and shooting out of pits dug in the fields. Most name makers in the Midwest never made either the full-bodied goose stick-ups or the goose floaters used along the Atlantic coast. One exception to this was Elliston, but the few geese he made, while effective, suffer by comparison with those turned out by any of the East Coast pros.

For the pit shooting, as well as shooting along the rivers, the stick-up type of decoys enjoyed wide popularity because of the ease with which they could be transported. Sheet-metal, cardboard, and wooden profiles were the common types. Their appeal to the collectors is minimal, though some of the patented folding types, as well as those turned out by hand, are ingenious and qualify as part of the sporting scene of a bygone day. Comparisons are odious, but an objective appraisal leaves no doubt that the best geese ever found started their wooden lives on salt water somewhere between Cape Cod, Massachusetts, and Cobb Island, Virginia.

The history of shore-bird decoys in the entire Mississippi Valley area remains a complete enigma. Edward Howe Forbush (1858–1929), one of our greatest ornithologists, writes that when the market hunters "turned to a new supply of game for the insatiable demands, it was found in the birds of the open land, the Upland Plover, Eskimo Curlew, Golden Plover and Buff-breasted Sandpiper which then swarmed in spring in the Mississippi Valley. In a comparatively few years thereafter these birds, destroyed by the hundreds of thousands, were nearly extirpated from the land."[2] The same authority, discussing the Eskimo Curlew, says: "From 1870 to 1880 they began to decrease. Between 1886 and 1892 they diminished very rapidly and after that were never seen in numbers."[3] The puzzling fact is that neither this nor any other contemporary account seems to describe in detail the actual method of

2 Edward Howe Forbush, *Natural History of the Birds of Eastern and Central North America* (Boston: Houghton Mifflin Company, Copyright 1939).
 3 *Ibid.*

shooting or netting these "hundreds of thousands" of birds. The fall migration of these same birds actually outnumbered the spring migration, since they were hunted incessantly on their winter grounds in Argentina and elsewhere. Nonetheless the fall gunner used decoys to secure most of these birds, while the following spring, during the mating season, the slaughter continued in the Midwest, and no record can be found of decoys ever being used for them. It is a genuinely frustrating situation, with the decoy collector definitely the loser. A passing reference in one sporting journal describes the stalking of Upland Plover by hiding behind a horse or cow and carefully working within gunshot, but it's a little ludicrous to picture hard-bitten commercial gunners using that stratagem as a means of making a living.

This seems a good opportunity to put at rest the fallacy that decoys were used, anywhere, for Upland Plover. They join the select company of Common or Wilson's Snipe and Woodcock as birds that were hunted without the use of working decoys. Replicas of these three may be admired and put on mantels, but they should not be described as decoys.

Turning again to ducks, there is a significant difference between the condition of inland decoys and those used on salt and brackish waters. By and large, when decoys of the same age and with the same amount of use are compared, the one used in fresh water is immediately recognizable by the superior condition of its paint, the lack of rust or corrosion on its nails or screws, and its better overall appearance. Thus the Midwest yields duck decoys in such good condition as is now rarely seen in coastal areas. For example, the highly desirable Mason Factory items, hard to find along the Atlantic seaboard in collectible condition, still occur with pleasing regularity when they were used on the "sweet waters."

The delights and benefits of seeking out duck replicas in this vast flyway are far from exhausted by a review of the work of Elliston, Perdew, Graves, and Walker, skilled and accomplished as the "big four" were. There are some decoys by unknown carvers which would enrich any collection. An example is the primitive shown in Plate 151. Others qualify as folk art as well as finely fashioned decoys. It seems impossible to attribute the primitive early examples to specific makers. The average Midwestern rig was small by East Coast standards, but as the nineteenth century drew to a close the number of hunters was legion. As in other areas the average gunner, by choice or necessity, tried to make his own rig of stools. Whether the result was good or bad, these small rigs were made by the thousands for several decades. It makes for a state of confusion that cannot be unraveled with the information now available to the student or collector. When men made small rigs, the mathematical possibility of more than one or two from each rig surviving to this day is certainly remote. This seems to explain the continual finding of excellent and intriguing decoys that are just one of a kind. The fragmentary old wives' tales that constitute their

"history" in most cases should be forgotten. Let the inherent charm and rarity of the piece speak for itself. The entire Midwest holds the promise of an occasional fine, undocumented example.

The Midwest is also rich, however, in documented work by other men. Some were market men, such as the McKenzie brothers, Thomas and John, of Henry, Illinois. Tube Dawson of Putnam made his own personal rig, and it was a good one. His work, like the McKenzies', was sturdy, conventional, and painted with an eye to durability rather than attention to every detail. Also, William Lohrman of Peoria made and used Ring-necked Ducks, scaup, Canvasback, and Mallards.

Speck Schramm, who hunted out of Burlington, Iowa, around 1880–1890, followed in the same working decoy patterns. Speck, an old-time fireman, whittled most of his work at the old North Hill firehouse. Between market hunting, fighting fires, and painting decoys, it must have been difficult to plan his days. None of these men are among the topflight makers in either carving or painting. They follow very much a basic pattern, and there is a complete lack of originality in their work.

A very large personal rig was made by Judge Glen Cameron of Chillicothe, Illinois. After he passed away a few years ago, it was broken up and because of its size made many people happy. All the usual ducks were included but the Canvasback deserve a special word. These birds, all in fine condition, show an excellent combed paint pattern and a fine proud head that reflects the look of this handsome bird. They are excellent examples of good handmade decoys of the area.

Almost on a par with Judge Cameron's work is that of the Burlington, Iowa, craftsman, Kenneth Greenlee. Ken, working around 1930, carved with a bold, free hand and just misses the nicety of detail so eagerly looked for by the discerning collector. (See Plate 145.)

As the list of those Midwesterners whose work has been evaluated and found worthy draws to a close, some further observations are in order. This was a vast and prolific wildfowl hunting ground, and the seeker of old decoys cannot help but pause and consider the possibilities of areas surrounding those discussed, which have gone unmentioned. Such covetous but natural thoughts are, alas, neither original nor rewarding, and many a weary decoy trailblazer will confirm that fact.

Several factors contributed to this scarcity of collectible local decoys throughout most of the Midwest. In particular, the northern portions of Minnesota, the Dakotas, Wisconsin, and Michigan had heavy seasonal migrations of choice wildfowl but practically no winter populations of these birds. Winter came early to these regions, and the feeding grounds were locked in ice for several months or even longer. The ducks continued southward to survive. This restriction alone curtailed market hunting and consequently the development and use of decoys. Furthermore, the northern part of the Midwest enjoyed pass shooting, which required no decoys. The birds flying from

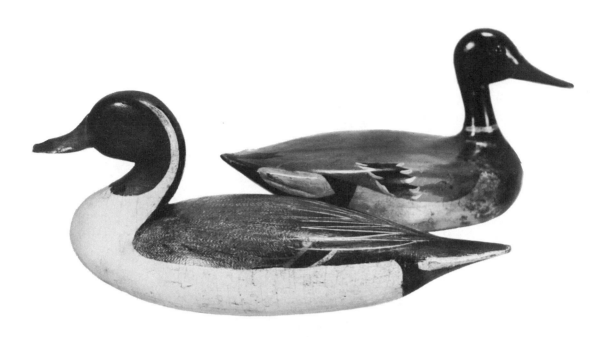

PLATE 151 (*top*). Fine items by unknown makers. The primitive Mallard (*right*) is both a good decoy and an example of effective folk art. The Pintail was obviously carved by skillful and devoted hands. PLATE 152 (*bottom*). Duck and drake Lesser Scaup from the Midwest. They were carried to and from the shooting grounds with the head, neck, and weight stowed neatly in the bottom. When the weight is released, a pull on the anchor line positions the head in place. These are charming, collectible "gimmick" decoys.

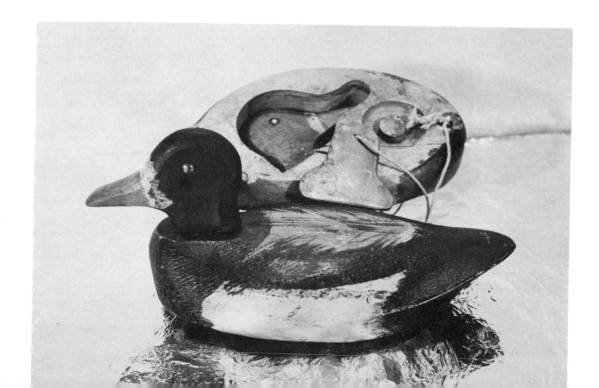

one feeding ground to another followed certain routes that placed them within range of the hidden hunter. A further factor tending to discourage the making of fine decoys was that when the fowl arrived during the hunting season they were either young birds or older ones which had been largely unmolested during the breeding season and were therefore unwary. Thus when pass shooting was not available or did not fill the needs of the hunter, then the crudest, simplest, and most easily made decoys would serve his purpose.

All of the larger rivers, such as the Mississippi, Missouri, and Platte, played host to millions of migrating ducks and geese. A terrific toll of these passing birds was taken by the local settlers, but on the northern reaches of all these rivers little organized commercial hunting took place. Difficulties of transportation and a scarcity of large urban markets discouraged the skilled market wildfowler and the use of any but the most ordinary decoys.

Even in more temperate locales such as southern Wisconsin and Indiana, where the hardier species such as Canvasback and scaup could stay for most if not all of the winter, little improvement is noted in the local decoys of the late nineteenth and early twentieth centuries. The unfortunate and discouraging fact is that we must conclude that there were no gifted or even good carvers of decoys by collectors' standards. This is not an individual opinion but the composite opinion of many observant and serious students, who have crisscrossed the Midwest thoroughly.

Wisconsin decoys, as a case in point, have received the study and attention of a dedicated local collector, Bud Appel of Genoa City, Wisconsin. He states, "There were those, of course, who made decoys for their own use and, perhaps, their friends. Some even gained considerable local prominence, but none, to the writer's knowledge, ever achieved the stature and fame gained by Holmes, Wheeler, Perdew, Elliston, and their like. So it is a paradox that a locale which saw so many thousands of decoys used never produced famous makers as did other such areas."

Appel's findings simply support those of others. So goes the continuing story of colorless, undistinguished decoys as we move out from the Illinois River and its neighboring communities. From the Lake of the Woods, on the north, to Reelfoot Lake in Tennessee comes an occasional quaint, primitive, or unusual example, but then the trail peters out. In the end all old decoy trails in the Mississippi flyway lead to the Illinois River. It's a shame that some of the old carvers have not survived to see the minor traffic jams they have brought about. Anyone still owning a rig of Charlie Perdew's Mallards or Pintails meets the nicest and apparently most enthusiastic collectors.

To try to evaluate the superb work being done by contemporaries would be a precarious business. With the several exceptions noted, this book is concerned with the work of those who lived in the past era and on which many collectors have passed judgment over the years. Many so-called decoy makers of the present lose sight of the fact

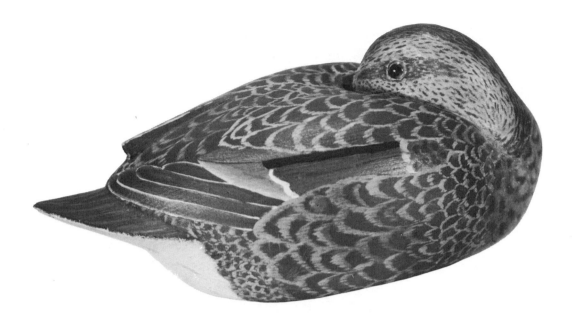

PLATE 153. Green-winged Teal by Harold Haertel of Dundee, Illinois. The masterful work of this bird and decoy carver is illustrated by a fine example. Proud owners of his work float them on mantels, and wildfowl never see them.

that a decoy is first of all a working tool and not a decoration or an ornament. When the objective is beauty and fussy detail rather than practicability, the product must be classified as an ornamental or "den" bird. Another requisite demanded of those included in this book is a volume of work all adhering to an established standard. Many of to-day's talented carvers and artists make solitary exhibition decoys. These one-of-a-kind items often are worked on for days, even weeks, which would seem to remove them from the category of working decoys. For these fair and understandable reasons an evaluation of the work of many deserving carvers, especially in the Midwest, is beyond the scope of this volume.

In the case of a man like Harold Haertel of Dundee, Illinois, who has made decoys for three or four decades, an exception should be made. His perfection of detail and adherence to species conformation and plumage pattern are second to none, and his present work is incomparable. (See Plate 153.) There are other modern carvers of note, such as Hector Whittington of Oglesby, Illinois, who has made noteworthy decoys since 1924. Hector's models in many ways reflect the Connecticut style rather than the

Illinois school to which he was born. Either way, he is a master of his hobby, and the delicate carving and modeling of his heads, especially the Canada Geese, indicate his remarkable skill.

Tom Schroeder of Detroit, winner of a national decoy contest and superb artist in many fields, must close this all too brief list. Others with deserving talents are asked to be patient, as their day will come. The purpose of this book is to look back through the past on those decoys that were a part of the greatest wildfowl hunt in human history. This is their story.

XIV *Crows and Owls*

CROW SHOOTING IS not a major chapter in hunting history nor do the decoys found date back to the days of the pioneer and his muzzle-loader. The use of Crow decoys resulted primarily from protective legislation on game birds that forced periods of inactivity on the nimrod. During these periods he turned to the bird that was always available and that furnished a degree of sport, the Common Crow. The gun and powder manufacturers, with an eye to business, mounted several "hate the Crow" campaigns. Certain states put a small bounty on Crows. The result was that more and more shooters turned to Crow hunting as an off-season pastime.

The Crow is acknowledged to be a wary, suspicious, and intuitive bird and soon reacted to this stepped-up persecution. The usual bounty was ten cents a bird and a few misses could put the day's hunt in the red if profit was the incentive. To make bounty hunting for Crows a paying proposition, a big bag was essential. Crow hunting in the early years of the twentieth century was followed by both the "sport" and the professional. Together they made the life of the Crow precarious, and it became an increasingly elusive target. The gregarious, though quarrelsome nature of the bird was its undoing. Crow calls were used to attract its attention, decoys were placed to bring it within gunshot, and even today it still blunders into these man-made stratagems. There are some things that birds never seem to learn.

The lack of color variation in the Crow decoy field might seem to indicate an almost deadly monotony. This is far from the case, and a group of carefully selected old Crows can be both historically and decoratively interesting. Their use was widespread, but the numbers used by each hunter were limited.

Examples are known from the Mississippi to the Atlantic and from the Canadian boundary on south to the Carolinas and Tennessee. Both the Mason and the Pratt decoy companies (Plate 154) offered Crow decoys in their catalogs, and sheet-metal replicas were made on both a commercial and a private basis. This indicates that the output was considerable. The demand did not go unnoticed by Charles Perdew of

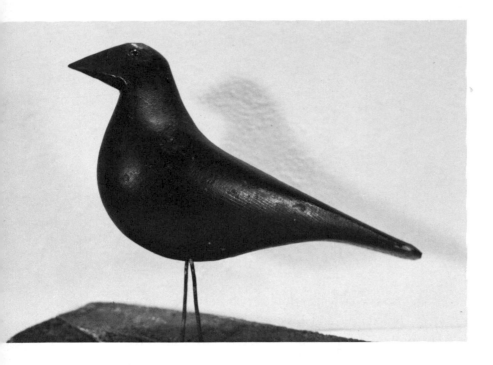

PLATE 154. The William E. Pratt Company of Joliet, Illinois, seems to have made a specialty of promoting Common Crow decoys. This interesting example shows their designer torn between Charles Perdew's model and the Common Crow made by Mason's Decoy Factory.

Henry, Illinois, and the Midwest received a scattering of his Crow handiwork. Plate 147 shows an example of Perdew's best Crows.

Handmade, oversized Crow decoys were popular on Long Island and in South Jersey. The variety is remarkable. Solid or hollow, pine, cedar, balsa or metal, normal or oversize, round or profile—at least one example of each type has been found and recorded. (See Plate 155.)

The Crow, a remarkable, wily bird, which has been persecuted by man and never received any protection, has one weakness that has been exploited. Every Crow seems to detest every owl with an insane, "unreasoning" hatred. Once an owl is located in some open, unprotected position, every Crow for miles will join in venting its abuse on the unwelcome neighbor, harassing and taunting the owl but strangely, never touching or pecking at it.

This flaw in the armor of the generally unapproachable Crow has been taken advantage of by the hunter. Larger owls, especially the Great Horned Owl, were stuffed and rigged by taxidermists so that the hidden hunter could yank a cord and the owl decoy would flap its wings. Driven to a frenzy by this apparent show of defiance on the part of the owl, the black attackers could be shot one after another as long as the hunter remained hidden. Those who wish can justify the collecting of stuffed owls as an adjunct to a rounded decoy collection, but it is seldom done. Rather seek out the

more conventional wooden models that were carved and used as acceptable substitutes. As none are known that have "flappable" wings, settle for the immobile type (Plate 156). Early examples were apparently made in wood by at least one factory, and manufactured tin profiles, beautifully painted, are known (Plate 5). An extremely practical manufactured model was made of printed fabric stuffed with excelsior. The example at hand has the actual beak of a Great Horned Owl.

The use of an owl to bring Crows within gunshot reverses the principle of all methods of luring or decoying birds. Every other decoy works on the principle of conveying to approaching birds the promise of congenial associates, food, or safety. The owl is an irritant and, since time began, an enemy of the Crow. Thus the owl decoy occupies a niche all its own.

There remain for discussion two birds that are so remote from the sporting field that proof that replicas of them were used as decoys must be conclusive. I have investigated them, and in both cases have given the decoy in question a field test.

The Yellow-shafted Flicker is the commonest woodpecker of the eastern half of our country. This robust and plump bird was sometimes shot for food, especially in Maryland. During the spring migration, the ornithologist Edward Forbush notes, ". . . the extravagant courtship of the flicker is notorious. We see the male in the early morning drumming rapidly on some resonant limb. The drumming is a long, almost

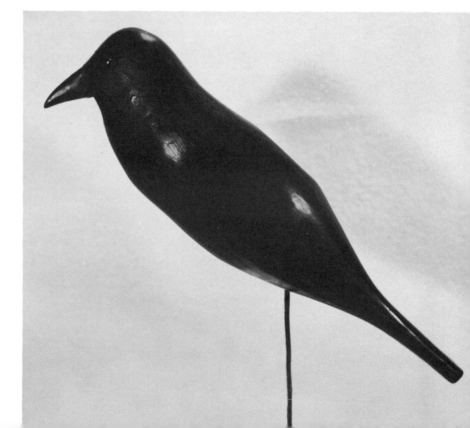

PLATE 155. Crow decoys seldom exhibit such distinctive characteristics as this huge hollow example from New Jersey. Made about 1920, it is rare and in mint condition.

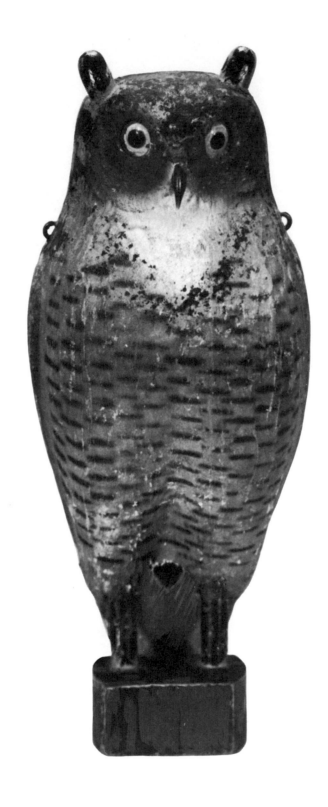

PLATE 156. Usual type of wooden Great Horned Owl decoy. Most skilled Crow hunters used stuffed owls, and for that reason, wooden owl decoys are rare. Factories turned out both wooden and stuffed cloth models.

continuous roll, and the bird frequently clings to his drumming post for a long time."[1] The observant natives around Chesapeake Bay also took note of this noisy Flicker courtship. It was several generations ago that the first suitable sounding board and its loosely attached Flicker decoy were placed in a strategic tree. Carefully balanced and hanging on a screw eye, the decoy could be manipulated by a dark thread strung between the hidden gunner and the decoy. The irresistible drumming of this sham lover was interrupted only by the blast of the gun as the inquisitive visitor learned too late not to rush into a situation of that sort. The Flicker in Plate 157 saw years of service. These rare and unusual items were collected some years ago. Spurious copies of the originals are made in Tidewater Maryland from balsa wood. They qualify as attractive ornaments or "den" birds, but not as collectible decoys. The old original crackled paint is the authenticating factor.

The last qualifier in the nonsporting category is the Red-winged Blackbird. Were it not for Lloyd Johnson, the knowledge that blackbird decoys were used might have remained a well-kept secret. He first noticed the blackbirds shown in Plate 158 during a conversation on the back porch of a house overlooking the Mullica River in southern New Jersey. "The reason I noticed the little group, perched on the limb of a dead tree," he related, "was that they never seemed to move." Sensing that decoy history was in the making, Lloyd said he would like to see how the little decoys worked. Before the visit ended, a tasty meal flew up to join forces and the unusual technique of back-porch hunting was ably demonstrated. But since great care and considerable skill had gone into the fashioning of these rare replicas, neither coaxing nor money could tempt the owner to part with even one of them.

The years passed and an occasional check confirmed the continued and successful use of the blackbird decoys by their owner. Finally the years themselves decided the issue, and they left their dead limb to journey far afield.

Undoubtedly there are other rare and until now unheralded decoys in the true and full meaning of that term. What about the Whooping and Sandhill Cranes? Surely at least one old, authentic Whooping Crane decoy was created and used in a bygone day to provide a pioneer with an easy meal? The Ivory-billed Woodpecker was hunted to extinction by both the Indian and the white hunter. Were Flicker hunters the only ones to use decoys for members of the woodpecker family? It seems doubtful.

Several decades ago songbirds such as Robins, Meadowlarks, and Mockingbirds were commonly shot and eaten. Some men, either smarter or lazier than others, carved duplicates, set them out and shot the visiting live birds. One such armchair pot hunter in South Jersey had a small trunk full of many varieties of these songbirds which he used. Beautifully made and painted, their fame spread. Many years ago I tried to pur-

[1] Edward Howe Forbush, *Natural History of the Birds of Eastern and Central North America* (Boston: Houghton Mifflin Company, Copyright 1939).

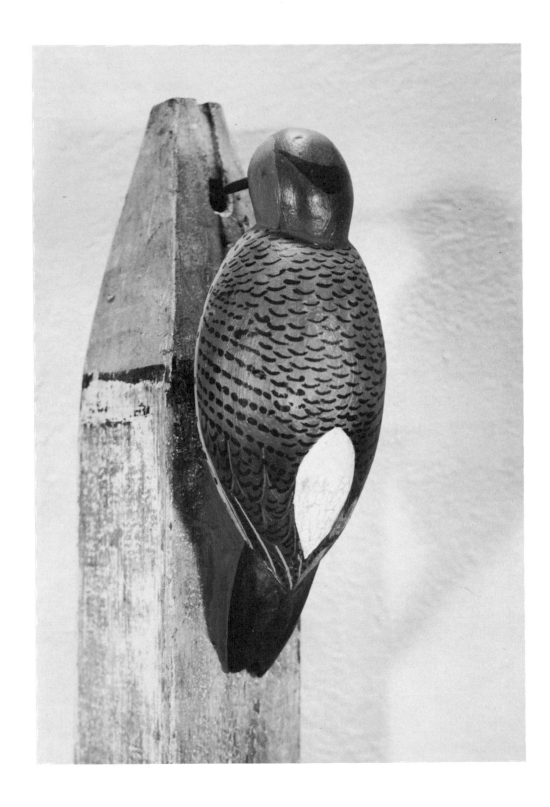

PLATE 157. Few old Yellow-shafted Flicker decoys are known. Every example reported has Crisfield, Maryland, as its place of origin. The originals have inspired counterfeits that now lure the unsuspecting collector. *Caveat emptor!*

chase them. A collection of that sort is almost worthy of the planning and marshaling of forces that Grant used in the taking of Richmond. The offer of cash alone couldn't do the trick. After pause and reflection a second visit took place, but that was all. The old gentleman had packed his belongings, birds and all, and moved away to parts unknown. The memory of those unique and priceless birds remains very clear. It is cheering to know that like the fish in the sea, ". . . the biggest haven't all been caught."

It would be nice to close this chapter with some documented evidence concerning handmade Mourning Dove decoys. Unfortunately, diligent research has failed to produce a single example worthy of mention.

PLATE 158. These blackbird decoys from southern New Jersey saw frontline service until recently. They served their original maker, who went far beyond the traditional figure of "four and twenty" when a good blackbird flight was on. They were made early in the present century.

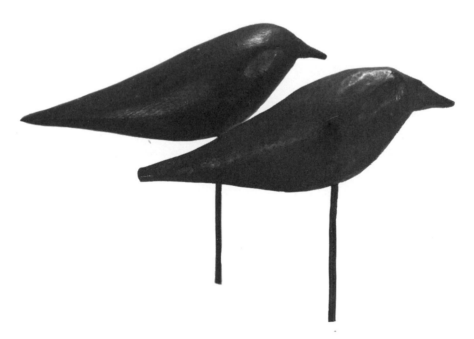

XV *The Confidence Decoy*

THIS APPEALING TERM has lately been misused. For example, to add a sleeper decoy or a "tip-up" to an otherwise average stand of decoys, and regard it as a "confidence" decoy, is stretching a point. Basically, it must be assumed that every decoy in successful use gives an air of confidence. Any discordant feature or decoy that does not inspire confidence on the part of the incoming bird or birds means the loss of a shot and an empty bag.

What, then, is a "confidence" decoy? There is only one bird that is not shot in its own right and is helpful in luring birds of another species within gunshot. The only true "confidence" decoy is a gull decoy. Generally a Herring Gull decoy is used; sometimes a Great Black-backed Gull (Plate 159). Used in conjunction with a rig of duck decoys, from one to four gull decoys lend an air of confidence or contentment to the layout. Veteran Black Duck hunters have used this stratagem for generations. Gulls in general are sagacious birds, and long before the day of decoys perhaps the generally unwary ducks found less trouble awaited them when they had the added protection of a gull sentinel. Gull decoys were made and used in the Midwest and along the entire length of the Atlantic coast. Both floaters and stick-ups are found. Sometimes, as on Lake Ontario, a rectangular shooting box would have one perched in each corner.

Generally gull decoys from Long Island, where many are found, are real prizes and have a boldness well illustrated in Plate 160. The occasional New Jersey gull decoy will have less carving and may be on the small side. A fine group of Herring Gull decoys were in the rig of G. E. Wallace, a game warden who gunned Barnegat Bay. In 1916 Wallace was shot and killed while hunting. His gulls were stick-ups and included one juvenile in the gray color phase, a refinement in gull decoys that is most unusual.

Almost every authentic gull decoy is more than fifty years old. To the regret of today's collector, gulls faded from the decoy scene early in the present century, and by 1920 their use was almost unknown. Their discontinuance seems to coincide with the

202

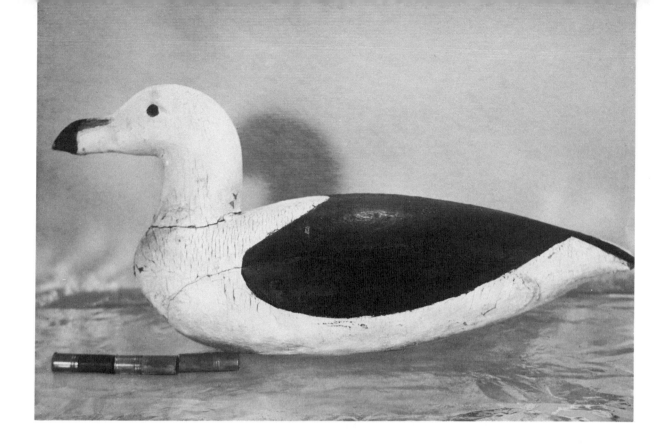

PLATE 159 (*top*). When winter's hand lay heavy on Cape Cod, Massachusetts, at least one Black Duck hunter noticed that the Great Black-backed Gull kept the ducks company. This confidence decoy represents the "Black-back," biggest of all coastal gulls, in cold weather plumage. Twenty-five inches long and a floater. PLATE 160 (*bottom*). A Herring Gull decoy from the South Shore of Long Island, New York. In this region, if anywhere, were made the perfect gulls from the collector's standpoint, like this big, bold example with carved wings. Its body length is 19 inches.

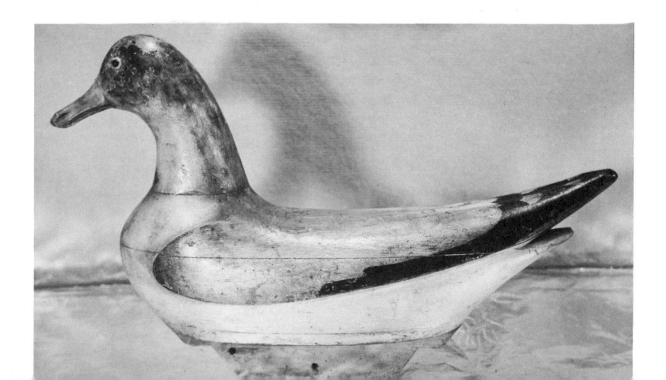

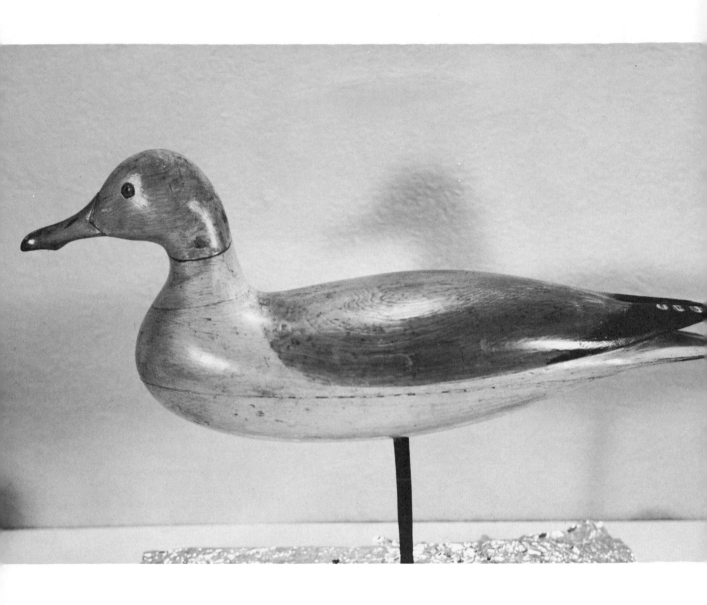

PLATE 161. A Herring Gull made by Harry V. Shourdes of Tuckerton, New Jersey. A delightful piece of floating sculpture painted with his customary skill. Originally made and used as a floater.

end of market hunting. Perhaps it is just as well that today's army of wildfowlers haven't discovered all of the old-timer's bag of tricks.

Another decoy that has a partial claim to the title of "confidence" decoy is a swan. Many swan decoys are a hundred or more years old. They were originally used to lure other swans. Therefore, a swan decoy, from its inception and based on its first usage, is not a "confidence" decoy in any sense of the word. Some of the massive, primitive Whistling Swan decoys of Currituck were in use during the early nineteenth century, long before market hunting came to that country, and their use and purpose was to lure cygnets, since only young swans are fit to eat.

Today, a low-level flying trip down Currituck Sound during the season will reveal many hunters using a couple of new swan decoys, mostly canvas-covered frames, along with a conventional rig. In a sense the use of a swan in this manner makes it a "confidence" decoy, but not fully. Actually, they are used to imply that food is available and the Widgeon, especially, take cognizance of that implication. A swan with its strength and extreme length of neck can tear food from the bottom that is out of reach and unavailable to the smaller puddle or nondiving ducks, like the Widgeon. It is a common sight to see a few swans, accompanied by a group of "freeloaders," majestically feeding and sharing their harvest.

Swan decoys are rare, though less so than the Common Tern, Wood Duck, Ruddy Duck, Hudsonian Godwit, and a few others. Still, the finding of one with an old head and neck is a collecting milestone. The decoys were used in rather limited areas, such as Virginia's Back Bay and the coastal sounds of North Carolina. Some of the finest and most graceful were used at the head of Chesapeake Bay and along the Eastern Shore as far down as Cambridge. Their use in other sections of the country was purely incidental. A noteworthy fact is that several decoy companies made these noble decoys. One such was the Mason's Decoy Factory of Detroit (Plate 162). Not to be outdone, the Dodge Company, also in Detroit, must have produced the example in Plate 163, since it has every characteristic of the authenticated Dodge decoys.

New Jersey, favored in so many other ways, had no Whistling Swan hunting worthy of the name. The oldest hunters I have interviewed had never heard of their ancestors' shooting these stately birds, but someone did. The only known New Jersey swan decoy was found by the writer in Waretown. I was a passenger in a Model A that beautiful fall afternoon when we sighted a group of children frisking on a lawn. Two of them were playing hobbyhorse on the object of this discussion. Upon the removal of the riders, the ancient, beat-up swan decoy was revealed, and purchased as soon as possible. Its days as a hobbyhorse were over and it has occupied a place of dignity ever since. It gives every indication that a member of the Parker family had a hand in its construction.

Some of the Carolina swan decoys must have been carved from amazingly large

PLATE 162. Whistling Swan by Mason's Decoy Factory. Height, 23½ inches, body length 31 inches. Head and neck were shipped in a separate box. The one-piece body has been hollowed out from the bottom and the opening sealed with a piece of galvanized sheet metal.

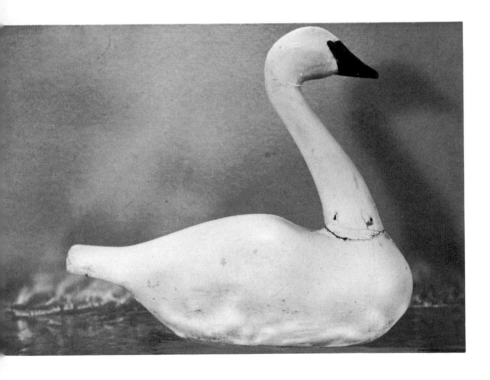

PLATE 163. This Whistling Swan decoy, obtained in Havre de Grace, Maryland, is without question a product of the J. N. Dodge decoy company. Its height is 21½ inches. It apparently was used as a model, because crude, hand-made counterparts from the Havre de Grace area are also known.

trees. The white cedar, which was always the wood used, is not, as we know it today, a huge tree, but apparently times have changed. One brute of a swan decoy became the object of study by a lumber expert, whose conclusion was that the tree from which it was hewn must have been at least 54 inches in diameter. "They don't even grow trees like that anymore," he said in a voice of awe.

PLATE 164. Sleeping Whistling Swan of Connecticut origin, but used in Virginia. Probably made by Ben Holmes, taken to Virginia, and gunned over by Charles ("Shang") Wheeler.

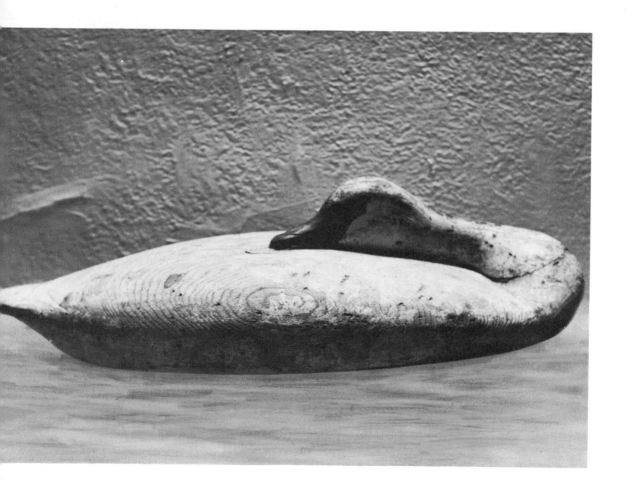

XVI *Factory Decoys*

IN THE FIELD OF decoys, the term "factory" must be used in the loosest sense. The basic distinction between a handmade and a factory-made decoy lay in whether a lathe was used in fashioning the body, and in how the products were distributed. We may say that when such mechanical equipment was involved, and the maker advertised his wares for sale to the general public, they were "factory stools." Some lathe-turned factory jobs, in addition, were hand-crafted and hand-finished.

The sporting journals of the second half of the nineteenth century are dotted with paid advertisements and references to both handmade and factory-turned decoys. The makers, for the most part, are no longer traceable, and their surviving decoys, if any, can no longer be identified. In the aggregate they now comprise the great bulk of the interesting but baffling items in present-day collections. Name items are desirable and when identification is possible, every effort must be made, but in the last analysis a decoy's merits rest on the decoy itself.

Continued interest and searching will add bit by bit to our collective knowledge of factory decoys. Two tiny ads by one M. C. Wedd serve as a case in point. *Forest and Stream,* February 14, 1878, carried the following advertisement:

DECOY DUCKS
M. C. WEDD

Manufacturer of Decoy Ducks, Mallards, Blacks, Canvas-Backs, Blue-Bills and Red-Heads. Extra size and very nice, by my customer's sending their best models to copy. 50 cents each. 87 Manhattan Street, Rochester, N. Y.

This message to the sporting public could have overwhelmed M. C. Wedd with

208

orders, because it was two years later before another and even terser message appeared in the same periodical for August 12, 1880:

DECOYS

Ducks that will decoy; manufactured by M. C.
WEDD; $4 per dozen; 87 Manhattan street,
Rochester, N. Y.

Apparently times had gotten tougher, however, for the cut in price was substantial. I find no record of any further appeals by M. C. Wedd to the reading public. But a rough woodcut of one of his decoys accompanied his earlier ad. Oddly enough, it is a Common Merganser, and when compared with the merganser decoy shown in Plate 143, they are apparently the same. The body of this decoy is lathe-turned, while the head is hand-carved. The paint job is original and interesting. M. C. Wedd did not run the ad in vain.

For the most part the enterprising makers of factory decoys served the sportsmen rather than the guides and market hunters, who seldom, if ever, purchased the "factory stools." This is not to say that the occasional derelict picked up after a storm, even if a "factory stool" was not added to the professional's rig. The pro was sometimes also the recipient of small rigs brought down by a "sport" for his own pleasure, and left behind. This was especially true of factory shore birds. It took a guide of great personal conviction and faith in his own handmade decoys to reject such contributions to his supply of decoys. Products of Mason's Decoy Factory of Detroit, Michigan, in particular, are likely to turn up in any rig, anywhere in the United States.

During the second half of the last century, Detroit became the machine-made decoy capital of this country. Two factors led naturally to Detroit's achieving this distinction. One was the never-ending supply of ducks on the St. Clair Flats and Sandusky marshes near the city; the other was an abundant supply of the finest cedar in nearby forests. The first important decoy maker to take cognizance of these obvious resources, and to purchase a turning lathe, was the hardworking Jasper N. Dodge.

THE DODGE DECOY FACTORY

Jasper N. Dodge started his business career as a clerk in a sporting goods store in Detroit. He was in business for himself by 1869 and thus qualifies as a pioneer manufacturer of the turned decoys that from then on were to be known as "factory made." Somewhere along the line, Dodge had a business relationship that is obscure. A four-column Dodge advertisement (Plate 165) in *American Field* in 1883 reads: "Successor

to Geo. Petersen." If Petersen fashioned decoys in Detroit prior to the formation of the Dodge factory, a backyard establishment on the outskirts of Detroit, there is no record of it, and this small mystery cannot be explained. Several other inconsistencies concerning the Dodge venture plague the historian. No catalog or printed matter of any sort is available except occasional advertisements. The ads appeared with reasonable frequency in sporting periodicals such as *American Field* and *Forest and Stream,* but beyond this the supply of information gives out.

PLATE 165. Advertisement of the J. N. Dodge decoy factory in *American Field*, October 1883.

The origin of the Dodge factory is better documented than its demise. Opinion favors the fact that competition, especially that of Mason's Decoy Factory, was more than Jasper Dodge could cope with. Mason's great period of expansion, from 1899 on, seems to coincide with the withdrawal of Dodge from the field. By the early twentieth century, the decoys of J. N. Dodge were a thing of the past. The pioneer in this field never reaped his share of the harvest that the halcyon decoy days of the next decade showered on his competitors. Certainly he tried, and although his "Cheap decoy ducks at $5 and $7 a dozen, made to order," with *"Satisfaction Guaranteed,"* were priced higher than those of his competitors in 1883, they were a good buy.

Nor was Jasper Dodge niggardly in the number of offerings he made to the public. An advertisement in W. B. Leffingham's book, *Wild Fowl Shooting,* published in 1888, gave this information concerning Dodge's wares: "I make all kinds of Decoys of White Cedar, the lightest and most durable wood. I have constantly on hand all kinds of Duck Decoys, also Geese, Brant, Swan, Coot, Snipe and Plover Decoys; also the best Duck and Turkey Calls in the market. Decoys made after any model furnished without extra charge. Send for illustrated price list. St. Clair Flats or Sleeping Model of Male Red Head. When placed on water it is a perfect imitation of a Duck at rest and entirely unalarmed." (See Plate 166.)

Also available, although not mentioned in print, was a hollow model. A rig of hollow Black Ducks, traceable through their owner to Dodge, was made. Plate 167

PLATE 166. Pintail drake by J. N. Dodge decoy factory. This lumpy, rather unattractive item is the St. Clair model that was widely advertised. Regular models must have outsold it many times over.

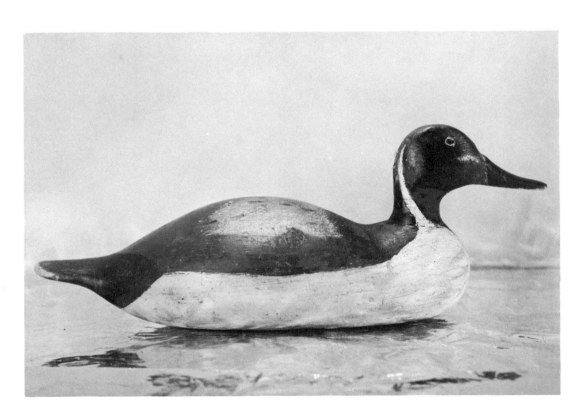

shows a well-battered veteran from the lathe of Jasper Dodge. Thus he offered the hunting public a companion line to each of the competitive Mason lines. First the fine quality hollow models, then the well-made, popularly priced solid type, followed by several cheaper grades. Doubtless many special and unusual decoys were turned out by the lathes of Jasper Dodge as a result of his blanket invitation, "Decoys made after any model furnished without extra charge."

No record of these decoys remains, however, as the Dodge factory did not mark or stamp any of its products. The painstaking process of trying to separate the products of this enterprise from the welter of their contemporary competition has now progressed to the point of positive identification of many models. In the main this has been possible through close scrutiny of the models illustrated in the ads and a study of the plumage patterns. Further help has been the fact that Dodge repeatedly stated the exact measurements of certain models. Last, but of great assistance, some have been obtained from individuals who recalled the source of the original purchase. Almost item by item, it is now possible to attribute certain decoys to this company. Circumstantial evidence, if you wish, but conclusive enough for the identification of their ducks, geese, Brant, and swans.

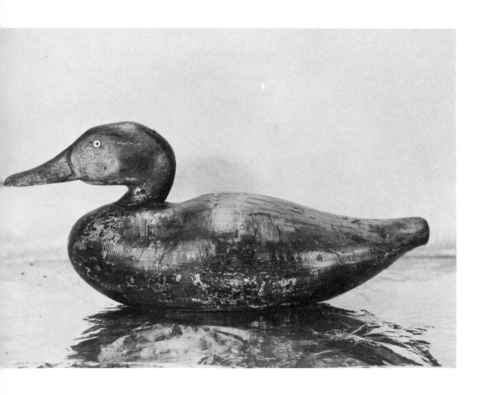

PLATE 167. The J. N. Dodge company made a hollow model to compete with Mason's Decoy Factory's Premier grade. This Black Duck is cruder, less attractive in conformation, and must have failed to curb Mason's growing sales. Its limited sale makes it a rare item.

The "Snipe and Plover Decoys" surely found a market of sorts along the Atlantic seaboard, but no specific proof can be submitted to link any individual shore bird to the Dodge Company. The ones shown in Plate 168 are turned on a lathe, have paint of the same texture and quality as Dodge ducks, and are similar in conformation to some models of the ducks. But the evidence is not overwhelming, and the case must rest for lack of more and better facts.

The Brant, goose, and swan shown in Plates 163 and 169 are unmistakably Dodge and exhibit similar construction details. Little regard was paid to the individual characteristics of the three respective birds, and the models are quite similar except for size. For the most part these decoys have failed to excite the collector. Their appeal has been historical rather than decorative with a few outstanding exceptions such as the Common Merganser (Plate 170), the swan, and surely the shore birds tentatively attributed to the Dodge factory. All of these have a great appeal to the eye and are extremely interesting finds.

PLATE 168. Lathe-turned shore birds that could have been made by the J. N. Dodge company. Conformation and paint patterns make identification difficult. A black patch on the bottom of the bird at the top indicates that it was meant to simulate a Red-backed Sandpiper. The other seems intended to represent the same species in winter plumage.

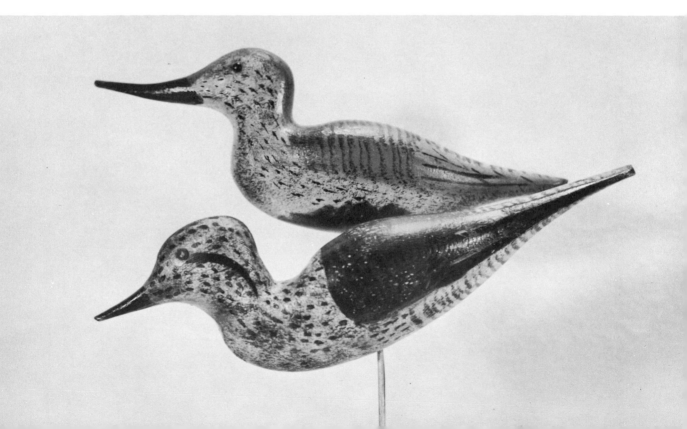

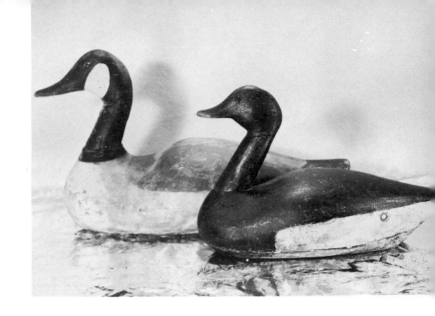

PLATE 169. This Brant, in front, and Canada Goose both display similar Dodge details of construction. The heavy, blunt tail is consistently noticeable. The heads of the swans, geese, and Brant are separate and pinned on the neck.

PLATE 170. American or Common Merganser, which in spite of its crudity and heaviness has a pleasing look. It is the one Dodge product that has excited collectors.

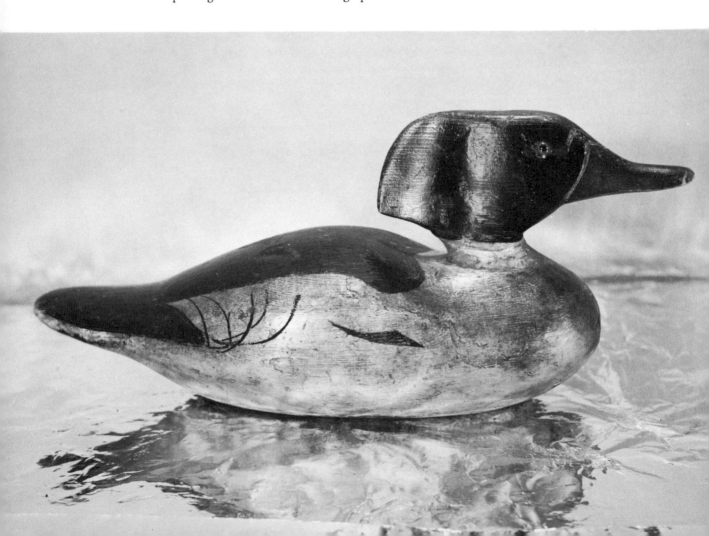

The remainder of the Dodge ducks, except for the Bufflehead, have a crude heaviness about them that detracts from their appeal to the average collector. Another thing hard to explain is why these decoys are almost unobtainable in good original condition. Battered and dingy as most of them are, it is difficult to work up much enthusiasm for them. But they were made for a rough purpose and were extremely rugged and durable. In original paint, they tell a plain but interesting historical story.

THE STEVENS DECOYS

The little rural town of Weedsport in Cayuga County, New York, was the scene of another of the first documented commercial ventures in the making and marketing of decoys. This operation was owned and managed for almost half a century by members of the Stevens family. The decoys were made in what was actually only a good-sized shed, rather than a real factory, and the working force averaged two men. No turning lathes or other machinery was ever used, so the Stevens decoys were not factory decoys in that sense. Since the Stevenses advertised to the public in the sporting journals, however, and printed sales literature, theirs was a true commercial venture, and this sets the Stevens decoys apart from the part-time, handmade products of the competition. The Stevens operation was free enterprise in the best tradition, and their product became famous. Both for their own time and for collectors, they obviously built a better duck decoy, and the demand for their products has continued.

Due to the Stevens' advertising and other promotional literature (Plate 171), their branded decoys, and the distinctive look and shape of all of their work, much information is available about them, and their story is as interesting as the decoys themselves. Harvey A. Stevens was the indispensable brother, and his energy and foresight deserve full credit for whatever measure of success the family venture attained. George, a younger brother, was partially crippled but a most conscientious workman. After Harvey's death he was able to continue the business for about three years. The latest Stevens ad I have found, in *Forest and Stream* for September 30, 1880, is shown in Plate 172.

A still younger brother, Fred, never seemed to become an integral part of the Stevens enterprise, but helped in several ways. A painter by trade, his greatest contribution was in selecting and mixing colors, and at times taking an active part in other work.

Weedsport is close to the famous Montezuma Marshes, a favorite stopping place for the choice Redhead. Ducking came naturally to young men of that vicinity, and Harvey Stevens was no exception. In all likelihood he was a market hunter at an early age, and this led him into the decoy business about 1866. No other maker or makers so consistently branded or stenciled their handiwork. The Stevens brothers certainly were

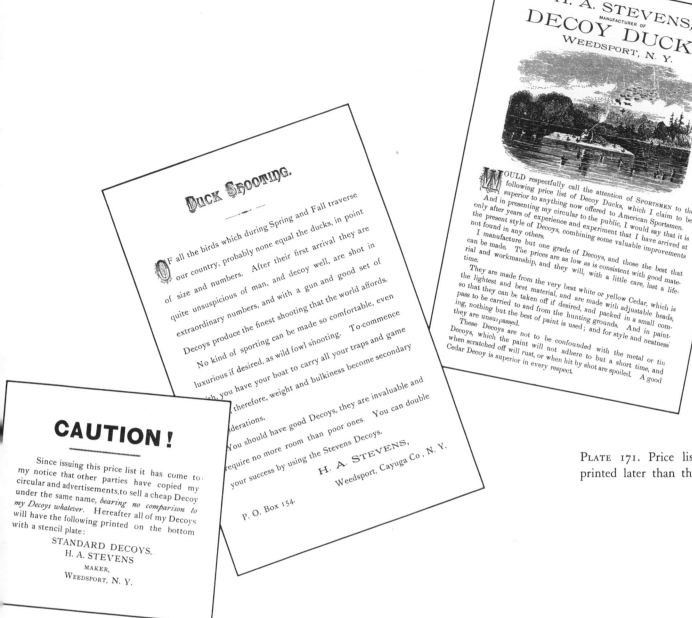

Plate 171. Price list printed later than the

Decoys SEND FOR NEW PRICE LIST OF THE FINEST DECOY DUCKS IN THE WORLD.

H. A. STEVENS, Manufacturer.

WEEDSPORT, N. Y

Plate 172. H. A. Stevens advertisement from *Forest and Stream,* September 30, 1880.

Plate 173 (*facing page*). H. A. Stevens made a wide variety of duck decoys. This Gadwall must have been made to a special order. All but the very earliest models of Stevens decoys are characterized by wide, flat bodies, paddle-like tails, and two holes for the lead weights.

PRICE LIST OF IMPROVED DECOY DUCKS

FOR 1891

Which are Boxed and Shipped to any part of the United States and Canada. The following prices include boxing and delivering at the freight office in Weedsport, N. Y.:

Canvass Backs,
Mallard,
Black Ducks,
Red Head,
Scaup Duck, (better known as Blue Bill,)
Golden Eye, (better known as Whistler,) $10 00
Buffle Head, (commonly called Butter Ball,) 1.00
Teal—Blue Wing, .75
Widgeon, (or Bald-pate,)

Price per dozen,
Anchors and Colored Cord for one dcz. Decoys,
Duck Call, (sent by mail on receipt of price,)

My Decoys are good size and are weighted. The weight and staple to fasten cord and anchor to are set in the bottom, so that they are all smooth and not nailed on as other Decoys are, and they have natural glass eyes. When sitting on the water they are as natural as life. Every Decoy bears the name H. A. Stevens, on the bottom ; none others are genuine.

TERMS.

Goods sent C. O. D. by Express upon receipt of 25 per cent. of order; collect balance on delivery. When sent by railroad as freight, cash down. ALL GOODS WARRANTED.

☞ Orders by mail promptly attended to.

☞ N. B.—Any of my Decoys make a good diving Decoy, by taking an old piece of iron or other weight of about five or six pounds, with a hole through it and a cord about thirty-five yards long. Fasten the cord just under the breast of decoy; put it through the hole in the weight and drop it where you want to shoot. Carry the other end to the blind, and when ducks are approaching pull the cord and the Decoy will dive as natural as a live bird. Color the proper color and length for diving Decoy, fifty cents. White cord should never be used to anchor Decoys with, ducks can see it a long distance in the water.

REASONS WHY DUCK SHOOTERS SHOULD USE GOOD DECOYS.

The ducks are wilder than in former years when they were not hunted to any great extent, but now are hunted from one end of the country to the other, and are harder to decoy.

How often it is you meet a friend just in from a ducking trip without getting any ducks, saying "there are lots of ducks, but they would not decoy." Look over his outfit, and nine times out of ten you will find he has a very fine gun of the latest pattern, made by one of the best makers, and clothing to match. Look at his decoys; they are a cheap, ill-shaped decoy, not much better than a block of wood, painted with a cheap paint that is coming off every time they are used; and perhaps painted by a man that never saw a duck sitting on the water in its natural state, and if he did could not get the colors and put them where they belong. Painting a decoy in natural colors is a trade in itself that requires years of practice. You can kill ducks with a cheap gun and poor stools, but you can't decoy the old birds with your fine gun and good stools.

I have manufactured decoys for twenty-five years, and in that time have hunted ducks from two to four weeks each season, and have experimented with decoys of different patterns until I have arrived at the present style, combined with all the improvements obtainable.

Remember I do not try to compete in price with the cheap machine-turned decoys; my decoys are a different style and cannot be turned, they are hand made throughout, and therefore the market will not be flooded with them, and the price is as low as they can be made.

I have been in the business a long time and have a reputation for good workmanship and fair dealings, and if you favor me with your orders, will try to fill them to your entire satisfaction.

Yours respectfully,

H. A. STEVENS.

distributed by H. A. Stevens, the Weedsport, New York, decoy makers, in 1891. The "caution" notice was circular and attached to its first page.

proud of the product they turned out in the shed in back of their homestead. Because of that it is possible to piece together the story of their success. Looking back, no one can deny that they furnished the decoy field with some of the most interesting and decorative items it is possible to collect. Harvey Stevens had a genuine faith in his decoys, and it seems only fitting that the reader should have his reasons, as expressed in the Stevens brochure reprinted as Plate 171.

PLATE 174. Stevens used three methods of marking his output. The stencil shown here seems to occur most frequently. Next most common form of identification was the company's name and town burned in the bottom. Third was a small paper sticker placed on the underside of the bill.

MASON'S DECOY FACTORY

Not the first, certainly not the last, but by every standard the greatest decoy company in America, was Mason's Decoy Factory. At 456 Brooklyn Avenue, Detroit, Michigan, Herbert William Mason and his skilled company of woodworkers and artists turned out the most numerous, finest, and most collectible of all factory-made decoys. Mason decoys could be considered a complete field of collecting in their own right.

The Detroit City Directory first lists William Mason as a maker of decoys in the year 1899. Some confusion occurs at this point since Herbert W. Mason stated in an application for a trademark that he had used the trademark "CHALLENGE" since 1894. The year of organization, therefore, still remains in doubt. It seems logical that

the signer of the application, Herbert W. Mason, is the "Wm. Mason" listed in the 1899 directory. His previous qualifications for this specialized field of endeavor are unknown. Whatever his own shortcomings, they were never apparent in his products. Perhaps his associates were masters of the various crafts and skills needed in decoy making, such as selection of wood and its turning as well as the skilled choice of paints and their application. We lack details of the inner workings and personnel of Mason's Decoy Factory, but Herbert William Mason set up the operation, and to him goes the credit.

Until the sale of its equipment to the Pratt Manufacturing Company of Joliet, Illinois, in 1926, Mason's Decoy Factory's dominance of the field was complete. The business life of this concern from the turn of the century to 1920 coincides with the great growth of wildfowling as a sport.

As Hal Sorenson, who yields to no one in his appreciation of the Masons, states, "There's a special thrill in searching through a rig and suddenly spotting a Mason 'Premier' or 'Challenge' in original paint. These grand old birds have qualities rarely found in other factory decoys. Mason's high-quality paint, which mellows beautifully with age, retains its original coloring, and the fine cedar wood which shows through where the paint is worn, displays an attractive patina."

Paints of this excellent quality and texture were used regardless of the grade or model; even the cheapest-quality Mason product received the finest paint. Every student of Masons should note the texture of the paint and the "swirling" technique of application. A reading glass is a great help in examining the paint. Once studied in detail, it is most helpful for future identification. In no other factory decoys was a comparable technique used. Even along the salty Atlantic tidewaters, the Mason paint held up extremely well, and that is a compliment for durability hard to match.

Mason advertising in magazines and sporting journals was limited. Competitors seemed to outdo the Mason factory in size and number of advertisements. A Mason ad appearing in *Field and Stream* during 1922 read dramatically:

> Once winged—twice shy! And you would be too—if you were a duck! Suppose you were flying along, and saw a lot of ducks down below swimming around. You would swoop down for a chat with them when—Zowie! Zowie!—something tore away half the feathers from one of your wings. So when ducks have been shot at as much as those you will see next fall, you will want the best decoys obtainable—MASON'S DECOYS—to bring them in. Perfect in shape and coloration. All species. At all good dealers. Send today for interesting booklet."

It is hard to believe such copy had much to do with the great success of the company. The excellence of the product itself, and a statement in the Mason factory's advertisement just quoted—"At all good dealers"—hold the key to the Mason factory's success.

WE show in this catalogue our "PREMIER" and "CHALLENGE" MODEL HIGH GRADE CEDAR DECOY DUCKS. These goods speak for themselves and we assure absolute satisfaction in the purchase of these Decoys.

In addition to the "PREMIER" and "CHALLENGE" Models shown herein, we manufacture three cheaper grades, all excellent values, and can duplicate any special Decoy that may be needed.

All leading jobbers and retailers handle our line of DECOY DUCKS and we refer you to your nearest dealer for quotations.

If you are unable to secure such specie or grade as you desire we will be pleased to have you write us direct.

"P R E M I E R" M O D E L
Reg. U. S. Patent Office

HOLLOW AND FLAT BOTTOMED. THE FINEST DECOY EVER MADE. The drawings for them were made from life, and as a consequence are mathamatically correct, particular attention being paid to all fine details, such as shape of the head, bill, arch of neck, etc. In hollowing them out they are cut in two ABOVE THE WATER LINE, thus preventing any leakage. Being flat on the bottom, they ride the water exactly like the living bird, and have not the rocking motion of the old-fashioned decoy in rough weather. The eyes used are the finest enamel, colored same as the living birds. No pains have been spared to make these goods surpass anything in the shape of a decoy that has heretofore been manufactured.

"C H A L L E N G E" M O D E L
Reg. U. S. Patent Office

BOTH SOLID AND HOLLOW. With the exception of our "Premier," the best decoy made, and meets the wants of those who do not feel like paying what our "Premiers" are worth, and yet desire a strictly fine decoy. These goods must not be confounded with the cheaper goods so common in the market. They are strictly what we represent them. viz.: THE BEST THAT CAN BE HAD AT THE PRICE. See cuts illustrating "Challenge" Model on pages 8-9-10.

NOTE:—That this model is manufactured in both solid and hollow grade and when ordering state clearly as to which model is desired.

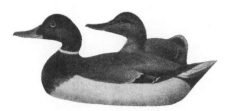

MALLARD
PREMIER MODEL
Reg. U. S. Patent Office

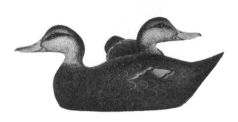

BLACK DUCK OR BLACK MALLARD
PREMIER MODEL
Reg. U. S. Patent Office

PLATE 175. Pages from the catalog of Mason's Decoy Factory of Detroit, Michigan, about 1915.

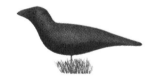

CROW DECOYS

Here it is! !

The finest Crow Decoy on the market.
It is becoming popular to shoot Crows over Decoys, especially in closed season on other birds.

Let us have your order for a few dozen of these goods, at an early date.

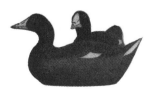

MUD HEN
CHALLENGE MODEL
Reg. U. S. Patent Office

SHORE BIRDS IN TWO GRADES
A-1.—Enamel glass eyes. B-2—Tack eyes
12-inch sticks for legs furnished

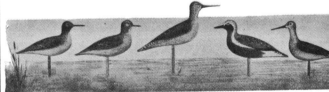

ROBIN SNIPE GOLDEN PLOVER YELLOW LEGS BLACK BREAST SNIPE

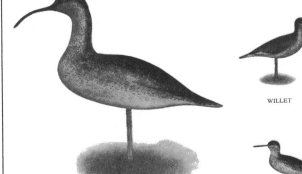

WILLET

DOWITCHER

LONG BILL CURLEW
CHALLENGE MODEL
Reg. U. S. Patent Office

This countrywide distribution, the one thing no competitor had, explains the use of Mason decoys in almost every state.

Mason's Decoy Factory issued at least three catalogs: one probably about 1915, one in 1918, and another about 1922. They constitute the most important original documents available to collectors. Six pages from the earliest and most complete of the three catalogs are reproduced as Plate 175.

It is possible to identify both the "Premier" and "Challenge" grades of Mason decoys if they retain at least part of the original paint. Lower grades are more confusing, because the competition could turn out a rather similar, mediocre product. But even in these more modest models, if original paint remains, the identification can be made through the texture and swirling of the superior Mason painting. This distinguishing feature is found in all ducks, geese, Brant, and shore birds the Mason factory produced.

The list of ducks the Mason concern made available to sportsmen was nearly complete. All, with one exception, have been found and identified. The Ruddy Duck listed in one catalog has never been found and recorded by any known collector or museum.

Approximate Measurement
Length - 18 inches
Width - 7⅜ inches
Depth of Body 5⅛ inches
Depth from top
 of Head - 9 inches

BRANT GOOSE
CHALLENGE MODEL
Reg. U. S. Patent Office

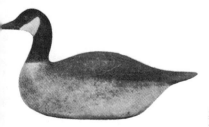

Approximate Measurement
Length - 20½ inches
Width - 9 inches
Depth of Body 7¼ inches
Depth from top
 of Head - 12½ inches

CANADA GOOSE
CHALLENGE MODEL
Reg. U. S. Patent Office

These are in solid model only.

This now desirable item would at best have had an extremely limited market and sale. Perhaps it was a marketing mistake and no orders for Ruddy Ducks were received. Still, the nagging hope remains that in some shed, perhaps on the bank of the Bush River in Maryland, a Mason "ruddy" lies dusty and unnoticed, but a collector's dream in original paint.

Decoys of the widely distributed but rather uncommon Ring-necked Duck, or "blackjack," have seldom found their way to the collector's shelf. Although they were listed and made by Mason, only a few are known. The Ring-necked Duck can be distinguished from scaup by the difference in the bill and the ring on the neck, which is hard to see. Decoys of this species cannot be identified when in poor condition or repainted.

PLATE 176. Price list of Mason's Decoy Factory.

"PREMIER" MALLARD
Reg. U. S. Pat. Office

You Want Decoys
That <u>Are</u> Decoys!

The day is past when "any dub" could go out with "any old equipment" and bring back a bag of ducks. Birds are scarce and "educated." Don't hazard your success—your precious few days of sport—by starting out with poor equipment. Most any gun will bring down the birds if you hold it right—but it takes **real** good decoys to bring in the wily old birds. Next trip take along MASON'S DECOYS—and watch the difference. At all good dealers.

MASON'S DECOY FACTORY
DETROIT, MICH.

Premier Model (Hollow)	$12.00 per doz.
Mammoth Canvas Back (Solid)	$12.00 per doz.
Challenge Model (Solid)	$ 6.50 per doz.
Challenge Model (Hollow)	$ 8.00 per doz.
Canada Goose	$18.00 per doz.
Canada Brant	$13.50 per doz.
No. 1 Snipe	$ 5.00 per doz.
No. 2 Snipe	$ 3.75 per doz.
Curlew	$ 6.00 per doz.

As with Dodge and several other decoy makers, Mason ads offer "Decoys made after any model furnished." The buyer of that day seems, however, to have been largely satisfied with the stock models available. There is little evidence that either Mason or Dodge had their production lines disrupted by special or offbeat models and species. Normal and understandable minor changes in Mason's stock models occurred over the years. Personnel shifts, machine improvements, and changing public tastes made variations inevitable, but for over twenty-five years this eminently successful organization held to a norm that seldom confuses the collector.

An example of a Mason decoy made to special order is the Golden Plover shown in Plate 177. Ten species were listed by the Mason factory, but the decoy pictured was not a stock item. The split tail was an exceedingly simple departure from the usual model and was readily made upon special order. However, the bodies in Mason split-tail Golden Plover and Dowitcher decoys are fuller than those usually found. A further deviation from the norm is that the Dowitcher has an original wooden bill instead of the usual iron bill. Others of this same rig have been examined and all have original wooden bills—conclusive proof that on these several counts the shore birds shown were made to detailed specifications. The limited use of wooden bills on the shore birds is something of a puzzle. Wood had one shortcoming—its weakness and fragility. The iron nails used as bills had two drawbacks: first, around salt water they would rust and split the heads; secondly, although the nails themselves were strong, a sharp blow on them would split the whole head—a worse disfigurement than the snapping off of the bill. The iron bill, however, remained standard procedure.

The conformation of Mason shore birds leaves something to be desired, as the necks of all the one-piece birds are too short and much too heavy. This was inevitable with the machine the Masons used, and it was probably excused on the grounds of durability.

Curlew decoys brought the Mason factory face to face with this same mechanical problem. The stately example with separate neck and head shown in Plate 178 is a noble decoy. This two-piece curlew specimen has been found in three styles, while the one-piece model is known in only one. Whether these four curlews were all stock models that varied from year to year, or in several cases special orders, cannot be determined. I have examined many examples of each type, and my best judgment is that all four were made as standard offerings, but at different times. The one-piece, short-necked variety seems to occur less frequently than the others. Certainly it least resembles a live bird. Apparently all of them were listed by the Mason factory under the designation of Long-billed or Sickle-billed Curlew.

The Greater Yellowlegs, or, if you prefer, Willet, shown in Plate 24 was definitely made to special order. From head to tail it measures 14 inches and that alone removes it from the standard category. Oversized yellowlegs were often used on Cape Cod, and there is considerable precedent for this tremendous model. Every factor of paint, con-

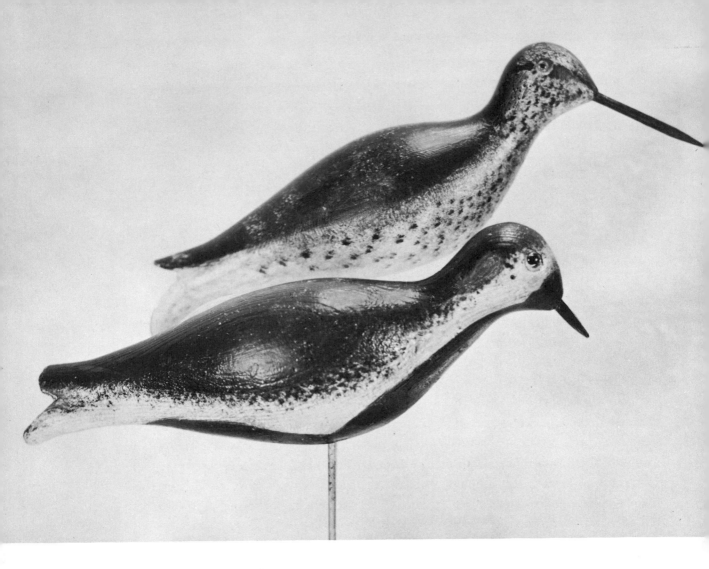

formation, type of glass eyes, and iron bill indicates that it is a product of Mason's Decoy Factory.

Specializing in the decoys of this company is a rewarding and pleasant field of collecting. The standard models alone offer a wide range. The possibility of the special models adds further excitement to this particular area of collecting.

The only undiscovered example in Mason's printed list of waterfowl decoys has been noted—the Ruddy Duck. The Oldsquaw duck is an unlisted item, and illustrates the ingenuity of at least one of the Mason foremen. The unusual request for this long-tailed duck was quickly met by taking a "Premier" drake Pintail body, then working the head of a Pintail just a little smaller than usual and painting a superb Oldsquaw pattern. Order filled! Oddly enough, other orders for this unusual species came in, for several examples are known in both the "Challenge" and a lesser grade. All examples under discussion are in original paint and excellent general condition.

PLATE 177 (*facing page*). The Golden Plover by Mason's Decoy Factory, in foreground, is an exceedingly rare decoy. Note that the black on the belly extends to the tail. The split tail detail is the same on the yellowlegs in the background. They are unmistakably by the Mason factory.

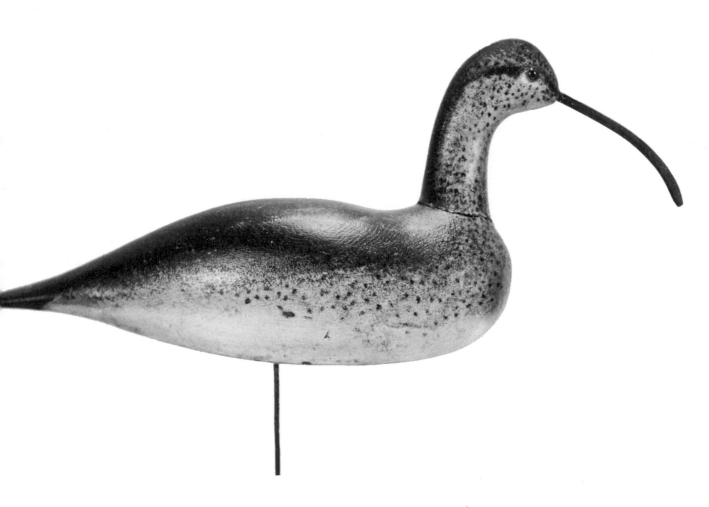

PLATE 178. The most stately of the four models of curlews made by Mason. In original paint, decoys like this one were the finest factory shore bird from every viewpoint. The model was used for both Long-billed and Hudsonian Curlews.

Examples of the Common Scoter, unmistakably of Mason origin, have turned up in collections on at least two occasions in good condition and original paint. (See Plate 179.) No background information was available in either case, so perhaps they both came from the rig of the same unknown purchaser who wanted Mason "coots." New England is the least likely area in which to seek Mason or any other factory stools. They were a thrifty lot along that rockbound shore, and besides they made darned good decoys of their own.

Doubtless the choicest Mason decoy yet found is the Wood Duck drake shown in Color Plate VIII. A "Premier" model in mint condition, it must lead the field as a unique and superb specimen. It was discovered by the writer in a gunning shed in tidewater New Jersey, which is far from a favored habitat of the Wood Duck. Furthermore, it had the company of no handmade Wood Ducks, and the owner of the shack had never bothered to use it. Further questioning produced no other details regarding what is one of the most desirable of all duck decoys. It is a proud and distinguished accomplishment of America's greatest decoy factory.

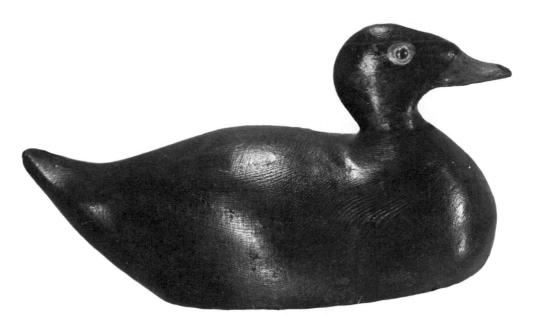

PLATE 179. Premier grade Mason Common or Black Scoter. The extremely limited demand for this item did not deter Mason's Decoy Factory from turning out a remarkably fine decoy for this specialized shooting.

THE WILLIAM E. PRATT
MANUFACTURING COMPANY

The William E. Pratt Manufacturing Company of Joliet, Illinois, made duck and crow decoys, also various types of anchors and weights for them. They featured a cast-iron weight about six inches long, anchored by a screw at either end. Its use on a decoy may indicate a Pratt decoy. The firm was engaged in the business of making decoys before 1926, but examples of that period are hardly collectible items. The year 1926 was a milestone in the company's history, for it was then that they bought the equipment of Mason's Decoy Factory and moved it to Joliet. After this the quality of their decoys improved.

From 1926 to 1938, when it ceased operation, the Pratt company made excellent decoys, copying with considerable skill those made on the same machines by Mason. Pratt, however, lacked a spindle carver, without which they could not carve or cut concave areas, which are apparent in some Mason ducks. This minor omission in the finished product does not detract from their general overall excellence. Considerable confusion exists as to whether certain decoys, especially the cheaper grades, were made by Mason or Pratt. This is certainly true during the 1920's, when some of the Mason personnel were with Pratt, and faithful adherence to the successful policies and models of the original company prevailed. A lowering of standards is noticeable as the operation came to a close in the late thirties. There is no sure way to identify a Pratt model, unless it be a hollow one. Inside, hollow Pratt decoys were finished unlike the hollow Masons, but obviously this drastic type of investigation is not to be used.

Certainly the quality of the painting, grade for grade, on the Pratt decoys does not equal that of the Masons. But unless two mint examples are compared, wear and exposure make clear-cut distinction difficult.

These two companies differed widely, however, on one type of decoy, and for this individuality collectors are grateful. Both made crow decoys and Pratt described its model as follows: "#20 is a Crow Decoy only. It is solid, the size of a crow with jet-black finish, glass eyes, wire stakes to use in fastening to trees, fence posts or placing on the ground." This uncommon and highly collectible item lives up to its terse description.

The Pratt price sheet extols the attributes of a contraption called the "Gazecki" that practical wildfowlers would view with horror. It is described in part as a "device similar, in operation, to a window shade inserted into a two inch cavity of the [decoy] body. The anchor is fastened to the cord on the spool. Taking in the decoys, a simple pressure on a lever causes the springs to wind up the cord." This gilded description of the gadget takes no account of the facts of wildfowling. Picture freezing

weather, and imagine a little corrosion on that "window shade" spool, or even some seaweed on the lines. None of these gadgets is available for testing or pictures, but they must have been called by names other than "Gazecki" before the last one, in exasperation, was hurled to oblivion.

The contribution the William E. Pratt Manufacturing Company made to decoy history was solid and uninspired. Its greatest achievement was the Pratt crow decoy. In 1938 the company was bought out by the energetic Animal Trap Company.

EVANS DECOYS

Walter Evans, born in 1872, was the proprietor of the Evans Decoy Factory in Ladysmith, Wisconsin. His early training and formative years were spent in the lumber business, an excellent prelude to making decoys. The quality and selection of the wood found in all Evans' decoys establishes his knowledge of wood and its proper seasoning. Seldom does his work show the checks and cracks prevalent in similar competitive items. Ladysmith was in the heart of Wisconsin's lumber country, and it is a certainty that Evans took full advantage of this favorable location. The bodies of his decoys are of cedar, and the heads are carved from white pine.

It was after World War I that Walter Evans, in collaboration with Karl Newman, went into the manufacture of decoys. Their output was limited, but since the use of turning machines was involved and since the company was a full-time occupation for at least two people, it qualifies as a factory, at least by decoy standards. The collector may expect to find Evans Mallards, scaup, Canvasback, Redheads, and Pintails, in about that order. Since the factory was in operation for only a decade and faced a great deal of cheap competition, good examples of its output are not easy to come by. Evans advertising was limited and the sales distribution was spotty except in the Midwest. These decoys are seldom found along the Atlantic coast.

Evans decoys are bulky and undistinguished in style and conformation. Certainly both the solid and the hollowed-out models are sturdy and rugged. The paint quality is good and the patterns are adequate on standard models, very good on most of the mammoth ones. Other than that, little about them appeals to the discerning collector. Somehow an Evans reminds one of a Mason decoy that failed to pass inspection. Evans decoys were adequate, and reasonably priced, but they lack the grace and detail dear to the heart of every collector. The major part of the Evans operation terminated in 1932, for all practical purposes. The standard and mammoth sizes of Evans decoys are shown in Plate 180. The differences in carving details and in painting should also be noted.

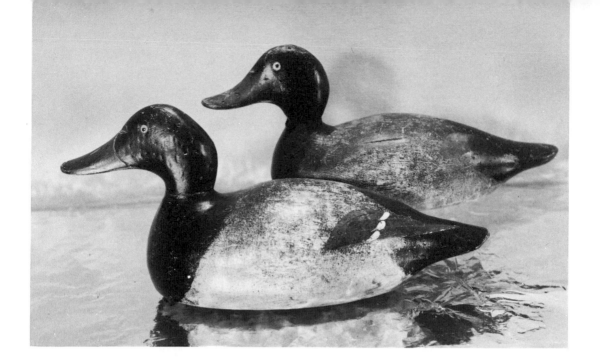

PLATE 180. Scaup marked with the "Evans decoy" stamp. In the foreground is the well-painted larger model. Its length is 12½ inches. The other, obviously inferior in detail and painting, is 11¾ inches long.

OTHER DECOY FACTORIES

The years following the First World War saw a revival of interest in wildfowling and a consequent shortage in decoys. Jasper Dodge was now only a memory and Mason's Decoy Factory was in the process of transfer from Detroit to Joliet. A void existed, and many newcomers rushed in to supply the demand. All of these, with the exception of the Pratt Manufacturing Company and the Animal Trap Company, were small operations with limited equipment, and their products in the main are undistinguished or unidentifiable as to origin.

Companies which are known to have offered for sale decoys of one kind or another include, among many others, the following:

Poitevan Bros., Inc.
 Pascagoula, Mississippi

Hudson Decoy Plant
 Pascagoula, Mississippi

Herter's, Inc.
 Waseca, Minnesota

Classic Woodcarving Co.
 New York City

Dan's Duck Factory
 Quincy, Illinois

W. G. Higgins
 Kansas City, Missouri

Sperry's Decoys
West Haven, Connecticut

Modern Decoy Co.
New Haven, Connecticut

W. D. Darton
Portland, Maine

J. M. Hays Wood Products Co.
Jefferson City, Missouri

Outing Manufacturing Co.
Elkhart, Indiana

Grubbs Manufacturing Co.
Pascagoula, Mississippi

Adams Decoy Co.
Hickman, Kentucky

Aschert Bros.
Los Angeles, California

J. P. Hendricks
Santa Barbara, California

David C. Sanford Co.
Bridgeport, Connecticut

Best Duck Decoy Co., Inc.
New York City

Some of these concerns did turn out excellent working decoys that constitute a study and field of collecting which will become of increasing interest as time goes on. The occurrence of a truly collectible item in this area of decoy making, however, is the exception rather than the rule. Such an exception are the Black Ducks shown in Plate 181. All too rarely, duplicates of these appear on the market and are eagerly snapped up. What little is known about them indicates that they are of recent origin, perhaps stemming from the 1920's, but they are extremely attractive to the collector.

In 1939 the Animal Trap Company of Lititz, Pennsylvania, purchased the decoy department of the Pratt Company who, in turn, had the records and equipment of Mason's Decoy Factory. The town of Pascagoula, Mississippi, had been selected as the site for the Animal Trap Company's decoy operation because it offered an abundant supply of suitable wood. But tragically, a fire destroyed all of the old records and patterns and some of the original Mason equipment.

Under the Animal Trap Company, the still-continuing line of the Victor-type decoys began their successful career. The last link with the decoy factories of the past was broken and a new era in decoy history began. Rubber, composition, and plastic productions would inevitably succeed the hand-carved and machine-turned decoys of the past.

MECHANICAL DECOYS

The latter part of the nineteenth century saw the United States Patent Office issue over seventy patents designed to make the life of every wild duck more hazardous. The fact that most of them were impractical did not deter the overeager and ambitious inventors. The most diligent search indicates that very few of these inventions were ac-

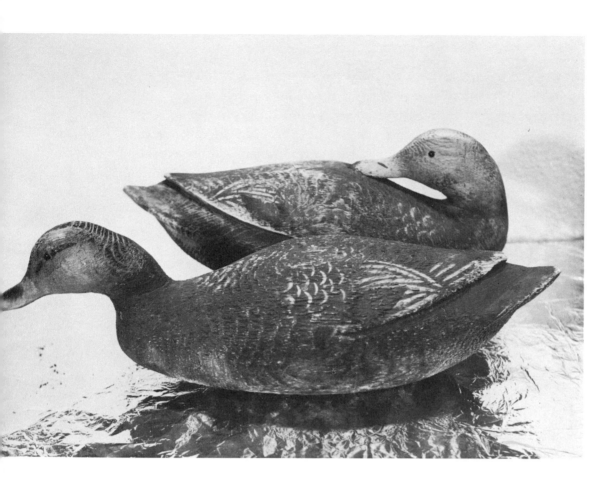

PLATE 181. Black Ducks of unknown origin. Similar Mallards have been found. The only clue to their origin is a partially obliterated yellow stencil on the bottom of one, on which the letters "EAST" are decipherable.

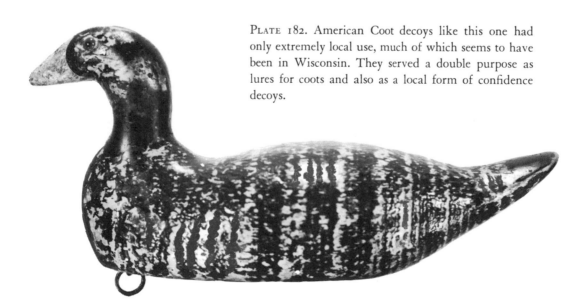

PLATE 182. American Coot decoys like this one had only extremely local use, much of which seems to have been in Wisconsin. They served a double purpose as lures for coots and also as a local form of confidence decoys.

tually placed on the market after the patents were granted, and of those that did reach the market place most were rejected by the hunting public.

There were mechanicals that dove, swam, quacked, flapped their wings, and wiggled their tails. Unfortunately, they had a short life. Freezing weather, tides, and currents, as well as seaweed, complicated their operation, and once the deadly corrosive action of salt water invaded their dainty mechanism the end was near. The field offers relatively little that is interesting to the decoy collector, or that was decorative; rather, it is a field of gadgets and oddments. However, there are exceptions.

PLATE 183. United States Patent Office specification for the folding

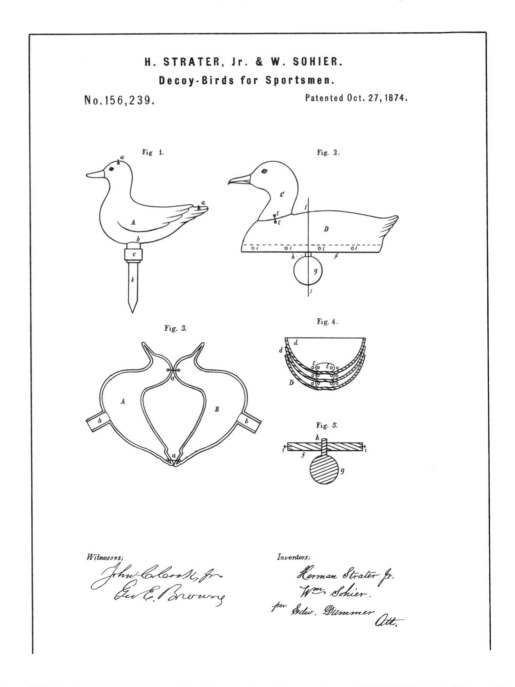

H. STRATER, Jr. & W. SOHIER.
Decoy-Birds for Sportsmen.
No. 156,239. Patented Oct. 27, 1874.

As far back as October 27, 1874, Herman Strater, Jr., and William Sohier of Boston made the most significant contribution, from the standpoint of both the sportsman and the modern collector, with Patent No. 156,239. (See Plate 183.) This patent concerns itself with the folding tin decoys that are known to every collector. The title "Improvement in Decoy-Birds for Sportsmen," was in its mild way an understatement.

This new folding method was used primarily with shore birds, and the varieties made under the basic patent rights include the Sanderling, Dowitcher, yellowlegs, Knot, and Golden and Black-bellied Plovers. After the patent rights expired, they were

decoys patented by Herman Strater, Jr., and William Sohier.

UNITED STATES PATENT OFFICE.

HERMAN STRATER, JR., AND WILLIAM SOHIER, OF BOSTON, MASSACHUSETTS.

IMPROVEMENT IN DECOY-BIRDS FOR SPORTSMEN.

Specification forming part of Letters Patent No. **156,239**, dated October 27, 1874; application filed August 10, 1874.

To all whom it may concern:

Be it known that we, HERMAN STRATER, Jr., and WILLIAM SOHIER, of Boston, State of Massachusetts, have invented Improved Decoys, of which the following is a specification:

Our invention relates to decoys, especially for birds, which are in so common demand by sportsmen; and has for its object, first, to so construct said decoys that they may be separated into parts, and that similar parts of several decoys may be set the one in another, or nested, for easy transportation; secondly, a device for readily setting up decoys on land; thirdly, to construct decoys for water-fowl that will float naturally.

Figure 1 shows a decoy to be used on land. It is made in two parts, A B, of sheet metal or other suitable thin material, the parts or halves coming together in the plane of a central vertical longitudinal section, and hinged at *a a*, as shown. These two parts are formed at *b b* into two semi-cylindrical portions, which make a tube when shut together. This tube has stretched around it a band, C, by which the parts of the decoy are held together, and by which, also, a supporting-stake, *k*, thrust into the tube and driven into the ground, is grasped.

Fig. 3 shows this form of decoy opened, and it is readily seen that in this condition several of them may be set one into another or nested.

Fig. 2 exhibits a form for the water-fowl. This is also made in the shell form, but of two parts; the one composed of the body D, the other of the head and neck C, to be separated entirely at the base of the neck. Eyelets E E are let into the sides of the neck and body, through which a string or wire is passed to fasten the parts together. To keep this decoy afloat a piece, *f*, of light material, as wood, is cut in a suitable shape, fitted into the bottom, and held by suitable fastenings, as *i i i*. A weight, *g*, having the stem *h* screwed or otherwise fastened into the piece *f*, keeps the decoy upright and properly balanced. A section, taken on the line 1 1 of Fig. 2, of the float *f* and ballast *g* is shown in Fig. 5.

Fig. 4 shows a section of the body D, taken on the line 1 1 of Fig. 2, and also shows other similar parts, *d d*, illustrating how the parts may be nested as stated.

The head and neck, of the form of Fig. 2, may be made to open, but being so small it is perhaps not necessary.

The decoys now in common use are made whole, and mostly of wood, and heavy. To carry any number of these is a sorry task for the sportsman. Moreover, it has been found difficult to make those for water-fowl ride the water naturally.

It is readily seen that our invention overcomes all these objections; that the decoys made as described, being very light and capable of being closely packed, many may be carried with the greatest ease; and that the parts are so joined they may be set up with the greatest facility.

We claim as our invention—

1. Decoys constructed of sheet metal or other suitable thin material, in parts to be separated for the purpose of nesting, substantially as described.

2. A decoy made of two parts, A B, hinged at *a a* and held together by the band C, substantially as described.

3. A decoy-bird composed essentially of two parts, a body, D, and head and neck portion C, the latter made removable, substantially as and for the purpose set forth.

4. A decoy-bird consisting of a body, D, head and neck portion C, float *f*, and balancing-weight *g*, substantially as described.

HERMAN STRATER, JR.
WM. SOHIER.

Witnesses:
EDW. DUMMER,
HORACE DODD.

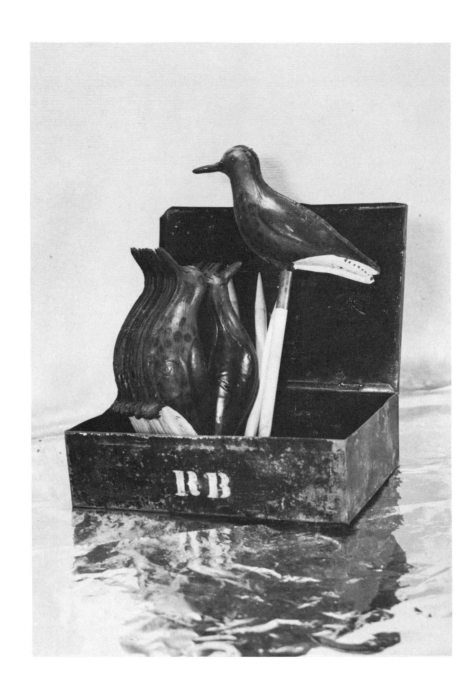

PLATE 184. Kit of tin "snipe," including stakes. The galvanized box bears the stencil "R B," indicating "red breast." This actually was the Knot, which was known by many local names.

stamped out in endless numbers by various companies, the last known supplier being the Brooklyn Sheet Metal Company of Brooklyn, New York.

These "tinnies" provide an interesting field for collectors. They offer a limited variety as far as species are concerned, but the various manufacturers present a pleasing variety of paint patterns. Those with the patent stamp on the inside are the best in quality and most desirable. They were always packed twelve to the box and sold with stakes included (Plate 184).

Less well known, and extremely rare in mint condition, is the duck variation of the all-inclusive patent. An example is shown in Plate 186. These ducks had patent date clearly stenciled on the inside. They never attained any degree of public acceptance, but the metal shore birds brought fame and some measure of fortune to the ingenious Messrs. Strater and Sohier.

Other patent decoys were wooden and wire folding contraptions which were patented and offered to the gunner during the 1890's. Two versions, basically the same, have come down through the years and are available to today's collectors. Plate 185 shows the three-way wooden stretcher version patented by J. W. Reynolds of Chicago, Illinois, the sole manufacturer. On small bodies of fresh water, they seem to have had

PLATE 185. Wooden stretcher with three scaup silhouettes, manufactured by J. W. Reynolds, Chicago. Extremely decorative, but impractical under the average conditions faced by the hunter. Their impracticality is proved by the almost mint condition of the examples that remain. Wire stretcher in the background made by Condon.

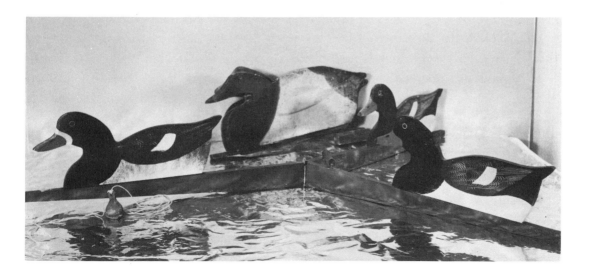

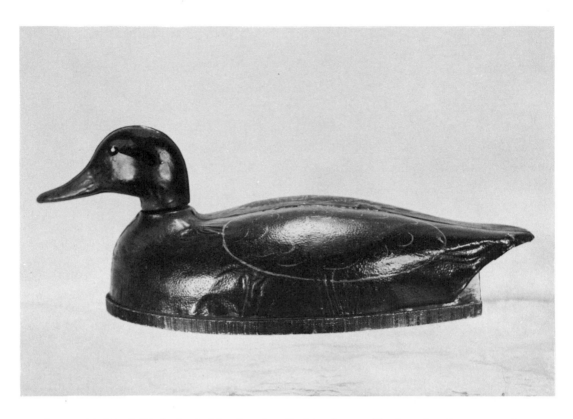

PLATE 186. Metal Black Duck like that described in the specifications for the patent taken out by Strater and Sohier in 1874. It is clearly marked with the patent date. A base board guarantees floatability.

some degree of success. Salt water would have quickly wrecked the light steel springs that kept the three silhouettes in proper position.

In the same plate is shown the Condon version of a three-way silhouette rack. An almost obliterated stamp indicates that its maker and patentee came from Aikin, Maryland. In this affair the three shadow decoys are arranged on wire spreaders. Both are desirable from the present-day collector's viewpoint, but the excellent condition of the few that have been found indicates that practical wildfowlers seldom used them.

I should also mention an ingenious invention that must have looked good on the planning board, and that looks good now on the collector's shelf, but looked ridiculous on the water. The Acme folding Mallard decoy was patented in October, 1896, and manufactured in St. Louis, Missouri. Over a wooden base is fastened a folding wire form operated by an exposed lever on the side of the decoy. All this is covered by a printed muslin shape resembling the Mallard in outline and coloring. A push on the lever—and the invention springs into the form of a duck and is ready for the day's sport! Later, another push collapses the whole thing, and that's that. They came packed twelve in a small suitcase for easy carrying. The Acme folks tried to think of everything to make it easy for the hunter.

XVII *Beginner Beware!*

THE PATH OF ANYONE embarking on a collecting program, regardless of the field, follows the usual precarious but fascinating course. Assuredly the decoy collector must travel his first few miles the hard way. All manner of obvious, and some not so obvious, frauds have turned up in antique shops, auctions, and the sheds and boathouses of so-called "old-timers." The unknowing or unsuspecting collector can purchase heads and bodies that have recently been "married," repainted items "antiqued" to simulate collectible originals, and cleverly faked new replicas of old masterpieces.

More subtle, but equally fraudulent, is the carving or stamping of a fine old name such as "Crowell" on an old but obviously inferior decoy—one which never knew the hand of the alleged maker.

Let us examine how the more obvious fakes are produced, with a view to helping the new collector feel more secure when he makes a purchase.

First, it is well to remember that the body of any decoy is sturdier and more durable than the head and neck. Old, headless bodies far outnumber corresponding decoys that have come down the years complete and intact. Sometimes, old detached heads are put to rest on these headless bodies. When this occurs, trained eyes can detect a difference in the paint or the degree of weathering on the respective parts. Also, traces of new glue or newly filled nail holes can give the trick away.

One exception must be noted. As we have seen in an earlier chapter, the use of swan decoys goes back over one hundred years. In these decoys, because of their size and weight, eventual breakage of the neck where it joined the body was almost unavoidable. Periodic replacement of the neck was common if the swan decoy continued in use. Thus, many old swan bodies have necks of a later date, but are still collectible items . . . in many cases, the only swan decoys available.

One of the first important rules for the collector in determining the authenticity of an old decoy is to *study the paint for age*. Any repainted decoy must be suspect because

of the concealment factor in new paint. The obvious dodge is to "distress" or sandpaper the recent coat of paint to give it an old appearance. Feel the paint carefully. If it has the "feel" of new paint, or has the smell of paint, pass it up. Many good, old decoys are found that were repainted in former years, and are desirable, but when an attempt is made to conceal the fact of repainting, then the buyer should beware.

When the decoy in question is a duck or goose, one can tell more about its original condition by studying it with its bottom facing one than from any other angle. Note especially the condition of the paint under the head and bill, since there is less wear in that area than any other. The original paint generally remains there as evidence. Also, the paint remaining under the lead weight can give helpful clues.

The second important rule in checking a decoy offered for sale is to *study the style for authenticity.*

One foolproof defense against being taken in by the fraudulent names and initials sometimes placed on old but ordinary decoys is to study the style of carving and painting used by the masters of the decoy trade. Each master decoy carver worthy of duplication had a distinctive style, and anyone starting to collect seriously must study these styles and familiarize himself with them. There is no shortcut to this, and pictures alone will not answer the problem. Since such "name" decoys bring big prices, the collector should take the time and trouble to visit with an experienced collector or dealer, or go to a museum, to study these items. Such consultation often leads to lasting contacts and sincere relationships with senior collectors and reliable dealers. Only in that way can the small but troublesome problems on borderline questions be answered. You will also find that the joy and pleasure of a prize acquisition can be enhanced by the mature judgment of one who has made his mistakes before you. Such a relationship is one of the human benefits in any field of collecting.

BUILDING A DECOY COLLECTION

Building a good decoy collection is not easy. Once the collector has acquired the background and knowledge to pass on the soundness of most decoys, he must face further and equally important decisions.

Gone are the days when an accumulation of good to excellent decoys could be gathered up by spending a weekend in an area where duck hunting prevailed fifty or more years ago. Even if great good fortune favors one and a sizable rig is found, the price factor will prevent all but the wealthy or foolhardy from buying more than a few.

Therefore, the collector is soon aware of two factors that will affect his purchases. One is the scarcity of truly collectible decoys and the other is the investment involved.

The financial outlay may be cut down in some isolated cases by using unlimited

time and energy—together with almost endless miles of travel—to acquire a few prizes. Calm reflection following such enthusiastic journeys usually indicates that these "bargains" came very high when all the cost factors are considered. Of course, if such junkets bring other satisfactions, they may be well worth it.

For this and other reasons, it is helpful when forming a decoy collection to stop and *ask yourself what your specific objective is*. The average collector, aware of the limitations noted above, has a big decision to make regarding his objective. What kind of decoy collection will he strive for, and to that end, what decoys will he seek?

First of all, one will do well to consider the entire decoy field and the classifications into which it may be divided. These would include ducks, geese, Brant, and shore birds; also swans, crows, and various "contentment" items. All the foregoing are available in both handmade and factory types.

The handmade decoys alone are available in so many local variations that their number is legion. To consider striving for a comprehensive collection consisting of prize examples in *all* groups staggers the imagination! Its size would be unwieldy and its cost prohibitive, if, indeed, the material is still available . . . and this is doubtful.

These facts are not intended to discourage anyone who is starting a collection, but rather to direct him to a carefully considered and geographically accessible source of decoys. Such a decision will result in a collection that will have genuine meaning and be a source of real satisfaction to its owner.

A special regional collection will have much more interest and be more satisfying to the collector than isolated examples gathered haphazardly from one end of the country to the other. Therefore *specialization* is recommended, and many fields for specialization are open. Among the many possibilities, for instance, would be Mason's Factory decoys, all in original paint; shore birds of the New England area; or, if you wish to cover a large geographical area, consider the possibilities of, say, a fine group of mergansers. It would be hard to imagine a more interesting or varied collection . . . and whether they were Red-breasted Mergansers, Common Mergansers, or Hooded Mergansers would make little difference. The important thing is to plan one's collection and *specialize*. Happy Hunting!

XVIII *American Decoys: Folk Art*

by Quintina Colio

DECOYS ARE FAITHFUL in nature to the purpose for which they were created, but describing them poses an unusual challenge. With the passage of time their original purpose has receded, and new values have emerged. They are folk art transformed from material facts and values . . . as though some mysterious force had created whittlers and carvers and then had absorbed their winged shapes into the contemporary scheme of sculpture. Decoys are a part of sculpture and must be treated as objects to be enjoyed.

We recognize that these forms are relevant to the goal of deception, but superimposed upon this are the artistic concepts they reflect. The decoy was clearly all-important among the people to whom this art belonged. The origin of each decoy style belongs no doubt to a specific region and people, peculiarly endowed with artistic ability and with definite traditions of their own.

Each style must have been more compatible with the temperament of the area to which it was indigenous. Its artistic quality was congenial to the hunter's tastes. A great change in materials or structures, such as the introduction of hollowed-out, laminated, and cork-bodied decoys, did not have a profound effect on their artistic quality. Art traditions were well established.

The art of the American decoy had no sudden changing, but its unbroken development was like the flow of a winding river into which there came, now and then, tributaries from hidden springs. This decoy sculpture, made without complacent thought as to its artistic future, has resulted in an opulent visual image. All decoys reflect a unity of purpose in the work, for they are all aimed at realism, and the purpose of the gifted whittler or carver was connected with his own survival and often that of his family.

American decoy carving was considered utilitarian, and most of it is devoid of

240

time-consuming elaboration. The decoys fulfilled a purpose and they were carved for more than a display of skill. The greatest number of decoys were fashioned by the hunters during long winter evenings. The art of decoy whittling was truly carried on in a social setting; its cultural content was part of the gatherings at the local general store, the Life Saving Stations that dotted our coastline, and the isolated shanty of the professional hunter. Later, decoys were made by professional carvers using more elaborate tools; following close behind were the factory-made decoys turned out by lathes, from tiny beach birds to "heroic" swans.

The only important subjects of prehistoric art are those creatures closely associated with the daily living of Paleolithic man. Hunting the quarry that supplied his subsistence and comforts was the chief objective in his primitive mind. It was natural that he should depict primarily these beautiful animals of great strength, speed, and menace. In those days the problem of safety and the hunt for food often required large numbers of men. The American wildfowler, with his use of decoys, had the advantage in more ways than one. Yet in both these widely separated ages, at least some men depended on game for support and left genuine legacies of inspired art.

In seeking primitive decoys, one must set aside sophisticated training in order to appreciate and communicate with a cultural ideal. Sculptural form without rhythm is not collectible, for the good reason that these carvings represent live creatures. Whether they are depicted awake, asleep, preening, or running, they are never too far from nature. An honest effort by a carver immediately attracts our attention, while we reject distortions and futilities by lesser hands. An object is not of artistic value simply because it is primitive. It must be true to its purpose, yet have a surprise quality displayed in such widely varying features as line, dimensions, scale, texture of materials, and color. There is no formula or stereotype for primitive sculpture; its strength lies in the original concept of its form and color pattern.

Massiveness, simplicity, and subtlety dominate the artistic image of Down East decoys. Theirs was a unique structure that promised durability and seaworthiness. Their fame was well earned, and today many of these decoys are still in excellent condition. Inletting of the head and neck to the body was the superior feature, an architectural detail that required an expert knowledge of wood for its correct use. This feature, a peculiar tradition in Down East decoys, does not affect their aesthetic quality. The carver uses massiveness to portray the boldness of the creature. An authority, he interprets the purposeful nature of the decoy in a sculptural form with subtleties and simplifications in rhythm. Consider, for example, the hen American Eider shown in Plate 187. Its maker bestowed upon it all his skill and talent. Note the simple, undulating shape, the round, textured surface, and the maker's respect for the beauty of his subject. The serenity of this decoy was not unconscious, but was deliberately added by the keen hunter-carver.

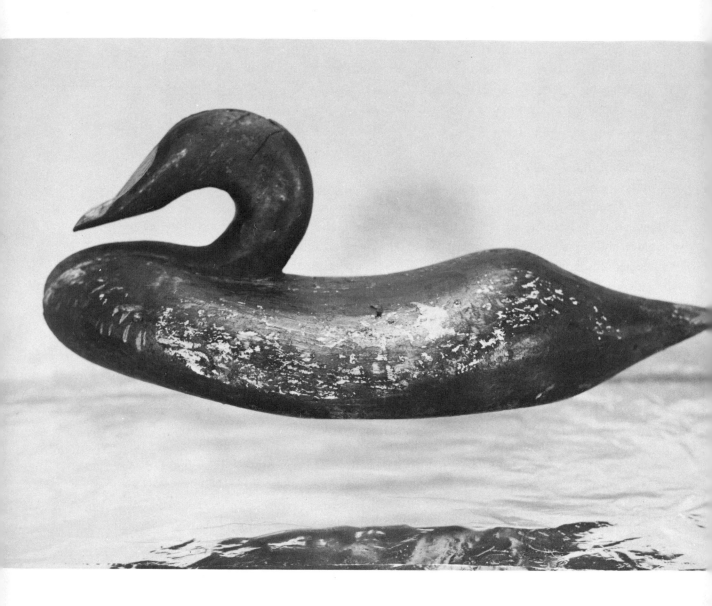

PLATE 187. American or Common Eider hen from Down East, that fulfills every requirement for a decoy and has strong esthetic appeal as folk art. This decoy, which is greatly oversized, is very old.

The special refinements of Cape Cod decoys are associated with movement, balance, and proportion. Perhaps the charm of each natural action of a bird was more important to the maker than "just a rig of stools." Every normal action was acceptable: running, feeding, trilling, preening, stalking, snoozing, and even, though rarely, the manifestation of alarm. This favored style of naturalistic detail is found in the carving of the breast, the feathering of the primaries and tail coverts, the suggestion of thighs, and definition of the mandibles. This distinctive carving did not lessen the importance of the impressionistic style of painting used, a technique that produces an extraordinary feathering effect. Upon close inspection, we see that the application of color next to color shares with the carving in forming the contours of these lifelike birds.

The skilled craftsman who treated decoys naturalistically, with an emphasis on truth, sometimes achieved a sculptural form of exceptional warmth, bold, virile, and seemingly ready to take flight. Consider the Crowell Canvasback in Plate 62. This feeling for color and form illustrates a classical taste. From his work one could easily see that the carver was also a naturalist. Such features as the texture, grooving, and painting, done in free, impressionistic mood, all contribute to the unity of color and contour.

Occasionally, as shown in Plate 67, New England produced decoys that show an extreme style of decoration. The fluidity of line is exaggerated, the color is applied as a decorative motif, and the feathering is dotted in a formal pattern. This stylistic quality is strangely suggestive of archaeological artifacts from Asia Minor.

The wildly crested Red-breasted Merganser seen in Plate 54 reflects a highly personal style of carving. This gives a most impressive sense of novelty that borders on caricature, yet is rich in poetic feeling. The carver, as though tempted to veer off into fantasy, exaggerated the natural dimensions, appealing to the beholder's sense of touch.

Decoys from the Stratford area (Plate 164) are carved with a refinement that rejected any excess line; there is no conflict between the aesthetic and practical, and no timidity. The Whistling Swan illustrated shows a combination of design and material, for performance, that have resulted in a creature of graceful repose.

The painting of decoy plumage led to the development of a rhythmic technique similar to graffito. This style reflects a carefully combed feathering with delicate shadings, as shown in Plate 48. These decorative areas are juxtaposed nonobjectively with tonal arrangements offering a design in gray textures.

Long Island offers a rare collection of uninhibited carvers with no uniform regional style. The informality of a sketch in wood, a Herring Gull riding the waves (Plate 160), suggests the quickness of the jackknife lest the bird fly away. This piece of folk sculpture is in extraordinary contrast with the very formalistic style of the Brant shown in Plate 8. Only a craftsman of exceptional artistic taste and architectural sense could

have realized the design, and plumage painting of this handsome bird that seems to glide past, a form patterned in grays.

The minute cork beach bird in Plate 84 not only shows an economy in material and physical energy, but also offers a rare surface quality surprisingly realistic in effect. The shore birds in Plate 138, plump and content, have to a marked degree that indefinable essence which even in conventionalized postures gives the beholder a feeling of life and movement. Conformation and texture suggest intense vigor and conviction in design.

The surprising lightness of New Jersey decoys gives one cause to ponder on the unexcelled skill of the craftsmen. The hollowing out of the body was important to reduce the weight of a rig, but how "close to the rind" did they dare to carve? An expert knowledge of wood was required of the master of this fine art, and a number of superb examples are still in excellent condition despite the rough handling required of decoys. Exceptional wildfowl decoys are Jersey Brant and geese such as the one shown in Plate 8, hollowed out, well painted, and notable for their graceful and beautiful lines. Such a Brant almost seems to suggest a racing sloop, and a rig of geese, a whole fleet of schooners.

New Jersey shore birds were individualistic in style, for each whittler enjoyed his own manner. One would feel it was important to exaggerate the flatness of a plover's head, another that the commanding touch of a huge, hooked bill was necessary to the carving. Yet there must be no fantasy; one must consider the truth. Only a really great artist could have executed such a strong, proud bird as the Cape May curlew at the right in Plate 114.

The inherent quality of the decoy shown in Plate 30 is utilitarian, but the artistic instinct of the painting and sculpture raises the performance to the level of an art experience. It is impossible to deny that the whittler felt the boundless joy of creativity. Content, shrimp-fed, and with all seams popping, this dumpling too is "overindulged" in design. Holding it in the hand, it suggests the organic conformation of an outsized chestnut, with an added knob for a head, while an extra snip suggests a tail. But the balance of color in the design is complemented by the use of graffito for texture. The color pattern is well controlled in composition in relation to the sculptural form.

Unlike the prehistoric man, the American hunter offered no ritual of propitiation, no fertility rite intended to insure the propagation and multiplication of the quarry on which his very existence might depend. Instead, almost defiantly, the hunter delivered the final shot from an already overheated gun to fell the last Passenger Pigeon (Plate 41). These were birds of beauty so rare that it seems to have been God's thought to create sunsets on the wing, sunsets to perch in one's tree. Two slivers from a pine log, shaped and held upended like symbolic exclamation points, are these pigeon decoys. In these silhouettes, bold in artistic design, the awareness of rhythm draws the eye to an

exquisite attenuation, a movement relating the form to the space around it. This unconscious concept executed by an untutored hand reflects the impulses of an individualistic rhythm pattern and a taste for natural simplicity in the manner of Rousseau.

An effect of direct transposition from drafting board to wood block is illustrated by the Delaware River decoys. Here the conformation is reduced to the least number of lines, as an aesthetic frame for the decorative carving and paint style. The crisp incising for which the decoys in this area are famed has the decorative air of cut-paper sculpture. The carved details are not executed with a free and romantic technique, as in the Cape Cod style; their design is symmetrical and studied, with the shadows playing a part in the decoration. Plumage is patterned meticulously; one becomes aware of a count of X feathers per square inch, a primitive effect of embellishment. The sophisticated palette used is an inspiration in luxurious selection of color that identifies a decoy with the Delaware River (Color Plate VI).

Early rules for decoy structure were set down by Maryland carvers, but their prolificness and imagination were such as to make imitation impossible. The magnificent head of a Canvasback decoy like the one shown in Plate 121 is like a signature reading "Maryland." The Snowy Egret decoy from Maryland shown in Plate 37 is a reminder that life cannot exist without art. This piece of folk art succeeds on a creative plane, a design springing from a naïve aesthetic impulse, its strength softened by an almost sentimental quality.

Iron decoys (Plate 12) might seem to offer no complexity, but their superb, textured covering comes from weathering and welcome neglect. Even the encrustations of the colorful rust suggest effects one treasures in cultural artifacts from archaeology.

The folk art of Virginia decoys is replete with harmony and nobility; harmony in that it served man's living needs, nobility in that, though inspired by necessity, it aroused the latent talents for remarkable sculpture. In its creative power it serves man a second time, but with a new nature, that of art. The collector takes great pride in displaying these beautiful birds representing a portion of America's background and traditions. Notable is the compact little flock of wooden plovers shown in Plate 131, whose bold faceting reveals a beauty and sincerity of line and form that represents a simplification of the truth in nature. They are pure forms of visual enjoyment.

The Hooded Merganser decoys depicted in Plate 137 suggest paper cutouts assembled in abstract. As a pair, they seem a wild delusion afloat, pretending to be chased by the furies. They are marked by a feeling for wood, vigorous color, and design. Their curves and sharp edges are characteristic of the sure hand executing the only folk art native to the area.

The strong tradition of fine structural inletting indigenous to New England carving, but here transferred to Virginia, is illustrated in the decoys by Nathan Cobb shown in Color Plate VII. With it, an authoritative and bold style of painting merges to pro-

duce an atmosphere of grandeur. Any departure from the truth in nature is veiled by the persistence in these decoys of nature's calmness and serenity.

The tendency to elongate the bird figure by means of the artistic device of turning extremities such as bills, necks, and tails into decorative features, is illustrated in the yellowlegs from Virginia shown in Plate 135. Here the neck is important in a design characterized by simple but fluid lines, the result of long observation of the living bird. Full of life, though the representation is stylized, this unusually sophisticated composition shows great originality in its feeling for nature. It is strongly reminiscent of Etruscan sculpture.

The untutored but gifted hand of a man who loved nature and was grateful for the existence it offered him and his family obviously carved and painted the exotic swans in Plate 141. Such swan carvings have an almost mythical quality, a grandiose style of figure and a dynamic effect that gives them distinction, especially when well weathered and bleached. North Carolina and Virginia lead the field in oversized cedar sculpture.

An inspired pair of yellowlegs are illustrated in Plate 188. The sharp planing uses the faceting and dark shadows for purposeful concentration to form the sculptures. The ingenious though untutored hand of this carver produced three-dimensional creations with a semblance of careless haste. Rather than copying from life, the primitive hand, with all its limitations, could yet infer a cubistic sensitivity.

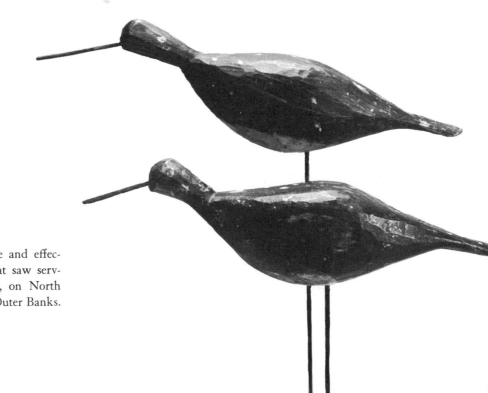

PLATE 188. Simple and effective yellowlegs that saw service at Whalebone, on North Carolina's lonely Outer Banks.

The simplicity of the Mason's Factory decoys in Plate 177 displays an architectural relationship. All contour is austere and modern in discipline, with great resultant artistic strength and individuality. The colors are classic in their luxurious, gemlike quality and give an effect of rich ornamentation. This style of painting is fixed in a traditional, rather rigid pattern, but there is no impression of monotony. The bifoliated touches of color for the specula are found in every Mason decoy. (See Color Plate VIII.) The painting of these decoys offers something of the feeling of Oriental calligraphy, whether the plumage is fine in detail or bold and sweeping.

Though wood was the prevalent material used for decoys, Plate 184 illustrates the use of metal in a new form of duplicity. Since the only handwork done on a metal decoy was the painting, these were designed to imitate wooden decoys, which in turn tried to duplicate the live bird. It is a rare *trompe l'oeil* that imitates another. Spread-eagle, the bird becomes a sculpture in bas-relief, seemingly abstract in design until closer observation shows us the creature it was intended to represent. These decoys strongly suggest nonobjective art, the double paint patterns, in juxtaposition, presenting an absorbing aspect. The concave sides are also decorative, since they are black and silhouette crisply. This metal decoy has a distinctive individuality in its suitability to its material and the ingenuity of its functional design.

Kinetic aquatic bird sculpture for a pond, or hung from a low branch, will add the interesting quality that makes a garden so charming. The three-armed forms shown in Plate 185 support ducks in silhouette, casting sharp shadows as they float idly. Mobiles had a practical use for many years before they assumed the status of a decorative art. A realistic technique of painting makes it impossible for a viewer at long range to determine the real dimensions of the ducks, whose actual thickness is one quarter inch.

The unsung folk art of decoy making has survived with all of its traditions and has passed into a fresh phase in the work of such eminent contemporary carvers as Lloyd Johnson of Bay Head, New Jersey, and Harold Haertel of Dundee, Illinois. In their models one sees the same intimate connection between the inner personality contemplating nature and the projection of it as art. The inspiration behind such a work as the Green-winged Teal shown in Plate 153 upholds tradition and maintains the old standards of excellence in the handling of tools, yet it is at the same time personal, alert, and aware of its contemporary character.

Today the production of handmade decoys is continued by a few specialists as an isolated form of craftsmanship. Otherwise, this eminently American form of folk art has disappeared. The individuality and variety of the past have given way to mass production now that it is possible to imitate these charming creations by machinery. A folk art that formerly contributed to the livelihood of humanity has now become the concern and pleasure of the collector.

Appendix: THE MACKEY METHOD
OF DECOY EVALUATION

WHEN I ORIGINALLY published in the *Decoy Collector's Guide* the method of decoy evaluation described below, the editor, Hal Sorenson, prefaced it with the following sensible comments which I repeat here by way of background:

> Decoy collectors have many reasons for adding particular decoys to their collections. Some of us insist on decoys in perfect condition, or in original paint only, or by well-known makers only, or pre-1920, or certain species only . . . or some of these specifications may be combined with others not mentioned here. Many of us collect on a purely emotional basis; i.e., "I collect what I like, regardless of maker, condition, rarity, etc."
>
> But for whatever reasons we select certain decoys, we tend to mentally evaluate and compare them with other decoys. When it comes to trading, especially, frequent disagreement arises as to the relative value of specific decoys. I am not talking about monetary value, but rather, the collector value of one decoy to another.
>
> Published here is the first guide we've seen that attempts to evaluate decoys in concrete terms on an objective, non-emotional basis. Developed by William J. Mackey, Jr., . . . it outlines the many factors of evaluation which should be considered by the serious collector. The author readily states that the system is not "foolproof" and will be difficult for the neophyte collector to use. However, we believe it gives all of us "food for thought" and will tend to make us want to learn as much as possible about each of the factors which combine to make a decoy "collectible."

Let us consider, then, what these factors are that are most important in making a decoy collectible. First, it may be said in general that our approach as collectors is not one of judging decoys as working decoys. In other words, they should not be appraised from the viewpoint of a judge in a contemporary decoy contest. The qualities that make a decoy delightful and collectible may be quite different from those that make it a success from the standpoint of the hunter in the blind.

With this understanding, we may conveniently evaluate the basic factors in decoy evaluation by means of a simple chart like the one shown on page 250. This system is

certainly not foolproof and anyone using it must sincerely and sanely appraise the various factors under consideration.

In planning an evaluation chart, I must presume a certain amount of intelligence and collecting background on the part of the person charting a decoy. For example, an elementary knowledge of the various makers is imperative.

Under the various headings on the chart I shall try to enumerate the major factors and give helpful hints such as the collectors whom I know would consider in giving their appraisal of a specific item.

The first category, that of the maker, immediately brings to mind Elmer Crowell, Charles ("Shang") Wheeler, Harry Shourdes, and Charles Perdew, among others. Since they were at the top of their field, an identifiable decoy by one of them would rate ten points. However, many decoys have been carved with no less skill and finesse, by men not so well known. For example, one can name Nathan Cobb, Lem and Lee Dudley, Joseph W. Lincoln, Albert Laing, Henry Grant, and Roland Horner. These equally skilled craftsmen, therefore, must also rate top grading. Rating perhaps eight points would be H. Keyes Chadwick, Ira Hudson, and Walter Brady.

Local makers producing sound, but undistinguished decoys, should rate about halfway down the scale, while two or three points are certainly all that can be given to clumsy "clunkers." The same idea can be followed through with the factory-made items—Mason "Premiers" and Stevenses taking the top spot, and the heavier and less distinguished decoys rating in proportion to their honest merits. As an example, Mason "Challenge" and Evans decoys might perhaps get seven or eight points, with the Mason No. 2 and Animal Trap Company decoys rating two or three. Occasionally a superb decoy appears, especially among the shore birds, whose maker is completely unknown. If the quality of such a decoy is equal to that of a top maker's work, it may be rated ten, but mark it "maker unknown."

The second factor, the rarity of the decoy, is of course important and is still subject to change. Some decoys considered "rare" only a few years ago now turn up in considerable numbers. This, however, is the exception, and certain basic conclusions may be arrived at.

First, one cannot judge rarity on a local basis. Perhaps the rarest decoy in the Midwest would be an Oldsquaw, but Oldsquaws turn up in considerable number on the Northeast coast. So consider the rarity of the decoy from a national viewpoint. It is worthy of note that some makers of both factory and handmade decoys specialized in certain species and almost completely ignored others. For example, a Harry Shourdes Canvasback, which, so far as I know, no one has ever seen, would rate ten points. A Shourdes broadbill or scaup, however, would rate only one, as he made thousands of these decoys, the most common items he turned out. To carry this further, a Harry Shourdes feeding goose would rate ten points, but his conventional hollow goose, the

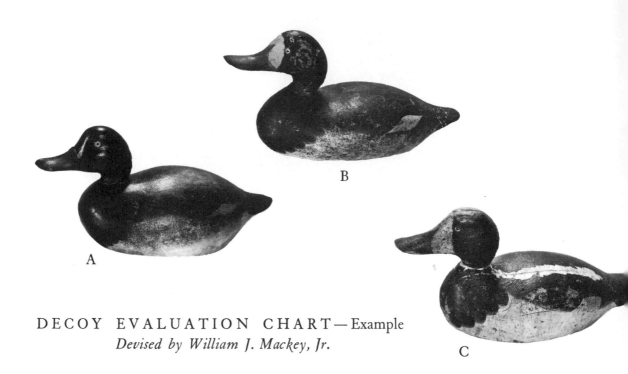

DECOY EVALUATION CHART—Example
Devised by William J. Mackey, Jr.

DECOY	MAKER & POINTS	RARITY	CONDITION	TOTAL POINTS	PLUS & MINUS COMMENTS
A. Greater Scaup Drake	Mason Premier 10 points	8 points	9 points	27	+Oversize model +"Duck" and Drake available
B. Greater Scaup Duck	Mason Challenge 7 points	5 points	7 points	19	+Overall pleasing condition, no cracks
C. Greater Scaup Drake	Mason No. 2 2 points	2 points	3 points	7	+80% original paint −Painted eyes −Disfiguring crack

type of Shourdes goose most commonly found, would rate low on the rarity scale.

This category has no relation to the excellence of the item, but is planned to keep in perspective the frequency with which the item turns up and its relative value compared with the maker's normal output. Even when the maker is unknown, this

rarity scale may be used intelligently if you have a background in the subject and a general knowledge of it.

To cite an extreme example in this matter of rarity, some years ago two ducks about which no historical facts could be learned were picked up on Long Island. They were average decoys in every respect, but they happen to be identifiable from the original paint as replicas of the now extinct Labrador Duck. They rate ten points under rarity.

The next category, "condition," will probably cause us less trouble than the others, ten points being reserved for those items in unused original condition. This would apply, for instance, to an Elmer Crowell bird that had always sat on a mantel or a Mason found wrapped in its original Detroit newspaper. Repainted birds, however, will cause us some trouble. Within this group the main consideration will be whether the original patterns were followed in repainting, so as to give the true picture of the original decoy.

Factories such as Mason's Decoy Factory and the Graves and Stevens shops can boast exceptional painting, with color tones and textures which cannot be duplicated. When these or similar decoys are repainted they must drop to the bottom of the list, since in their case the original paint plays such a large part in what we refer to as condition.

Any repairs whatsoever will detract from the top rating in proportion to their extent. I would suggest that the loss of a bill should take off at least two points; repairs to the tail should be treated similarly. Any cracks, scars, or disfiguring shot marks are grounds for devaluation.

Factors worthy of consideration in the fourth column, headed "Plus and Minus Comments," cover the widest and most varied range. It is impossible to anticipate all of the characteristics which make a decoy collectible. This category allows the widest latitude in outlining additional points regarding a decoy that make it more or less desirable. Some suggested points are listed below, but by no means do they exhaust the field:

Historical associations
Decoys in unusual poses, such as sleepers, preeners, and feeders
Unusual features of construction
Unusual materials used in construction, such as whalebone bills for shore birds, or
 surface coatings such as burlap, skin, and seaweed
Paint techniques, such as shading and special textures

Space is allowed on the evaluation chart to give a full description of such special characteristics, which may make an item unique and particularly desirable, or lessen its relative importance.

AFTERWORD

A Remembrance

IT WAS IN THE SPRING of 1964 that my father decided to write this book, and I remember it well. I was a sophomore in college then and I first heard about the project during one of my father's weekly telephone calls to me. Never one to mince words, he said simply: "Kit, I've decided to take early retirement and am leaving Minwax to write a book on the birds." (Minwax was the company he worked for, and the *birds,* as we called them, almost as if they were part of the family, were the decoys.) I was stunned by this bold move and must have showed it because my father continued: "Don't worry, nothing's going to change. I'm just going to devote myself full time to the decoys."

On the surface he was right, not much did change, but on another level, watching my father write this book was inspirational. For the first time he was doing exactly what he wanted to do—devote all of his time, energy, and talents to the subject of decoys. It was a joy to see. He loved every moment of it, and it never was a chore. He recognized and appreciated this rare opportunity he had and that few get and didn't squander a minute of it. Every morning after brewing a fresh pot of coffee, he would sit down at the kitchen counter and start to work. He used a yellow legal pad and would write in longhand with a newly sharpened pencil. His handwriting was strong and handsome, and he was very organized and neat, so there was no mess. There weren't any of the usual writer's symptoms, either, such as writer's block. My father *loved* writing this book. Every so often he'd look up from his text and discuss what he was doing and ask for advice or read a passage to see how you liked it. When it was done, I was presented with a lovely green-leather-bound edition with two golden shore birds on the cover for my own. It was a beautiful moment.

There was talk of another book after this one, and my father asked that I do it with him, because I am a writer myself. Unfortunately he died before the project got under way. It would have been not only a great honor to have collaborated with him but great fun. I'm sure there would have been a third book, too, with my brother joining in, for he has grown up to become a photographer, and I know Dad would have put him to work. Luckily, though, we have *American Bird Decoys*, for it remains the definitive work on the subject. It was my father's hope that it would educate and inspire its readers. It's my hope that with this new edition, my father's knowledge, enthusiasm, and influence will live on.

KATHRYN H. MACKEY

1986

252

Index

Page references to the illustrations and captions are in italics; references to the color plates are in roman numerals.

Accomac, Virginia, 157, *158*
Adams, Frank, 73
Adams Decoy Co., Hickman, Ky., 230
Alexandria Bay, 106
American Coot, 25
 decoys, 25, *26*, 182, *231*
"American Decoys: Folk Art" (Colio), 240–247
American Egret; *see* Common Egret
American Eider; *see* Common Eider
American Merganser; *see* Common Merganser
American Widgeon, 136
 decoys, 25, 27, *138, 148,* 149
Anger, Ken, 109–110, *110*
Animal Trap Company, Lititz, Pa., 228, 229, 230, 249
Appel, Bud, 192
Applegate family, 116, *116*
Armstrong Stove and Foundry Company, *32,* 32–33
Aschert Bros., Los Angeles, 230
Assawaman Island, Virginia, 37, 157, *158,* 159, *159*

Bailey, Clarence, 85
Baldpate; *see* American Widgeon
Baldwin, John Lee, 71, 98–100, *99,* 101
Ballance family, 170
Baltimore, Maryland, 142
Barber, Joel, 121–123
Barkelow, Lou, *55,* 119–120, *120*
Barnegat, New Jersey, *117,* 118–124, *120, 121, 122, 123,* 131, *161*
Barnegat Bay, New Jersey, 112–134, *115*

Barnes, Harry, 146
Bay Head, New Jersey, *114,* 115
Beach Haven, New Jersey, 129
Bell, "Mocker," 137
Bellport, Long Island, 104
Bessor, Philip, 54–55
Best Duck Decoy Co., Inc., N.Y.C., 230
Birdsall family, 115, 119
Birdsall, Jean, 115
Birdsall, Jess, *123,* 123–124
Birdsall, Jess (Mrs.), 124
Birdsall, Nat, 115
Black, Charles, 138–139, *139*
Black-bellied Plover, 46, 134
 decoys, *18, 35, 37, 40, 42, 42,* 46, *51, 52, 72, 84, 87, 88, 102,* 119, *124, 127,* 132, *135, 158, 159,* 233; III, IV
Black Duck, 27, 31, 112, 167
 decoys, 25, 31, *65,* 66, *67,* 69, 70, 77, 79, 80, *81,* 84, 89, 103, *104,* 116, 121, 126, 127, 129, 130, 131, 132, *133, 138, 140,* 163, 186, 211, *212,* 230, *231,* 236
Black Scoter; *see* Common Scoter
Blair, John, 138
"Blair" decoys, 138, *138*
Blue Goose, decoys, 25
Blue-winged Teal, 111, 179
 decoys, 25, 27, 182
Brady, Walter, 156, *157,* 249
Brant, 28, 105, 111, 112, 118, 152, 166
 decoys, 16, *16,* 21, 24, 25, 27, 28–29, *29,* 31, 32, 33, *68,* 77, 105, 120, 125, 126, *128,* 129, 133, 134, 153, 160, 163, 165, 172, *192,* 212, 213, *214,* 238, 244; VII

Bronsdon, Mr., 80, 81
Brookhaven, Long Island, 104
Brooklyn Sheet Metal Company, Brooklyn, 235
Brown, Mr., 123
Buff-breasted Sandpiper, 188
Bufflehead, decoys, 25, 27, *88,* 89, 126, 182, 215
Bullhead Plover; *see* Black-bellied Plover
Burr, E., 40, 87, *88*
Burritt, F.; *see* Laing, Albert
Bush River, 142

Calico-back; *see* Ruddy Turnstone
Cambridge, Maryland, 146
Cameron, Glen, 190
Canada Goose, 28, 83, 112, 167, 188, 194
 decoys, *16,* 25, 27, 28, 31–32, *34,* 70, 84, 85, *85, 86,* 109, 120, *122, 123,* 126, 129, *129,* 149, 153, *157,* 182, 188, *192, 214;* VII
Canvasback Duck, 31, 105, 106, 112, 142, 143, 145, 146, 150, 170, 174, 178, 179, 183
 decoys, *16,* 25, *26,* 27, *34, 81,* 109, *110,* 113, 143, *144,* 145, *145, 147, 169,* 170, 172, *173, 174, 181,* 182, 186, 190, 243, 245, 249
Cape Charles, 150
Cape May County, New Jersey, 55, 134, *135*
Carman, T., 101
Chadwick, H. Keyes, 73–74, *75,* 85, 249
Champlain, Lake, 106

Chesapeake Bay, 142–149, *145*
Chincoteague Island, Virginia, 159, *161*
Classic Woodcarving Co., N.Y.C., 229
Cleveland, Grover S., 143
Cobb, Albert, 153
Cobb, Elkenah, 152, 153
Cobb, Nancy Doane, 151, 152
Cobb, Nathan, 17, 30, 152, 153, 245, 249; VII
Cobb, Nathan F., 151, 152
Cobb decoys, 152, 153, 156–157, *157*
Cobb Island, Virginia, 151, 152, *155*
Colio, Quintina, 8, 240–247
Collins family, 71
Collins, Samuel (Sr.), 71
Common Crow, 195–197
 decoys, 195–197, *196, 197*
Common Egret, 55
 decoys, 55, *56*
Common Eider, decoys, 25, 27, 84, *93, 242*
Common Goldeneye, 91
 decoys, 25, 27, 31, *32,* 84, 87, *88,* 89, 105, 121, 126, 129, *131,* 134, 149, *162, 163*
Common Loon, decoys, *58*
Common Merganser, decoys, 25, 27, *152, 173,* 209, 213, *214;* V
Common Scoter, decoys, 25, 226, *226*
Common Snipe, 189
Common Tern, 57–58
 decoys, 57–58, *58*
Connecticut, 63–71
Connett, Eugene V. (III), 36*n,* 84*n*
Conover, George, 55
Coombs, Frank, 106–107, 108, *108*
Cornelius, John, 55
Corwin, Wilbur A., 104
Corwin, Wilbur R., 104–105
Cramer, Chalkly, 131–132, *133*
Cranford, Ralph, 103
Crisfield carvers, 146–149
Crisfield, Maryland, 146–149, *148*
Crow, 195–197
 decoys, 195–197, *196, 197*
Crowell, Elmer, 36, 40, *43, 56,* 73, 74, *74, 75, 77–82, 78, 79, 81,* 83–84, *84,* 237, 243, 249, 251; II, III
Crowell, Kleon, 77, 82
Crumb, Charles H., 154
Crumb family, 154
Crumb, Joseph H., 154
Culver, R. O.; *see* Holmes, Benjamin
Currier, James, 95, 143, 144, 146
Currier and Ives, 95

Dan's Duck Factory, Quincy, Ill., 229
W. D. Darton, Co., Portland, Me., 230
Davis, Jefferson, 152
Dawson, Joe, 140
Dawson, John, 139–140; VI
Dawson, Tube, 190
Decoy Evaluation Chart, 250
Deegan, Bill, 73

Delaware Bay, 136, 137
Delaware River, 136
Delaware River decoys, 136–137, 138–141, *139 140, 141*
Delaware Valley, 137
Denny, Samuel, 106–108
Dirksen, Frank, 160
Disbrow, Charles, 70
Dixon, Thomas (Jr.), 152, 156, *156*
 quoted, 155
Dize, Elwood, 147, *148*
Dodge, Jasper N., 209–215
J. N. Dodge Company, Detroit, 27, 180, 205, *206,* 209–215, *210, 211, 212, 213, 214*
Doughbirds; *see* Eskimo Curlew
Dowitcher, 35, 156
 decoys, 35, *37,* 42, 47, *51, 84,* 101, 103, 124, 126, 135, 156, *156,* 159, 160, 175, *176,* 223, 233; IV
Dudley, Lee, *14,* 24, 168–170, *169,* 249
Dudley, Lem, *14,* 24, *169,* 170, 249
Dunlin; *see* Red-backed Sandpiper
Duxbury, Massachusetts, 85–89
Dye, Ben, 144, *145*

Easton, Maryland, 146
Elliston, Robert A., 180, *181,* 182, 183, 186, 188, 189, 192
English, Mark, 134, *135*
Eskimo Curlew, 36, *44,* 60, 62–63, 76, 188–189
 decoys, 35, 44, *44*
Evans Decoy Factory, Ladysmith, Wisc., 228, 229, 249

Feist, Irving, 123
Finger Lakes, 106
Fitchett, "Hard Times," 151
Forbush, Edward Howe, 188, 197–199
Forester, Frank, 94
Forked River, New Jersey, 119, *120*
Frazer, Nate, 134
French, Joseph, 9, 182
Furman, Wallace, 8

Gadwall, 167
 decoys, 25, 27, *217*
Gaskill, Tom, *115,* 116
Gelston, Thomas H., 98, 99
Golden Plover, 36, 46, 76, 92, 96, 97, 188
 decoys, 35, 46, *56, 76, 81,* 92, *93,* 223, *224,* 233; II
Grandy, A., *172, 173*
Grant family, 119
Grant, Henry, 113, 120–121, *123,* 249
Grant, Stanley, 121
Grant, Ulysses S., 143
Graves, G. Bert, 185–186, *187,* 189
Graves, Millie, 186

Graves, Orville, 186
"G. B. Graves Decoy Co.," Peoria, Ill., 186
Grayback; *see* Dowitcher
Great Black-backed Gull, *203*
 decoys, 202, *203*
Great Blue Heron, 54–55, 119
 decoys, 54–55, *55, 56, 59,* 133; I
Great Horned Owl, 196
 decoys, *19,* 196–197, *198*
Great South Bay, Long Island, 94
Greater Scaup, 31, 61, 170
 decoys, 25, 27, *65,* 67, *68,* 70, *75,* 115, 116, 120, 121, 126, *131,* 134, 137, 170, 180, 182, 250
Greater Snow Goose, 167
 decoys, 25
Greater Yellowlegs, 35
 decoys, *35, 42, 43,* 44, *88, 99,* 113, 119, 126, 223
Green, E. S. (Jr.), 118
Greenlee, Kenneth, *181,* 190
Green Plover; *see* Golden Plover
Green-winged Teal, 13, 146
 decoys, *14,* 25, 27, *34,* 146, *147,* 184, *193,* 247
Griggs, Dan, 174
Grinnell, George Bird, 179
Grubbs Manufacturing Co., Pascagoula, Miss., 230
Gunpowder River, 142

Hackensack, New Jersey, 111
Haertel, Harold, *193, 193,* 247
Haff, John, 153–154, 177
Hall, Severn, 24–25
Hammell, Guarner, 134
Hance, Ben, 113–114
Hancock, Herbert, 73
Hancock, Miles, 38, 159–160
Hancock, Russell, 73
Hankins, Ezra, 114–115
Hardy, Jack, 105
Hatch, Herbert F., 86–87
Havre de Grace, Maryland, 143, 144, *145, 206*
Hay bird; *see* Pectoral Sandpiper
J. M. Hays Wood Products Co., Jefferson City, Mo., 230
Heath Hen, 11
J. P. Hendricks Co., Santa Barbara, Calif., 230
Herring Gull, decoys, 126, 202, *203, 204,* 243
Herter's, Inc., Waseca, Minn., 229
W. G. Higgins Co., Kansas City, Mo., 229
Hitchens, George, 156
Holly, "Daddy," 144
Holmes, Benjamin, 64, 66–68, *68,* 69, 71, 180, 192, *207*
Holmes, Lothrop, 88, *89*
Hooded Merganser, decoys, 25, 27, *141, 163,* 164, 245